TEMPLES OF BOOKS
Magnificent Libraries Around the World

gestalten

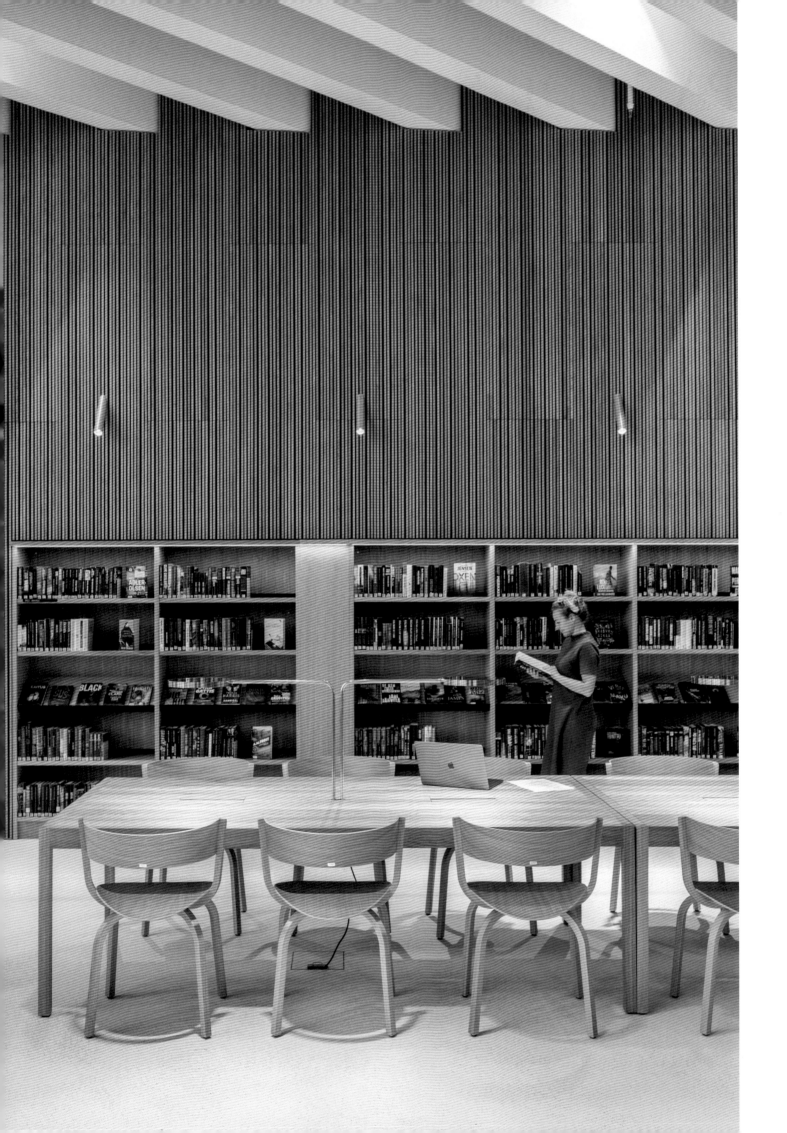

PARADISE REINVENTS ITSELF

INTRODUCTION BY MARIANNE JULIA STRAUSS, AUTHOR AND CO-EDITOR

The Argentinian writer Jorge Luis Borges once said that he always imagined Paradise to be a kind of library. Could he have been picturing a place of winding spiral staircases and precious manuscripts, like the Jesuit Library at Maria Laach Abbey (p. 30)? Perhaps he was imagining an inspiring, book-filled "living room" enjoyed by an entire community, like at Kirkkonummi's shimmering copper library (p. 22). Or a library like the Parque Biblioteca España (p. 188)—a powerful demonstration of how education can usher in social change.

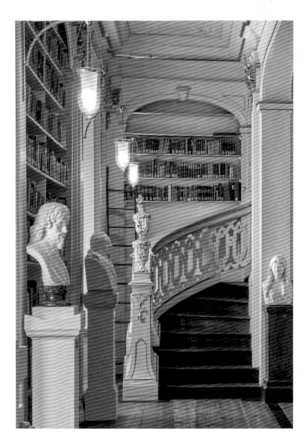

Temples of Books explores the history, mission, architecture, and changing role of selected libraries around the world. The following pages reveal extraordinary public and private collections, national and monastery libraries, repurposed engine sheds, and UNESCO-protected mud buildings from Mexico to Vietnam and Mauritania. These libraries are merely representative of their fellow institutions across the globe, all seeking to curate and preserve knowledge that has been accumulated over the years. There are some 120,000 libraries in the United States alone, of which around 70 percent are school libraries designed to inspire, educate, and entertain the adults of tomorrow.

Knowledge Is Power

The history of libraries goes back to Mesopotamia 5,000 years ago. Its first major milestone was the Library of Alexandria in the 3rd century BCE. As this peerless temple of knowledge grew, it transformed Alexandria into →

→ the scientific, intellectual, and cultural capital of the ancient world (p. 222). Different peoples came together here, and new knowledge emerged. Librarians started to develop the systems of cataloging and categorization that their successors use to this day. For the first time, the world's entire collective knowledge was brought together under one roof. The Library of Alexandria was fairly ruthless in acquiring it: scrolls were confiscated from any ships that berthed at the city's docks, and only returned in the form of a copy. The original manuscripts of Sophocles' *Tragedies* were "borrowed" for an astronomical fee, but never returned. While all this was going on, thinkers, philosophers, and scientists were also enjoying the active support of the ruling family.

Although this golden age of the empire originally founded by Alexander the Great was short-lived, its cultural impact was immense. When the Roman Empire assimilated the very last areas of land dominated by Hellenistic culture just before 0 CE, it also took over the libraries. The Library of Alexandria was expanded under Claudius, and the famous Hadrian's Library was built in Athens in 132 CE; the ruins of Hadrian's Library can still be visited today. During Roman antiquity, libraries flourished everywhere from Britain to Jerusalem, and so did the level of education. When the Western Roman Empire crumbled, the cultural focus of the northern hemisphere shifted to the Islamic world. At around the same time that religious fanatics were burning non-Christian books in Europe, Fatima al-Fihri, a wealthy merchant's daughter with a thirst for knowledge, founded what is now the world's oldest library in constant operation in Fez, Morocco (p. 174).

Meanwhile, the libraries of Western Europe filled up with texts that conformed to doctrine. In their scriptoria, monks diligently copied and illustrated the Bible and countless works by thinkers from antiquity, thus preserving them for posterity. Even today, their precious manuscripts reside within monastery walls, as at Strahov, Czech Republic (p. 12), and Schlägl, Austria (p. 104). Universities gradually began to build up their own collections. In the early 14th century, the Bishop of Worcester founded the oldest collection in the now-legendary Bodleian Libraries (p. 216), which not only constitute a working library for Oxford University but also served as a backdrop for magical scenes from the Harry Potter films.

The Roman Emperor Hadrian had the legendary Hadrian's Library (right) built in Athens, with an extensive archive of scrolls, four halls, and a courtyard lined with columns. Across the Mediterranean lay the Library of Alexandria, whose successor (top) continues its legacy today.

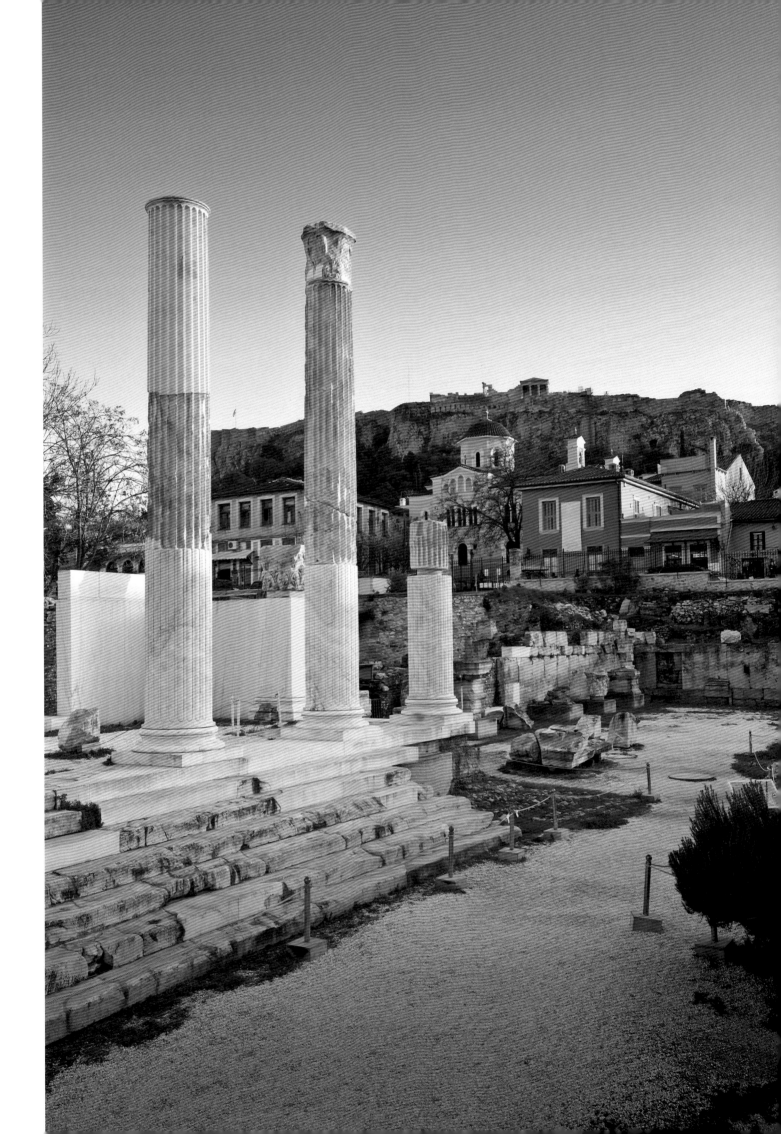

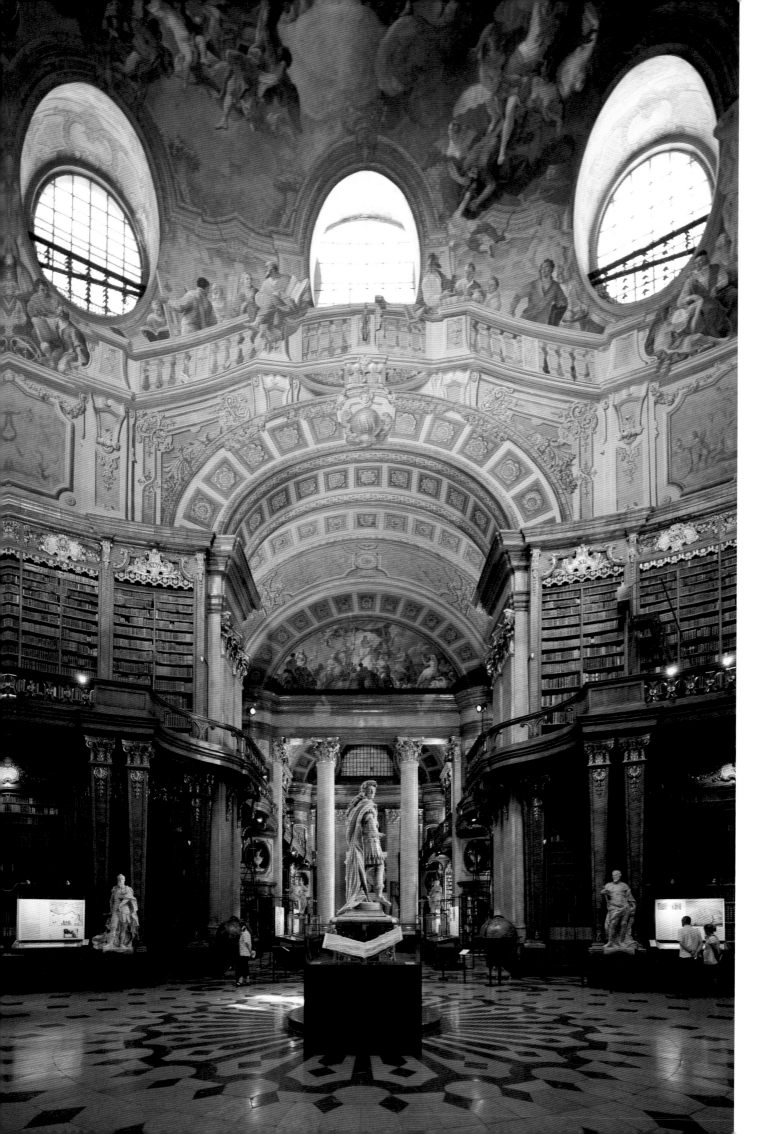

Libraries Gain Momentum

People must have felt that they were witnessing sorcery when they first encountered the movable-type printing press invented by Johannes Gutenberg in the 1440s. As the number of books exploded, knowledge spread like wildfire, igniting the Renaissance. In Florence, the Medici family invested in timelessly beautiful architecture and founded the first private libraries, while the Protestant princes further north began to amass important book collections. Having a library became a status symbol. In West Africa, the minor caravan post at Chinguetti (p. 170) became a place of pilgrimage for scholars thanks to its libraries. In the southern hemisphere, the Inca are believed to have recorded their rich knowledge on canvas and stored them in large archives. At around the same time, the first Europeans landed in South America and founded Western-style libraries, thus imprinting their books, ideas, and values on the continent. The Real Gabinete Português de Leitura (p. 272) in Rio de Janeiro is testament to that period and continues to engage with the historical legacy of the colonial era through genuine exchange and critical scrutiny. Even in the 20th century, libraries continued to spread western ideas all over the world. In 1920, for instance, colonial settlers from the Netherlands created some 2,500 libraries in present-day Indonesia, stocking their shelves with journals, reference books, technical manuals, and Javanese translations of adventure fiction from the West.

As early as the 17th century, the abbots of European monasteries started having exquisite baroque halls built specially to accommodate their growing collections of books and manuscripts. Scandalous and Enlightenment writings found their way into the infamous "poison cabinets"—sections of the library kept under lock and key and only accessible to librarians of impeccable moral standing. The number of secular libraries also increased. In 1712, Trinity College in Dublin laid the foundation stone for its Long Room (p. 258), which remains its crown jewel. In Vienna, the Holy Roman Emperor Charles VI spent a fortune on his court library, still one of the most beautiful national libraries in the world (p. 236). Meanwhile, thinkers like Diderot, Hume, and Kant were sowing the seeds of the Enlightenment, and they fell on fertile soil.

Opening Up the Institution

The French and American revolutions turned the social order of the Western world upside down. The palaces and stately homes of the erstwhile rulers were opened up and their accumulated knowledge poured into the hands of the bourgeoisie. In France, the royal library became the property of the people. While still in its infancy, the United States founded the ambitious Library of Congress, today the second-largest research library in the world. For a time, Johann Wolfgang von Goethe worked as a librarian at the →

A larger-than-life statue of Emperor Charles VI stands in the middle of the magnificent hall of the Austrian National Library (left). The monarch commissioned the beautiful building as his court library. The rococo hall of the Duchess Anna Amalia Library (right) in Weimar is just as impressive, and it is a UNESCO World Heritage Site.

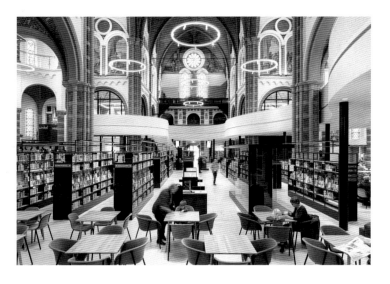

→ Duchess Anna Amalia Library and its famous rococo hall, doubling its inventory of books during his tenure. Learning was no longer the sole preserve of the privileged few—lending libraries sprang up all over the place and became popular places for the middle classes to gather. Rather than academic works, these readers tended to be interested in literature as entertainment, including poetry and fiction by authors like Gustave Flaubert, Mark Twain, and Charlotte Brontë, who remain hugely popular today.

The turn of the 20th century marked a new focus on library design: big-name architects, such as Alvar Aalto and Rem Koolhaas, and a whole host of librarians from all over the world redefined the library as an essential element of any downtown area, with flagship modern architecture. These were to be places of egalitarian learning, entertainment, community, and education for all. The library finally assumed a role at the very heart of society—and it didn't stop there.

Today, the almost 2,000-year-old St. Catherine's Monastery, at the foot of Mount Sinai, is digitizing its historical manuscripts in order to make these rare artifacts accessible to anyone who might be interested. Mexico's Biblioteca Vasconcelos (p. 228) draws in visitors with appealing add-on features revolving around art, culture, and its botanic garden. The Uncensored Library (p. 164) exists exclusively online and makes the censored works of brave journalists from all over the world freely accessible.

As an institution that can curate knowledge, scrutinize the status quo, and encourage education, the library is more important today than ever. This responsibility is only growing as the freedom to publish on all manner of channels increases. Its job is to infuse our collective memory with truth. As such, the library is not, as is often feared, the victim of new media advancements, but rather a willing participant in them. It is constantly evolving to keep pace with society, with events that foster a sense of community, workshops, book nights, exhibitions, free computer use, and new digital options. Reaching back millennia, its roots provide the perfect grounding for healthy cultural growth all over the globe. Jorge Luis Borges had it exactly right: the library is a paradise, and its constant reflowering is the proof.

Marianne Julia Strauss is a travel journalist who writes about the good things in life. After her first book Do You Read Me?, *published by gestalten in 2020,* Temples of Books *is again dedicated entirely to the love of books.*

Opened in 2013, the Library of Birmingham (right) is home to 800,000 books and the most important Shakespeare collection in the United Kingdom. The hallowed halls of the Bibliothek DePetrus (top)—built in the 19th century and formerly a church—are now home to a museum and community center.

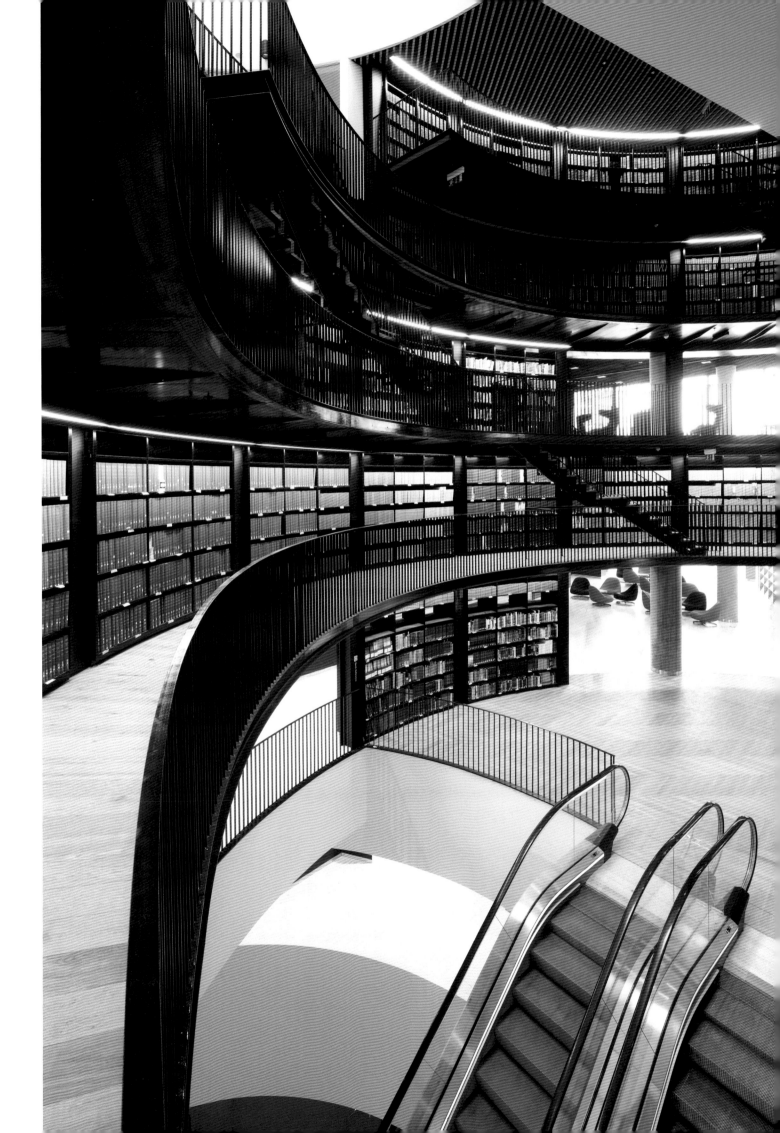

STRAHOV MONASTERY LIBRARY

Where else would you find a cabinet of curiosities connecting halls dedicated to theology and philosophy?

DESIGNED BY GIOVANNI ORSI DE ORSINI AND IGNAZ PALLIARDI
BUILT 1671–1790
PRAGUE, CZECH REPUBLIC

Strahov Monastery Library is the largest of its kind in the Czech Republic and boasts a formidable collection of manuscripts, maps, and precious scriptures. The founding of the monastery in the 12th century was followed by the early-Baroque Theological Hall, which was finished in 1679 and expanded in 1721. The inscription across the vaulted ceiling reads *Initio sapientiae timor domini:* "The beginning of wisdom is fear of the Lord." Today the library's shelves mainly hold theological writings and various translations of the Bible. During the High Baroque period, the two-story Philosophical Hall was built, with exquisite walnut shelves reaching all the way up to the frescoed ceiling. In the 18th century, the corridor running between these two magnificent halls was filled with an ever-growing collection of strange finds from nature, from dried rays to yellowed tusks. However, the library's most treasured possession is a book of Gospels dating from the 9th century, in jewel-encrusted bindings. Visitors today can marvel at a replica in the Cabinet of Curiosities.

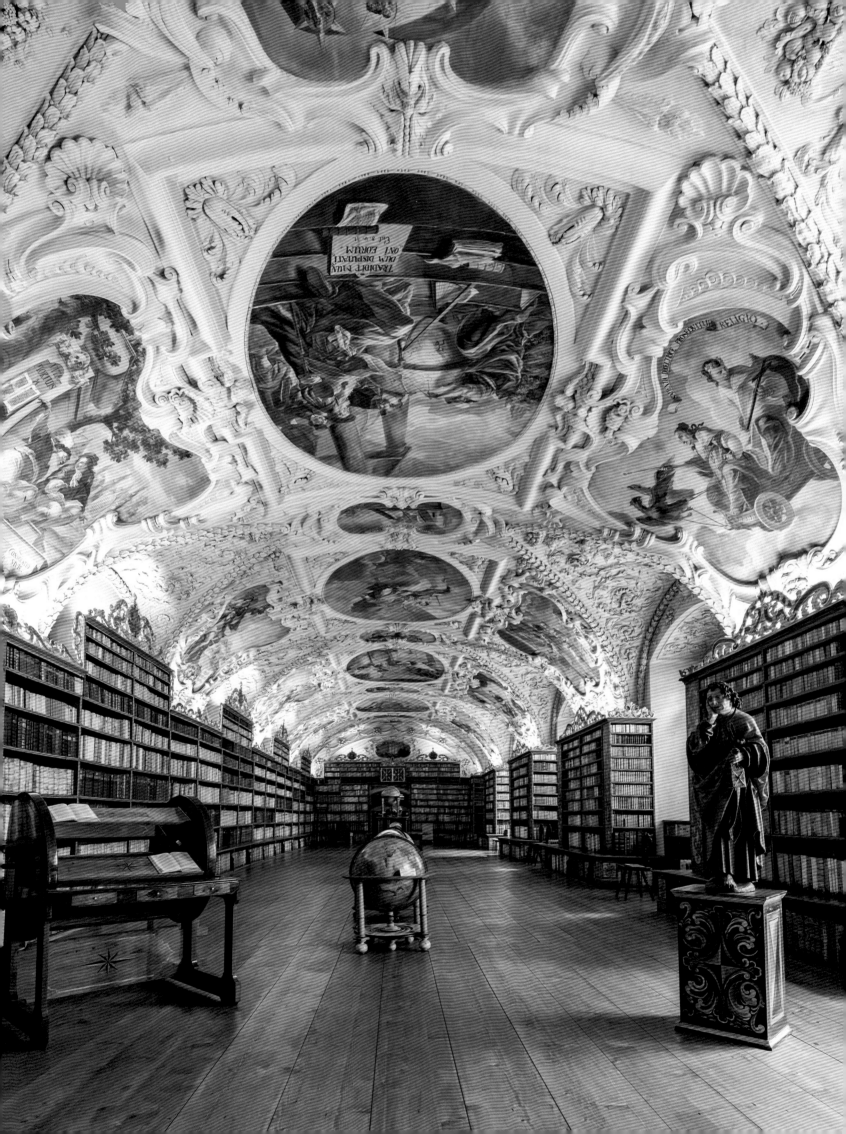

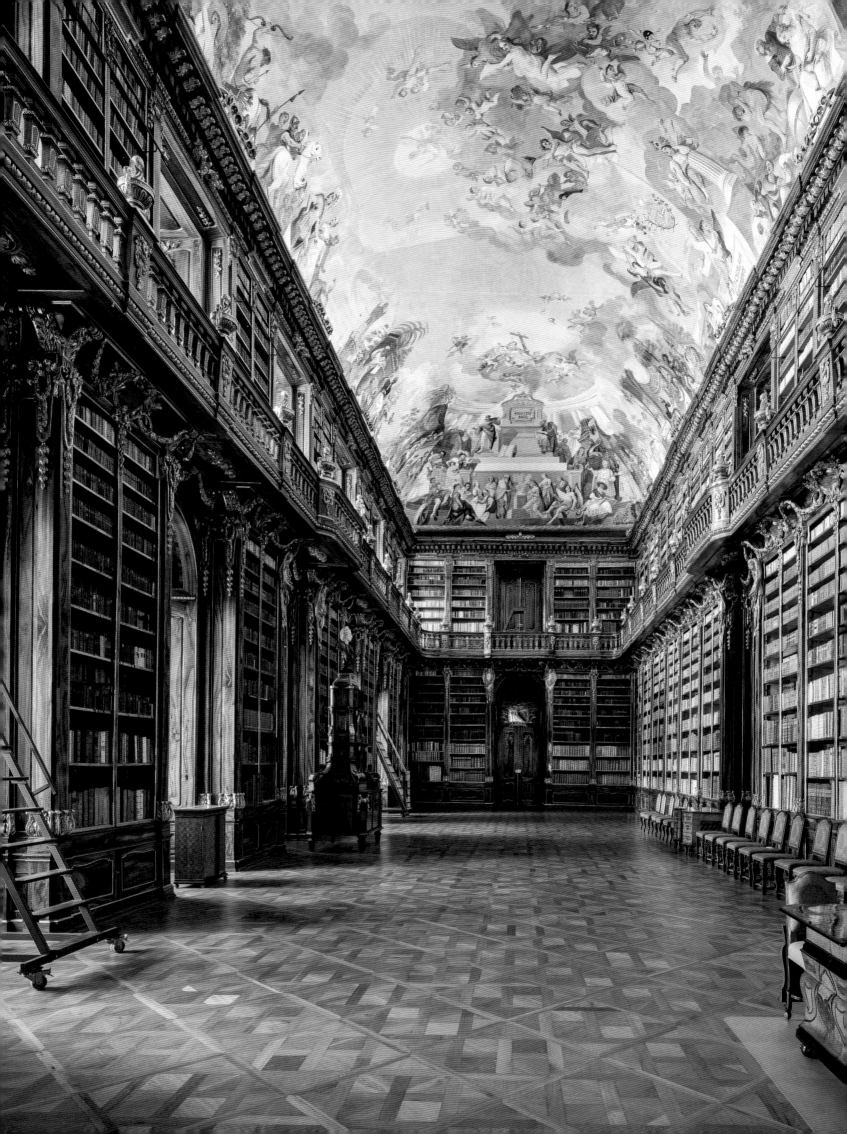

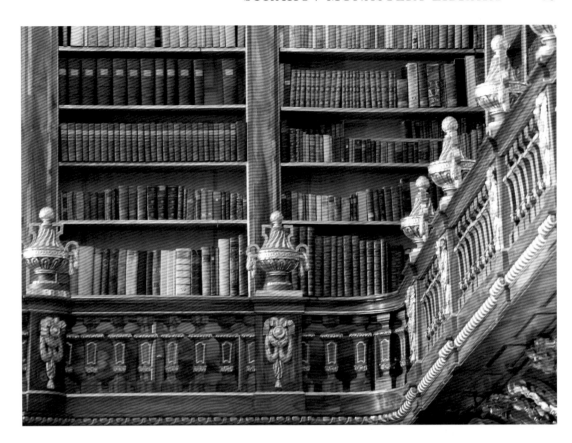

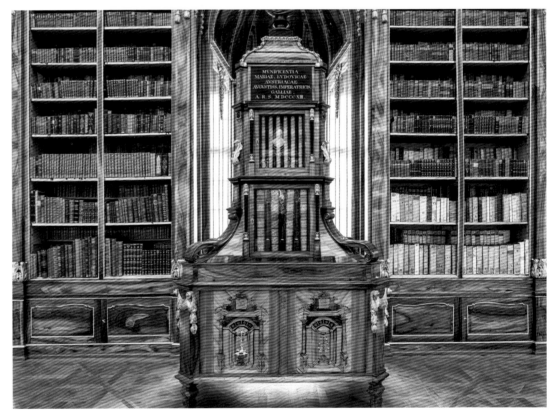

The Philosophical Hall (left), a high Baroque showpiece, was created in the late 18th century following plans by the Italian architect Palliardi. There are a good 42,000 books here, among them donations from Marie Louise of Austria, Napoleon Bonaparte's wife.

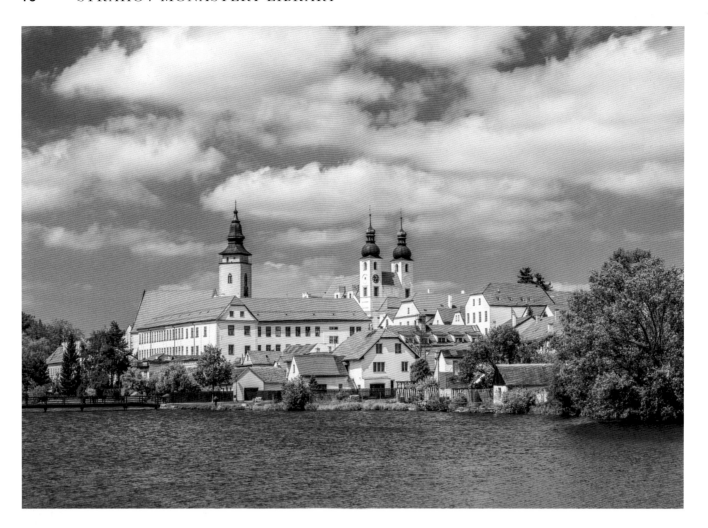

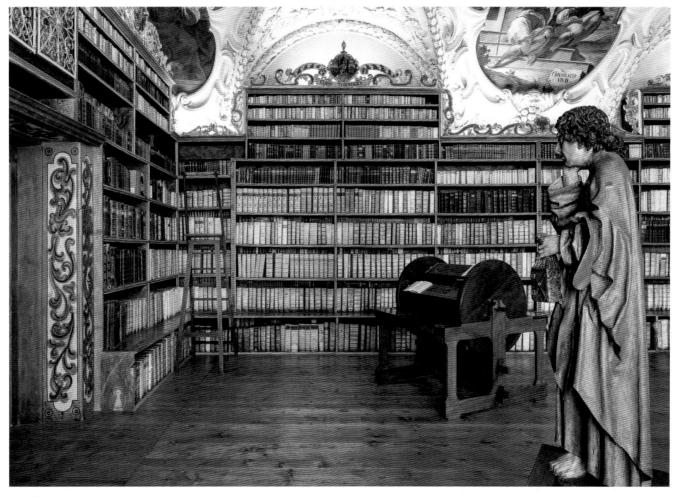

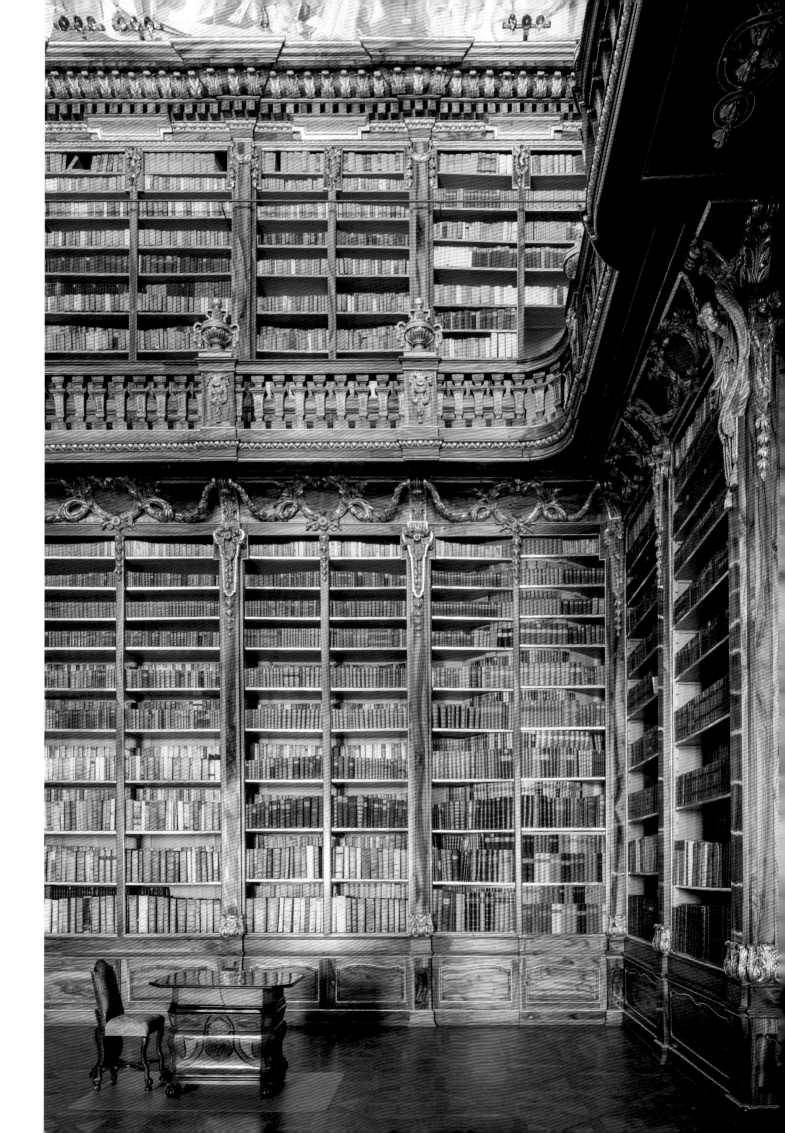

DEPETRUS LIBRARY

When this church needed saving from demolition, a team of architects transformed it into a sanctuary for book lovers

DESIGNED BY VON MOLENAAR & BOL & VAN DILLEN ARCHITECTS
CONVERTED IN 2018
VUGHT, NETHERLANDS

After several years of standing empty, this church, built in 1884 in Vught, Netherlands, was in a sorry state. When the local parish suggested that the former place of worship should be repurposed in a respectful way, a team of architects rose to the challenge. Today the people of Vught have exactly what the community needed: a gathering place complete with a museum, restaurant, bar, and several shops. At the heart of the building is the new DePetrus Library. The original floor plan and stunning stained-glass windows have been carefully preserved. The architects installed a new mezzanine level with spacious areas for study and meetings in the side aisles, so as not to detract from the majestic views down the nave. The new level also offers a spectacular view over the library from above. The heavy bookshelves are on rails and can be pushed aside, so DePetrus can morph into a venue for all kinds of events.

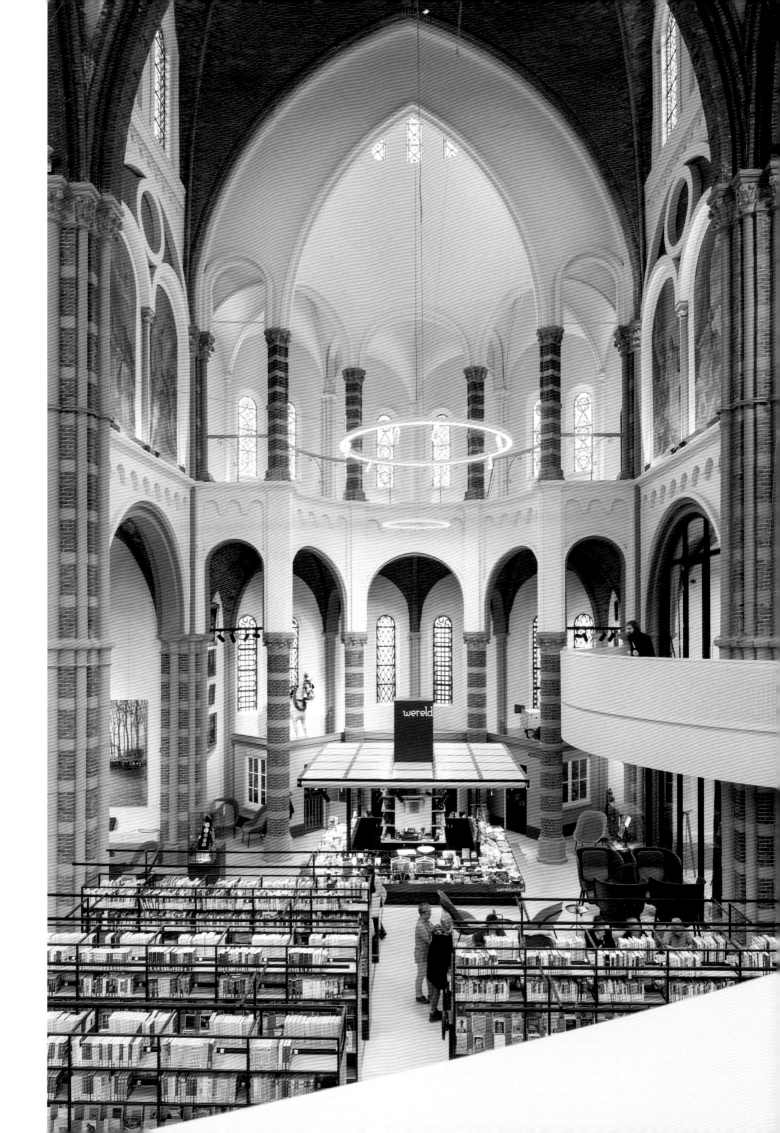

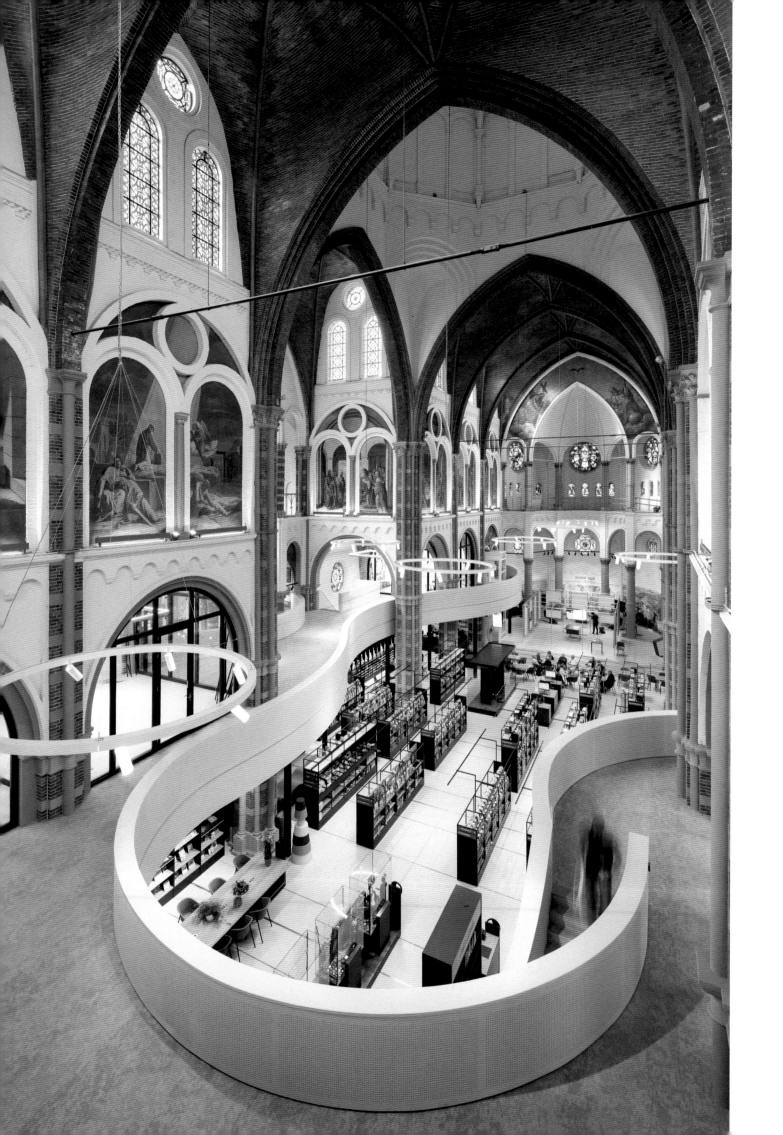

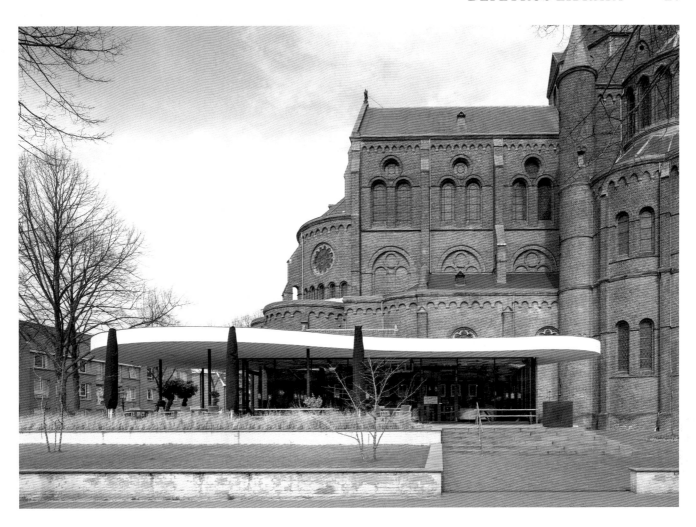

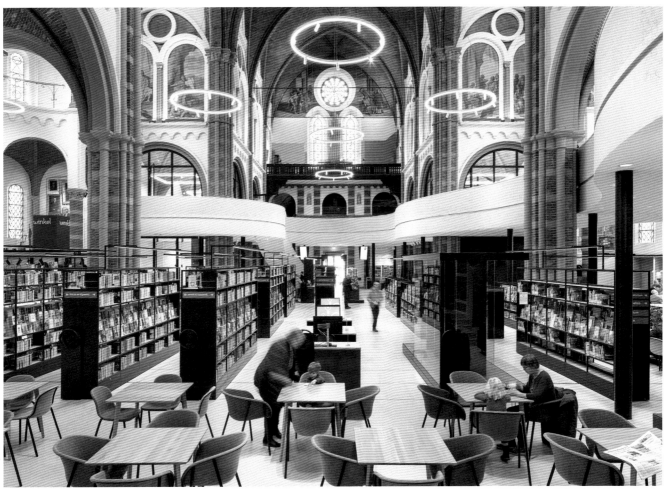

FYYRI LIBRARY

DESIGNED BY JKMM ARCHITECTS
BUILT IN 2020
KIRKKONUMMI, FINLAND

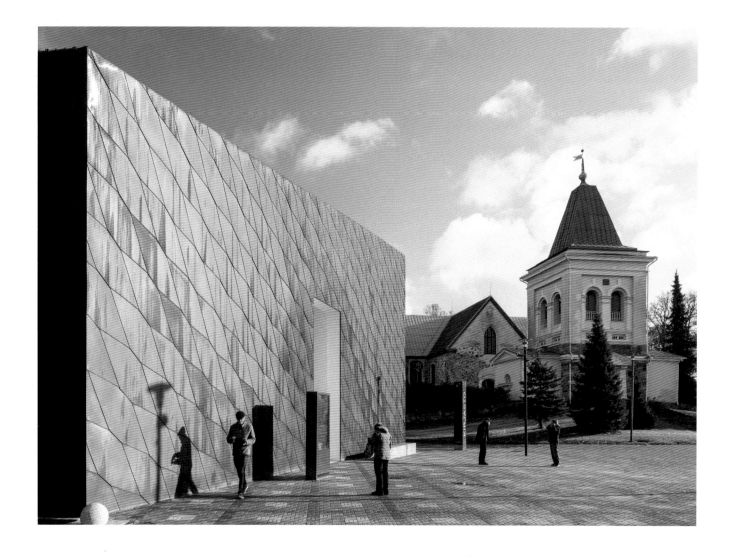

Behind shimmering copper shingles, exposed concrete columns, and long, vertical windows lies a new living space for this small Finnish city—a place of books, community, and contentment

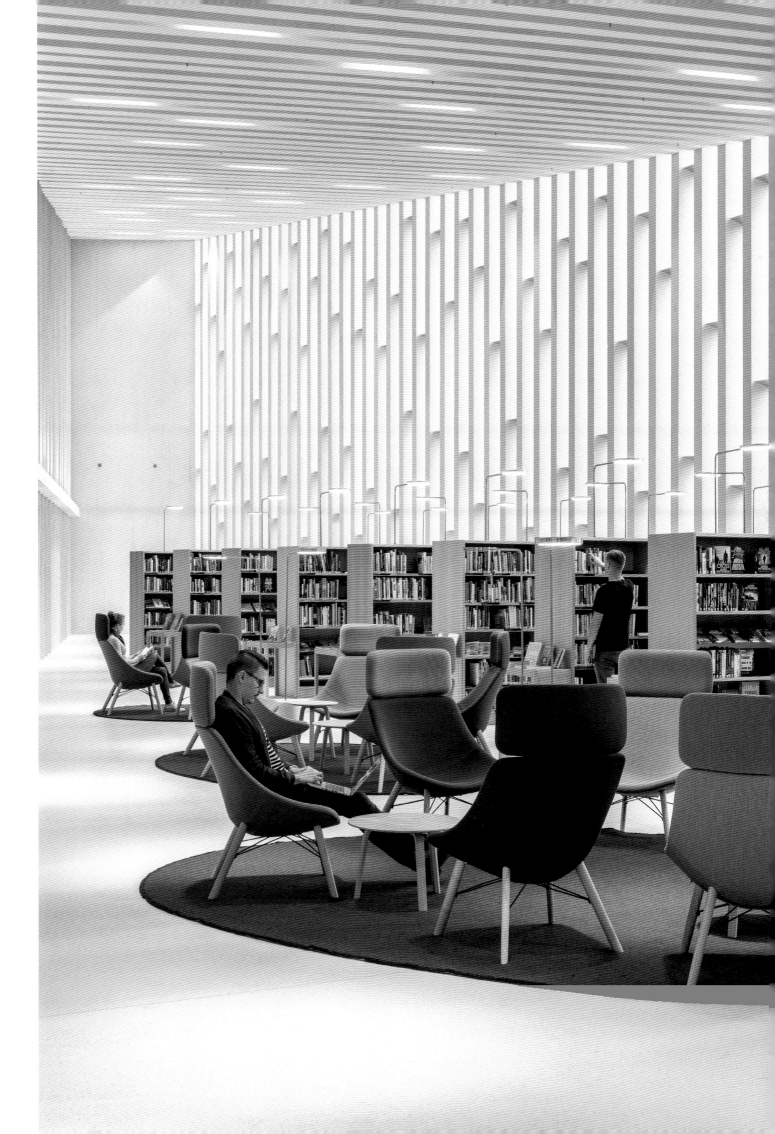

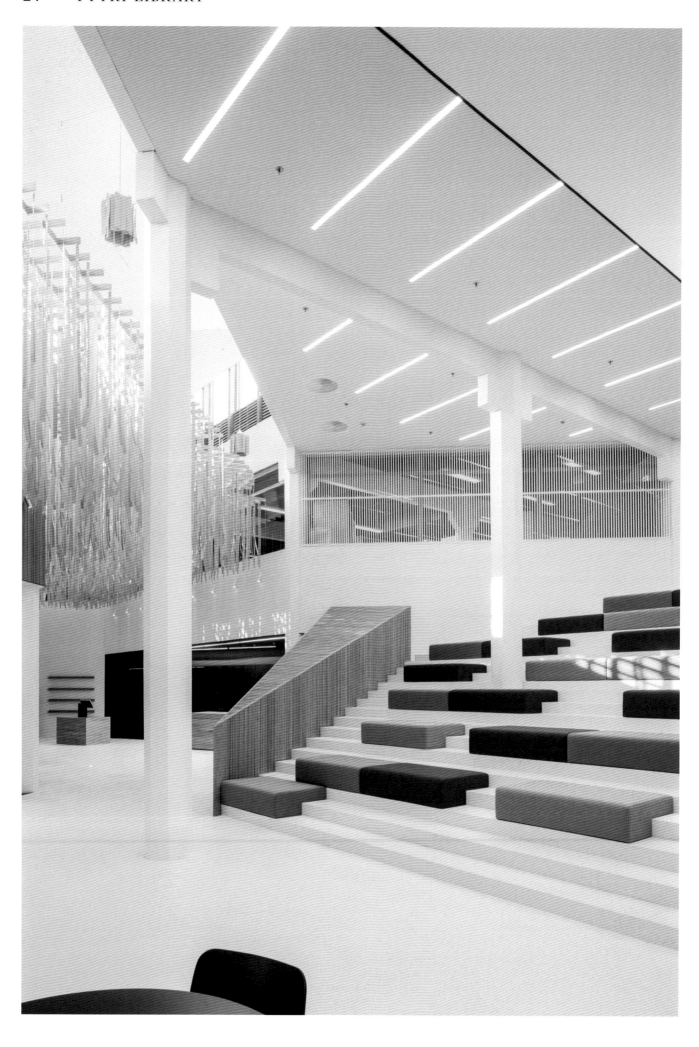

The future has taken up residence opposite the medieval stone church that marks the center of Kirkkonummi, a small city west of Helsinki. JKMM Architects converted and expanded the former Fyyri Town Library, originally built in the 1980s, and integrated it into a new design. The copper-shingle cladding glints in the sunshine. On the other side of the building, tall concrete pillars diffuse the natural light so that it pours into the vast open-stack library.

"Libraries represent the core values of our society," says Teemu Kurkela, a founding partner of JKMM. "Culture and knowledge are important, not just money. That's why I cannot imagine a city without values or a library." Fyyri represents a new generation of libraries that accommodate not only books, but also new learning options—and do a superb job of both. This worldwide phenomenon is fundamentally changing libraries as we know them. The exclusive nature of the old monastery libraries and the diktat of silence customary in their public counterparts are now coming up against new concepts of meeting and communal learning.

"Libraries need to keep changing with the times," says Kurkela. "The library in Kirkkonummi is no longer designed simply to house books, but to give people a new living space to come together and access knowledge. In the future, knowledge will change, and so should libraries."

Newspapers and magazines are laid out in the café of the city's new living room, and the reading lounge is proving popular. Those who want to stretch their legs can take a stroll around the exhibition area within the building. The program of events offers something for people of all ages and interests. Teens have a dedicated "chill zone," while next door, the youngest visitors to the library can romp around between child-friendly felt shapes. Fyyri is more than living up to its new role as a gathering place. It's easy to see why JKMM Architects won the selection process with their proposal, which sought to revitalize the heart of Kirkkonummi. And like a cardiac surgeon, an architect has to use the utmost care when operating on a living body—the city.

"We remodeled the existing library from the 1980s in a way that creates a strong community feel, for example by reiterating the relationship with the neighboring church," says Kurkela. "The difficulty was orienting the building so as to make the most of its connection to its wider urban setting. That was one of the reasons for introducing multiple →

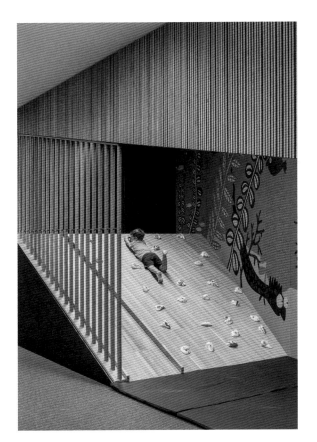

It wouldn't be a proper living room if it wasn't a place to read, play, and relax. In the bright, flowing foyer, the architects set up a contrast between quiet, softly lit nooks to retreat to and a mini paradise for children, complete with a colorful climbing wall.

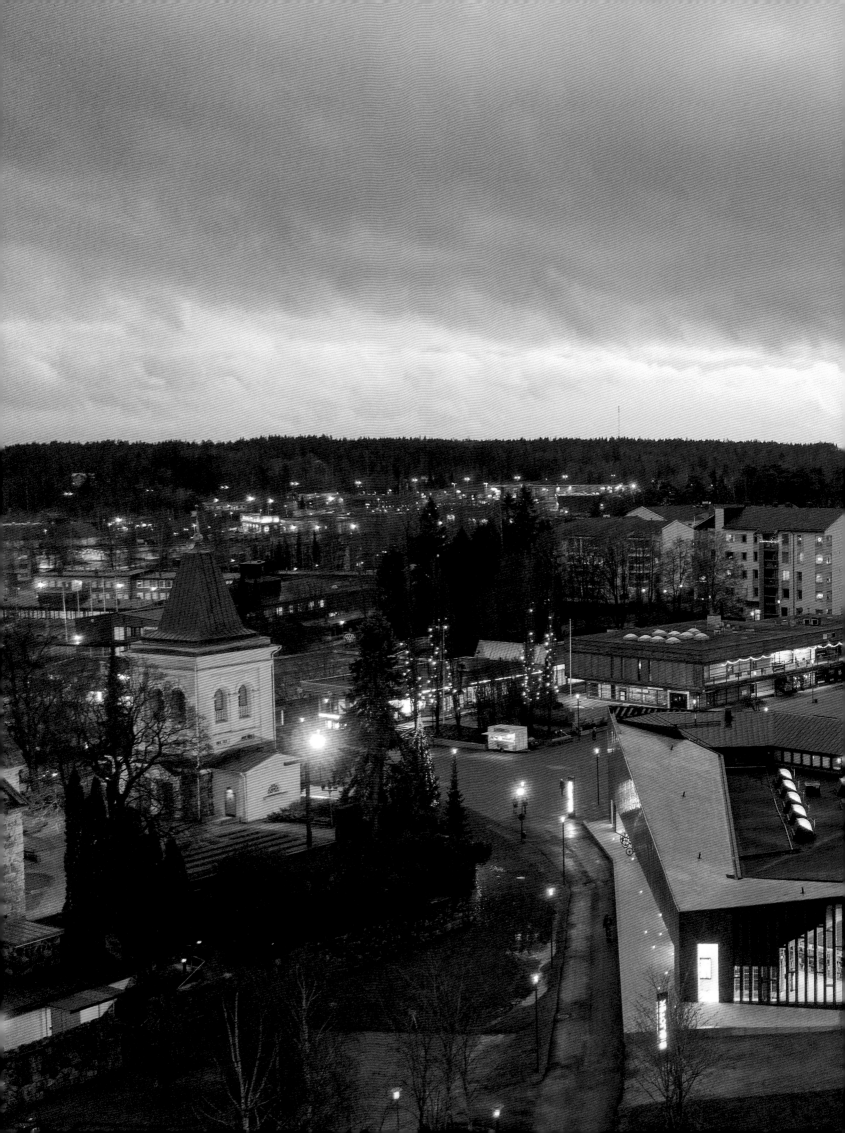

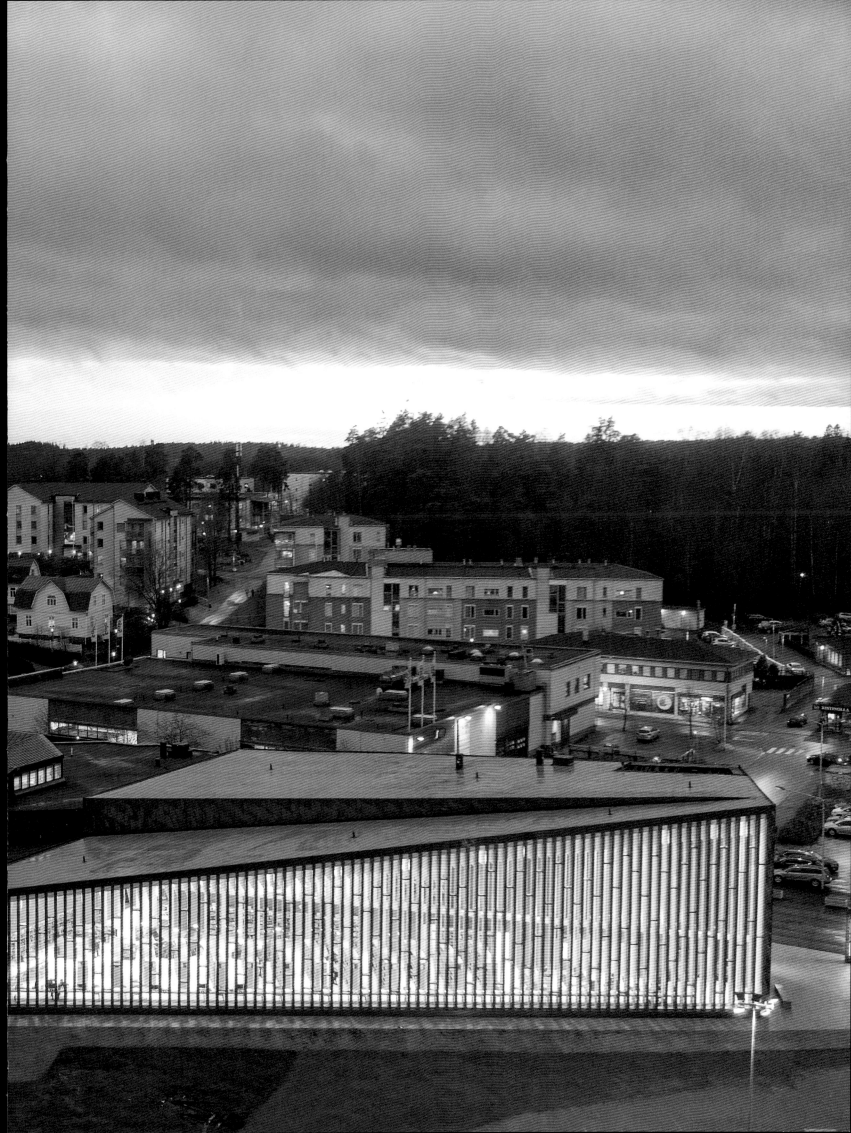

Fyyri is more than living up to its new role as a gathering place. It's easy to see why JKMM Architects won the selection process with their proposal, which sought to revitalize the heart of Kirkkonummi.

→ entry points to the building. A new design opens up opportunities and possibilities to level up the city as a whole, reenergizing and thus improving the public space."

This sense of social responsibility goes to the very core of JKMM's architectural designs. As a firm of architects based in one of the happiest countries on Earth, the team comes up with a lot of concepts aimed at boosting the feeling of happiness within society at large. JKMM bases its approach on a hierarchy of social needs, with business and technology at the bottom. The next level up is culture, knowledge, and well-being. At the very pinnacle is happiness.

"The building is very much about fostering a sense of inclusiveness, solidarity, and well-being within a community," says Kurkela. "The library was designed for the local people to use and enjoy. Libraries are important cornerstones of society; in fact, the whole library system can be seen as infrastructure geared towards happiness."

From Fyyri's terrace, you can look straight out onto the bell tower of the medieval church, also covered in copper. At the same time, you're gazing into the future; the little church is the very epitome of growing old in style, while remaining a stalwart of the community. Can Fyyri do the same? "I hope the library will look even better in 50 years than it does now," says the architect. "That it will be filled with life, generations of locals who have enjoyed it, and its copper façade will have developed a beautiful green patina. The modern library will be as familiar a feature of the cityscape as the medieval church."

JKMM Architects have integrated the new Kirkkonummi Library into its urban setting to superb effect. As part of their design, they created several entrances, which define the walkways and angles inside the present-day building.

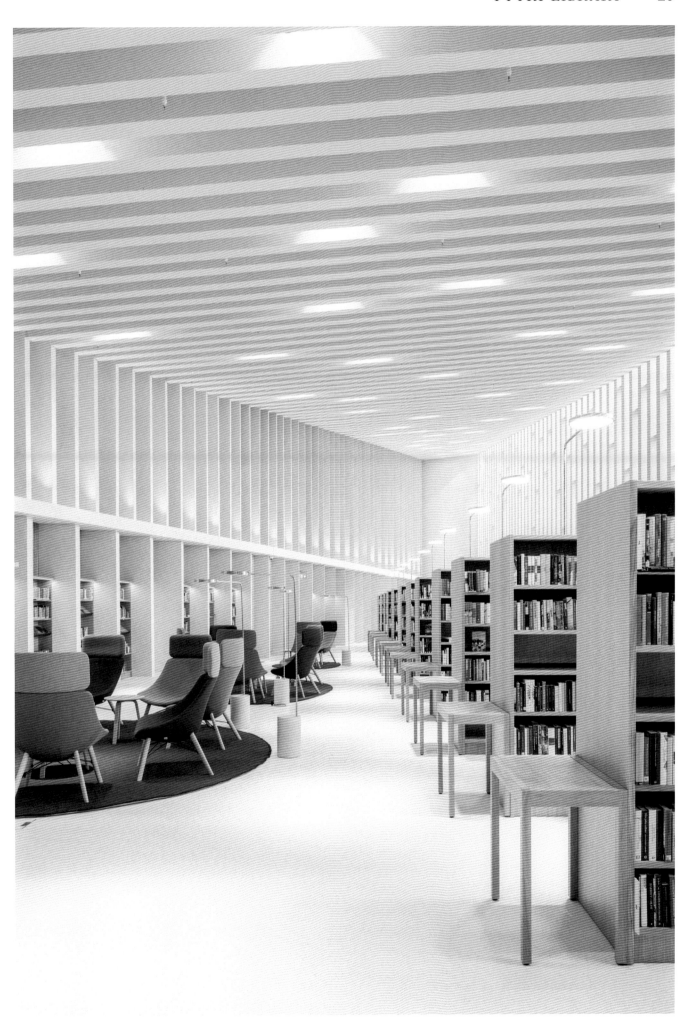

JESUIT LIBRARY AT MARIA LAACH ABBEY

CONSTRUCTED TO A BAROQUE-INSPIRED DESIGN

BUILT IN 1865

MARIA LAACH, GERMANY

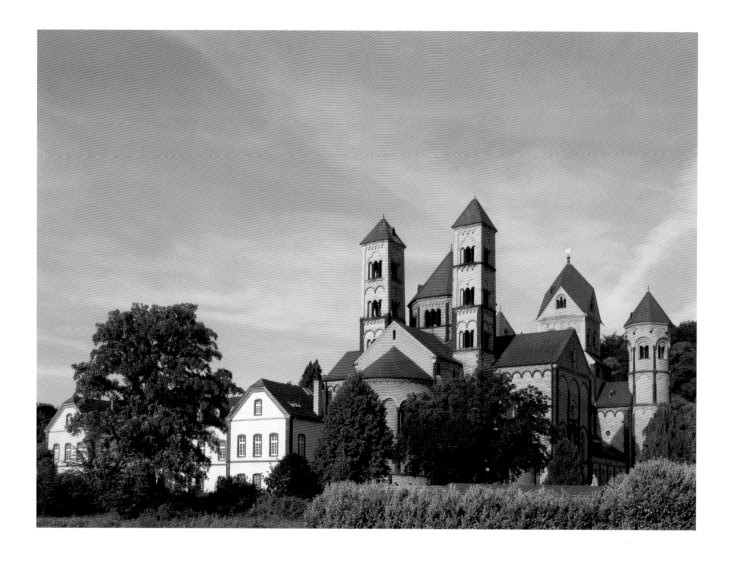

Modern monastery libraries move with the times and rely on climate-controlled stacks, book vaults, and digitization to preserve the priceless jewels of knowledge within

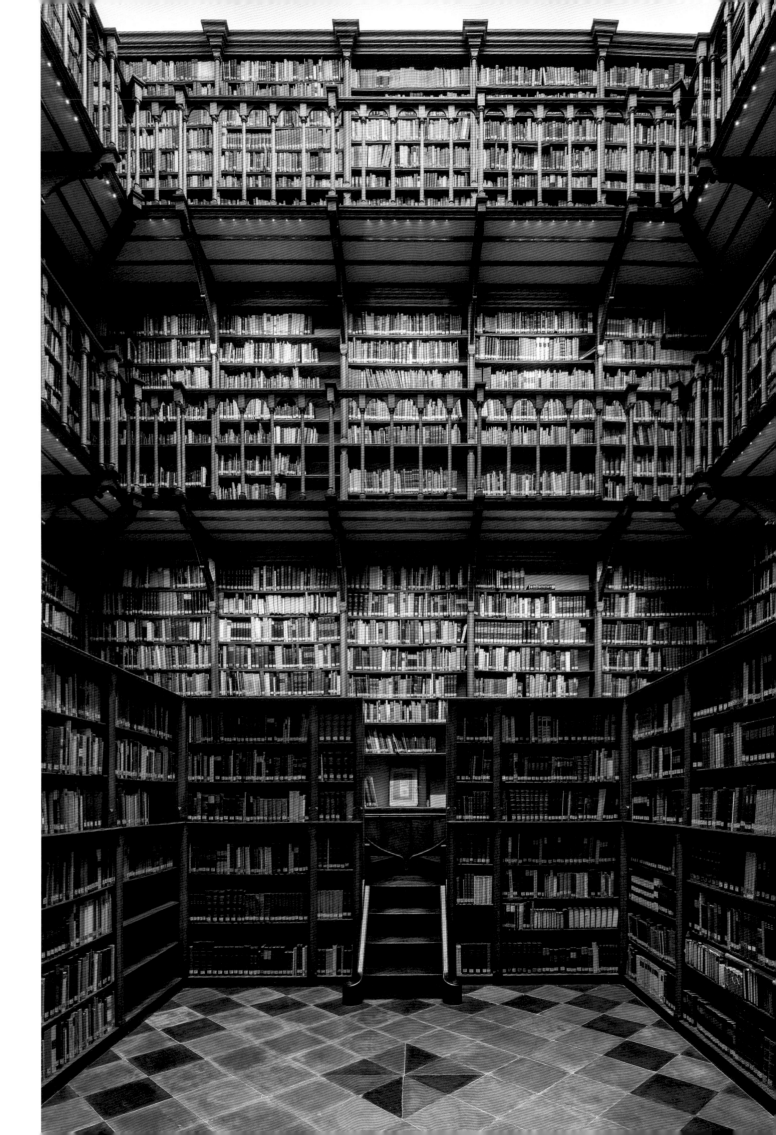

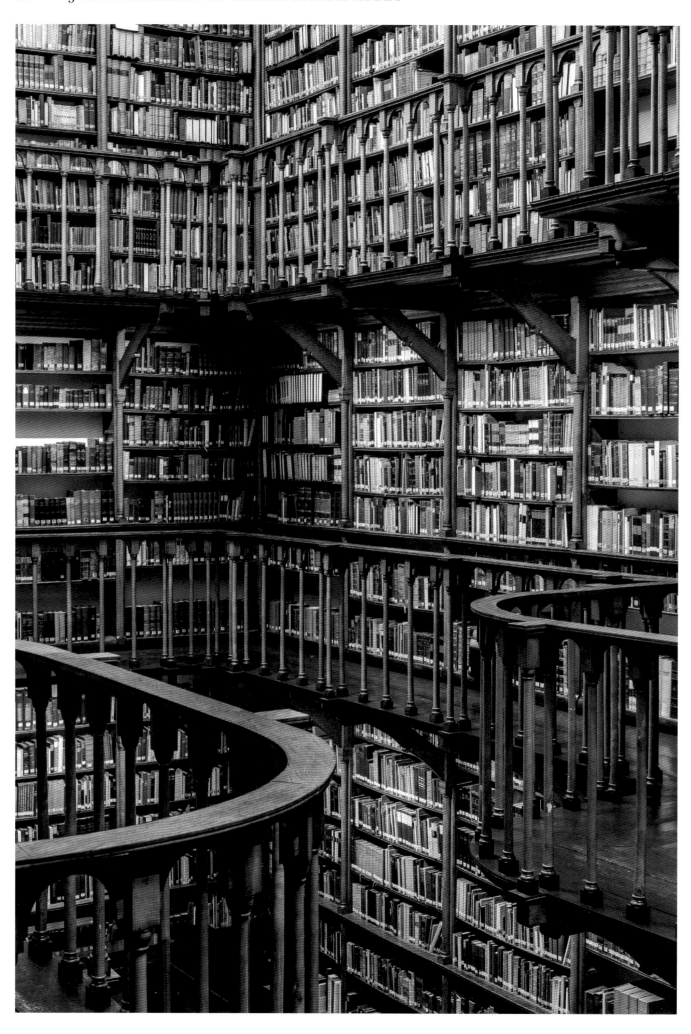

T he Latin motto of the Jesuit Library at Maria Laach Abbey is *Claustra sine bibliotheca sine armatura*: A monastery without a library is like a fortress without weapons. The abbey was founded in 1093 but closed after some 700 years. The Jesuit order acquired the entire complex in 1862 and added the library a little while later. Unfortunately, the Jesuits were only able to enjoy their magnificent building for a short time: they were expelled from the German Empire in the 1870s. Finally, after the abbey had been standing empty for 20 years, the Benedictines moved in and filled the orphaned library with books that had been gifted, donated, or bequeathed to them.

Some 40 Benedictine monks live and work at Maria Laach today. One of them is Father Petrus, the librarian responsible for the Jesuit Library at the abbey.

"Just recently, the library's books were included in Germany's official list of valuable cultural assets," says the priest. Since 2019, its precious books and manuscripts have been registered as cultural property, noting the exemplary nature of this monastery library, developed in the 19th and 20th centuries. Some key factors in this status were the almost 9,000 volumes written before 1800, the 95 early prints, some 100 incunabula, and seven manuscripts from the 14th and 15th centuries.

The collection of the Jesuit Library is growing all the while. "Every library has highlights in its collection," says Father Petrus. "In our case, we focus on theological subjects like liturgy and monasticism. We also collect literature relating to the region. Books may come into our possession if they're needed by the monks at the abbey or may be of interest to us. A monk reads aloud during mealtimes at the monastery, so we also purchase books for that purpose."

The cast-iron steps and many little wooden landings are striking features of the Jesuit Library. It is modeled on the tradition of Baroque monastery complexes and is now one of the most important monastery libraries by virtue of its cultural legacy. "Originally, it wasn't actually a monastery library at all," says Father Petrus. "The library was built as a Jesuit study house when the order was based here." Overall, the Jesuit Library numbers some 265,000 volumes today, including manuscripts of incalculable value such as a chapter book of martyrology dating from 1500, the Laach Necrolog, and the Rule of St. Benedict, in which the founding saint sets out the precepts of monastic life.

Umberto Eco once said that the library is a labyrinth, and therefore no less than the image of the world. With its winding corridors and its works on all disciplines, from medicine to mathematics, Maria Laach comes very close.

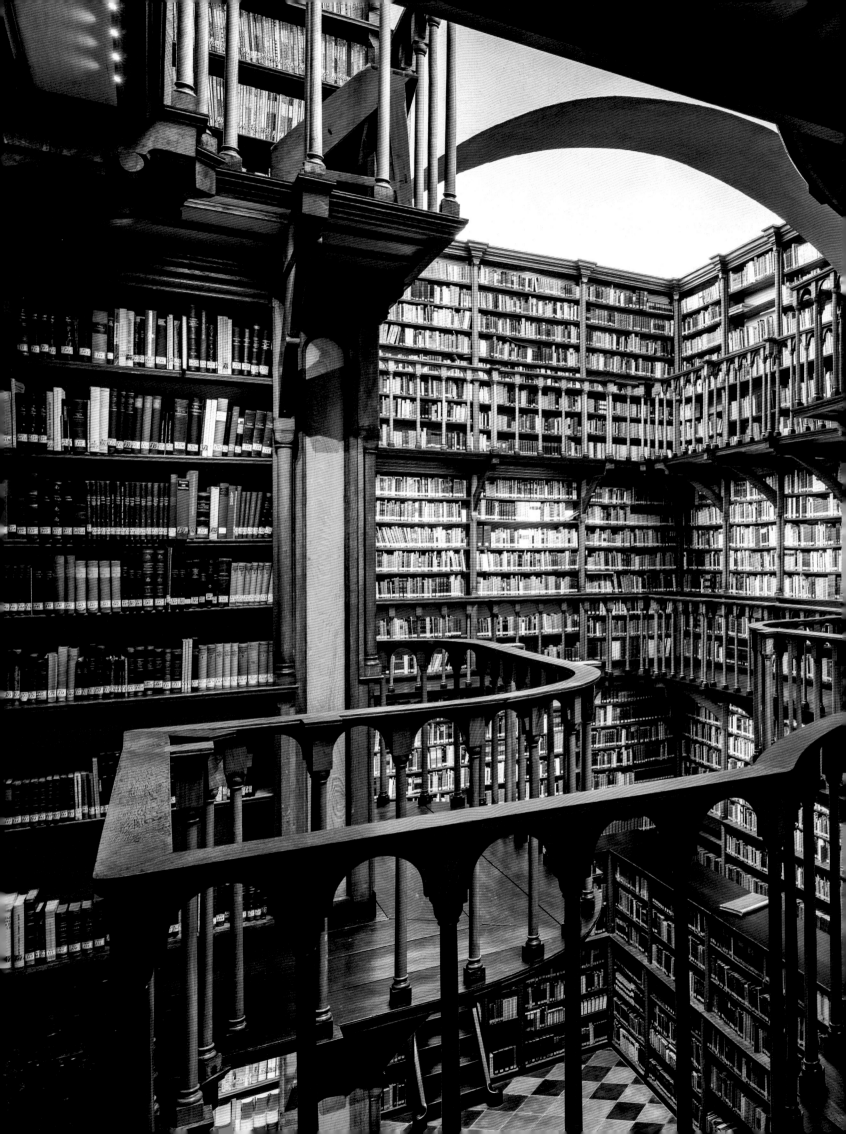

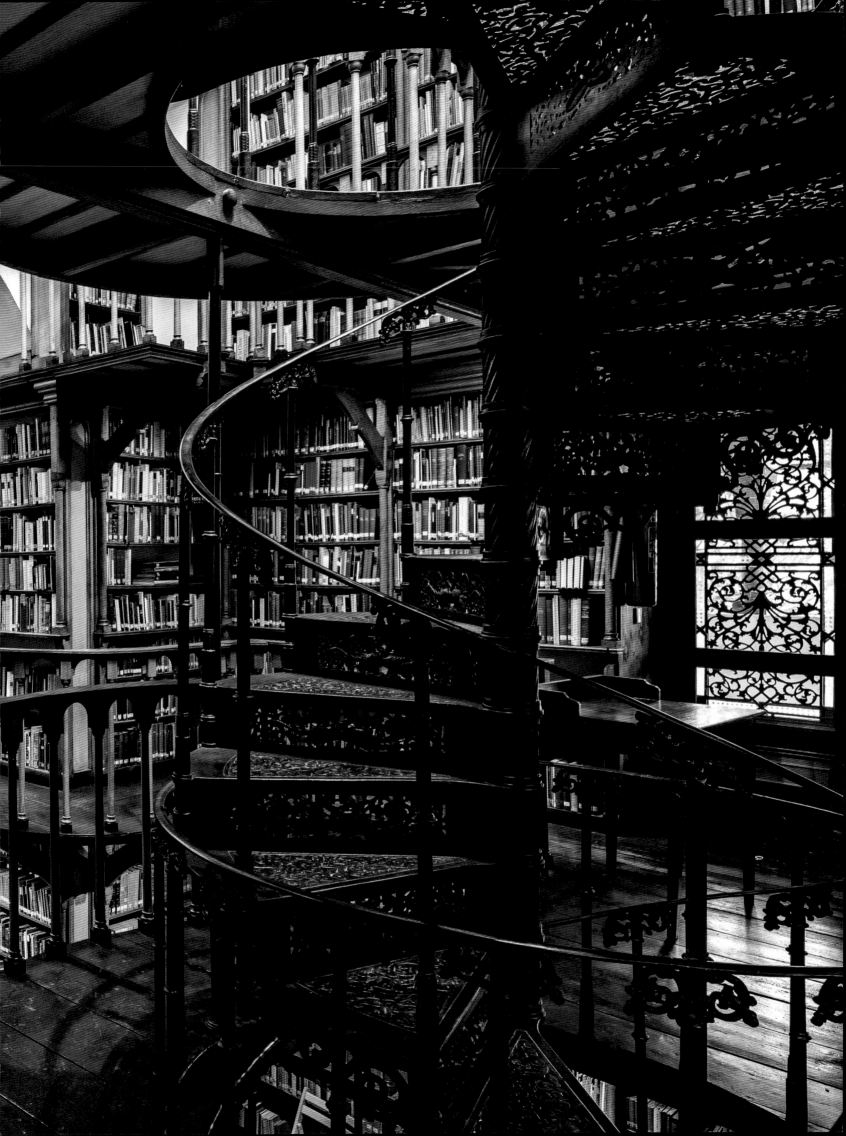

"We also provide volumes on inter-library loan if they're requested from other libraries, so the contents of the collection are accessible to anyone outside the monastery who may be interested."

Monastery libraries all over the world continue to play a leading role in the preservation of such ancient knowledge. Many books have survived the centuries thanks to the thick monastery walls and the care of the monks. Today, many of these pieces are gradually being digitized and stored afresh in perfect environmental conditions, including at Maria Laach Abbey.

In 2013, new book stacks were created in a former cowshed due to lack of space. "This is home to books that were catalogued after 1970, among others," explains the priest. "The 8,900 books that are older than 1800 are also stored in the new stacks." Especially rare items go into the rare book stacks. This is where Father Petrus keeps the cimelia—ancient Greek for "treasures."

"The library is used for academic work and serves the needs of the monks here," he says. "We also provide volumes on inter-library loan if they're requested from other libraries, so the contents of the collection are accessible to anyone outside the monastery who may be interested." The Jesuit Library also offers popular guided tours on a regular basis. Bibliophiles and architecture enthusiasts can register online for the themed library tour and experience the charm of the creaky floors, curved bannisters, and well-thumbed manuscripts for themselves. "I'm always delighted when our library arouses a new interest in books among visitors," Father Petrus concludes. "It gives them a sense of the cultural and intellectual wealth that resides in the volumes here."

One thing's for certain: His monastery has the very best weapons of any fortress of knowledge.

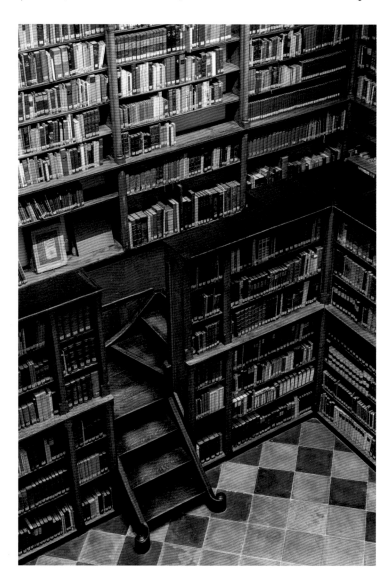

At one time, offensive works—from lust to Luther—were securely stored on the upper floors. Today, the monastery demonstrates a more enlightened attitude, proving that the Regula Benedicti can fit very well into modern times.

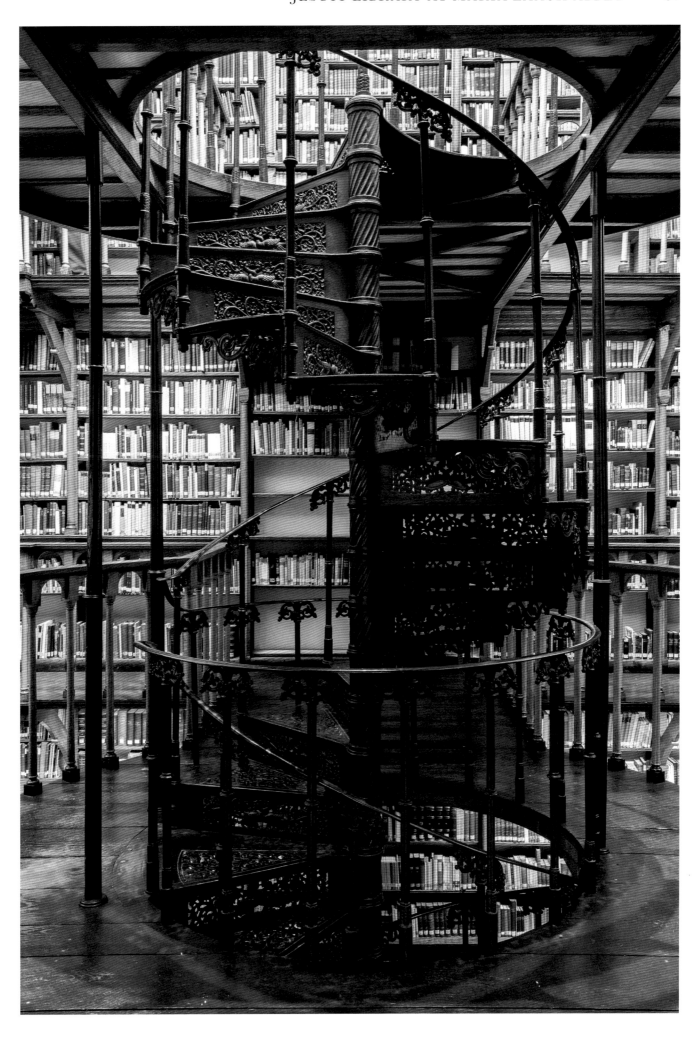

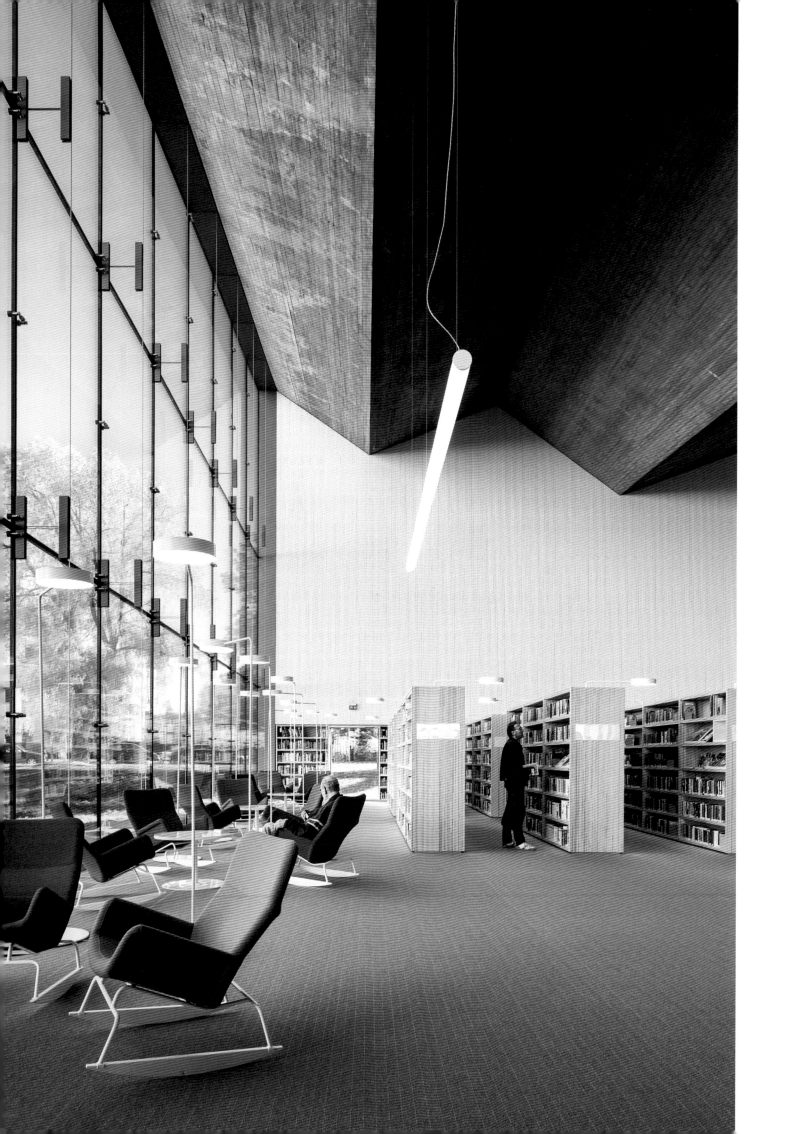

SEINÄJOKI LIBRARY

This bold yet sensitive addition to an iconic library is a stunning success in its own right

DESIGNED BY ALVAR AALTO AND JKMM ARCHITECTS
BUILT IN 1965, EXPANDED IN 2012
SEINÄJOKI, FINLAND

In the 1960s, Finnish urban planner and architect Alvar Aalto realized his vision for designing the entire downtown area of Seinäjoki as a unified whole. This meant that an especially delicate touch was required when it came time to expand the main library. JKMM Architects won the contract with a bold proposal that respected the existing architecture. Their new building establishes a visual dialogue with the original library, making reference to the features of its older counterpart with a unique visual style that asserts itself within the townscape while blending in with the other buildings. At the same time, the new library meets the

requirements of today's users, as the spacious reading terrace inside can be used for events and serves as a popular gathering place. The architects also paid particular attention to the design of the areas dedicated to children and young people. The contrast is reflected in the façade: the copper-colored new building stands out against the white of Aalto's library and looks as though it was always intended to go there.

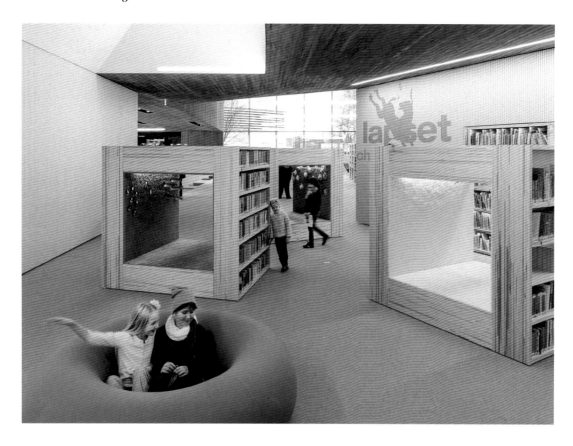

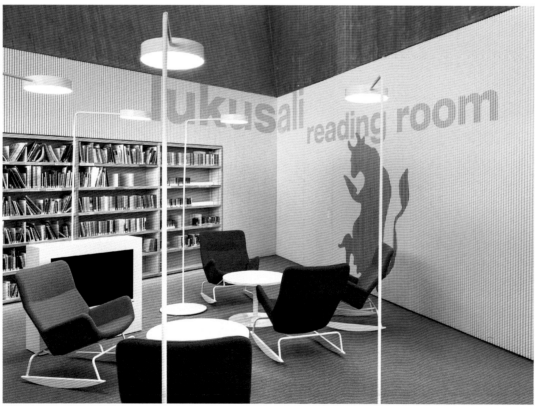

The architects paid special attention to an inspiring area for children and teenagers, as well as to the spacious reading area, which tells a story of its own and has transformed the Seinäjoki main library into a new meeting place.

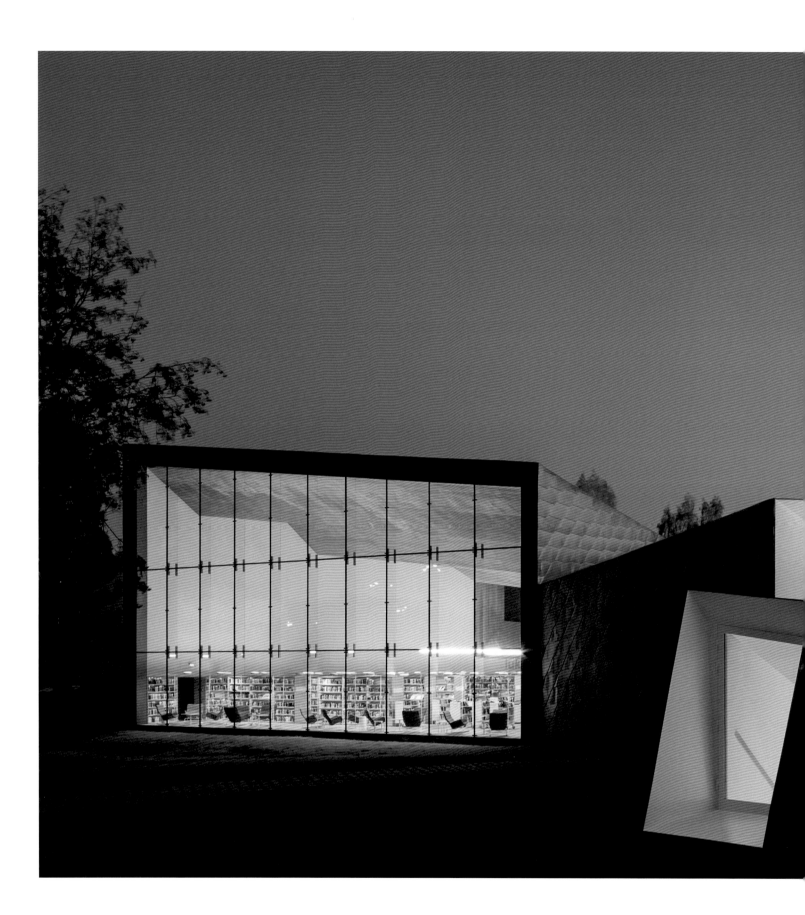

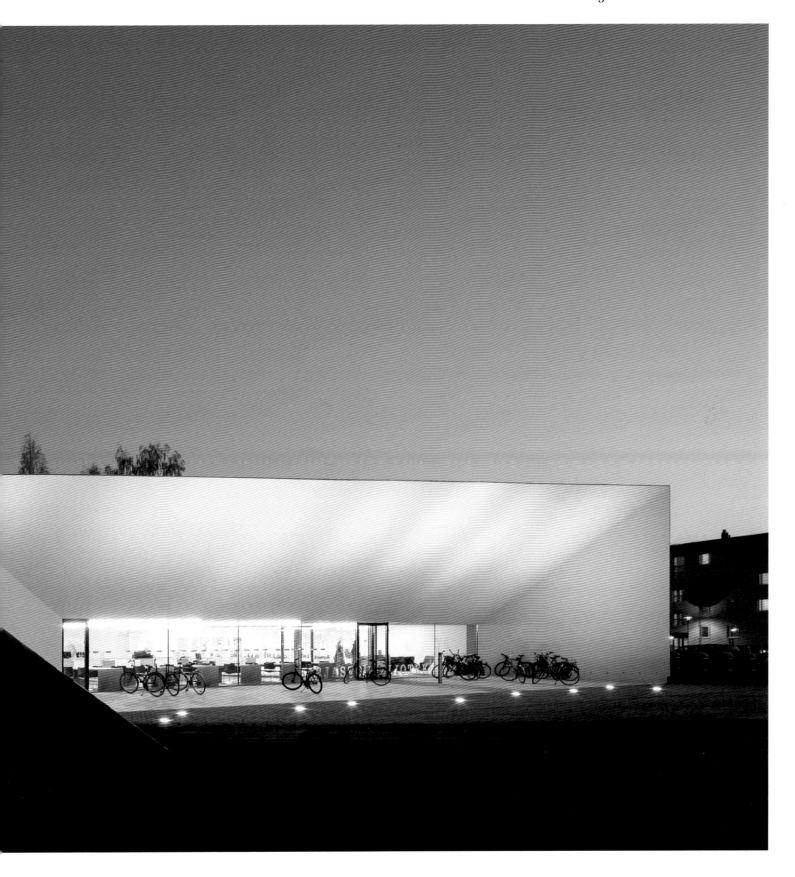

The library, conceptualized in the 1960s by Alvar Aalto, is a masterpiece of modern architecture and is part of a downtown area with a consistent design. The challenge for JKMM Architects was contained therein: to simultaneously respect the city's visual character and make a bold statement of its own.

HUNTERS POINT LIBRARY

Irregular-shaped windows frame glorious views of Manhattan and lend this library its remarkable structure

DESIGNED BY STEVEN HOLL ARCHITECTS
BUILT IN 2019
NEW YORK, NEW YORK, USA

This gleaming, white cuboid looms over the water in Long Island's waterfront district. Steven Holl Architects designed the Hunters Point site of Queens Public Library to stand out against the urban skyline along the East River. Behind the aluminum-coated concrete shell lies a vertically structured space comprising open-access stacks, little reading nooks, and larger event spaces. High ceilings and sweeping expanses let the imagination soar. There are separate areas for children, teens, and adults, with the distinction between them reflected by the irregular effect of the windows in the façade. From inside, those enormous windows frame glorious views of the skyscrapers of Manhattan, which lies across the water. The bamboo-wood surfaces create a sense of warmth and flood the building with bright light. Staggered stairs lead up through the floors to the covered reading terrace, with views over the river and the city. At ground level is the reading garden, which blends in seamlessly with the surrounding park. Come evening, the lights come on in Hunters Point Library, and there's no doubt about it: This truly is a shining example of superlative library design.

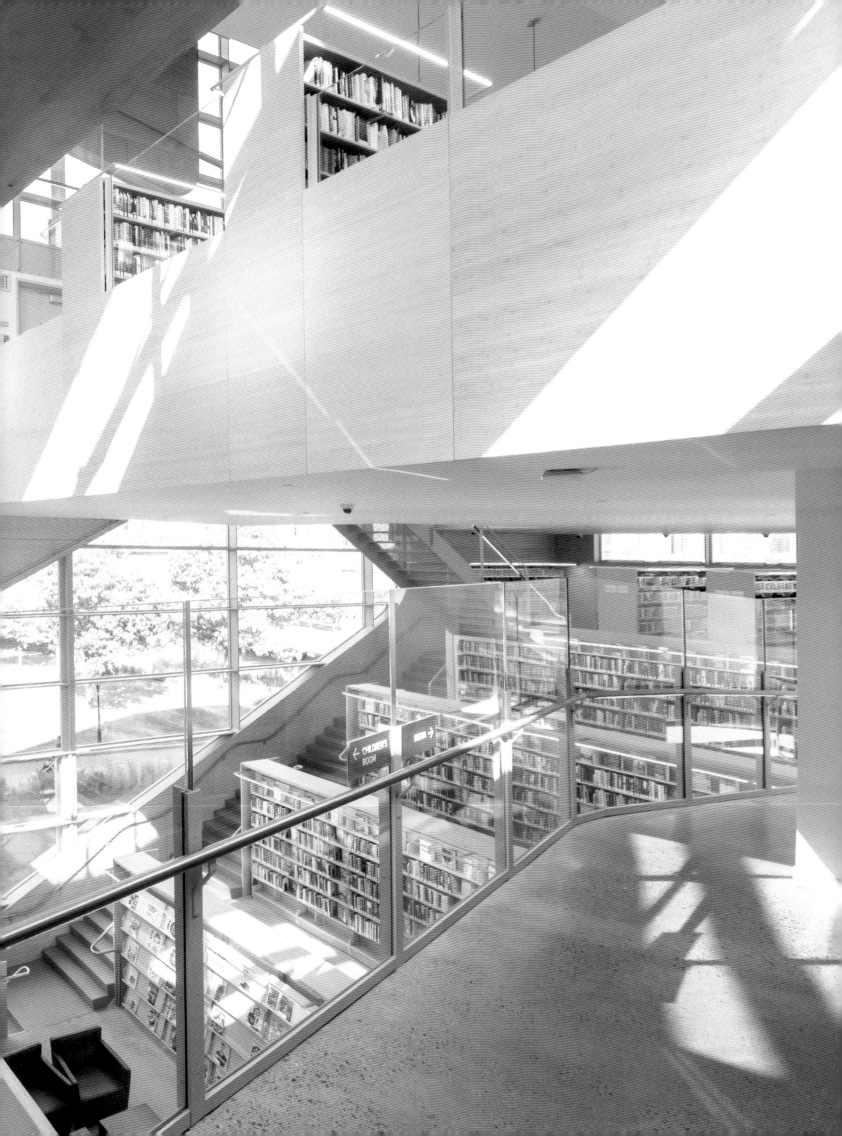

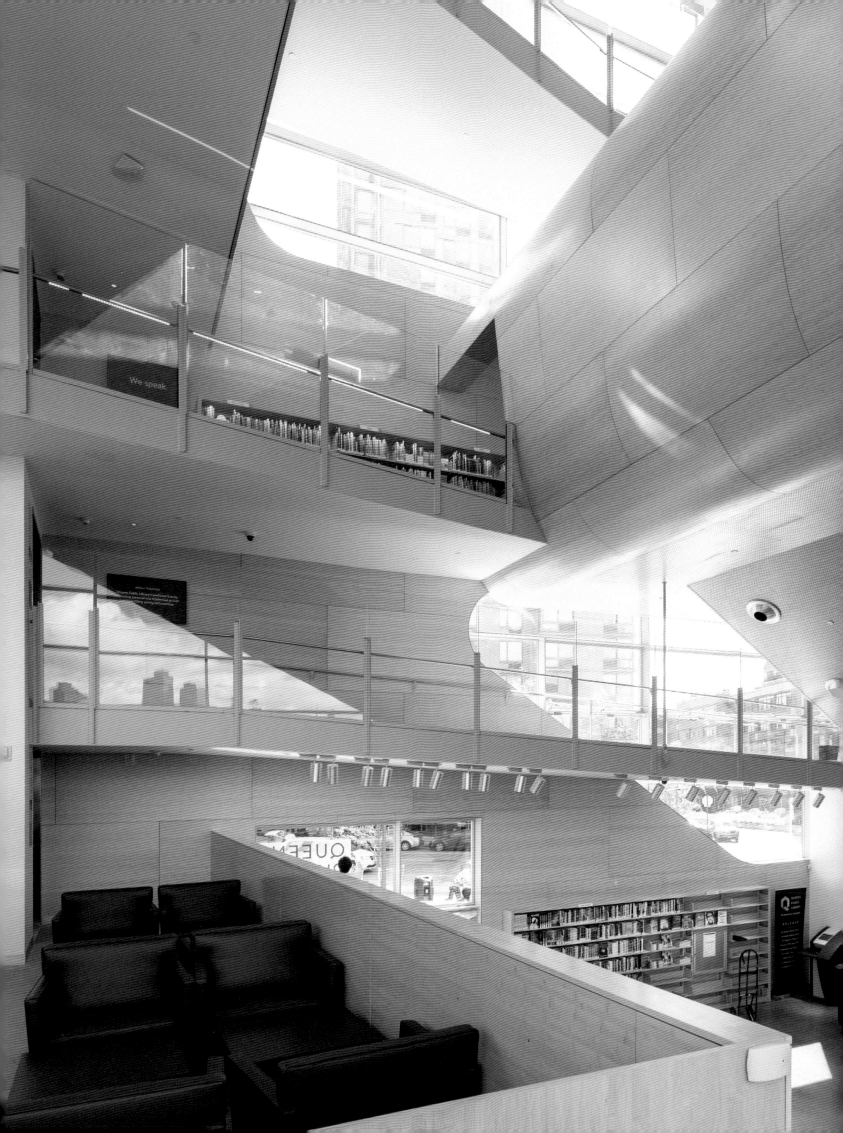

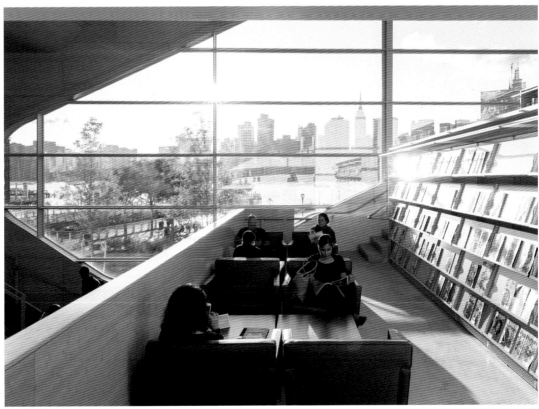

Bright, reader-friendly daylight streams through the organic cutouts in the Hunters Point Library façade. From the rooftop terrace opens an unobstructed view of the East River, and on the opposite shore, the Manhattan skyscrapers stretch toward the clouds.

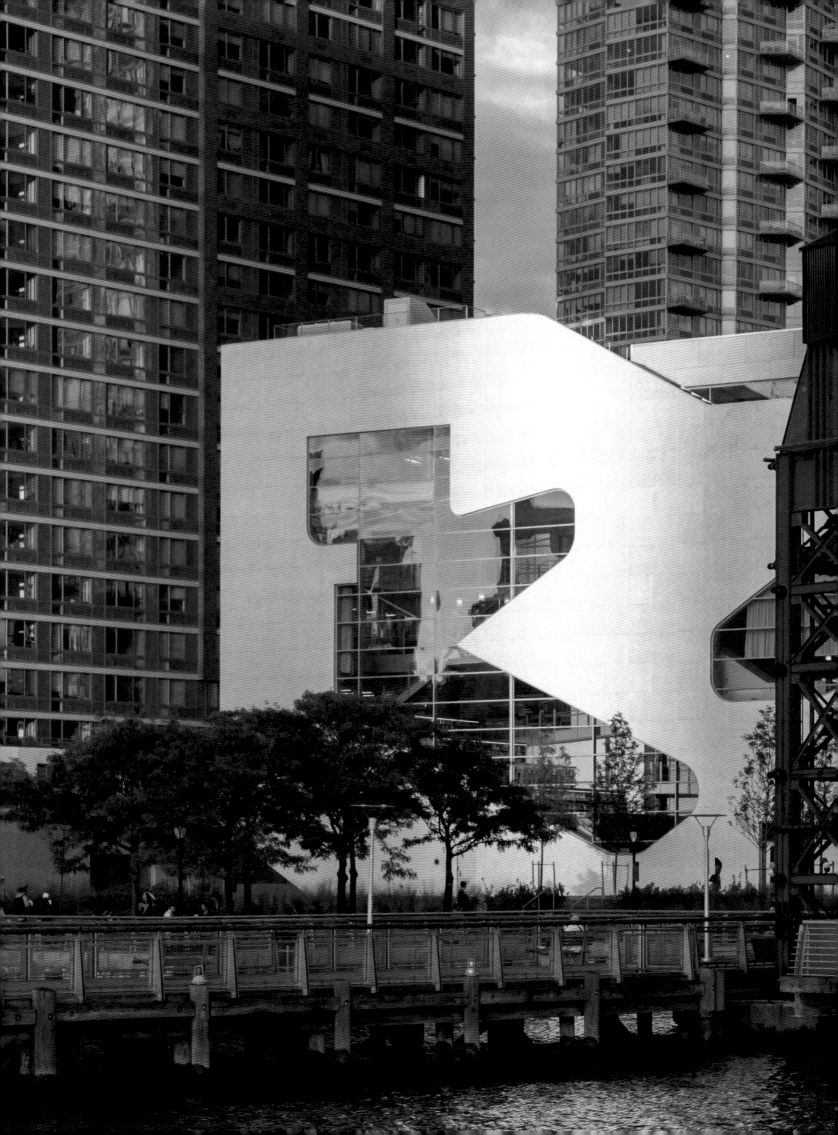

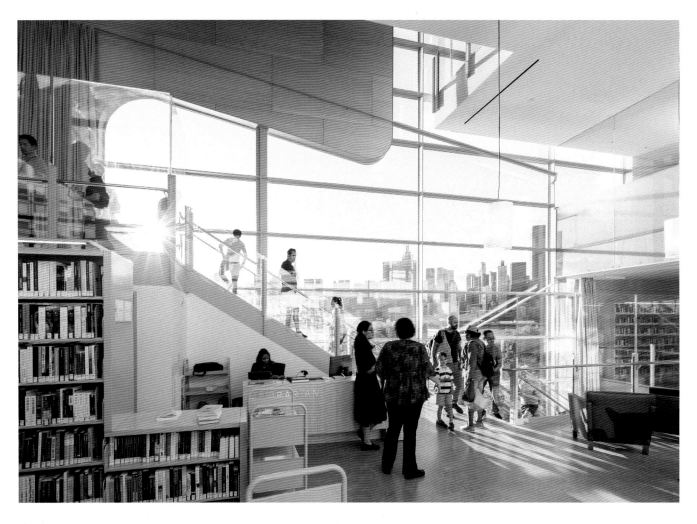

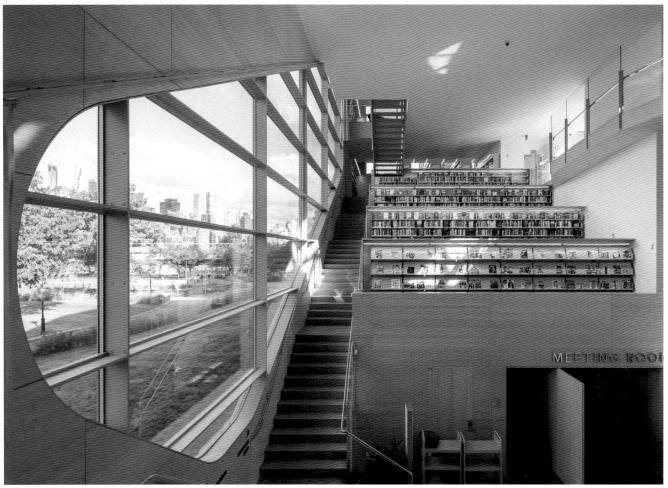

ST. CATHERINE'S MONASTERY LIBRARY

One of the world's oldest monasteries relies on digital techniques to safeguard its precious manuscripts

TRADITIONAL DESIGN
BUILT IN THE 1ST CENTURY CE
SINAI DESERT, EGYPT

When a wall accidentally collapsed during construction work at St. Catherine's Monastery during the 1970s, the monks made a sensational discovery: a room that had languished forgotten for centuries, filled with never-before-seen manuscripts. Today, they form part of the monastery library. Dating back almost 2,000 years, this is the oldest library of its kind in the world, with a collection second only to that of the Vatican. To safeguard these priceless treasures while also making their contents accessible to the public, the monastery stores the books in custom-designed metal boxes, but also relies on digitization and a special multispectral photographic process that reveals all past versions of the ancient palimpsests—manuscript pages that have been used multiple times, with the writings beneath scraped over or washed out. Imprints of the various writings inscribed on them appear when the pages are exposed to different wavelengths. Inscriptions that monks simply scratched away centuries ago are of incalculable value to scholars all over the world today.

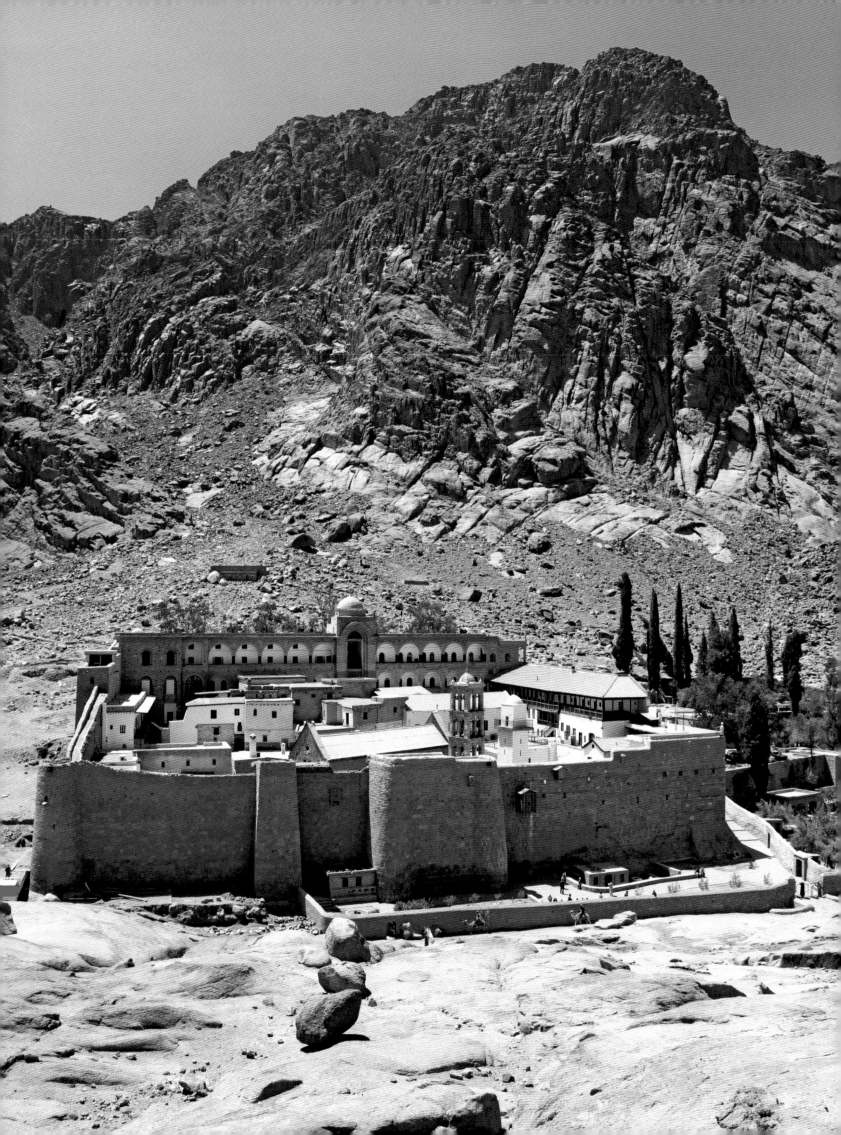

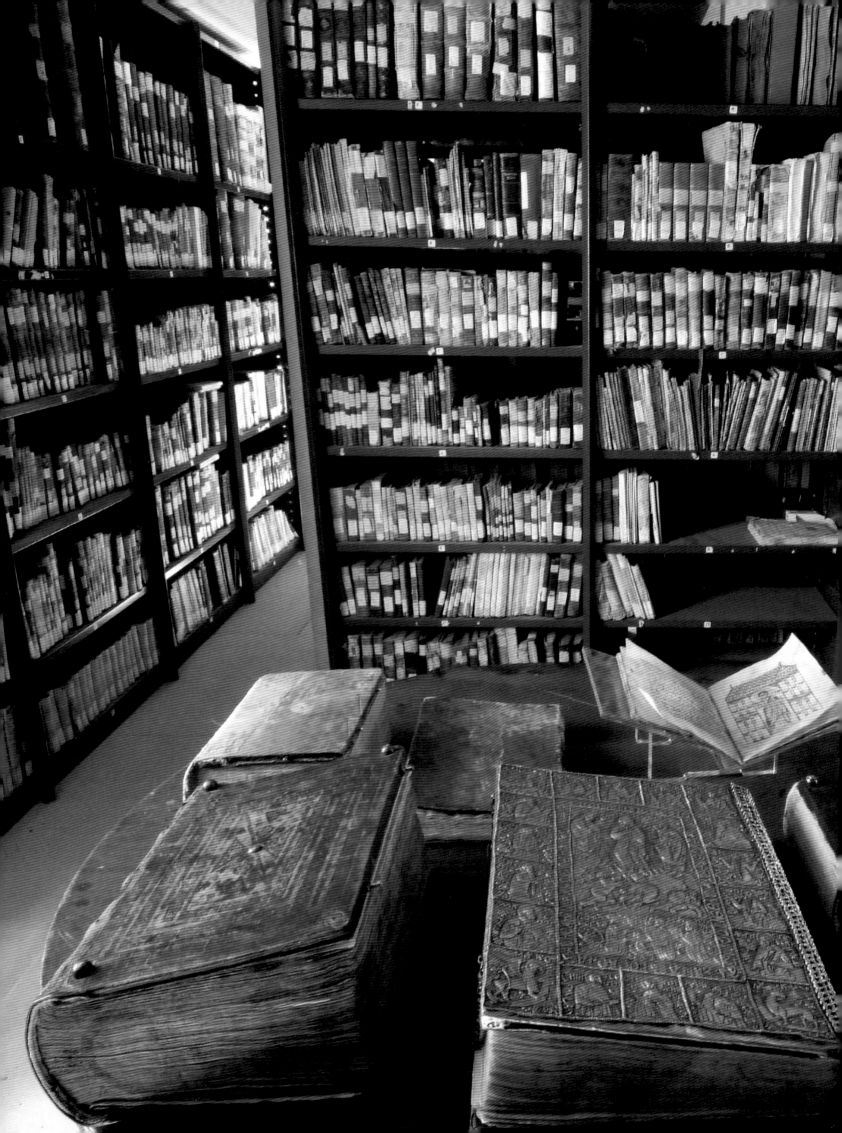

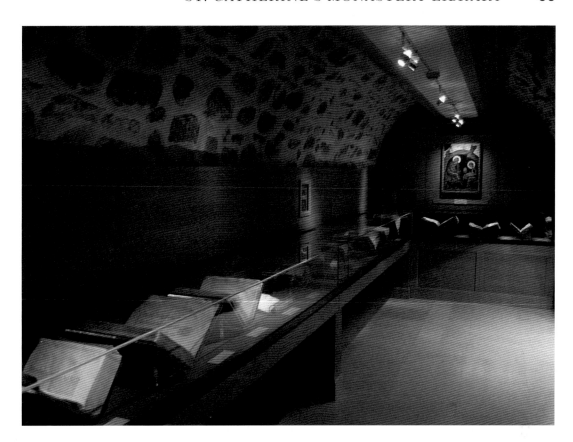

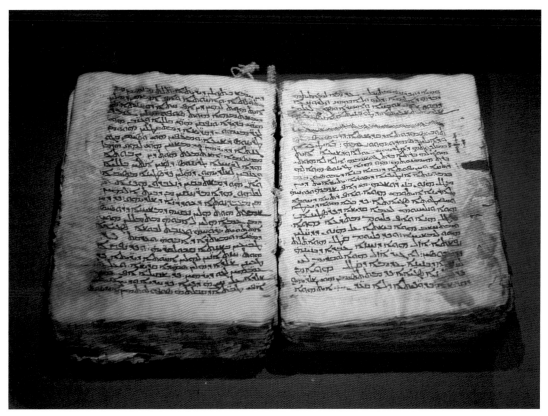

The most valuable books from St. Catherine's Monastery are only taken out from their secure display cases for the purposes of research. Thanks to ongoing digitization efforts, the delicate pages can now also be viewed close-up on-screen.

LINCOLN COLLEGE LIBRARY

Studying in this stunningly beautiful reading room is a true privilege

DESIGNED BY HENRY ALDRICH
BUILT IN 1720
OXFORD, UK

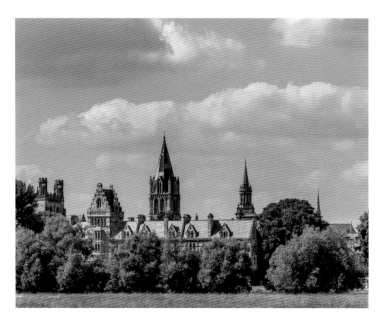

The books of Lincoln College, Oxford, really do reside in hallowed halls: the library of one of this college, one of the 39 that make up the famous university, is located in the former All Saints Church, which was rebuilt in the early 18th century and converted to its current purpose in the 1970s. These major renovations included installing an intermediate floor to create space for several reading rooms. Today, this space is poised between the past and the future, amid church bells and Wi-Fi boosters. The upper hall, the exquisite Cohen Room, is an especially glorious setting to get stuck into a book and immerse oneself in study. The ornate ceiling makes this one of the most beautiful reading rooms in the world. Bright daylight floods through the tall, latticed windows and onto the long, communal table. When darkness falls—the library stays open until 2 a.m. most evenings, to cater to the students—one is reminded of lyrics by Leonard Cohen, who shares the room's name, in his iconic song "Hallelujah": "There's a blaze of light in every word."

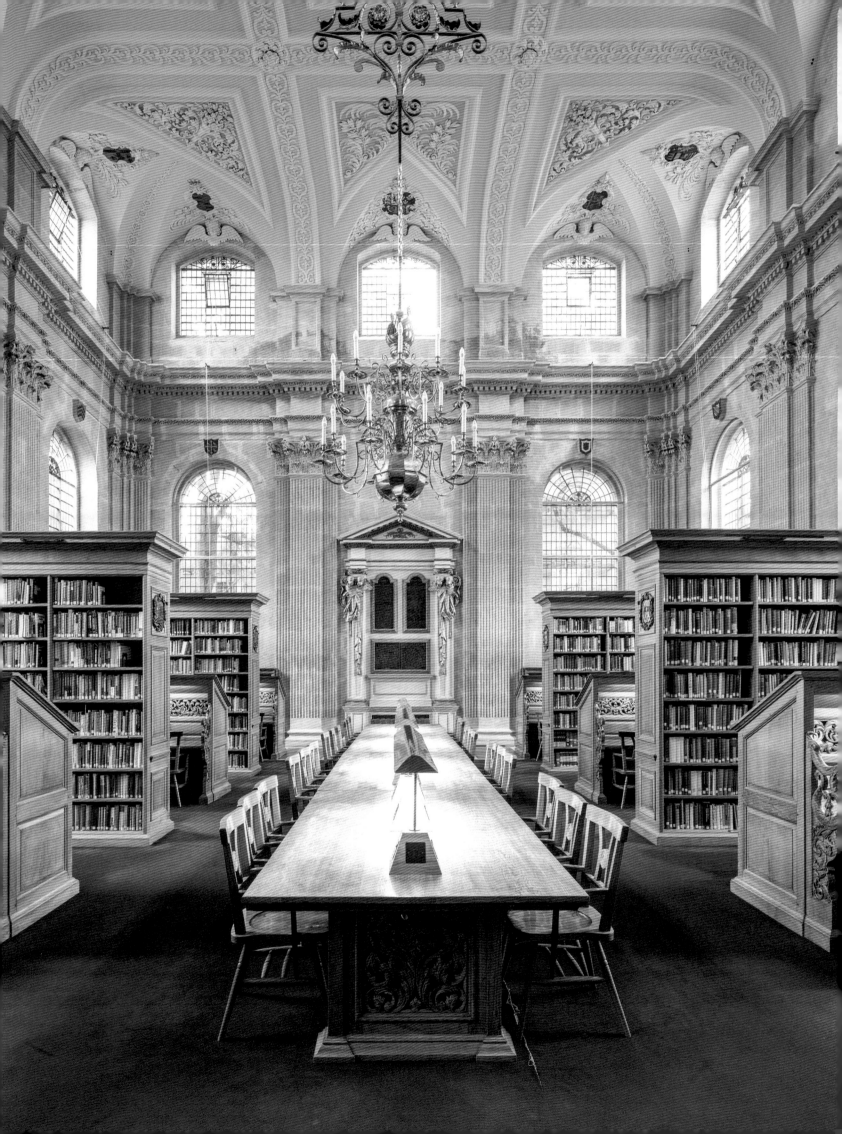

WILLIAM W. COOK LEGAL RESEARCH LIBRARY

Thanks to a generous endowment by a lawyer, Michigan's law students now study in magnificent surroundings

DESIGNED BY EDWARD YORK AND PHILIP SAWYER
OPENED IN 1931
ANN ARBOR, MICHIGAN, USA

"The character of the legal profession depends on the character of the law schools. The character of the law schools forecasts the future of America," wrote William W. Cook in his will. The lawyer bequeathed his entire fortune, which today would amount to some $260 million, to Michigan Law School in the late 1920s. Thanks to his generosity, the Law School's library remains one of the most beautiful of its kind. It was constructed together with other buildings on the campus according to designs by the firm of architects run by Edward York and Philip Sawyer. The windows of the magnificent 13-story building are adorned with 182 seals of the world's most prestigious universities, from Harvard to Oxford. The library houses over a million printed volumes on all aspects of the law. The oldest work of them all, *De contractibus mercatorum* by Johannes Nider, dates from the 1460s. The physical volumes are joined by some 500,000 digital titles. Law students come here to study all manner of topics, from international law to the legal status of indigenous peoples, and shaping America's future in the process.

ROBARTS LIBRARY

A university library makes a bold case for Brutalism

DESIGNED BY WARNER, BURNS, TOAN & LUNDE WITH MATHERS & HALDENBY
BUILT 1968–1973
TORONTO, CANADA

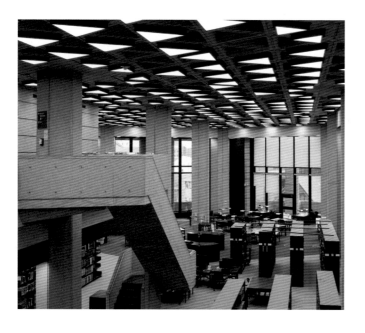

The Robarts Library stands like a proud, oversized concrete peacock on the University of Toronto campus. The aesthetics of the Brutalist building are still the subject of much controversy today, but its superb conditions as a repository for delicate manuscripts and books are not in dispute. Thanks to its almost windowless design, the library offers perfect protection against temperature fluctuations and UV radiation. Little reading nooks, seemingly endless bookshelves, and dark mahogany fittings feature across the 16 floors and million-plus square feet of the Robarts Library. The façade contains no right angles or curves whatsoever. The design for this colossal exposed concrete building was devised in partnership between the New York-based firm of architects Warner, Burns, Toan & Lunde and the Canadian studio Mathers & Haldenby. They came up with their initial design back in 1960 and met with a lot of public criticism—the building was soon somewhat unflatteringly dubbed "Fort Book." These days, however, Toronto is proud to be the home of one of the most significant Brutalist structures in North America.

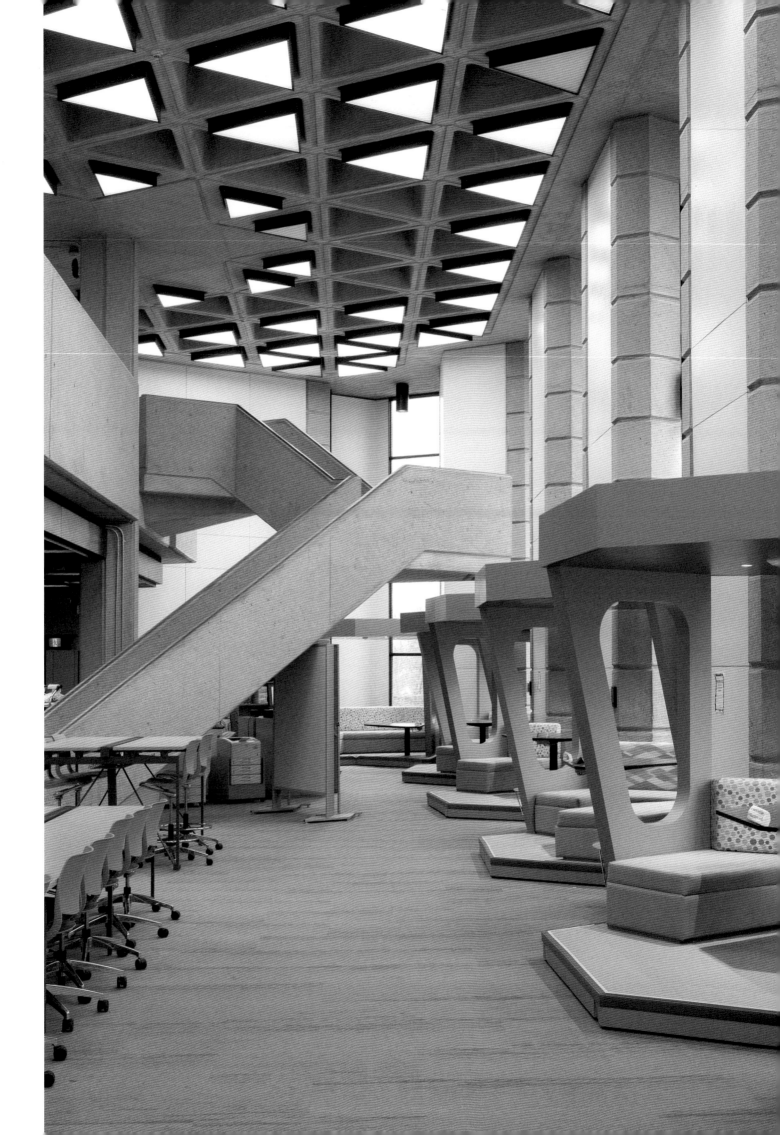

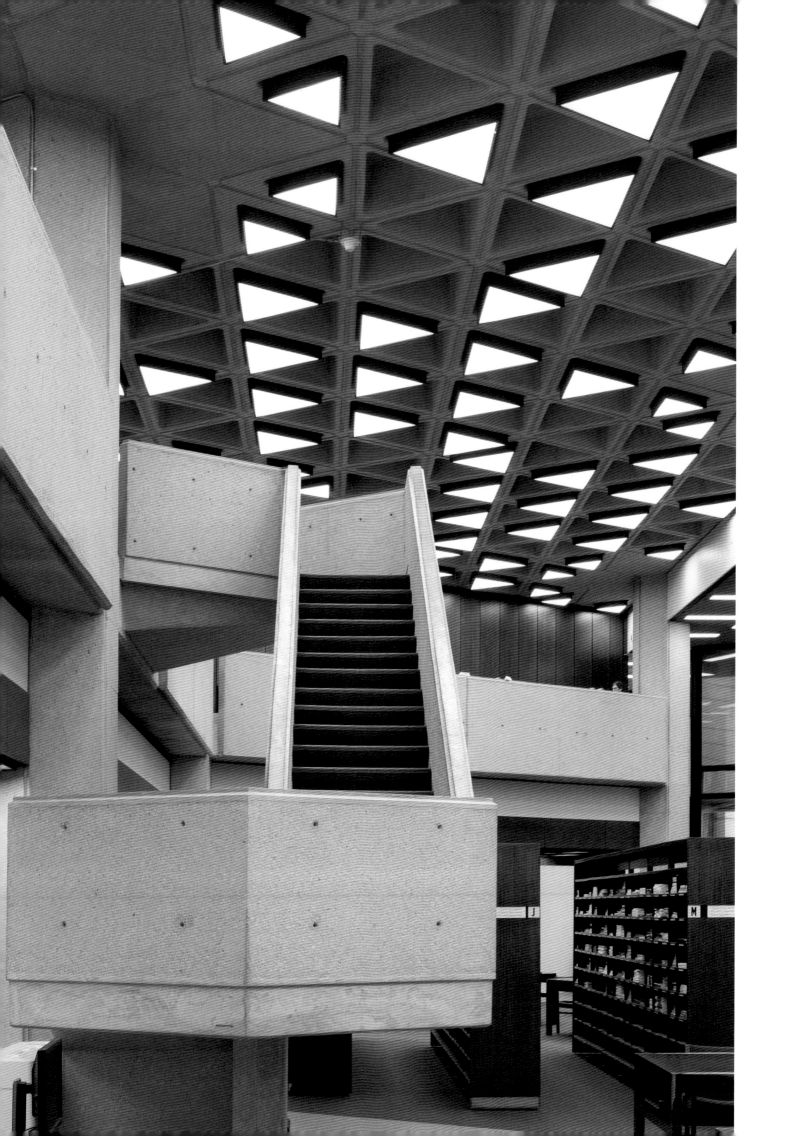

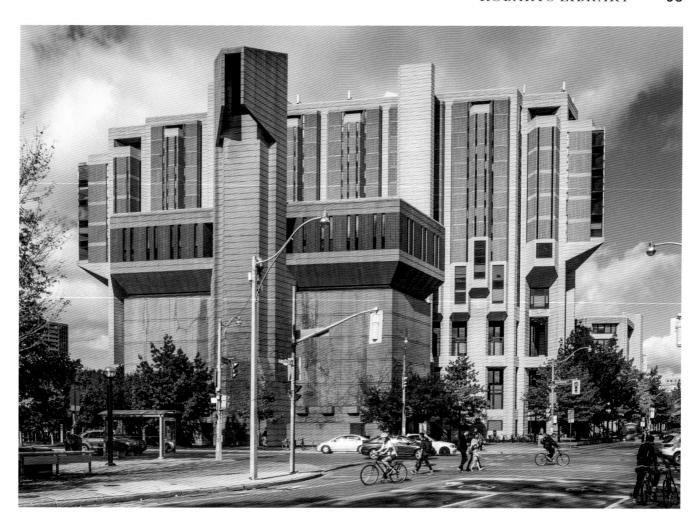

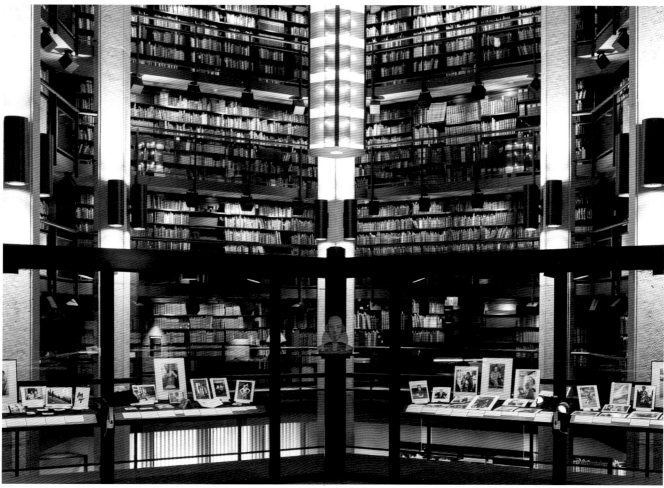

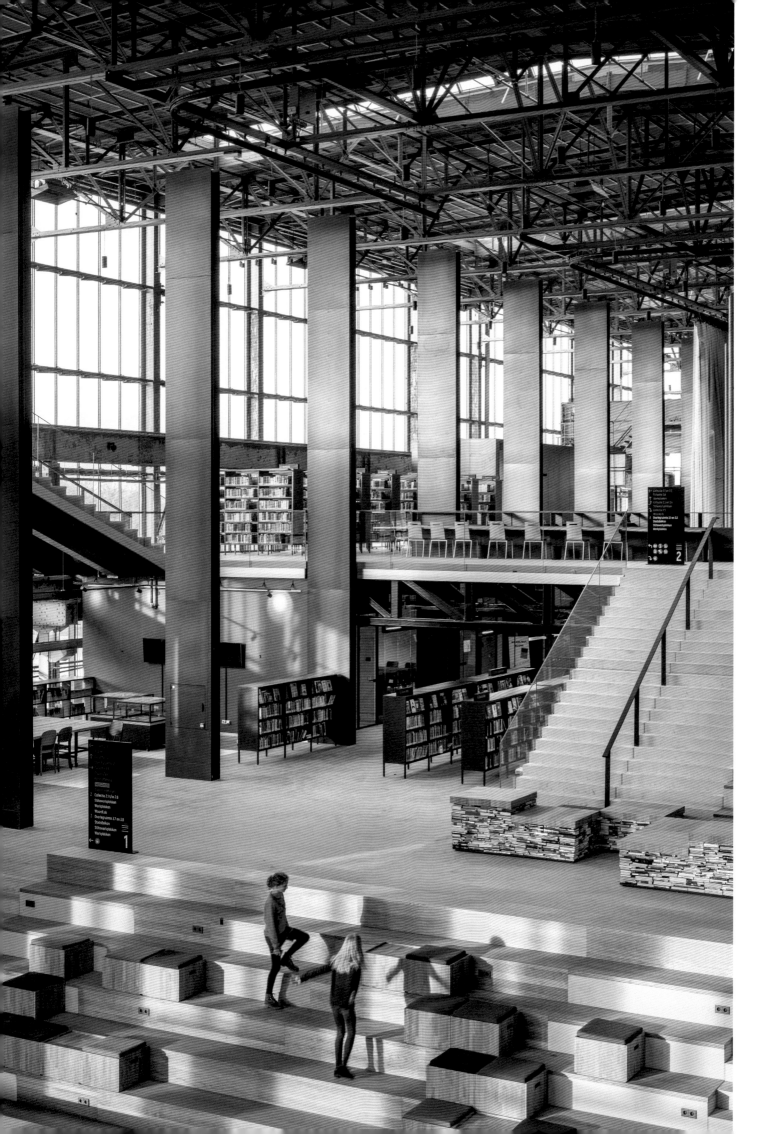

LOCHAL

A hybrid library in a former railway depot provides a new take on urban community living

DESIGNED BY CIVIC ARCHITECTS, MECANOO, AND BRAAKSMA & ROOS
OPENED IN 2018
TILBURG, NETHERLANDS

The architects behind LocHal describe their prize-winning community project as "an urban living room for Tilburg." This former railway depot, dating back to the 1930s, is now home to a wealth of services: a public library, conference rooms, coworking areas, a bistro, and plenty of space for events, exhibitions, and workshops. The plan was always an ambitious one: LocHal is the centerpiece of the whole new neighborhood currently under development on the 185-acre (895,400 square yards) site of Tilburg's former railway maintenance station. Modern developments are being constructed alongside historic buildings to create a unique

mix. The hybrid concept behind the library chimes with the overall ethos. The three large reading tables in the entrance area can be pushed together on original railway tracks to create a catwalk or stage. Various laboratories—including GameLab, FoodLab, and FutureLab—are scattered across the hall and encourage visitors to experiment and try something new, all within a setting that makes the most of its industrial heritage.

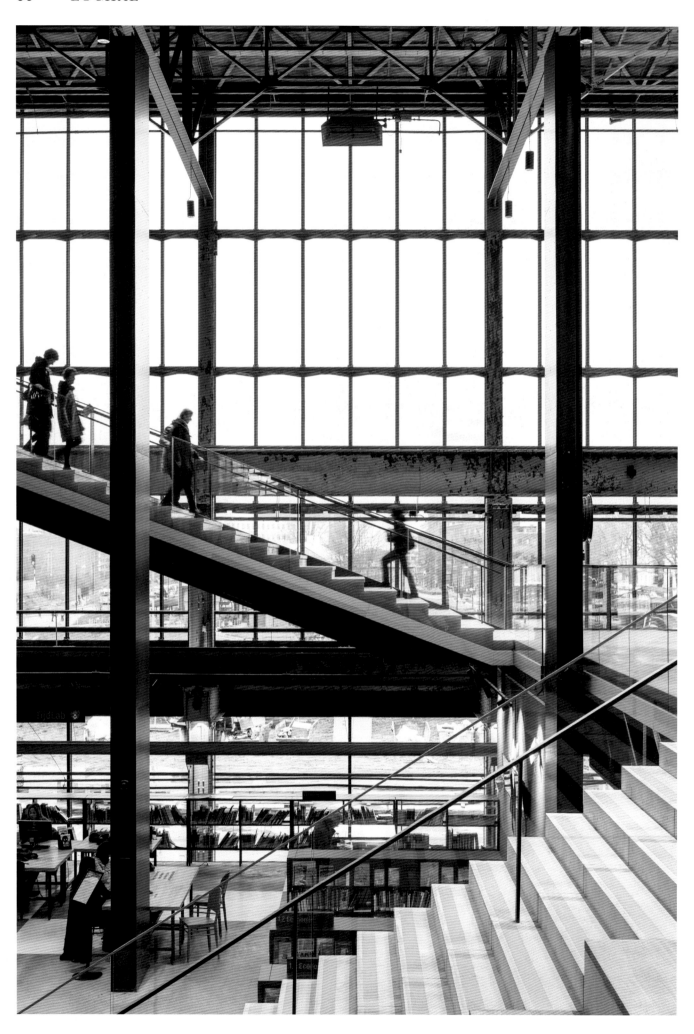

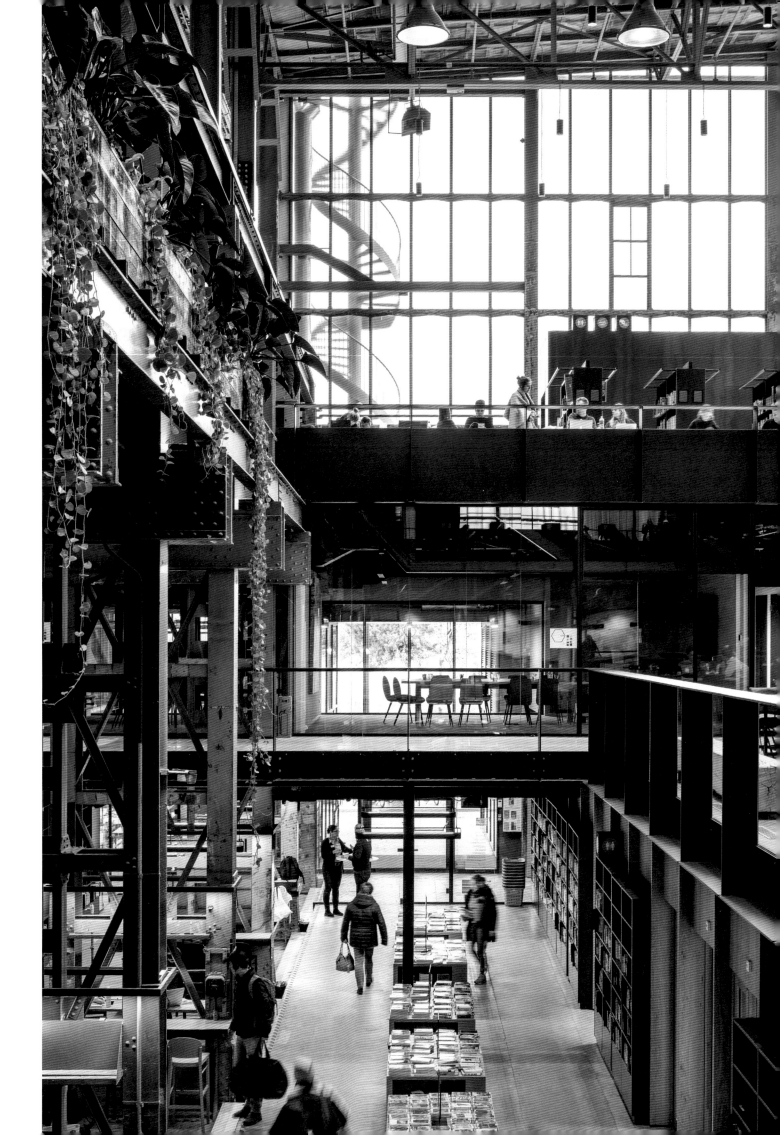

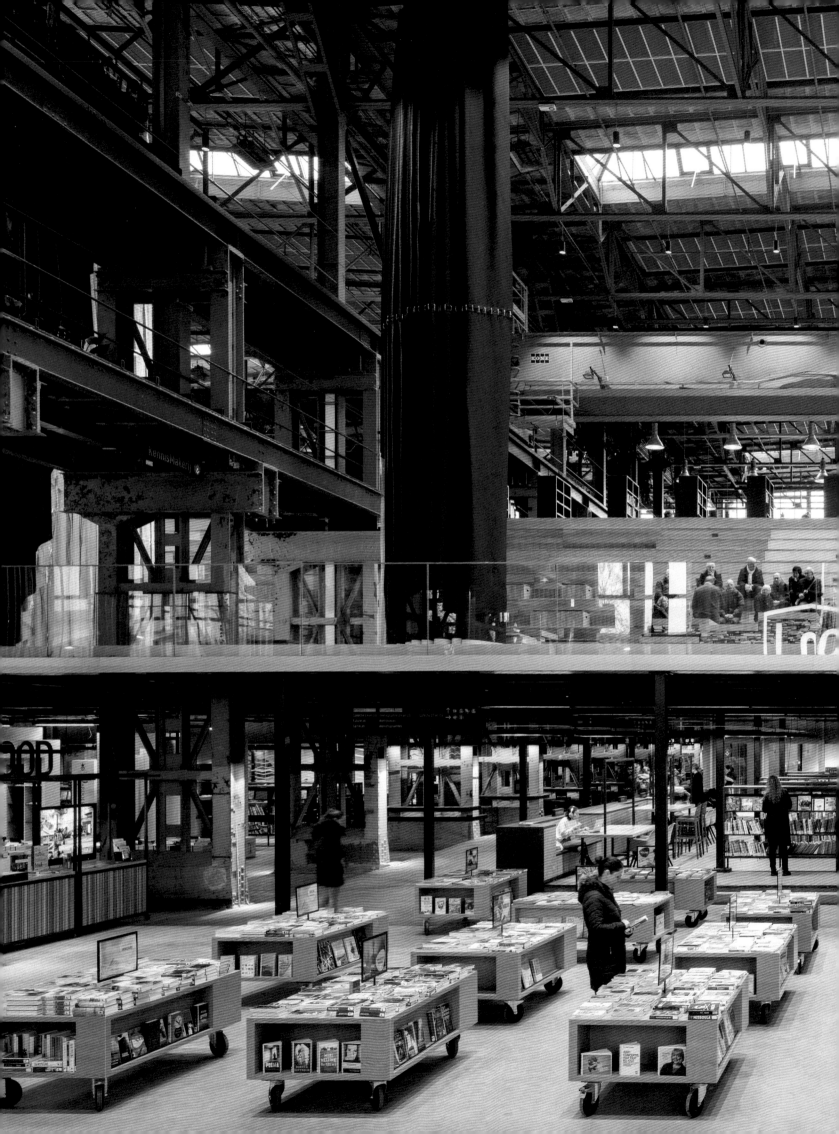

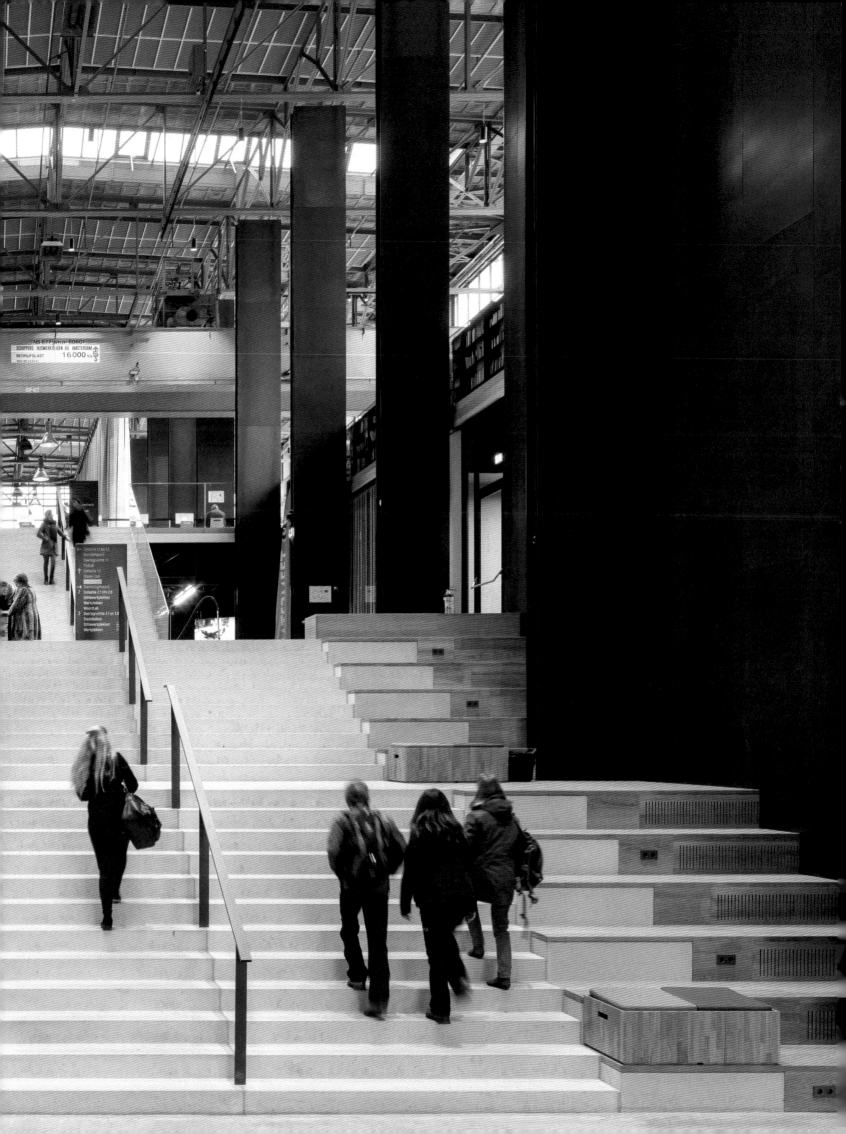

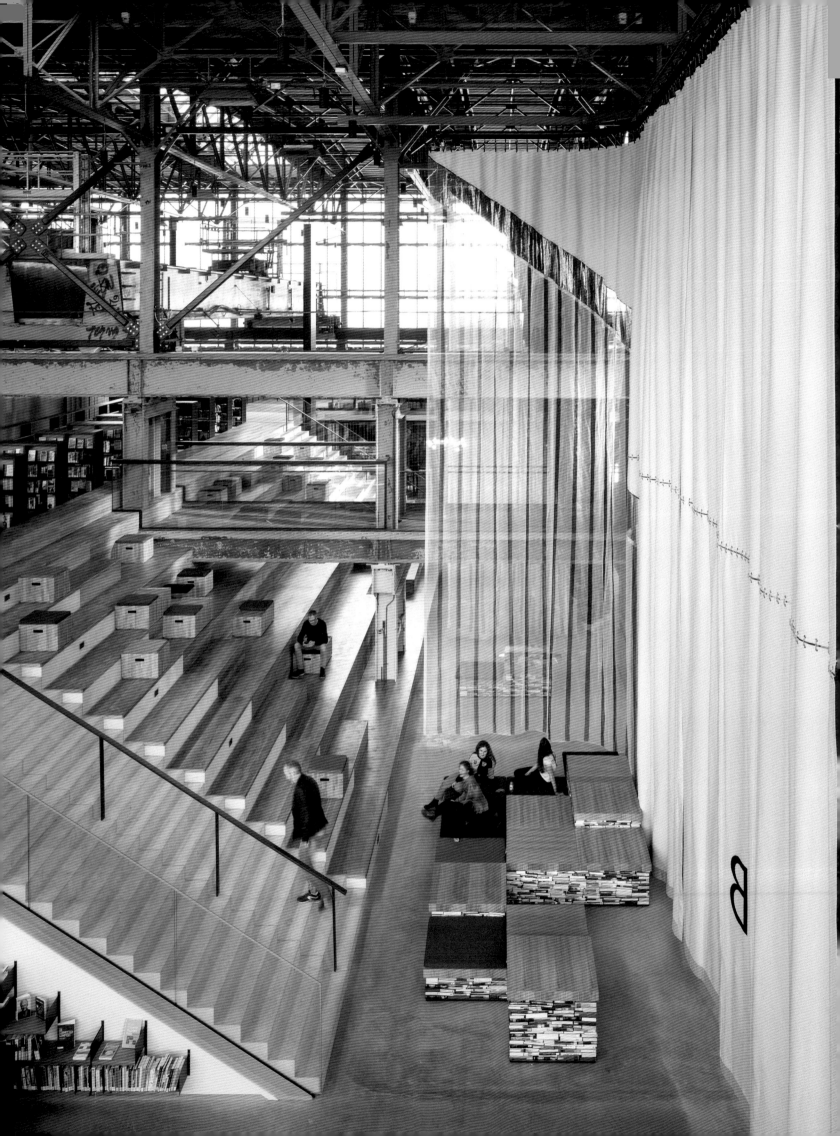

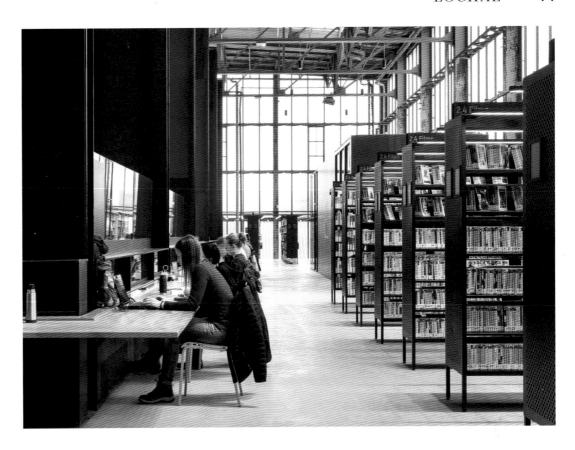

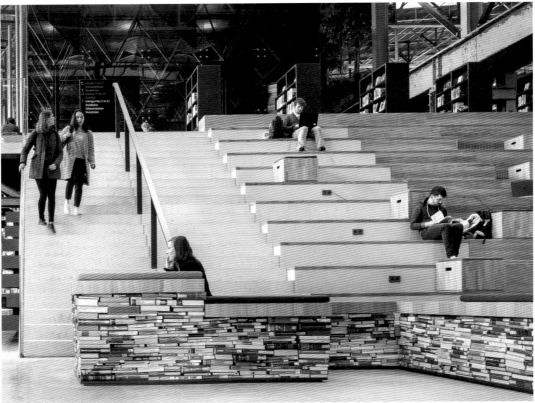

This former railway depot from the 1930s is a city library and versatile event space in one. The curtains and platforms can be moved around to create a stage, a catwalk, or a completely open space.

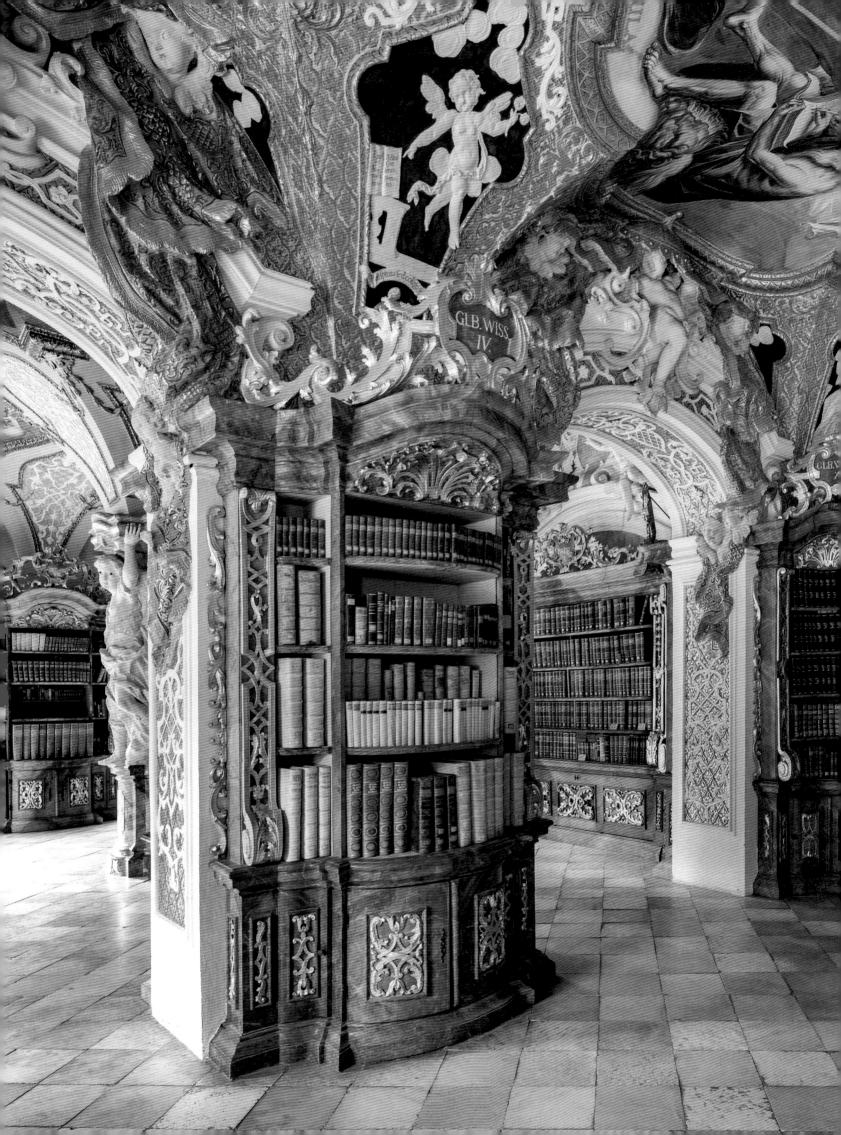

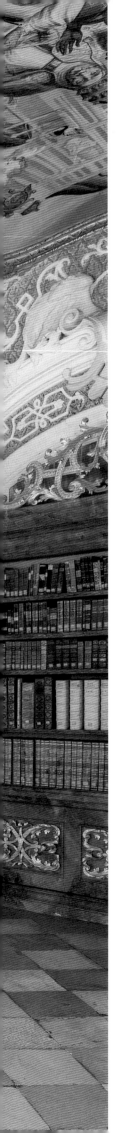

METTEN MONASTERY LIBRARY

Belief, knowledge, and stylistic panache form the three cornerstones of this remarkable monastery library

DESIGNED BY FRANZ JOSEF HOLZINGER AND INNOZENZ WARÄTHI
UPGRADED 1722–1726
METTEN, GERMANY

Abbot Roman II Märkl knew exactly what he was doing when he entrusted the Baroque remodeling of his monastery library to Franz Josef Holzinger, a stucco sculptor, and Innozenz Waräthi, a fresco artist. Visitors are greeted by masterfully crafted figures that, like Atlas, appear to bear the exquisitely decorated library ceilings aloft. The frescoes depict scenes including St. Bonaventure and Doctor of the Church St. Thomas Aquinas deep in conversation. Aquinas asks what the source of knowledge is; St. Bonaventure provides the answer on the opposite end of the ceiling: "Wisdom comes from the cross." Between them, we see the four Evangelists toiling over their Gospels, recounting the life of Christ, while St. Benedict, surrounded by a multitude of angels, reaches for paper and quill. The library's bookcases groan with some 35,000 books. A new area of the Benedictine abbey was opened in summer 2009, with a large reading room accessible to the public and central book stacks. The old Baroque library can be viewed on tours, which come highly recommended.

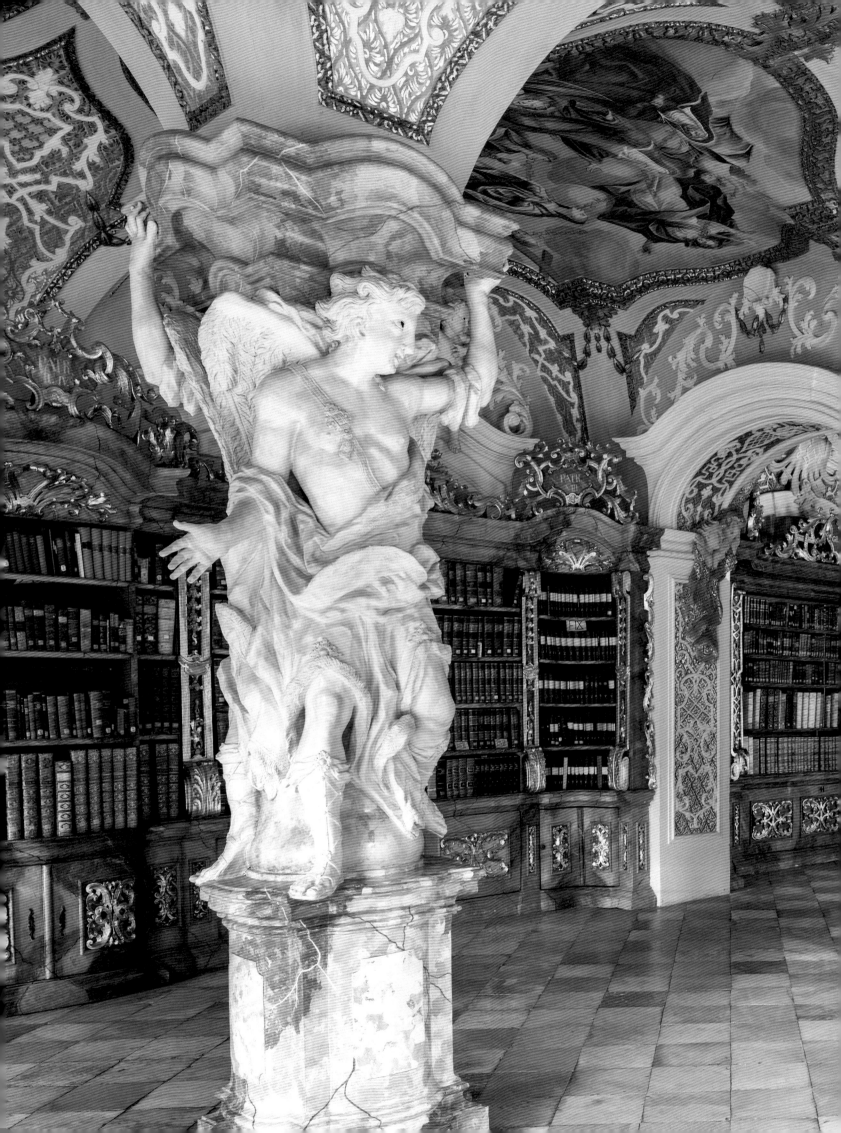

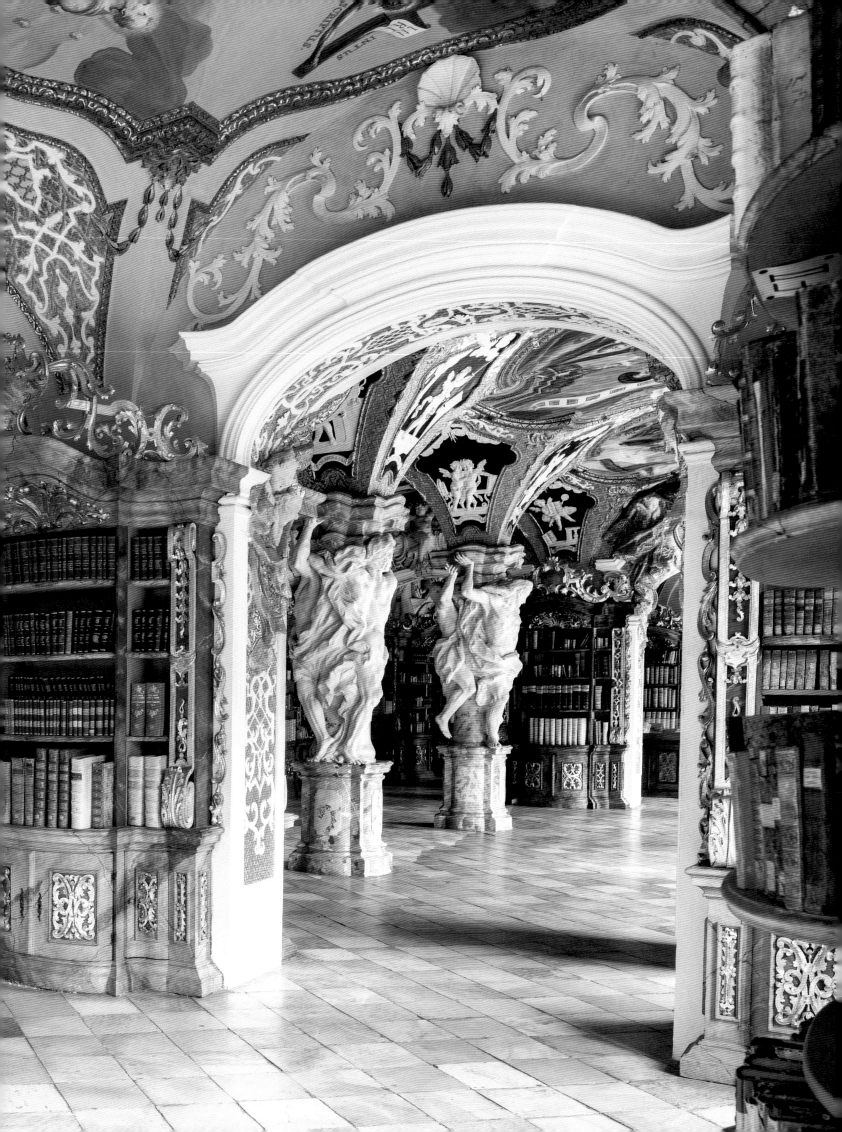

Where are the books? The Baroque splendor of this historical monastery library steals the show from
the precious volumes. Using classical techniques, the sensational frescoes were gradually applied
to the still-wet plaster—a process that took four years.

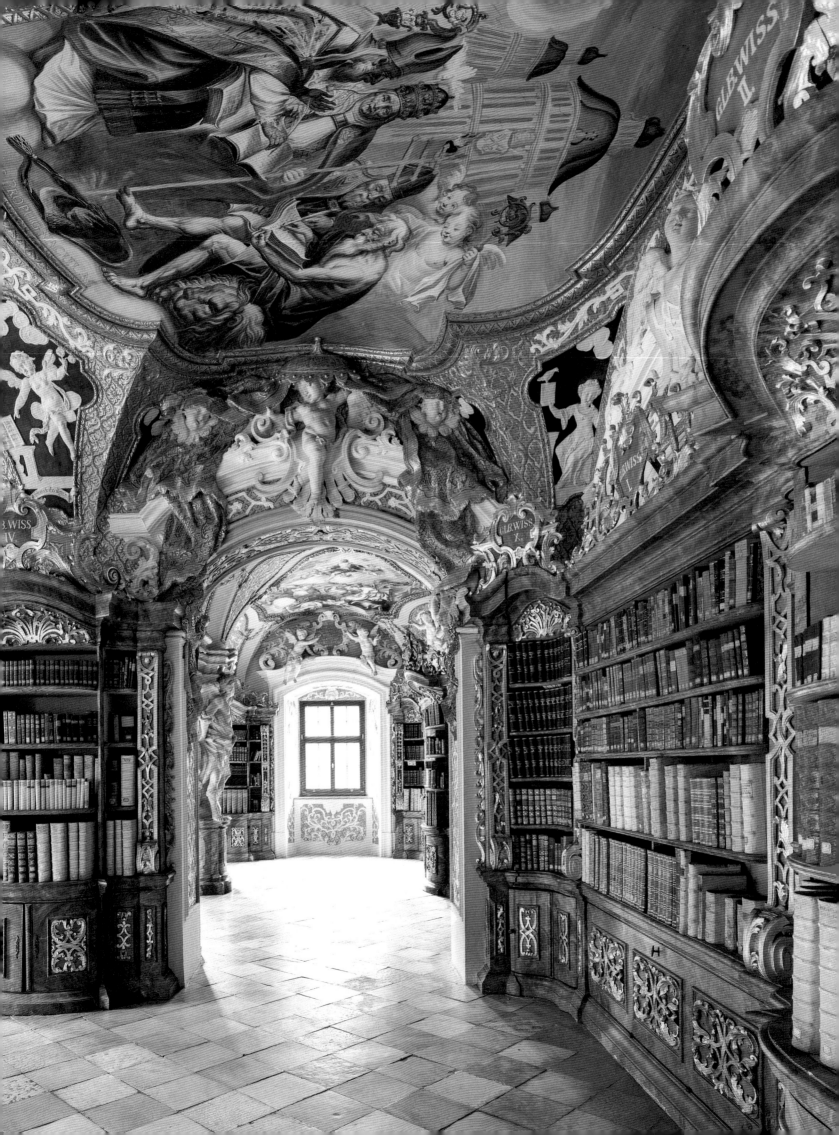

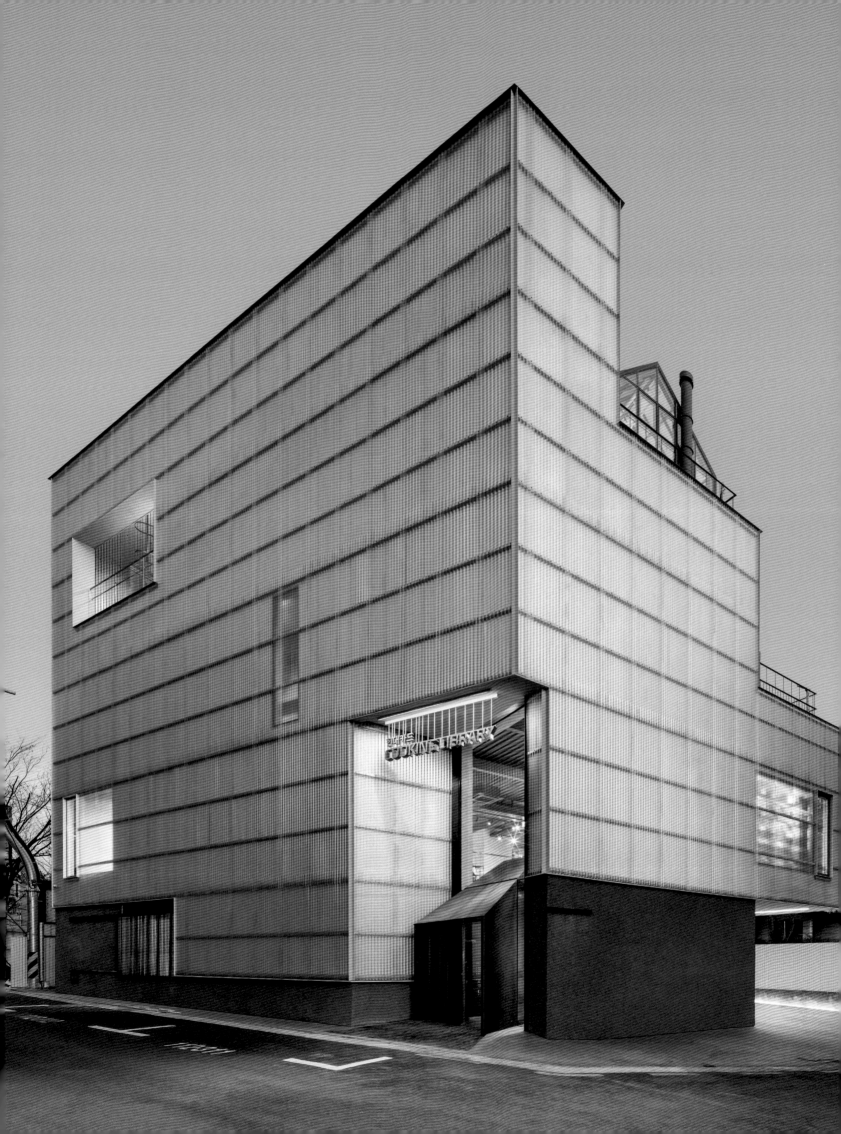

HYUNDAI CARD COOKING LIBRARY

Cookbooks and culinary bibles take center stage at this unique library for foodie bibliophiles

DESIGNED BY BLACKSHEEP
BUILT IN 2017
SEOUL, SOUTH KOREA

Talk about a feast for the eyes: the Hyundai Card Cooking Library certainly fulfills its brief to the letter. This five-story library is located in the trendy Gangnam neighborhood of Seoul. It brings a whole host of key works on cooking, eating, and culinary indulgence together under one roof. And the Cooking

Library itself offers a unique culinary experience. Visitors to the library can leaf through heavy tomes on the art of coffee making over an oat-milk cappuccino in the in-house café. Deli bibles aid navigation through the charcuterie section of the gourmet shop or prompt the choice of baked treats from the artisanal bakery. The Recipe Room is the place to rifle through recipes, attend talks on cooking, or get newly released cookbooks personally signed by their authors. London-based studio Blacksheep designed the Hyundai Card Cooking Library as the newest of four special libraries sponsored by Korean credit card company Hyundai Card. Libraries based on a similar concept but dedicated to music, travel, and design can be found in other districts of Seoul.

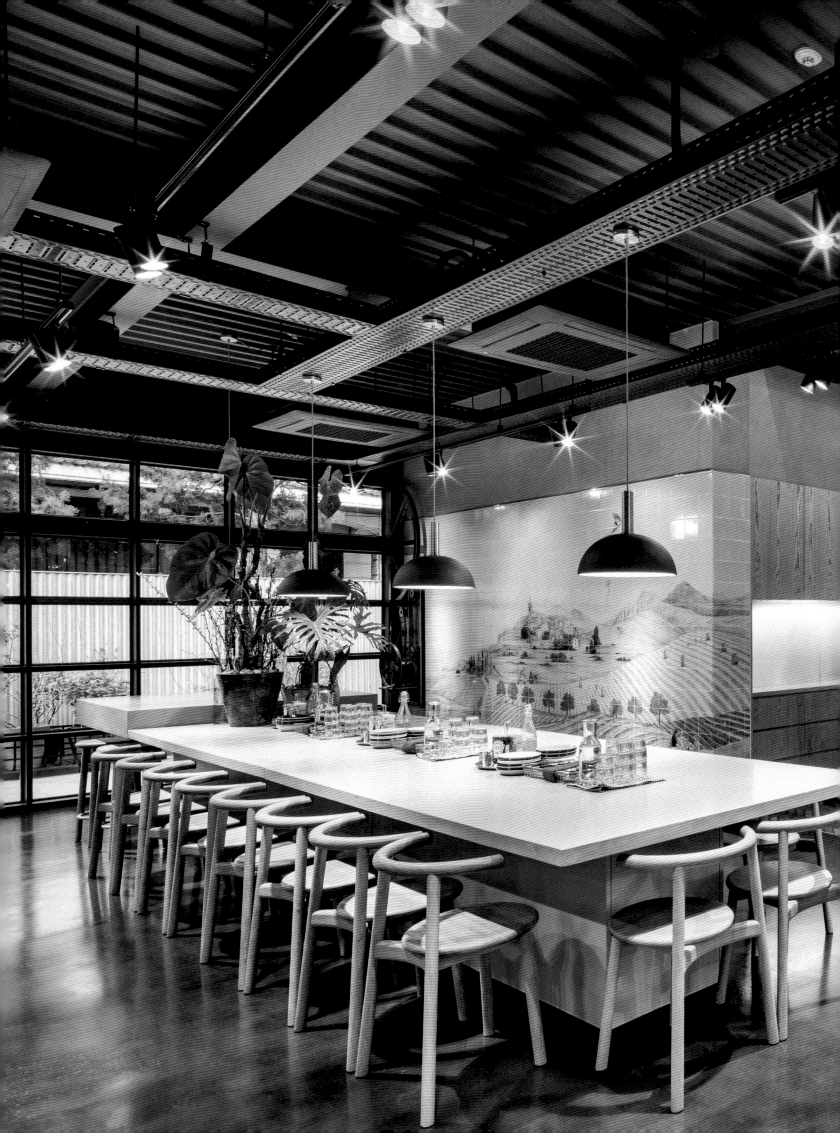

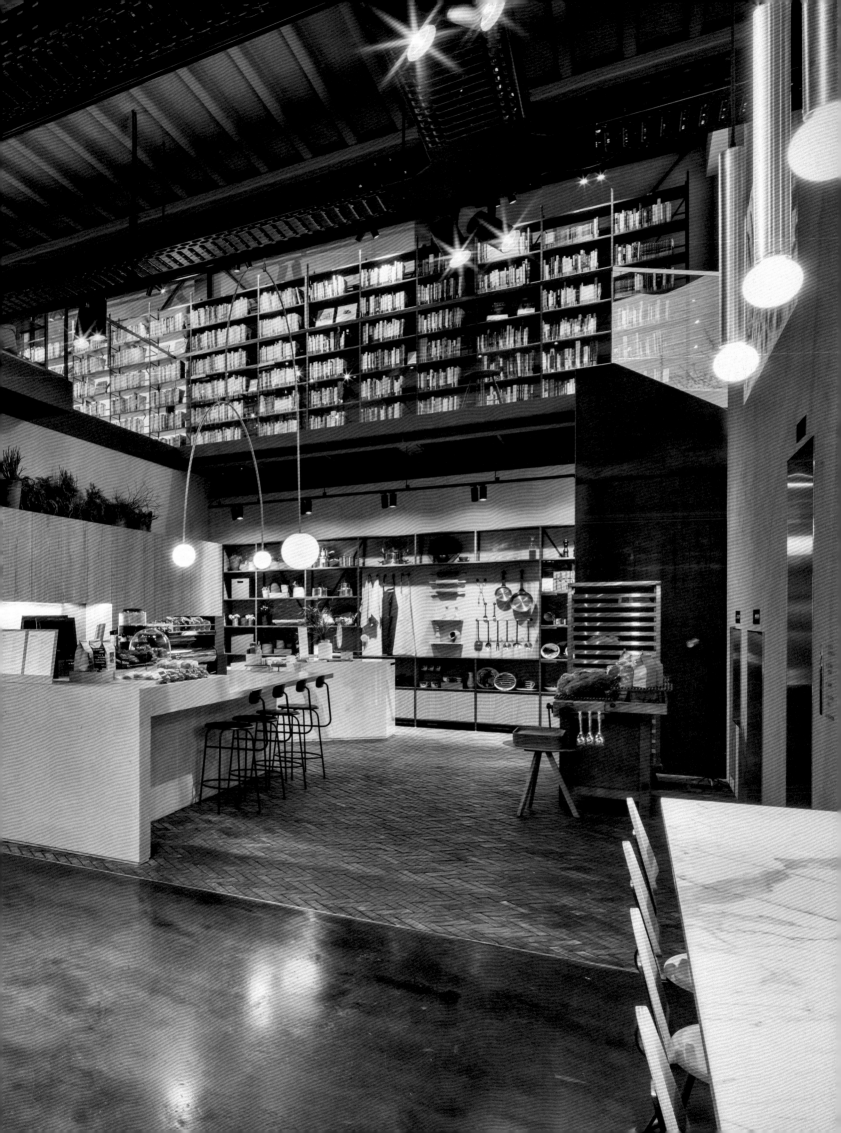

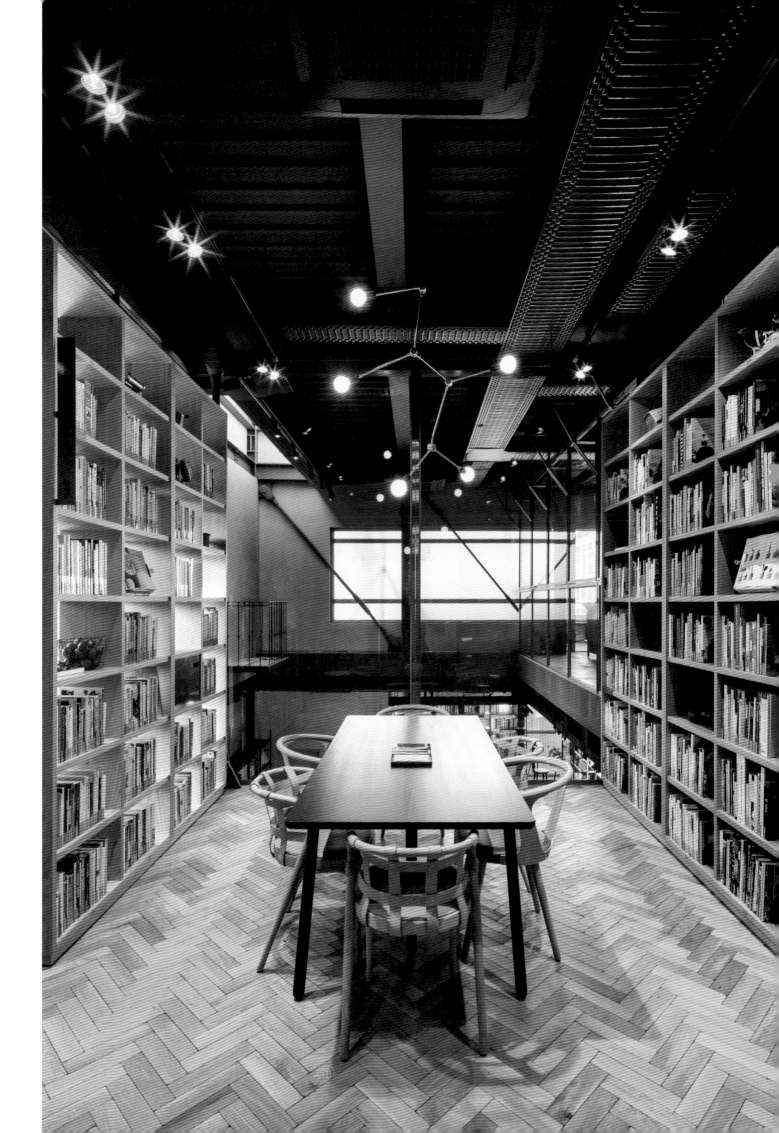

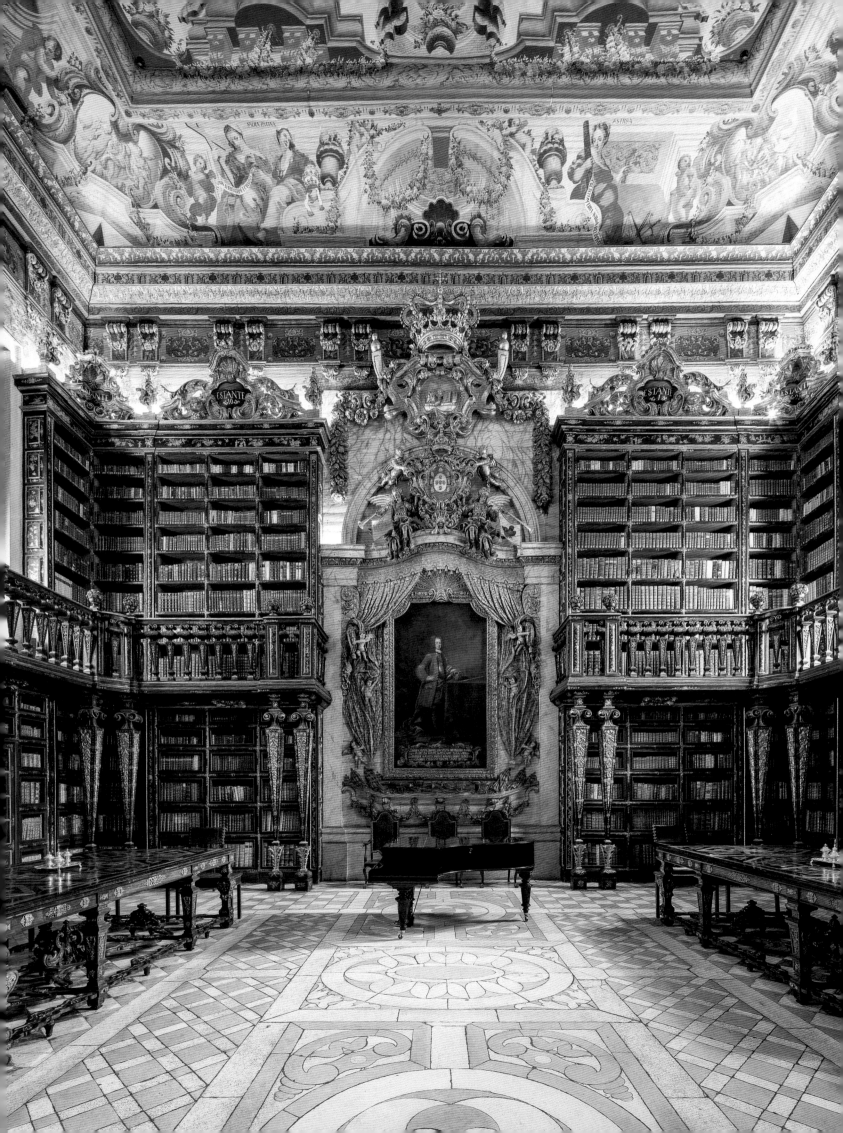

BIBLIOTECA JOANINA

A bat colony is just part of the team helping keep this Baroque library free of pests

DESIGNED BY JOÃO CARVALHO FERREIRA
BUILT 1717–1728
COIMBRA, PORTUGAL

Opulent gold leaf, ceiling frescoes, and tropical wood fittings provide an exquisite setting for the literary treasures of the Baroque Biblioteca Joanina. King John V ("the Magnanimous") had the library built in the 18th century in Coimbra, making it one of the oldest university libraries in Europe. Its collections range from philosophy to medicine and are in remarkably good condition. The wood paneling, the teak doors, and the outer walls (which are over six and a half feet thick) help regulate the humidity and maintain a stable climate for the delicate manuscripts. The most precious books are stored in the library's safe. They include one of only 20 surviving first editions of *The Lusiads* as well as a 48-book Latin Bible dating from 1492, considered to be the finest of the first-ever four printings of the Bible. At night, things take a Gothic turn: Bats flit through the dark halls, devouring insects that feed on paper and helping preserve the library's incredible legacy.

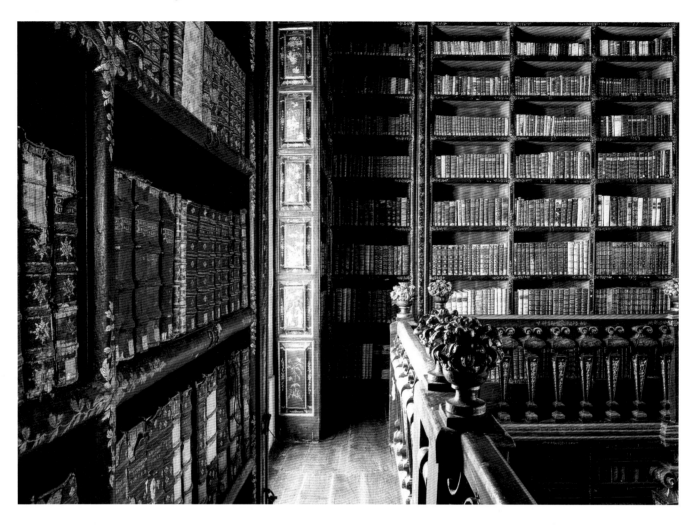

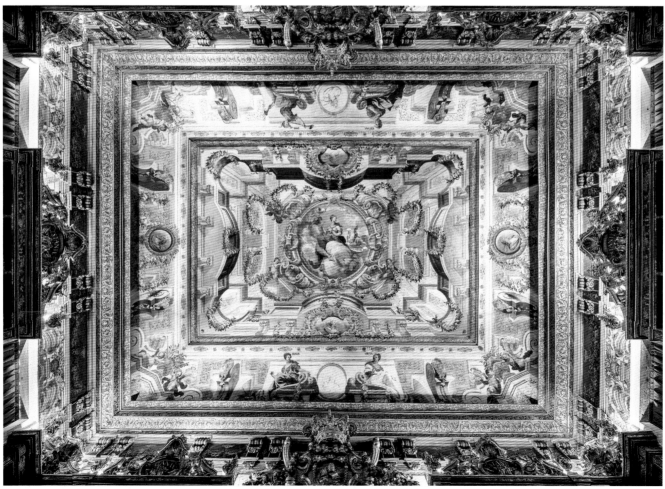

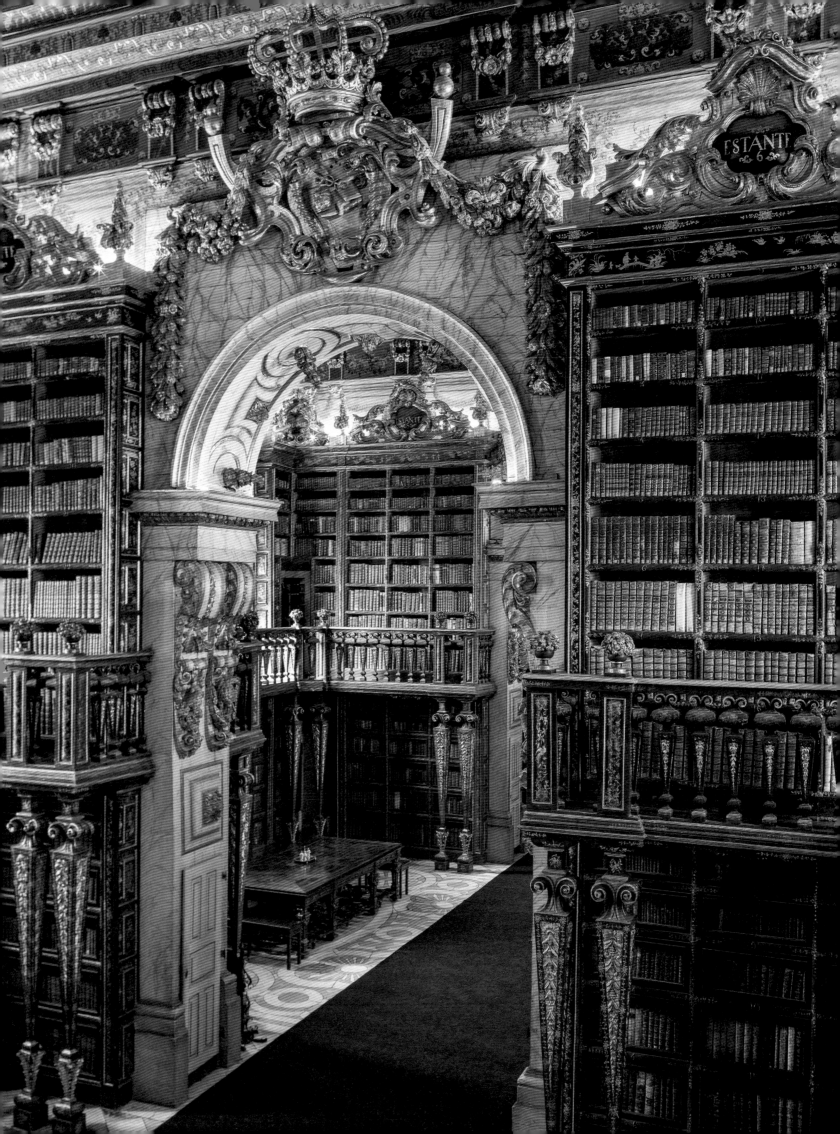

SEATTLE PUBLIC LIBRARY

DESIGNED BY REM KOOLHAAS AND JOSHUA PRINCE-RAMUS
BUILT IN 2004
SEATTLE, WASHINGTON, USA

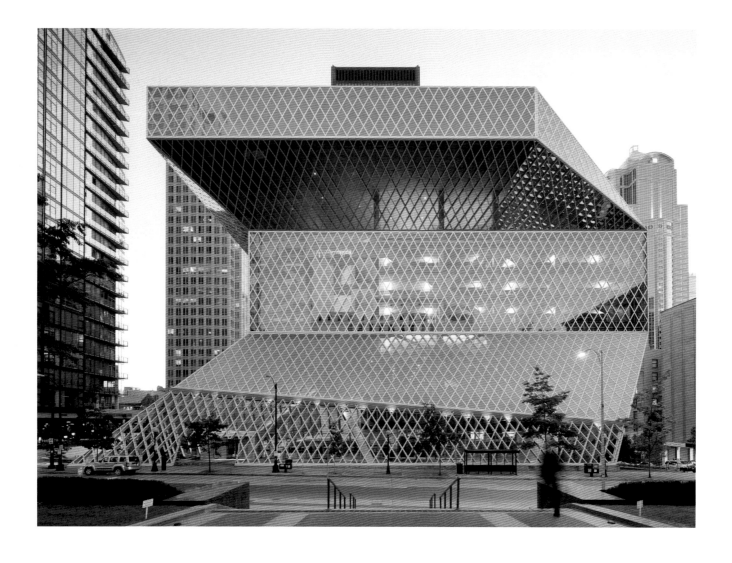

A radical take on the diktat "form follows function" resulted in a remarkable congruence between the layout of the books and the routes intuitively suggested by the architecture

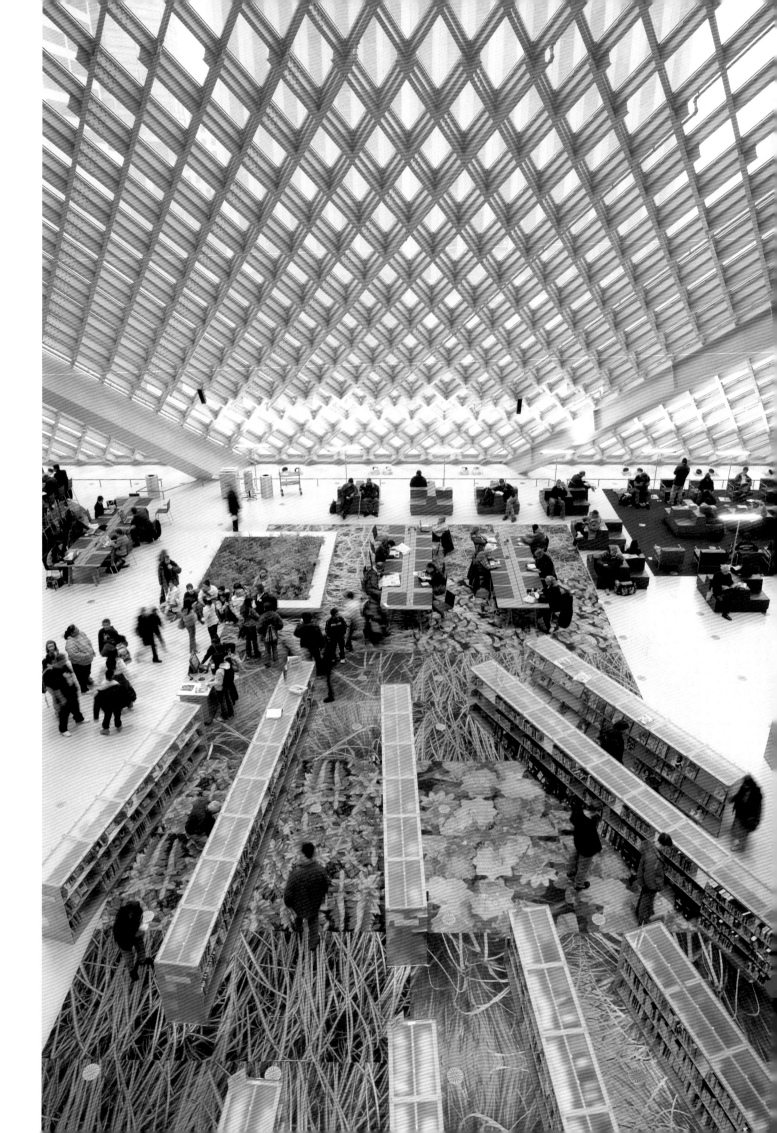

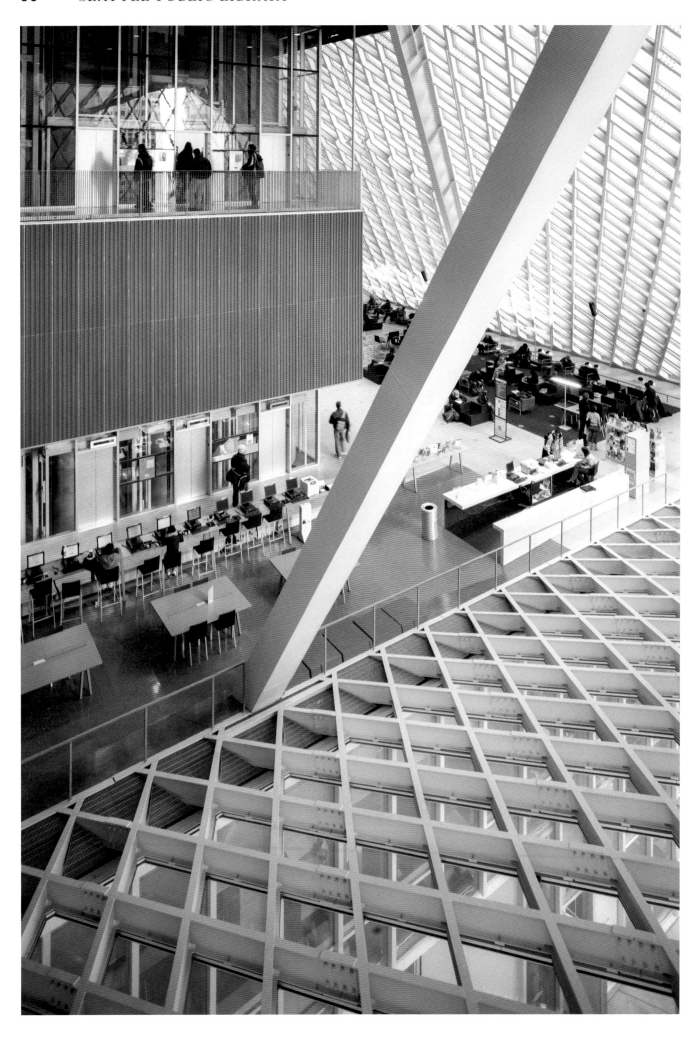

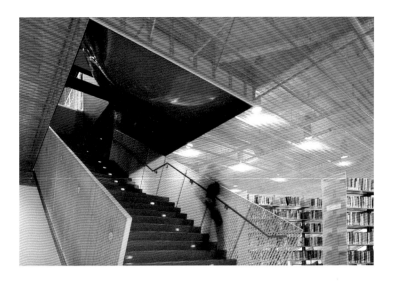

The Seattle Public Library lies like an oversized pile of books on Fourth Avenue in this city on the shores of the Pacific. Its 1.5 million books are spread over several interleaved floors, designed by architects Rem Koolhaas and Joshua Prince-Ramus as an intuitive flow of spaces. It opened in 2004. "The fact that readers can now help themselves to books from the open stacks of the library is the result of a long process of gradual opening up that began in the United States," writes German architecture scholar Tina Zürn[1]. "But to what extent does direct access to books change flows of movement around the library building?" As far as Zürn is concerned, this was the first library to provide a radical response to this question and deploy unconventional solutions to guide visitors through the library system.

There is nothing here to interrupt the natural progression of seeing, searching, and moving around. The shelving connects the different sections like thematic synapses, allowing visitors to stumble upon related areas that may be of tangential interest to them. Pathways spiral up through the library at right angles to reach the upper floors; there are no stairs to inhibit intuitive browsing. "The design eschews differentiation between the floors, which alters the way visitors move and fundamentally changes their approach to searching for books," explains Zürn.

Koolhaas and Prince-Ramus incorporated the Dewey Decimal Classification, the book numbering system used in almost all public libraries across the United States, into their design. This means that library visitors can find their way around the bookshelves themselves and track down the books they're looking for without having to flag down a librarian. It wasn't always like this. Long before open-access systems, libraries

relied on alphanumeric codes that could only be deciphered by librarians; it was far too arcane for outsiders. Modern book numbering systems, by contrast, are straightforward and user-friendly. Seattle Public Library was the first such institution to enshrine this new practice of open access through its very architecture.

Today, the library serves as "the city's living room." Seattleites study, read, and write at the well-lit tables. Visitors sink into the pink and red sofas and chat away. Others wander at will between the rows of books, which radiate outwards. The creation of this library only became viable when the public voted in a referendum to allocate $200 million to the project. The library's remarkably liberal entry rules →

A shell of steel latticework and diamond-shaped glass panes encloses the book-filled floors of the Seattle Public Library, which sometimes flow together seamlessly. The deconstructivist design, by architects Rem Koolhaas and Joshua Prince-Ramus, has won several awards.

Today, the library serves as "the city's living room." Seattleites study, read, and write at the well-lit tables. Visitors sink into the pink and red sofas and chat away.

→ (enabling homeless people to access libraries, for instance) were developed in 1998 as part of the "Libraries for All" initiative. "What today we take for granted is actually the result of a long process of gradually opening up," says Zürn. "Allowing the public unrestricted access to library buildings and, later down the line, letting them peruse the books in them freely, formed the foundation for the freedom of movement that distinguishes libraries today."

Seattle Public Library spearheaded the evolution of this type of building. According to Koolhaas, it also lives up to the most important task of architecture: creating symbolic spaces that meet people's insatiable need for community. "These days, a library isn't just about introducing books," says Zürn. "People crave actual public gathering places as a counterpoint to the increasing virtualization of knowledge-based society, so as to offset the social isolation that comes from spending so much time gazing at screens. Today, libraries often employ future-forward architecture as a way of casting off their fusty image and making it clear that they are more than a match for the challenges of digitalization. The building itself has to be appealing if it is to tempt people away from their screens at home and entice them to visit."

It's clearly working. Since the opening of this building, which has proven groundbreaking in so many ways, the number of visitors to the Seattle Public Library has more than doubled.

1 Tina Zürn: Gebaute Signatur: Die Seattle Public Library von Rem Koolhaas [An architect's autograph: The Seattle Public Library by Rem Koolhaas], in: LIBREAS. Library Ideas, 28 (2015).

With its fluidly designed open-access stacks that intuitively guide visitors through the bookshelves, corridors, and various themed areas, the Seattle Public Library is considered a milestone in user-friendly library architecture.

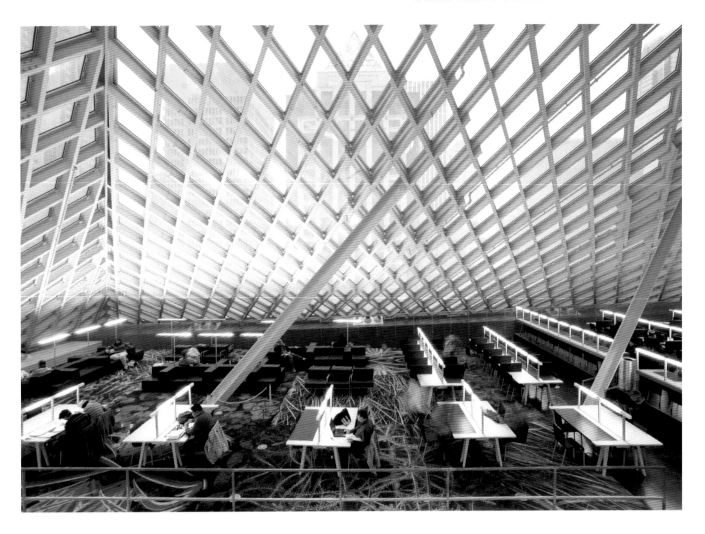

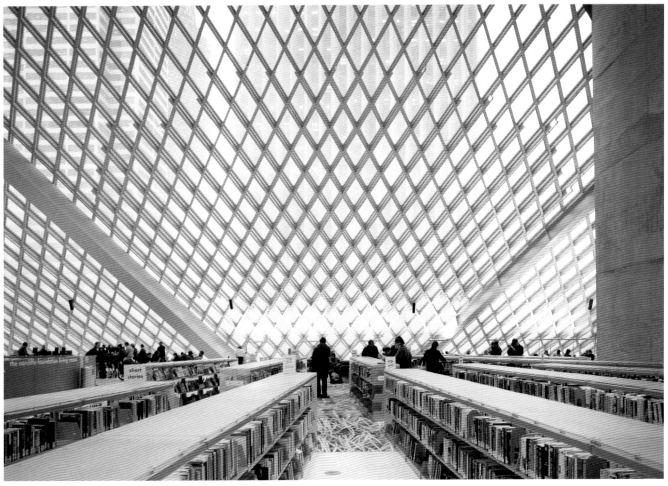

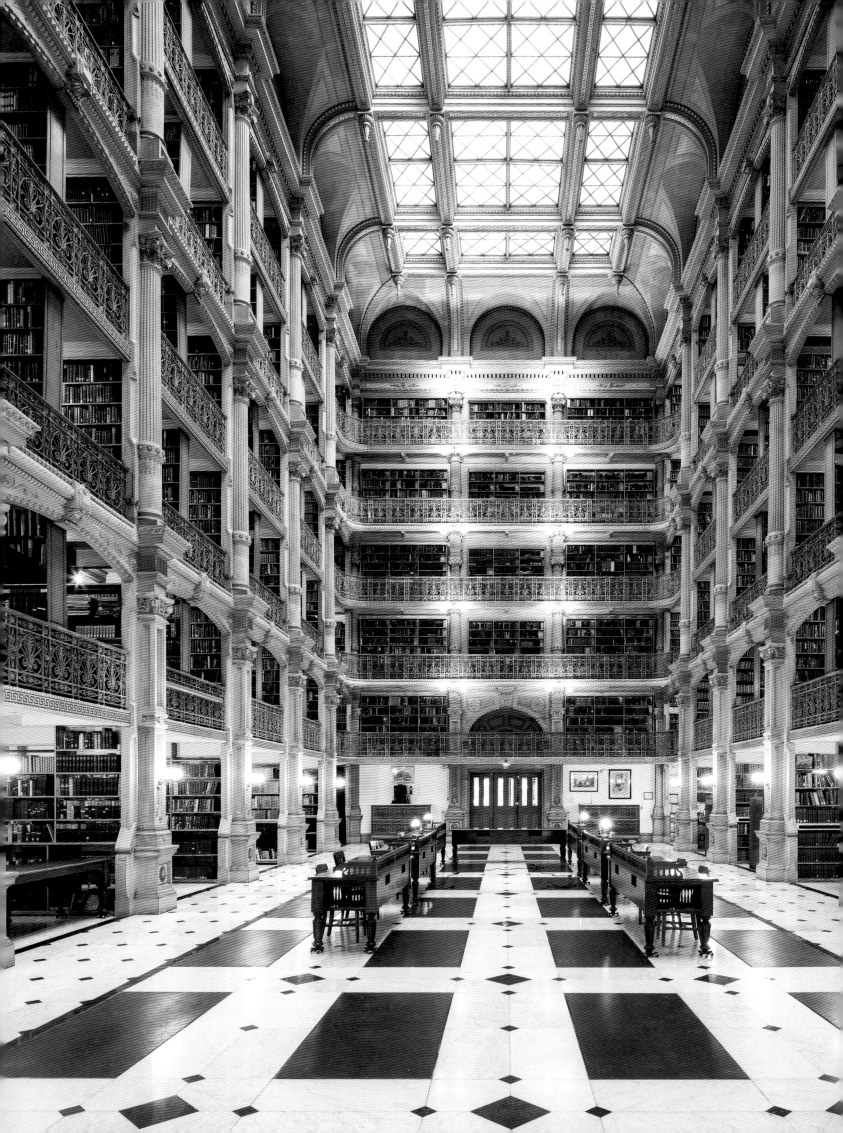

GEORGE PEABODY LIBRARY

If this library is anything to go by, Baltimore is a byword for hospitality

DESIGNED BY EDMUND LIND AND NATHANIEL MORISON
BUILT IN 1878
BALTIMORE, MARYLAND, USA

Sunlight streams down through the huge skylight, illuminating the six floors of the George Peabody Library. With its lovingly sculpted columns, arches, and cast-iron balconies, this library has a deserved reputation as one of the most beautiful in the world. In the 19th century, George Peabody, a patron of the arts, donated the Peabody Institute and Library to the citizens of Baltimore in gratitude for their "kindness and hospitality." That ethos informs the running of the library to this very day: Instead of keeping the enchanting space for scholarship and research alone, the team rents out the vast reading hall and the exhibition areas for private events such as weddings, receptions, and parties. On such occasions, string lights, bar tables, and music transform the George Peabody Library into a peerless party venue, complete with trained waitstaff. In turn, the venue's reasonable rental fees help preserve this unique Baltimore landmark for the future. It's a win-win concept that is now being adopted by libraries all over the world.

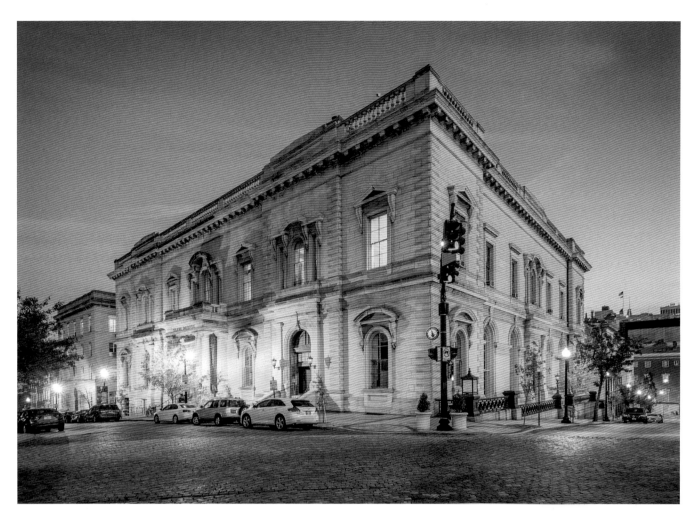

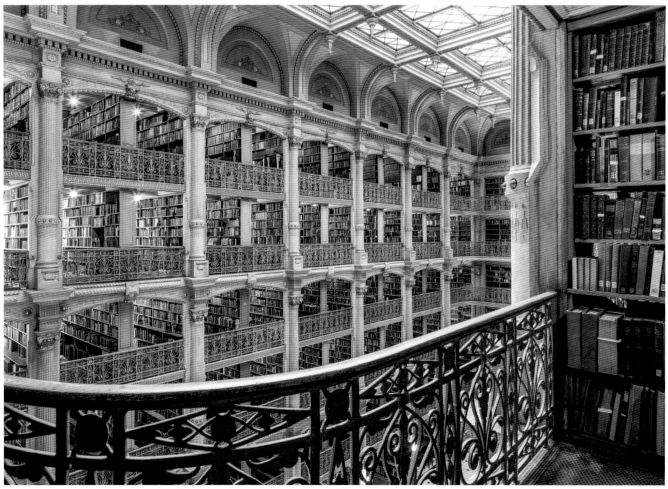

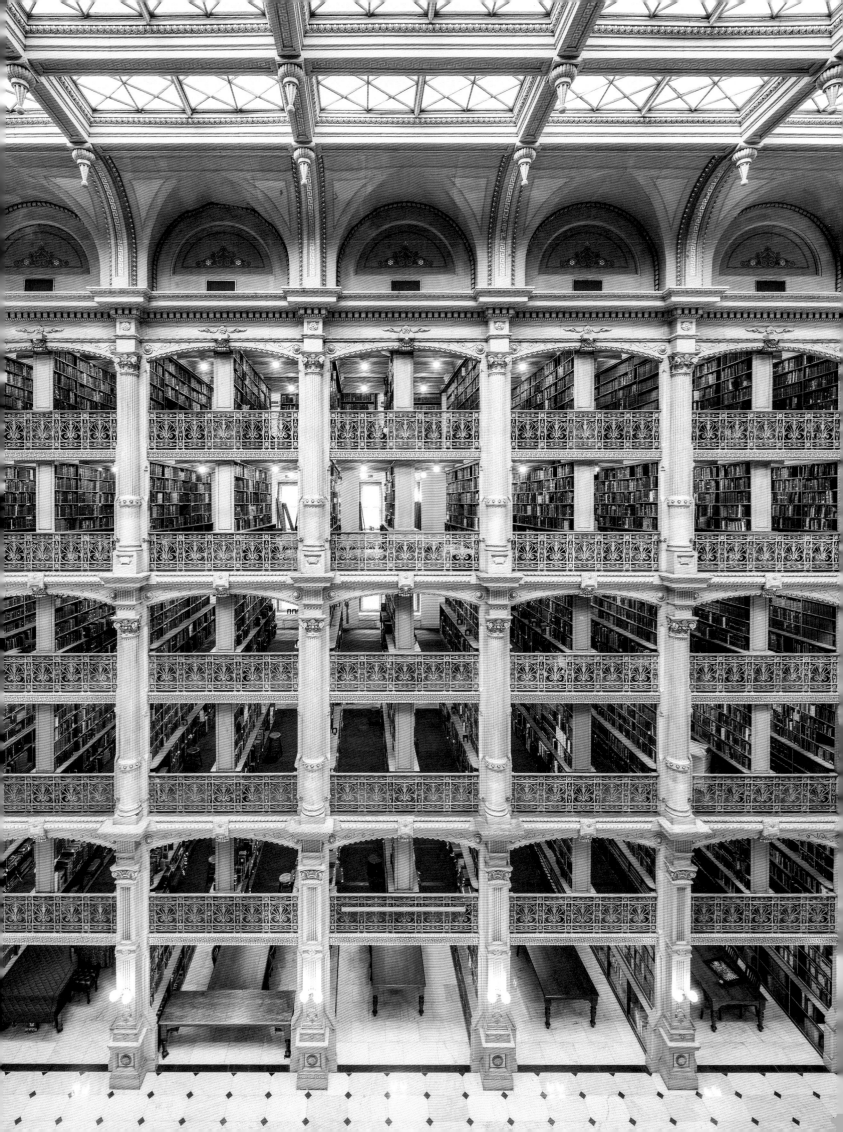

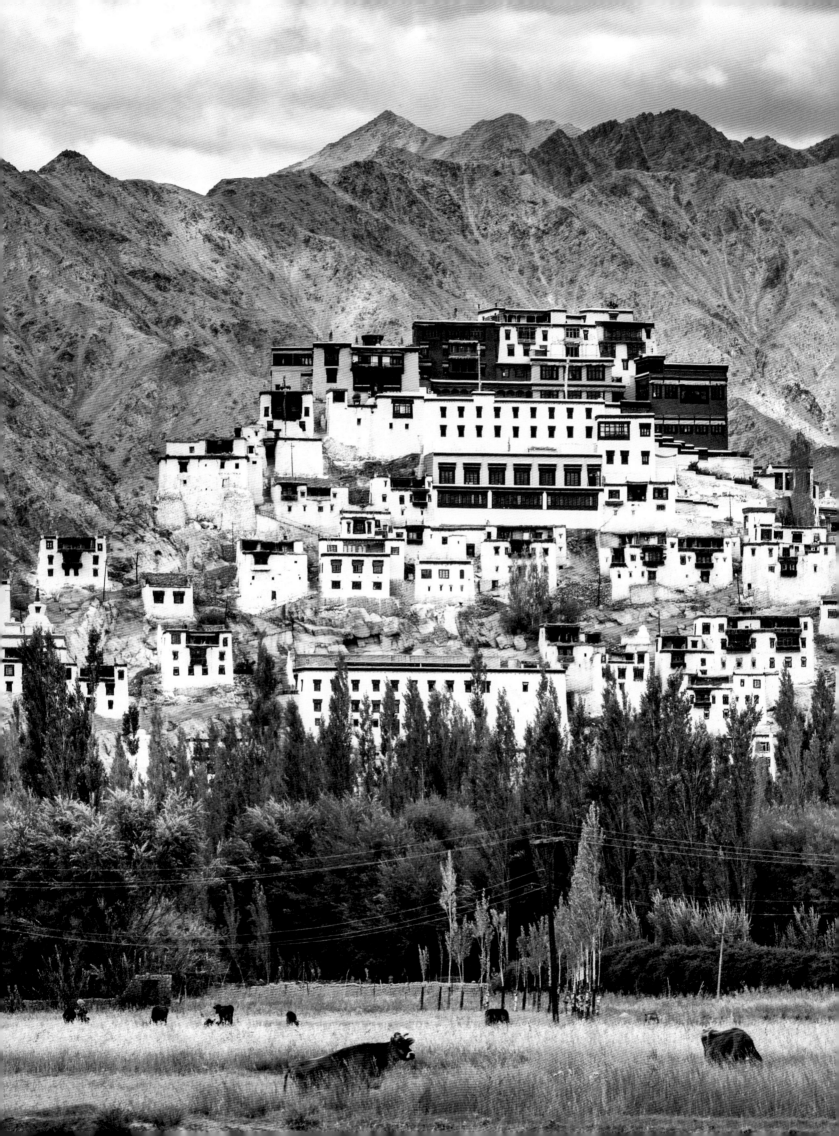

THIKSEY GOMPA LIBRARY

This Buddhist monastery recently opened a new study center dedicated to the preservation of Tibetan culture

DESIGNED BY SPON PALDEN SHIRAB
BUILT IN 1433
LEH, INDIA

No trip to the remote Indian region of Ladakh would be complete without visiting one of its many Buddhist monasteries, known as *gompas*. Legend has it that Thiksey Gompa was built on this mountain after a crow dropped an offering that had been made by two monks on that exact site. Countless handwritten and hand-painted scriptures have been stored in the rooms beyond the traditional assembly hall over the centuries. The main hall is home to a silk-bound Kangyur—a canon of Tibetan Buddhism, containing the words of the Buddha, with a commentary by the religious teacher Bu-ston. The ninth incarnation of the monastery's founder, Thiksey Rinpoche, recently had a new library and study center built nearby. Once finished, it was officially opened by the Dalai Lama. It has a manifold mission: to preserve Tibetan culture, foster interfaith harmony, promote human values and young talent, protect the Tibetan environment, and revive ancient Indian knowledge. Is it any wonder that "Thiksey" translates as "perfect order"?

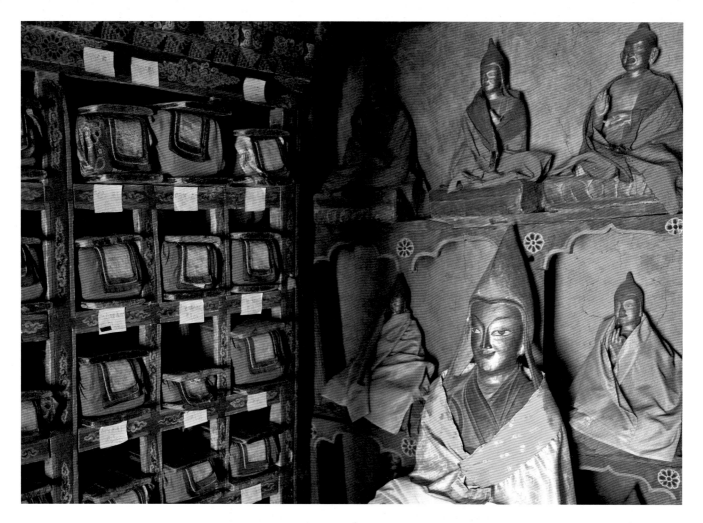

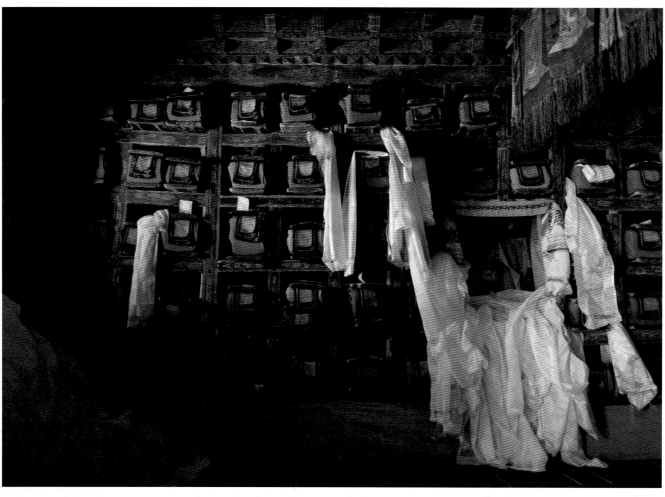

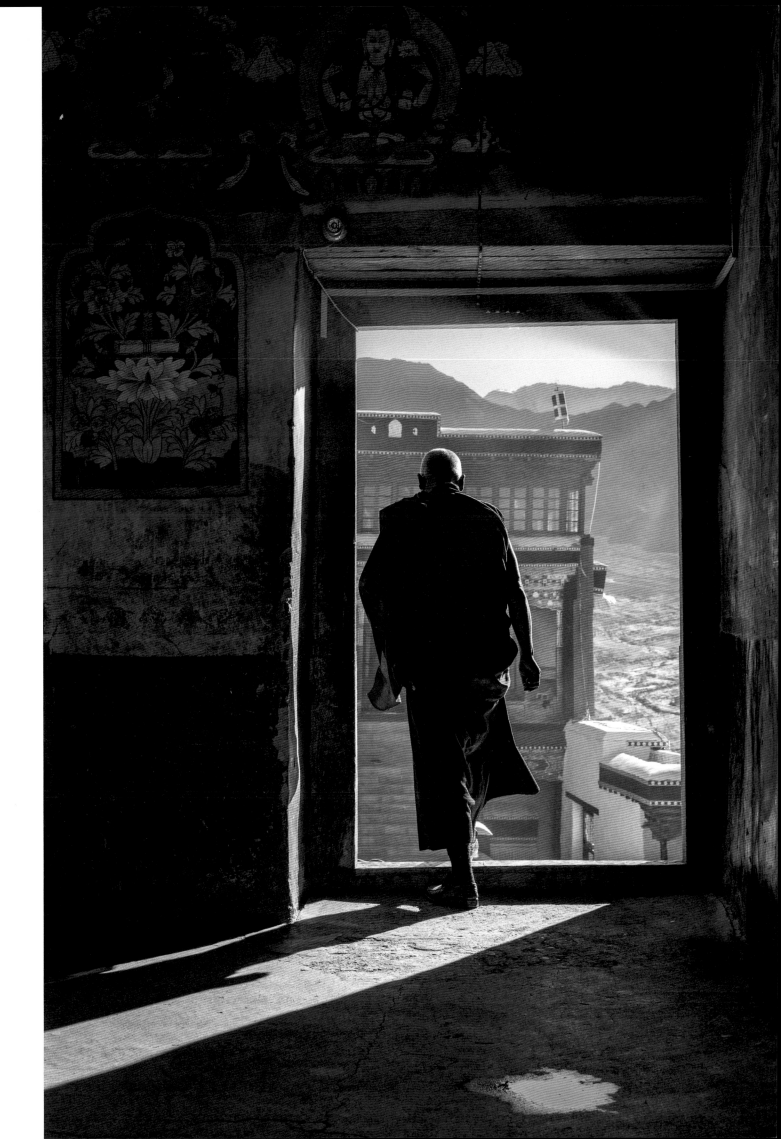

BIBLIOTECA DA CRUZ VERMELHA PORTUGUESA

This palace and its glorious library can be booked out for private events

DESIGNED BY DOM VASCO DE MASCARENHAS
BUILT IN 1638
LISBON, PORTUGAL

The Biblioteca da Cruz Vermelha Portuguesa is rightfully considered to be one of the most beautiful parts of the Palácio Rocha do Conde d'Óbidos. This palace was built in the second quarter of the 17th century and was originally a residence of an aristocratic family, before being acquired by the Portuguese Red Cross in 1919. It remains the organization's headquarters today. For a time, the Red Cross also housed the offices of the Royal Academy of Portuguese History within the palace's walls, and it even allowed Portuguese painter Jorge Colaço to live here while he was creating his many tile paintings for the palace. During World War II, the Red Cross set up an infirmary here to care for wounded prisoners of war. With its exquisite decoration, perfect location, and sweeping views over the River Tagus, the Palácio Rocha do Conde d'Óbidos has long been one of Lisbon's most beloved buildings. These days, the palace—and its library—can be booked for cultural or private events. Civil weddings, workshops, and cocktail parties take place here among some 16,000 volumes, mostly books on humanitarian topics or historical legal texts.

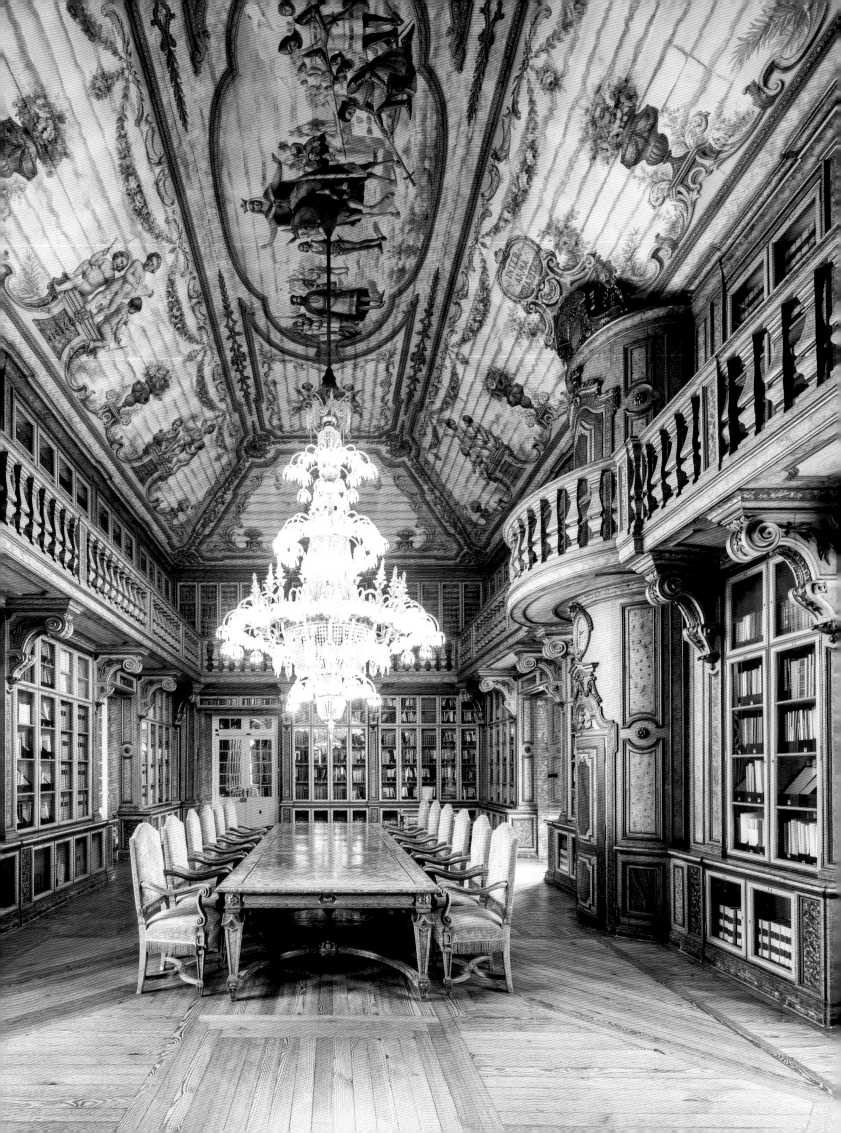

STIFT SCHLÄGL LIBRARY

This monastery has not one highlight but two: its exquisite library and unique brewery

DESIGNED BY ANTON SIMMEL
BUILT 1830–1852
AIGEN-SCHLÄGL, AUSTRIA

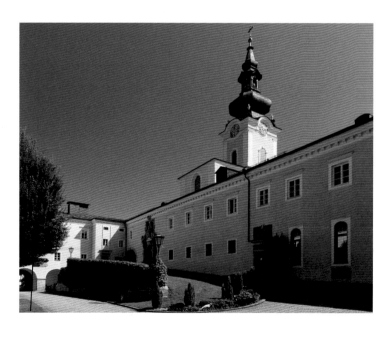

Stift Schlägl was founded as a Cistercian monastery back in the early 13th century, only to be taken over a short time later by the Premonstratensians, who live here and run the monastery to this day. By the 19th century, the monks' collection of books had grown so large that they decided to build a big library to house them. The present-day library was officially opened in 1852. In the great hall, magnificent ceiling frescoes by the painter Augustin Palme watch over the most exquisite examples from among over 100,000 manuscripts gathered here. Anton Simmel, the monastery's carpenter, designed all of the fittings for the library. If you want to see the splendid rooms for yourself, it's best to book one of the tours, which come highly recommended. And visiting the monastery's own brewery afterwards is an absolute must. Over 400 years old, Austria's only monastery brewery offers a state-of-the art visitor experience that, like the library next door, offers up a wealth of knowledge—in this case, best sampled with a freshly poured beer in hand.

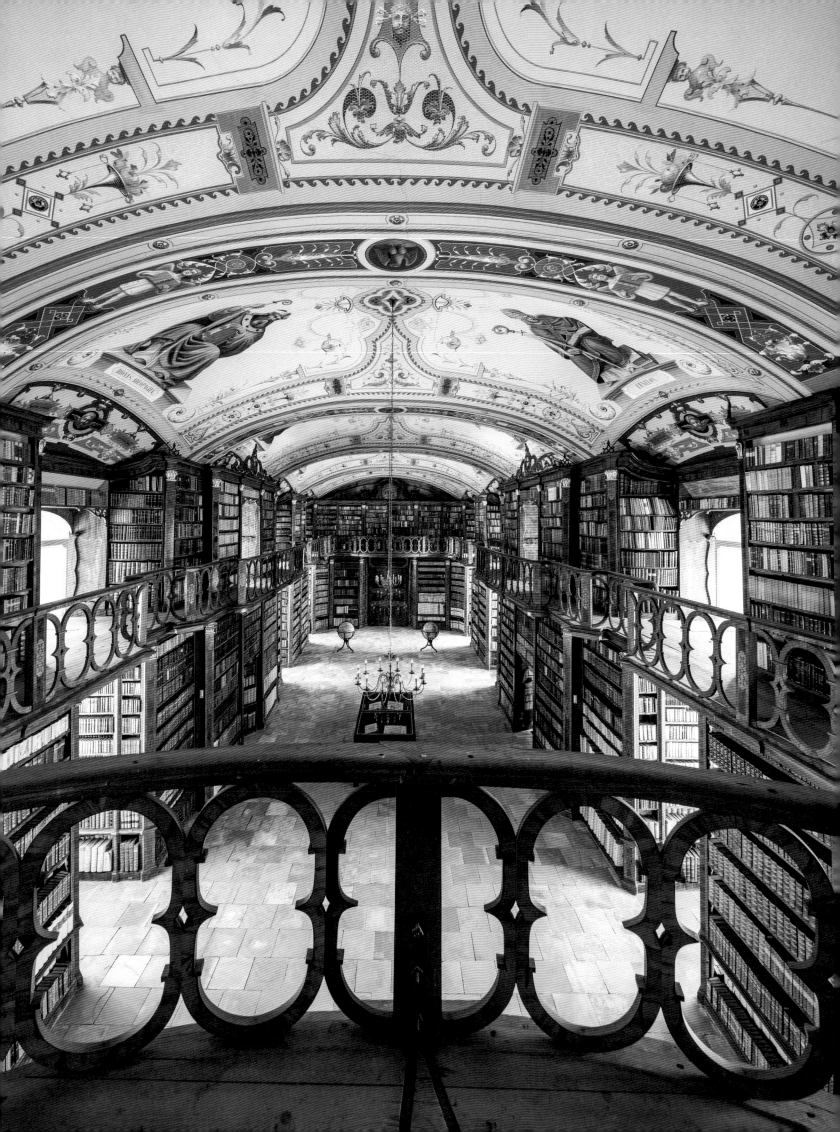

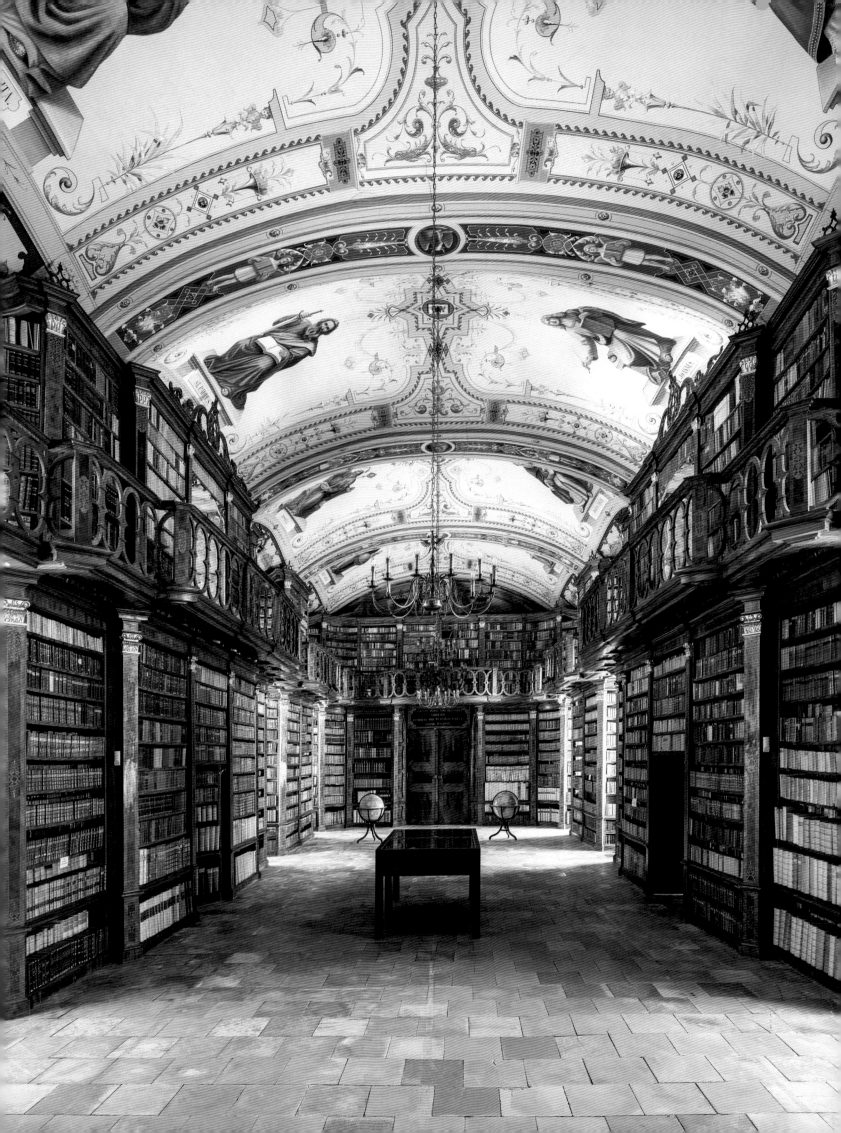

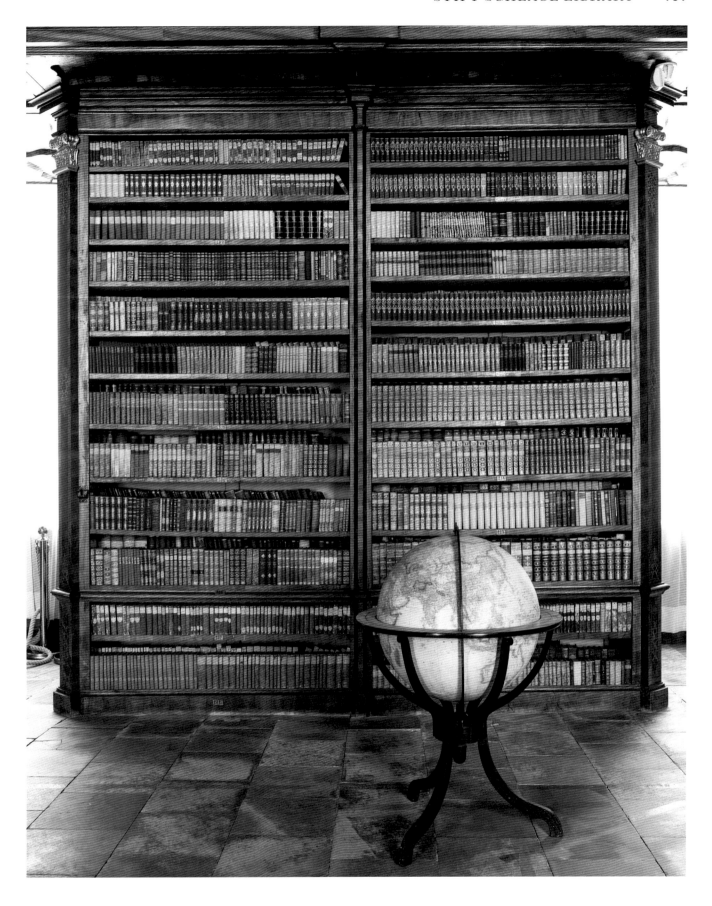

The monks of Stift Schlägl copied countless books in the monastery's scriptorium from the early 15th century onwards, but the striking library hall was only built some 400 years later. Today, the monastery library contains around 100,000 books, including 191 incunabula and 240 manuscripts.

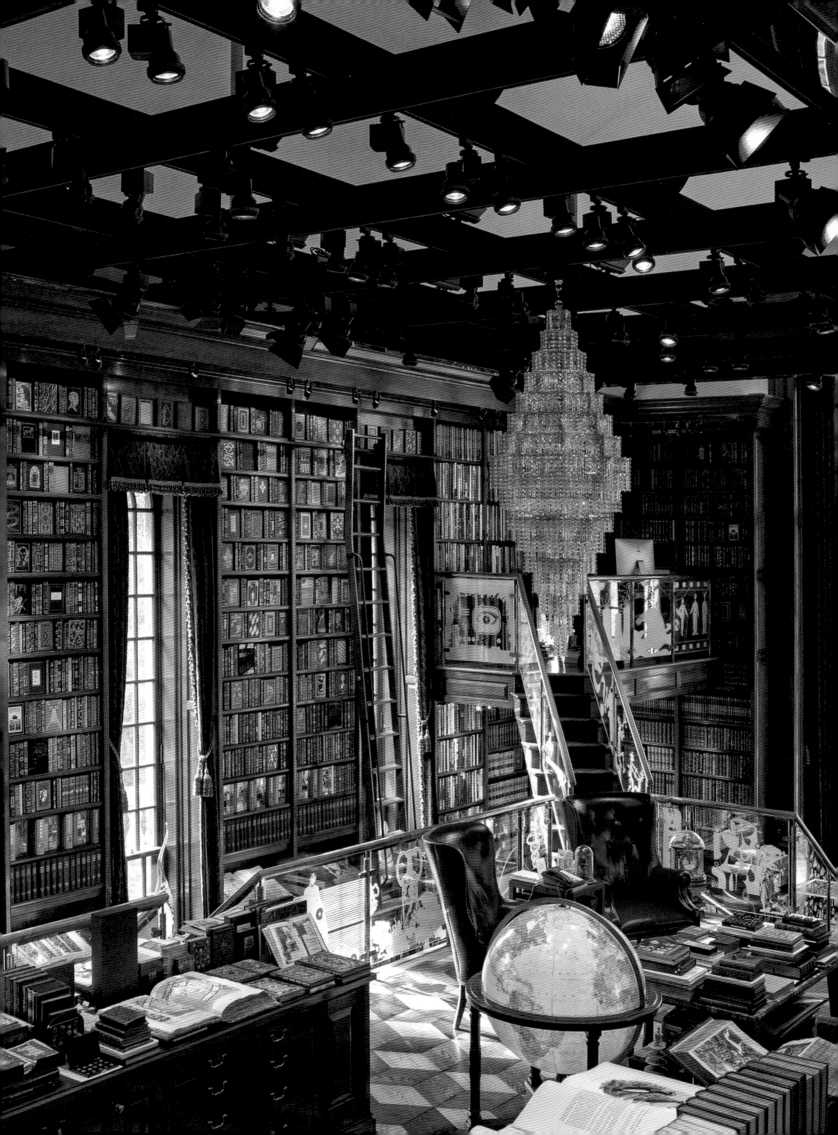

LIBRARY OF THE HISTORY OF HUMAN IMAGINATION

DESIGNED BY JAY S. WALKER, MARK P. FINLAY, AND CLYDE LYNDS
BUILT IN 2002
RIDGEFIELD, CONNECTICUT, USA

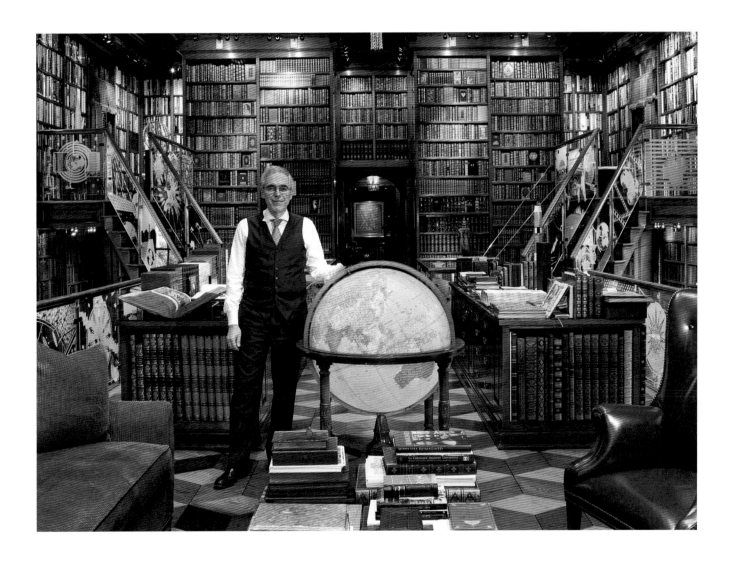

We all know how inventive humans can be, but the ingenious creations, books, and artifacts in this private collection still have the power to surprise

The Library of the History of Human Imagination is a peerless *Wunderkammer* (cabinet of curiosities) thronged with some 30,000 books and 5,000 curiosities. The private library of the American visionary Jay Walker brings together the cleverest, most bizarre, and most groundbreaking inventions in human history, from the operating instructions for the Saturn V launch vehicle—which we have to thank for achievements like the Apollo 11 mission to the Moon—and the original "Thing T. Thing" signed by the entire Addams Family to a cocktail napkin on which President Franklin D. Roosevelt sketched out his plan for victory in World War II. Such exhibits are interspersed with rare treasures, including diamond-studded books crafted by London bookbinding legends Sangorski & Sutcliffe, a medieval tome full of dazzling illustrations of dwarves, and Robert Hooke's *Micrographia* (1665), which contains the first detailed depictions of tiny creatures.

"Imagination is so central to the history of humanity that it deserves its very own library," says Walker, who is an inventor himself, with over 1,000 patents to his name. None of these have yet made it into the Library of the History of Human Imagination, however: "The qualifying bar is higher than I have been able to reach so far!"

Walker's library began with a collection of Bibles; he recalls that he wanted to retrace the influence of Holy Scripture on Western thought. This soon developed into a passion for the intellectual milestones of mankind. Almost 20 years ago, his ever-growing collection of books and artifacts had become so large that Walker decided to build an entire library to house them. He commissioned architect Mark P. Finlay and artist Clyde Lynds, and together they came up with a space so stupendous that it would pass the library's

criteria for inclusion in its own right. The stairs, floating platforms, and winding aisles make the library a veritable labyrinth of ideas. The space is divided up by panes of glass that bear sketches of important achievements and change color according to the music playing. Above it all soars one of the original type-1 replacement Sputniks—the first artificial Earth satellite to be launched into orbit, in 1957—and a chandelier from the set of the James Bond film *Die Another Day*, which Walker has fitted with new wiring and 6,000 LEDs.

Heavy tomes with the collected works of genius artists, architects, and designers are testament to mankind's passion for discovery, along with historical maps and the carefully assembled skeleton of a young raptor.

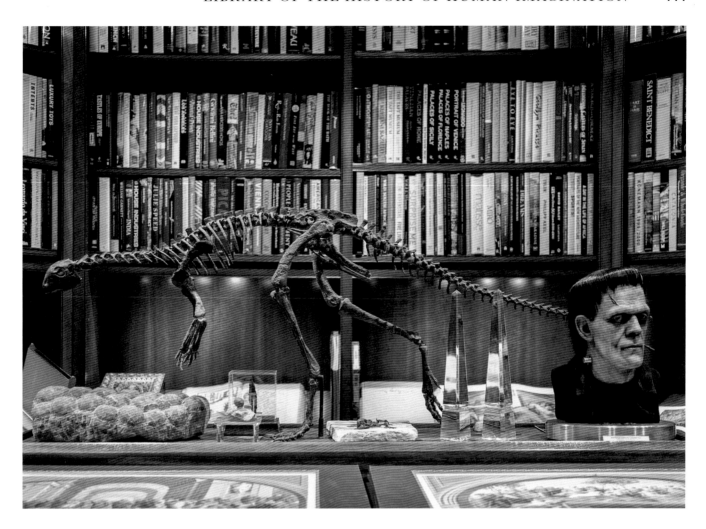

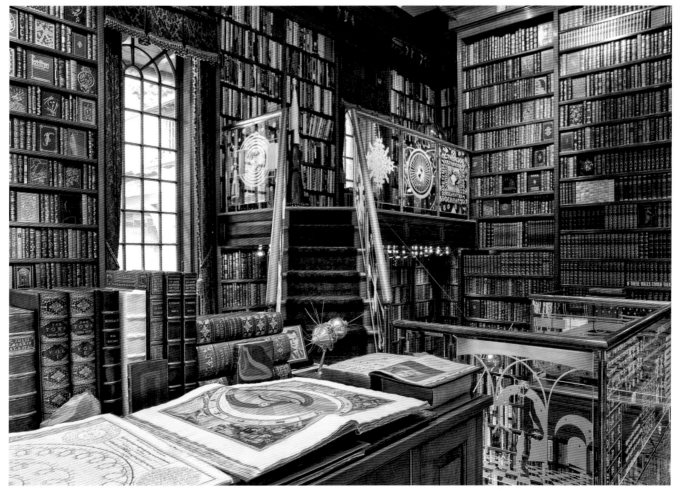

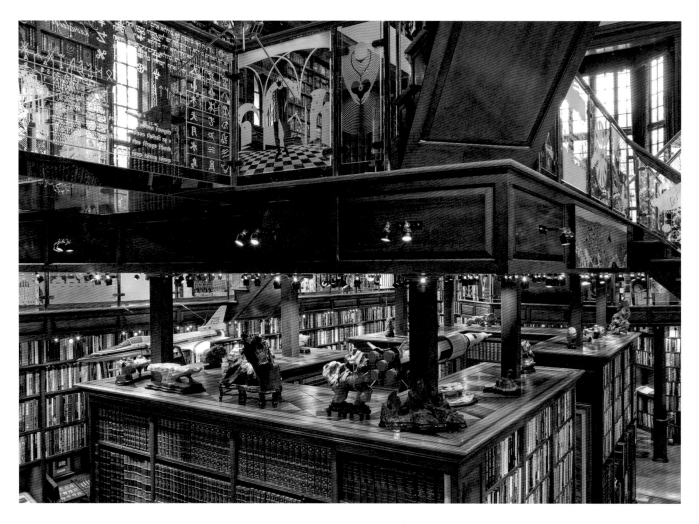

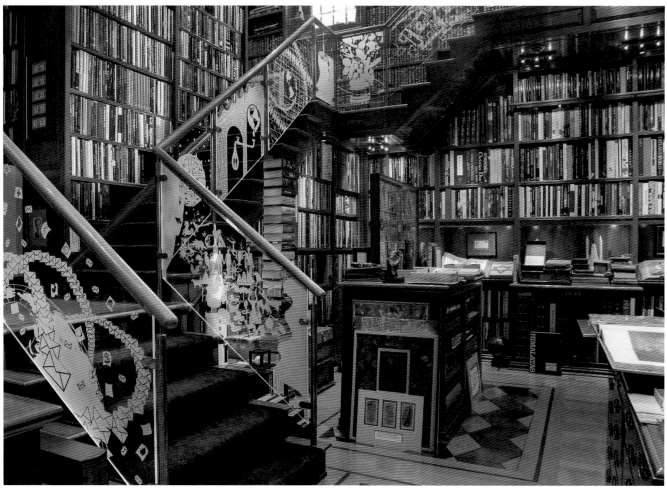

> *"I consider thousands of new items each year and select a very small percentage. Each object takes its own path to arrive. I found a few amazing treasures on eBay ten years ago!"*

"I consider thousands of new items each year and select a very small percentage," explains Walker. "Each object takes its own path to arrive. I found a few amazing treasures on eBay ten years ago!"

Every now and then, lucky guests are invited to marvel at the riches within these hallowed halls. Walker gives these guests—politicians, scientists, and even classes of schoolchildren—a personal tour of his creation. He likes to demonstrate the expansion of mankind's intellectual—and proverbial—horizons through the juxtaposition of objects. Thus the first printed book about cryptography, the *Polygraphia* by the German abbot Johannes Trithemius, sits alongside a replica of the Enigma cipher machine employed by Nazi Germany before eventually being cracked by the Allies. Maps of the world from different centuries clearly show where cartographers came up against the limits of knowledge and passed into the realm of fantasy. Between them gleam various inventions by Thomas Alva Edison.

Walker often holds brainstorming sessions with his team in the Library of the History of Human Imagination. He's aware that there's nothing more inspiring than being in the company of brilliant minds and ingenious inventions. Indeed, it seems conceivable that visitors might even imbibe a little of the wisdom of the writers, thinkers, and geniuses gathered together here. Walker's library no doubt contains a book on that very subject. For those who fancy creating their own private library, Walker has the following sage advice: "Collect to learn! Books that can teach you what you never thought you were interested in or can inspire you in ways that stretch your imagination—no matter the resale value—are worth their weight in gold."

One of Walker's favorite pieces is an atlas dating from 1699 that shows the Sun, not the Earth, as the center of the known universe for the very first time, thus drawing a clear historical line between belief and knowledge (see p. 111 bottom).

BIBLIOTHÈQUE DE L'INSTITUT NATIONAL D'HISTOIRE DE L'ART

To this day, the Salle Labrouste is considered the blueprint for magnificent reading rooms all over the world

DESIGNED BY HENRI LABROUSTE
BUILT IN 1860
PARIS, FRANCE

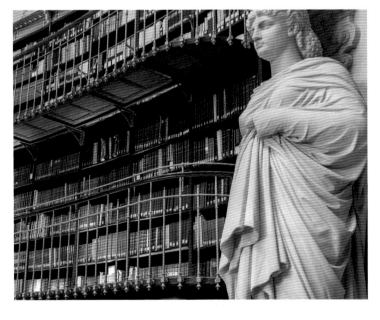

When French architect Henri Labrouste was commissioned to rebuild the French royal library in 1854, he had to contend with a hodgepodge of disparate and, in some cases, ramshackle buildings. He decided to save what could be saved and rebuilt what is now the Hôtel Tubeuf and the Galerie Mazarine. To give the collection a setting befitting its stature, he also designed a spectacular reading hall—the Salle Labrouste— that would serve as a model for countless libraries that came after it. Its square floor plan merges with a semicircle at the southern end. The nine domes are supported by 16 cast-iron columns. Light streams down through the round skylights at the top of each dome into the sweeping reading hall. Some 150 years after it opened, the Salle Labrouste was carefully restored, and it officially reopened in December 2016. The most important works in the collection of the INHA Library are displayed here today, covering everything from art history to archaeology. You can enjoy its awe-inspiring architecture individually or on a tour—no library card required!

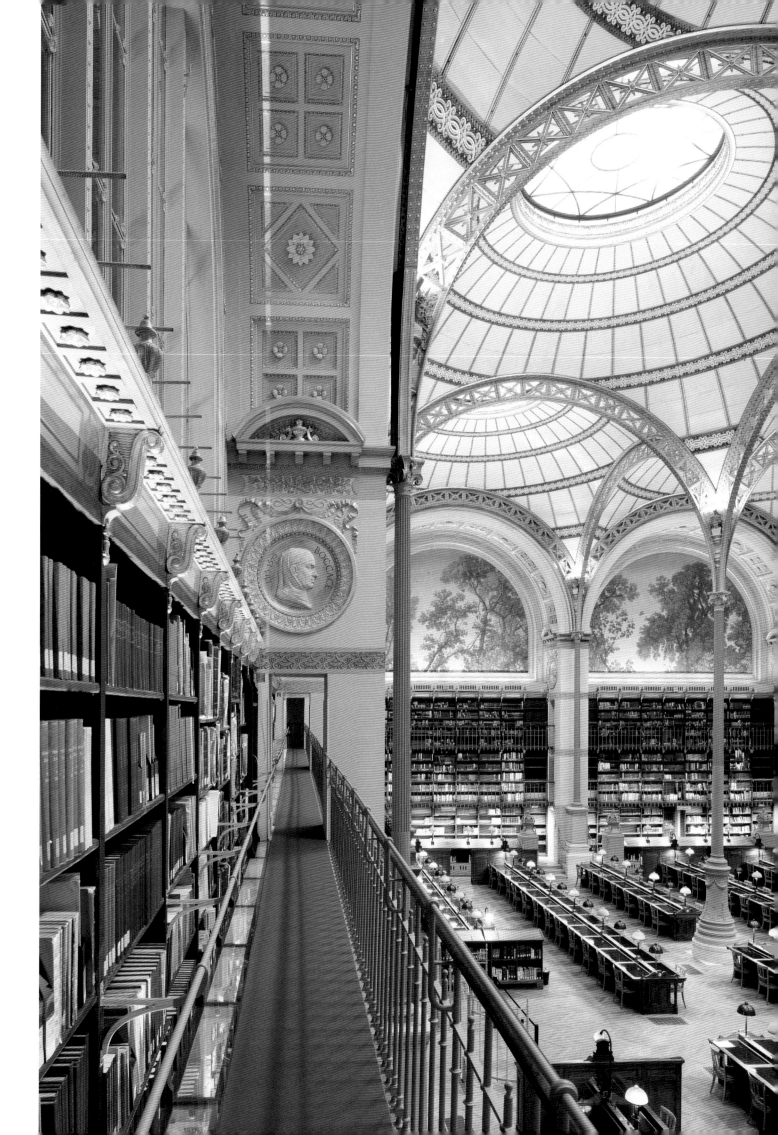

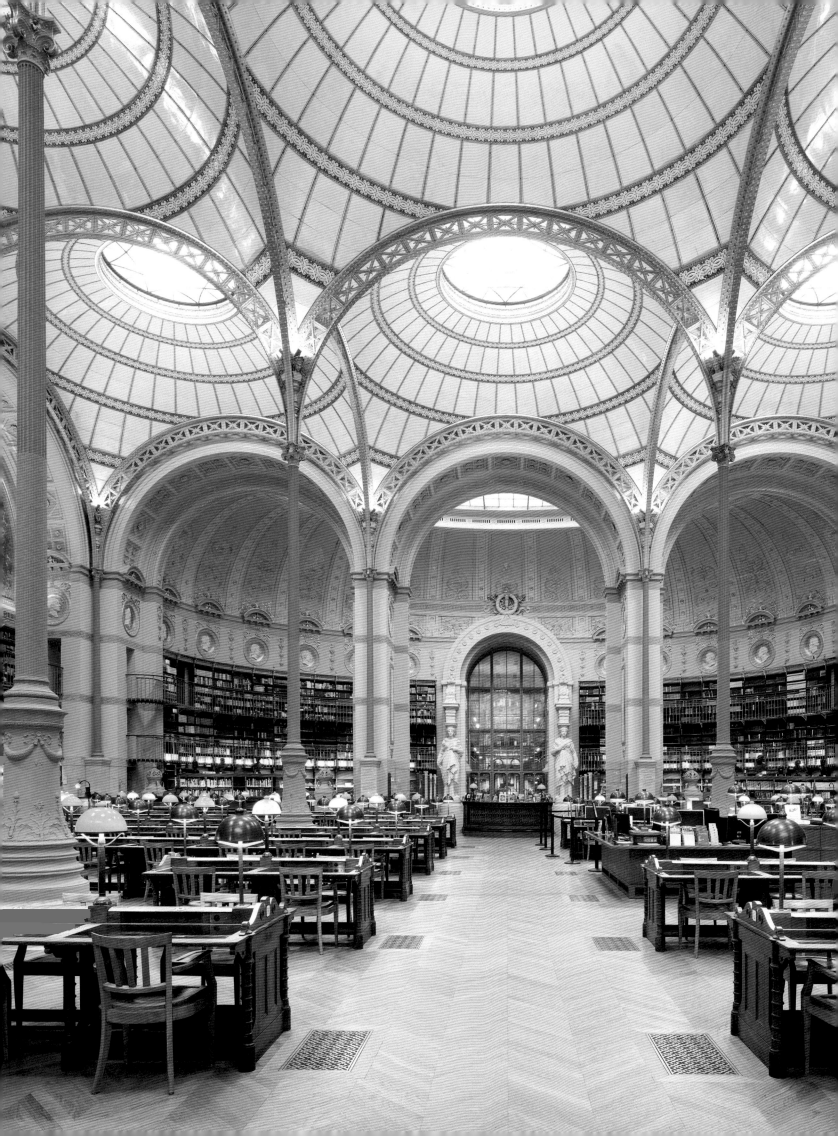

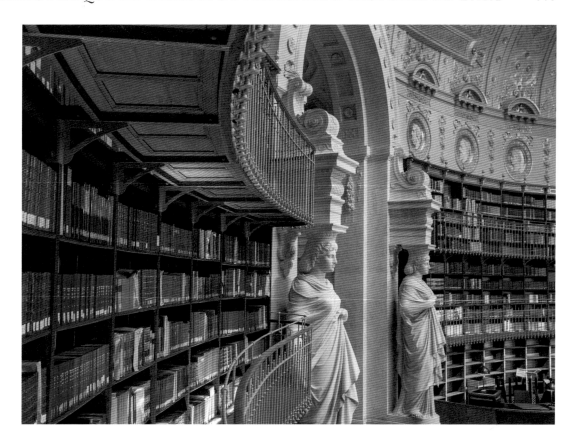

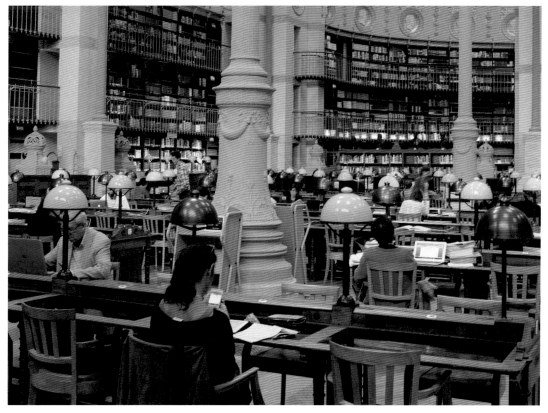

The distinctive domes of the Salle Labrouste have been inspiring librarygoers for years. This institution has been variously dubbed the "Basilica of Books" and "Garden of Knowledge" and bawdily likened to a "peep under a hooped skirt."

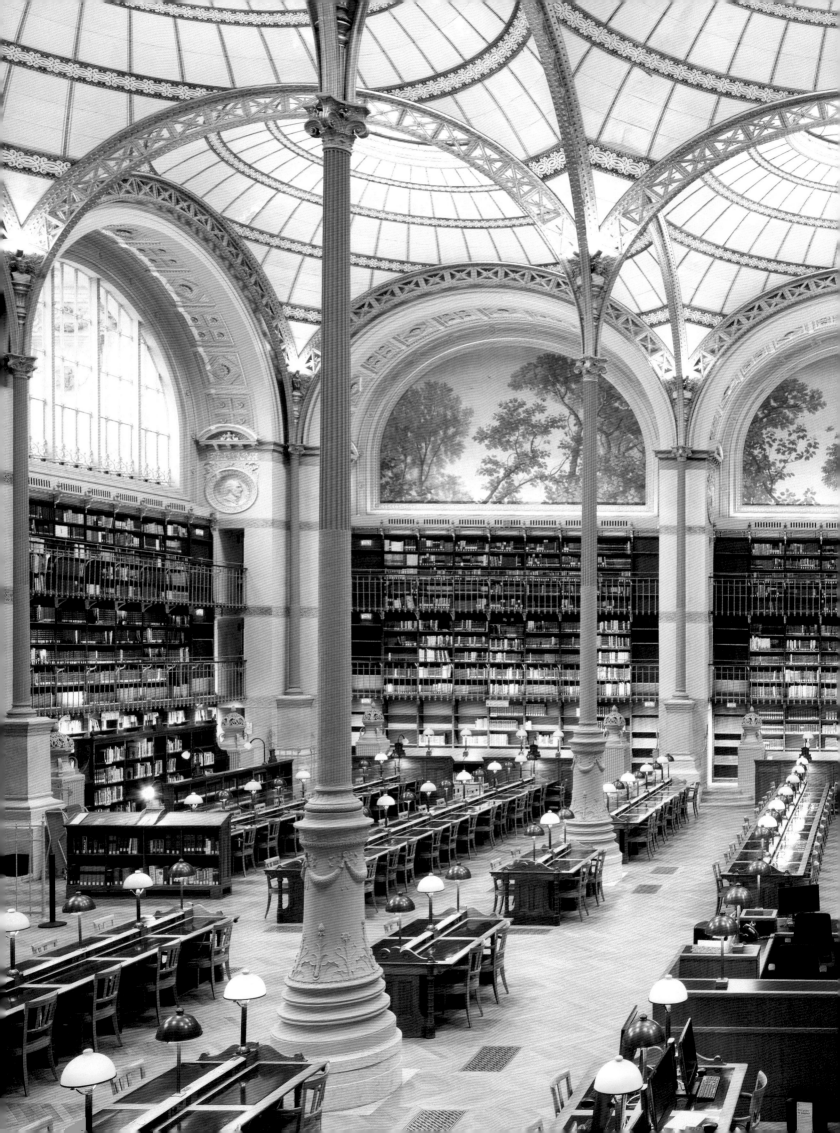

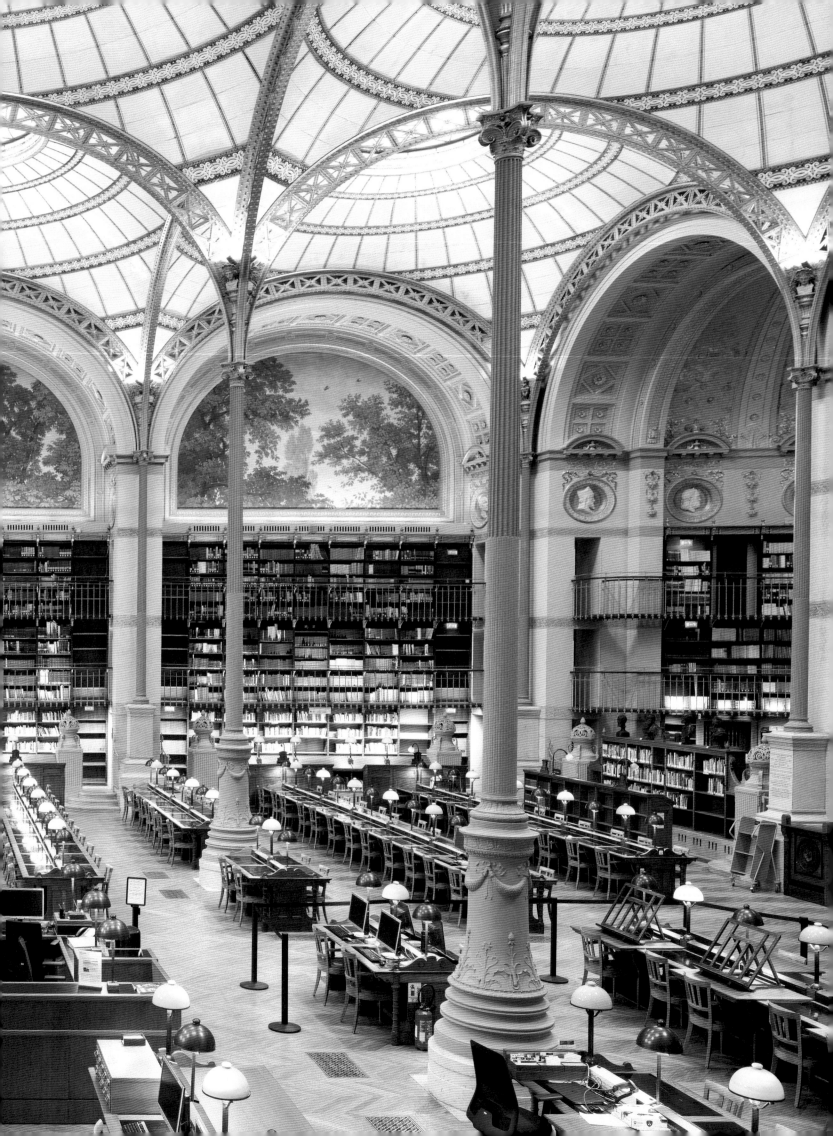

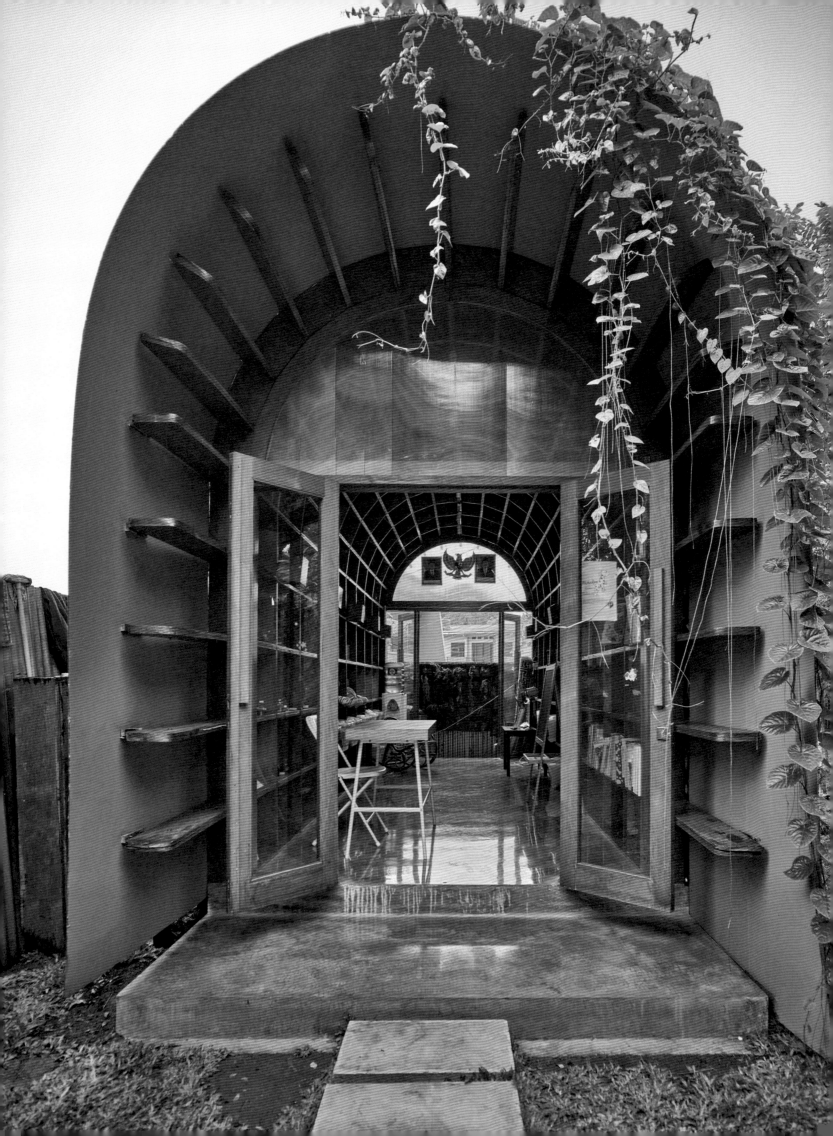

OMAH LIBRARY

This library sits alongside a dental clinic and architecture studio—a unique triumvirate

DESIGNED BY REALRICH ARCHITECTURE WORKSHOP
BUILT IN 2020
KECAMATAN KEMBANGAN, INDONESIA

This building is as unusual as its setting. The Omah Library is part of the Guha Bambu new development and renovation project in Kecamatan Kembangan, which also includes a dental clinic and an interior design and architecture studio. The Indonesian team from RAW Architecture enhanced the existing library by creating generous space for more bookshelves, an art gallery, and a new bookstore. Cleverly placed doors allow flexible use, so the library can be used for events and entertainment if necessary. A private living area within the building was designed separately and has its own entrance. The architecture studio adjoins the library. A three-floor upper building made of steel, bamboo, and concrete rises above the two basement floors, which offer plenty of storage space. The delicate-looking yet ultra-sturdy portals were created using centuries-old handicraft techniques from West Java, Indonesia. This building lays down a marker for the future: semi-private, semi-public houses are starting to be built according to the same model across the whole of Indonesia.

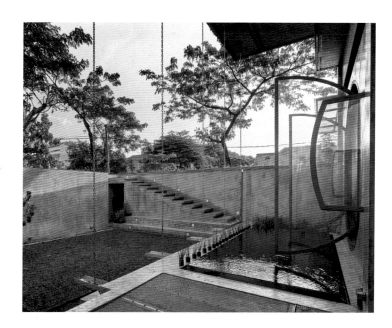

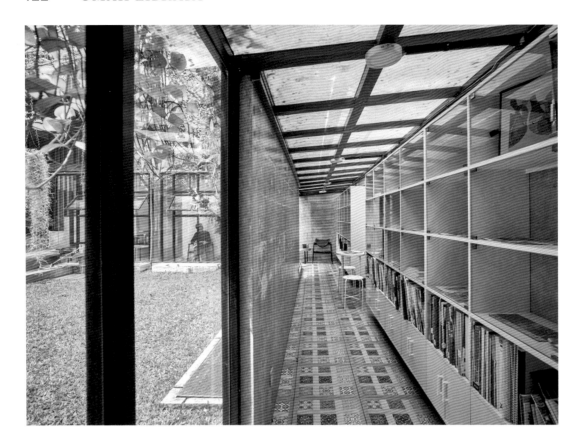

Glass façades and roofs, oversized cut-out recesses, and areas open to the outdoors blur the boundaries between inside and outside, and between public and private life, to stunning effect.

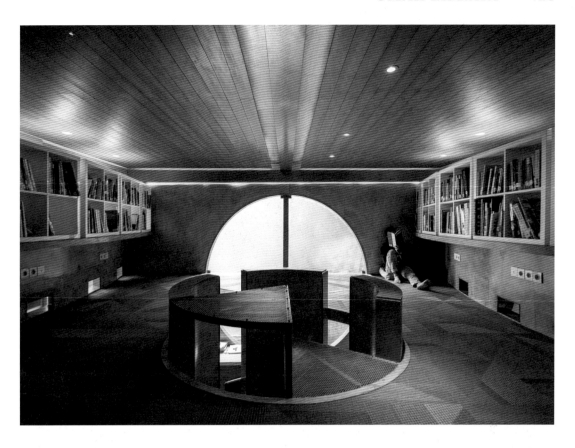

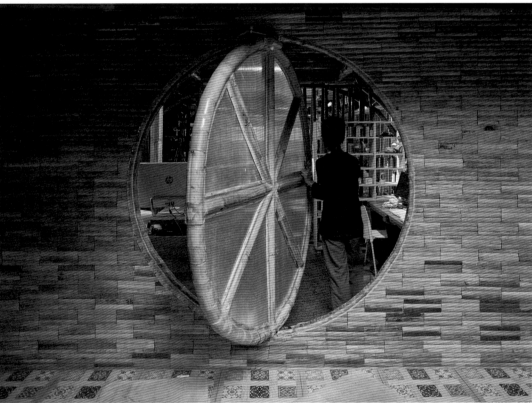

The architecture creates surprising juxtapositions throughout, in keeping with the inclusive concept behind the library. The result is a thrilling, atmospheric mix of features.

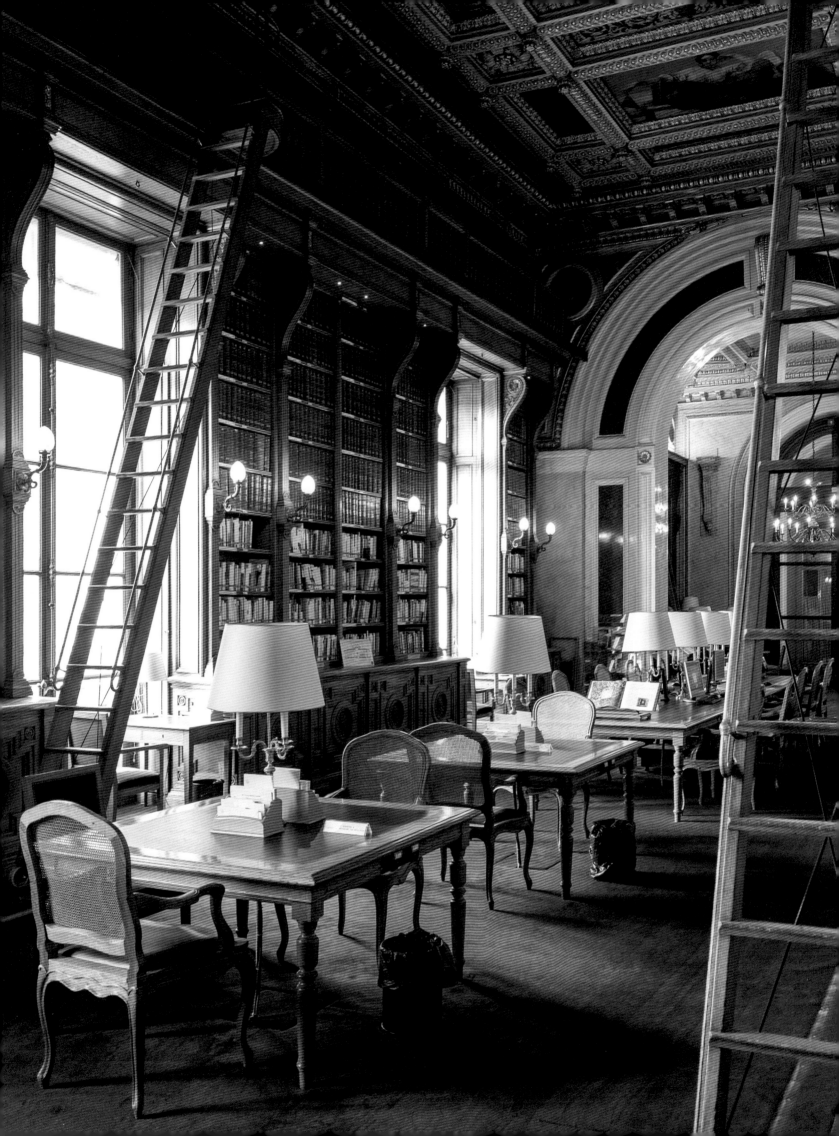

BIBLIOTHÈQUE DU SÉNAT

Study beneath magnificent ceiling frescos by Eugène Delacroix

DESIGNED BY ALPHONSE DE GISORS
BUILT 1837–1846
PARIS, FRANCE

Fifty years after the French Revolution, the Palais du Luxembourg became too small for the growing number of elected representatives, and the decision was made to extend the south façade, including the building's library. Alphonse de Gisors had just been appointed architect to the Chambre des Pairs, and in 1834 he began planning the current reading room. He commissioned French painter Eugène Delacroix to decorate the dome and the semi-dome over the central window with late Romantic motifs, including Alexander the Great, Orpheus, and Sappho. The shelves in the 52-meter-long (171-feet-long) gallery and the cabinets on either side of the Salle des Séances began to be filled from 1841. Seven windows look out over the surrounding Jardin du Luxembourg. Those who are lucky enough to get the chance to study here couldn't be in better company: Anatole France, winner of the Nobel Prize for Literature, worked here as a library assistant up until 1890, when he left to devote himself to his literary endeavors.

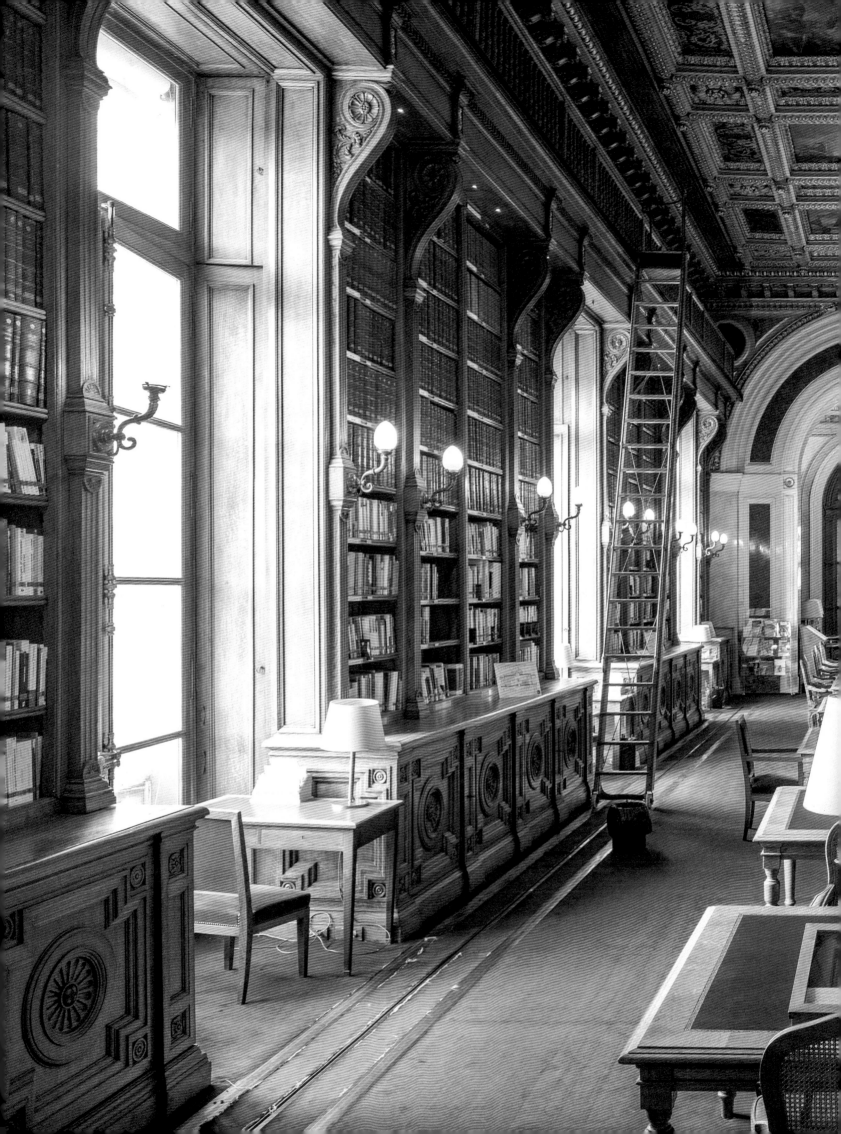

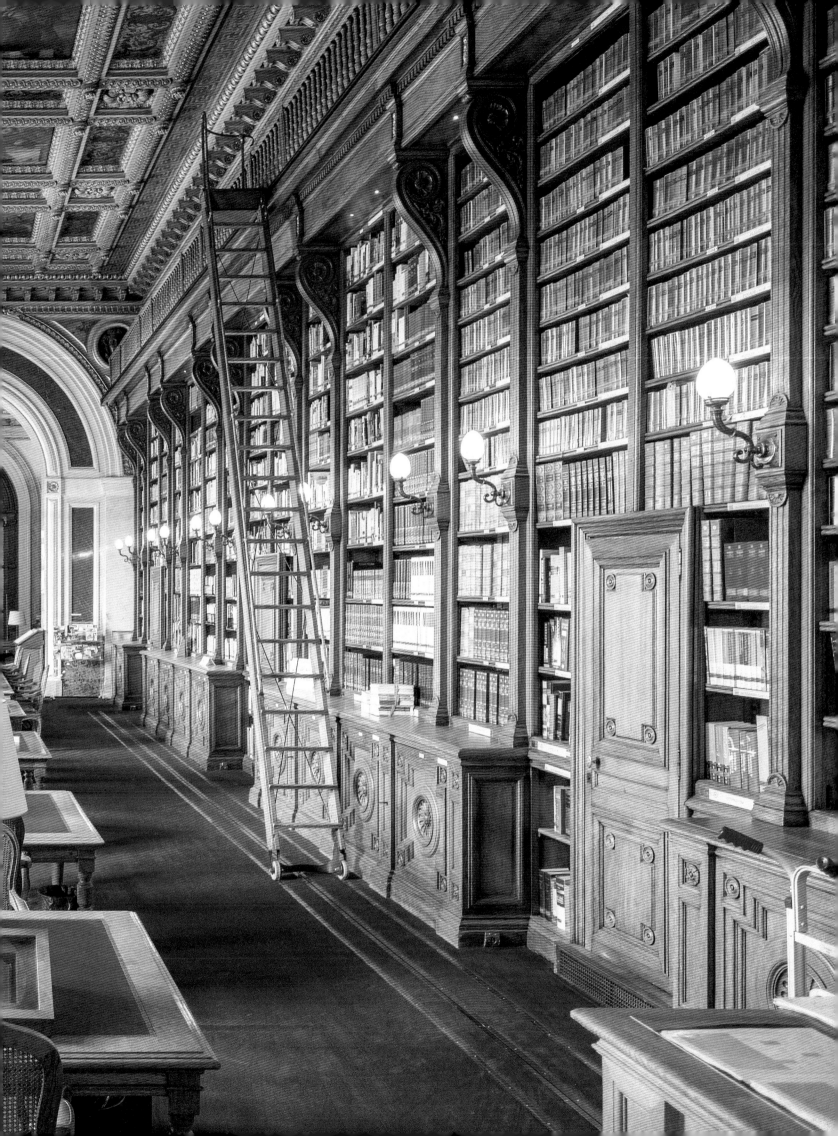

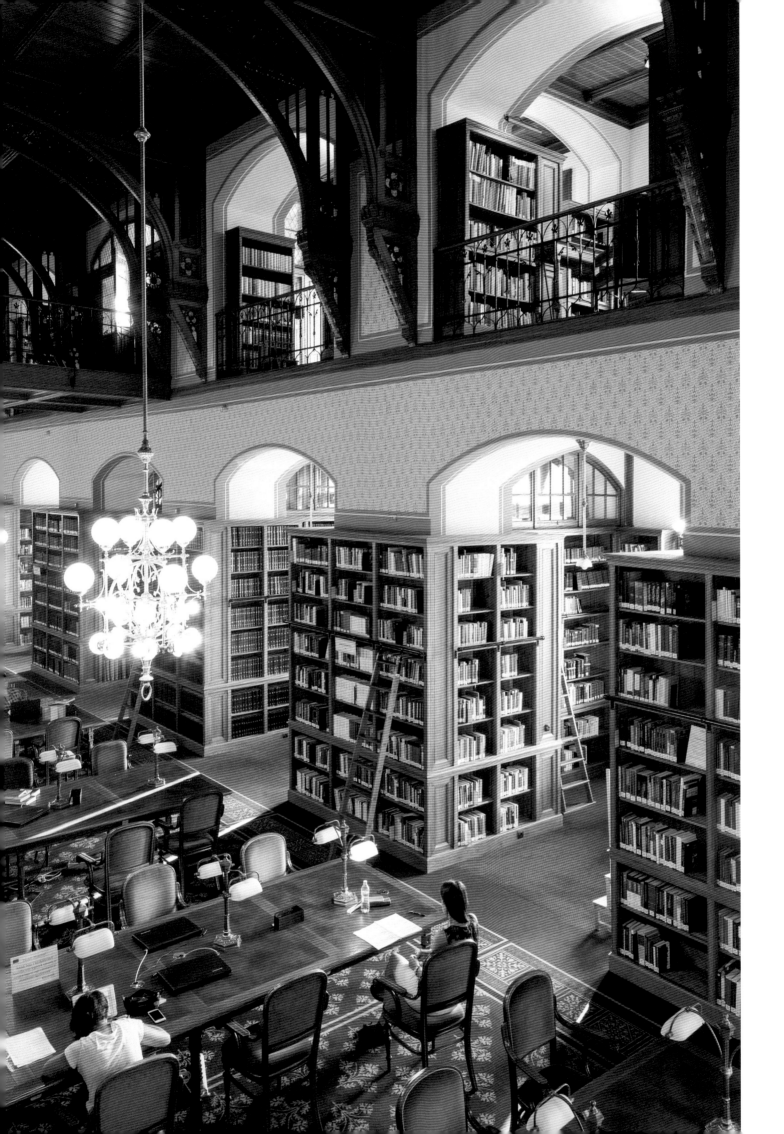

LIBRARY OF THE HUNGARIAN PARLIAMENT

When the clamor for public access to its collection grew, Parliament opened up its library

DESIGNED BY IMRE STEINDL
BUILT 1885–1904
BUDAPEST, HUNGARY

The Library of the Hungarian Parliament, built around the same time as Heroes' Square and Andrássy Avenue, was originally reserved solely for members of Parliament and their research work. Its collection ranges from political science and legal texts to modern history, philosophy, sociology, and economics, plus historical newspapers and museum documents. Perhaps due to its location adjoining the spectacular Parliament building, calls for the library to be opened up grew ever louder over the years. A separate reading room within the sumptuous Baroque building was opened to external visitors in the 1930s, before Parliament finally decided to make the library public in 1952. Since then, it has been under the control of the Ministry of Culture, which has continued to add to its collections. Today, it stocks many contemporary books. The Library of the Hungarian Parliament also purchases historical works at auctions and receives major donations from the private collections of scholars and members of Parliament.

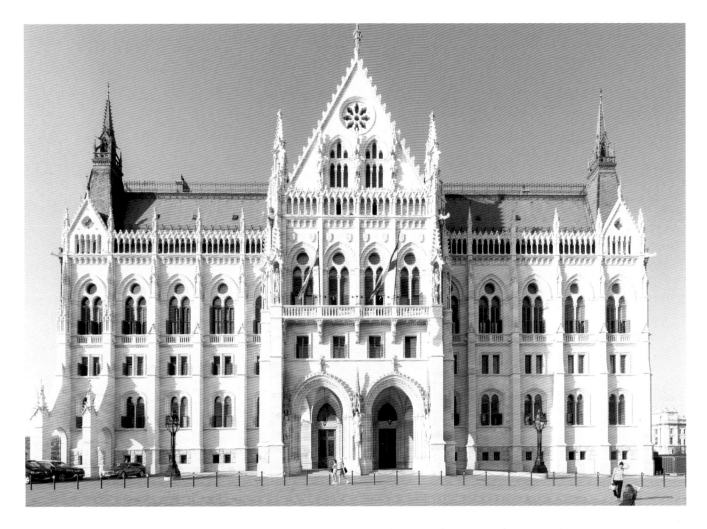

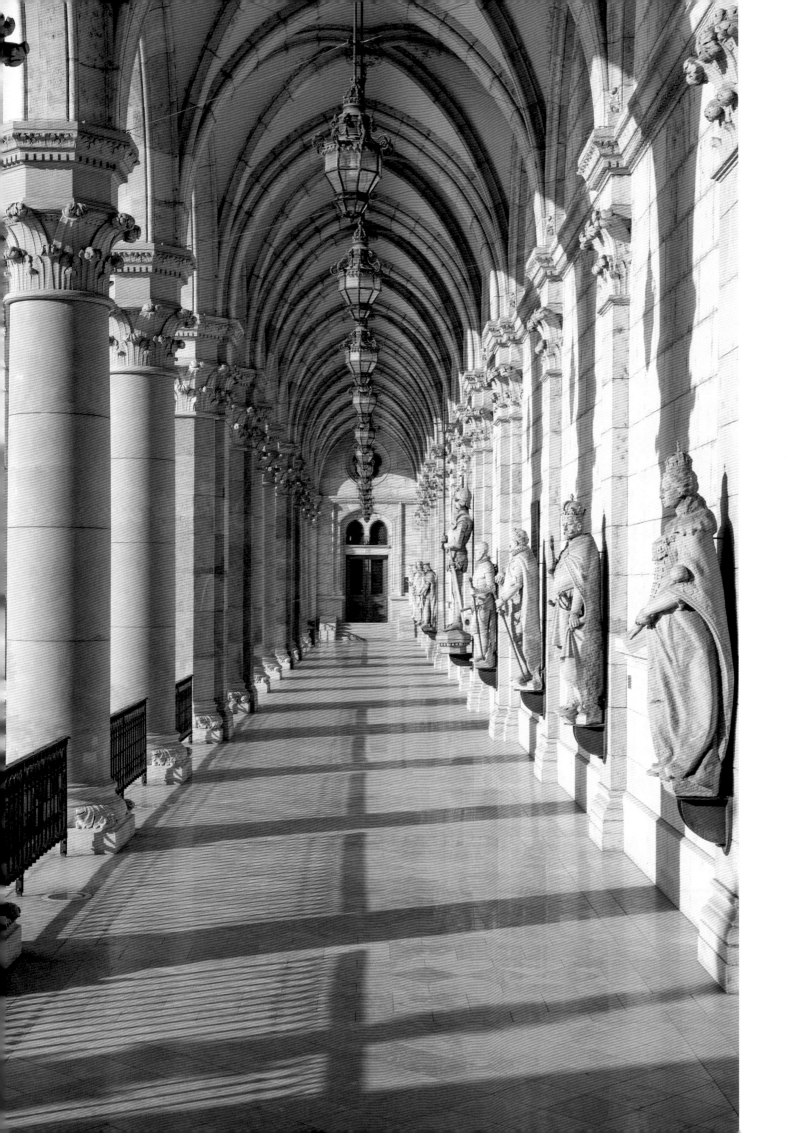

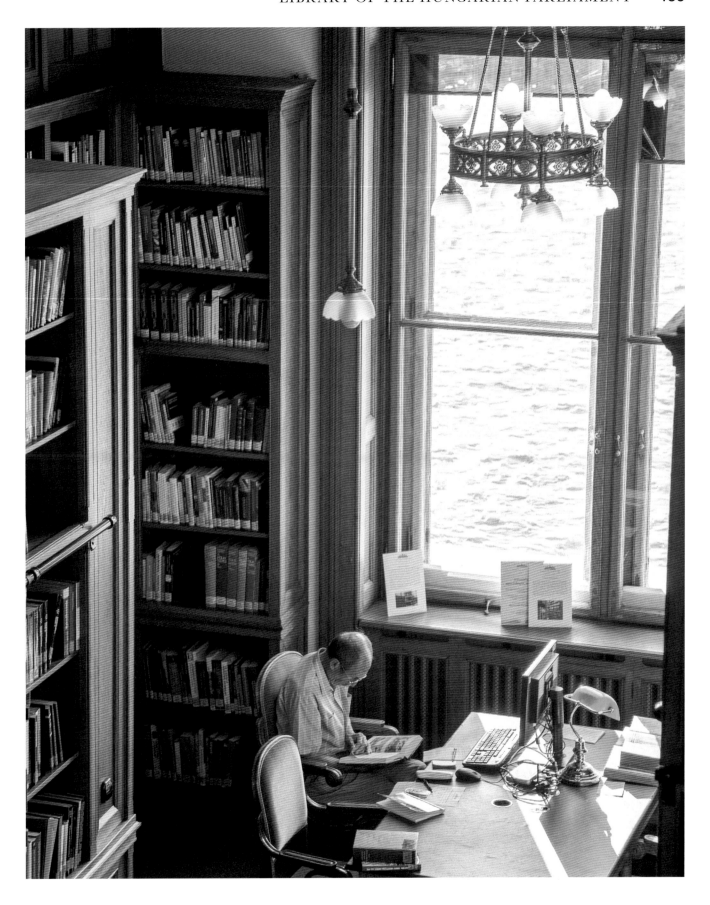

For decades, the Library of the Hungarian Parliament in Budapest was off-limits to anyone but members of Parliament, but today, anyone can come here to read, study, and enjoy the incredible views over the River Danube.

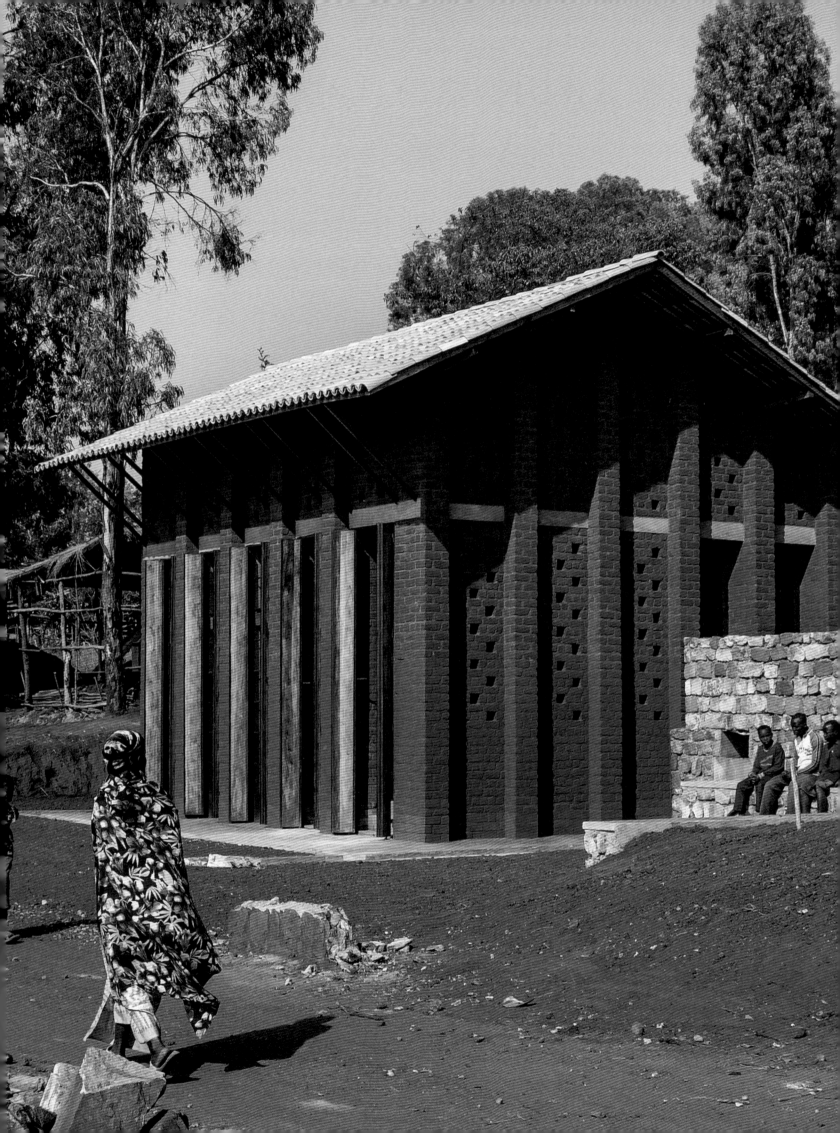

LIBRARY OF MUYINGA

This inclusive library truly is a feast for the senses

DESIGNED BY BC ARCHITECTS
BUILT IN 2012
MUYINGA, BURUNDI

Every culture on Earth is defined by its stories. In many countries, like Burundi, tales continue to be passed down through the oral tradition. Yet this kind of storytelling culture can easily leave hearing-impaired people feeling left behind and excluded. Together with local colleagues and with support from a number of nonprofit organizations, BC Architects designed a library for an inclusive school where children with and without hearing impairments could be taught together. The Library of Muyinga cannot give its little visitors the gift of hearing, but it grants them something else: an opportunity to partake in the legacy of their culture. In doing so, it fosters learning and opens up new prospects for the future. The library also serves as a place of exchange and collaboration. Students, trainees, and young architects all helped make this vision a reality. Cooperative thinking is also evident in the library's board of directors, which is made up of the principals of all the local elementary and high schools in Muyinga.

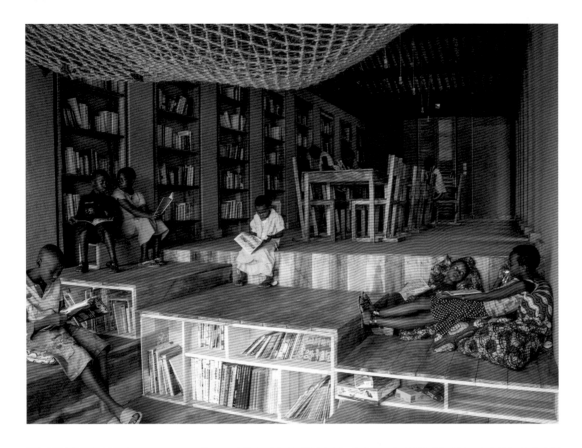

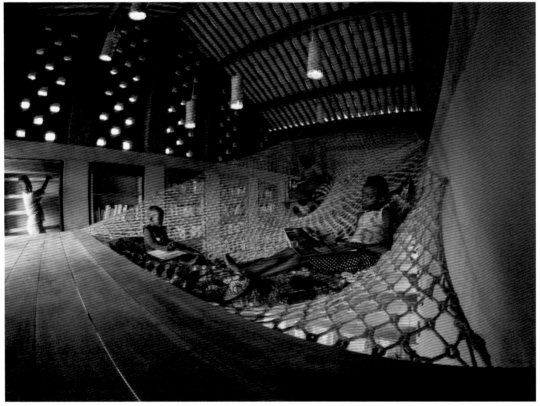

The soft, stretching nets and staggered levels are wonderful for reading, relaxing, and climbing. The low steps also serve as child-friendly bookshelves where little ones can rummage among books at their height.

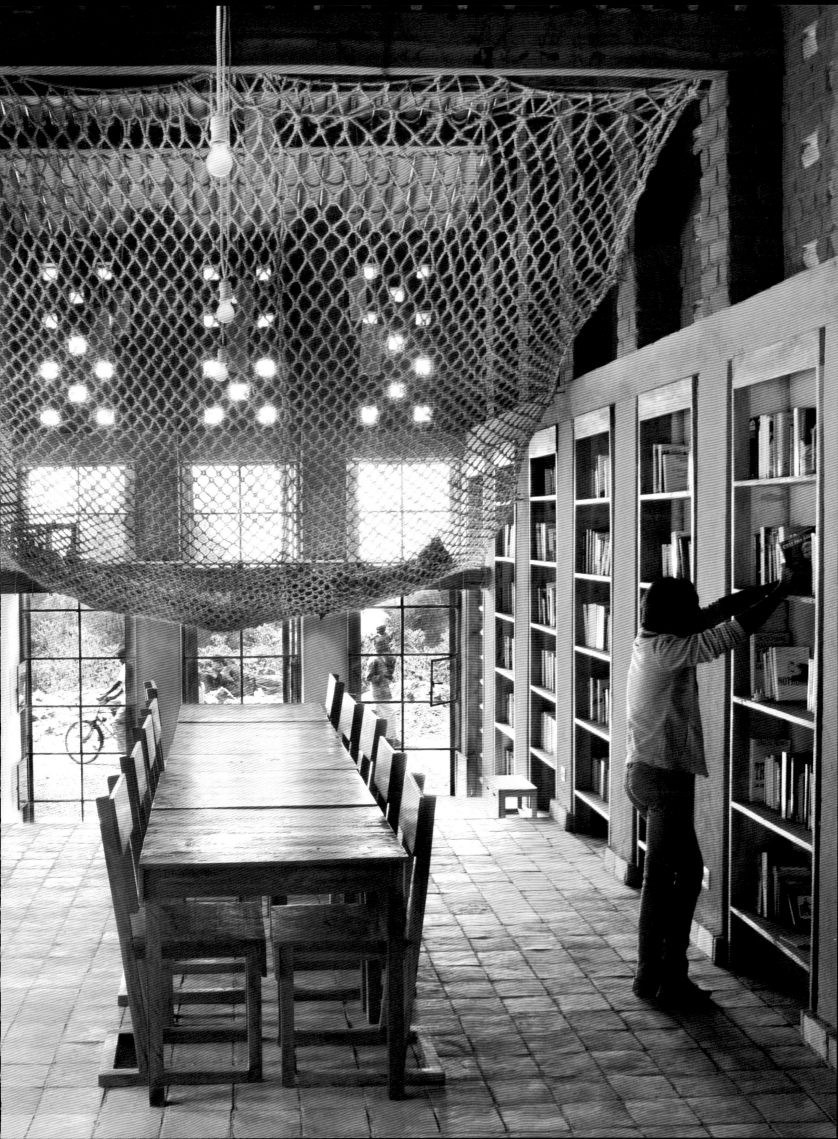

ALTENBURG MONASTERY LIBRARY

Liturgical treasures from the 12th century are preserved in this monastery library

DESIGNED BY JOSEF MUNGGENAST
BUILT BETWEEN 1715 AND 1756
ALTENBURG, AUSTRIA

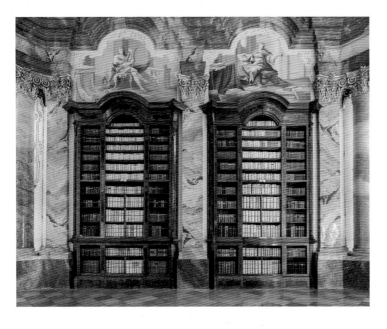

The great hall of Altenburg Monastery Library is justly considered to be one of the finest buildings of the Lower Austrian Baroque. The stunning stucco work, detailed frescoes, and marble pillars date back to the major renovation of the entire monastery complex in the early 18th century, for which the monks appointed architect Josef Munggenast. There is some evidence that this Benedictine monastery was founded in 1144, but the origins of its library cannot be traced back with any certainty. The founding fathers probably brought the first manuscripts with them from their mother monastery. The earliest documentation, a catalog from around the year 1200, lists 25 books, mostly of a liturgical nature. Two of these works have been preserved and are among the library's most valuable pieces. The library has now expanded its collection to include countless theological and fiction books, today numbering some 25,000 volumes across four separate collections: the monastery library, incunabula and early printed works, the Great Library, and the archive library.

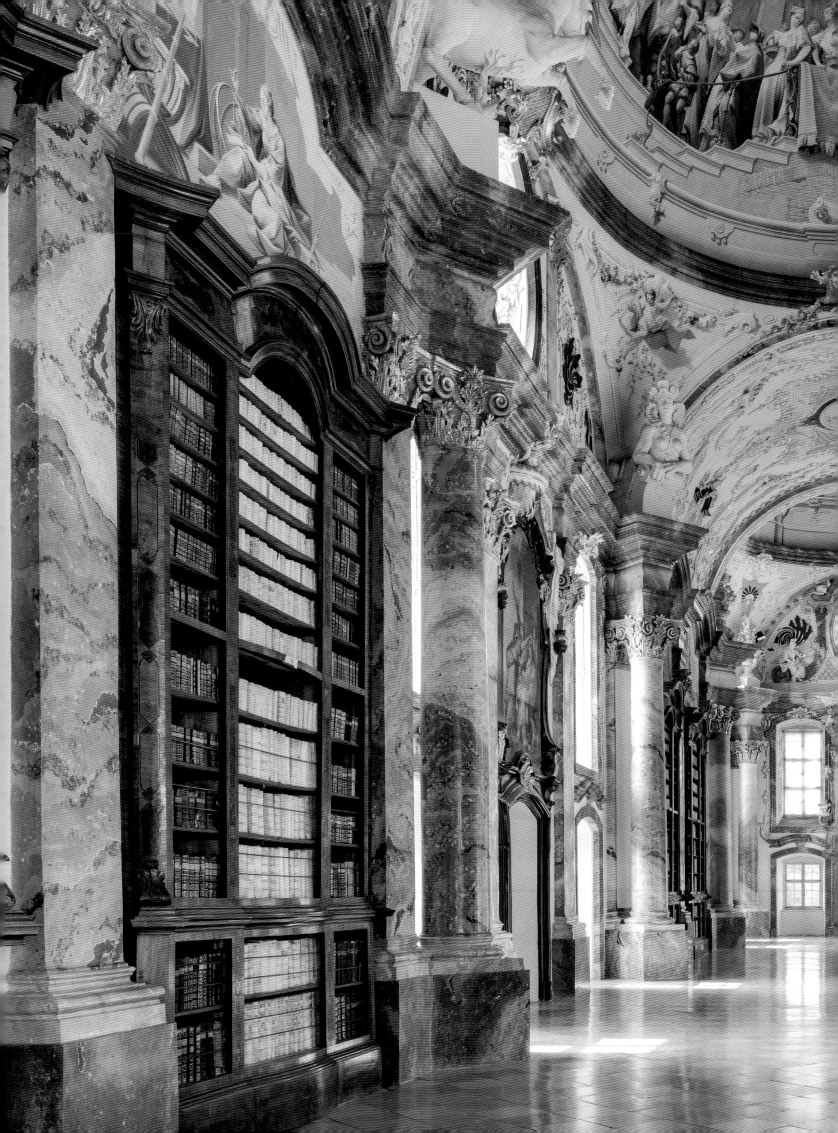

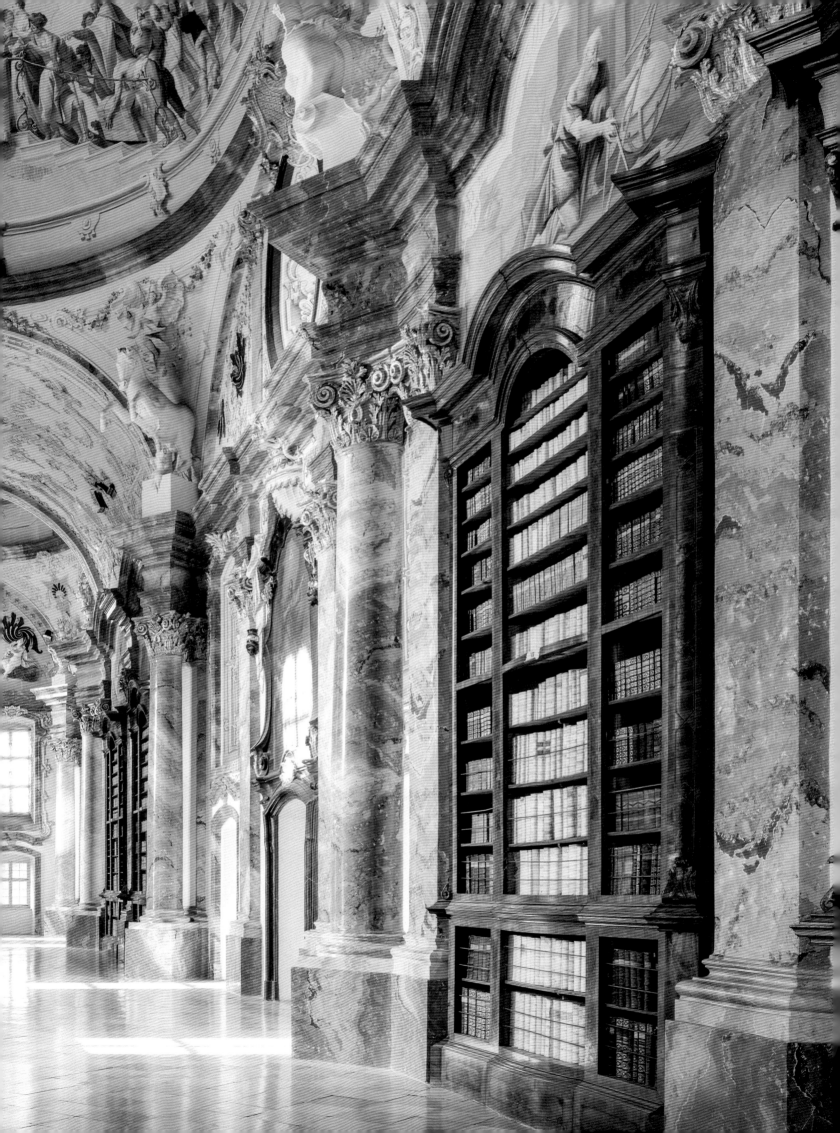

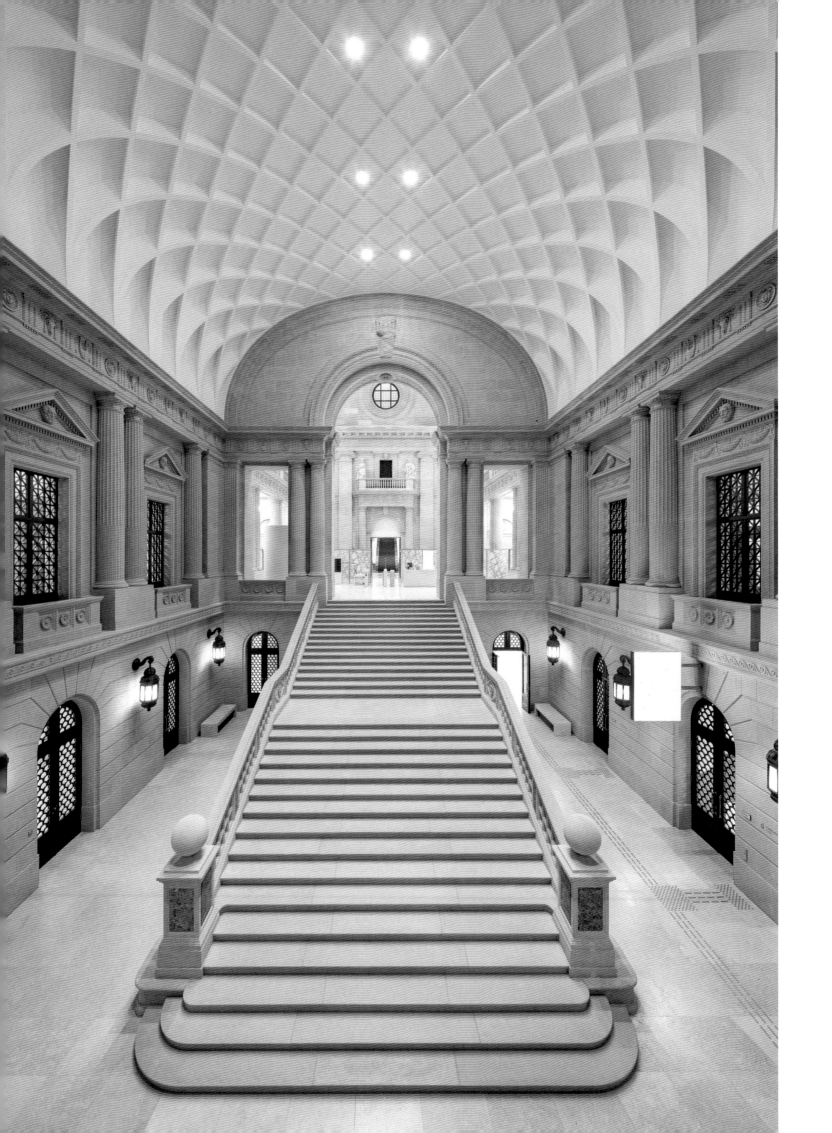

BERLIN STATE LIBRARY

The two main buildings that make up this library echo the story of German reunification

DESIGNED BY ERNST VON IHNE AND HANS SCHAROUN
BUILT 1903–1914 AND 1967–1978
BERLIN, GERMANY

Some 350 years after Frederick William, Elector of Brandenburg, founded the Electoral Library at Cölln on the River Spree, the contents of what is today the Berlin State Library are now spread across two iconic buildings. When it was built between 1903 and 1914, the Unter den Linden building was the largest library complex in the world. Following 15 years of renovation work, this splendid neo-Baroque building, originally designed by architect Ernst von Ihne, was reopened to great fanfare in January 2021. When Germany and Berlin were divided after World War II, the library's collection was also dispersed. Some of the books had already been transported to Western Germany amid the chaos of the war, eventually finding a temporary home at Marburg University Library from 1946. When the contract for a new library building in West Berlin was put out to tender in 1963, architect Hans Scharoun was awarded the commission, having completed the neighboring Berlin Philharmonic concert hall just a few weeks earlier. Having long been separated by the Berlin Wall, the historic library building and Scharoun's masterpiece on Potsdamer Straße are now just an easy bike ride apart.

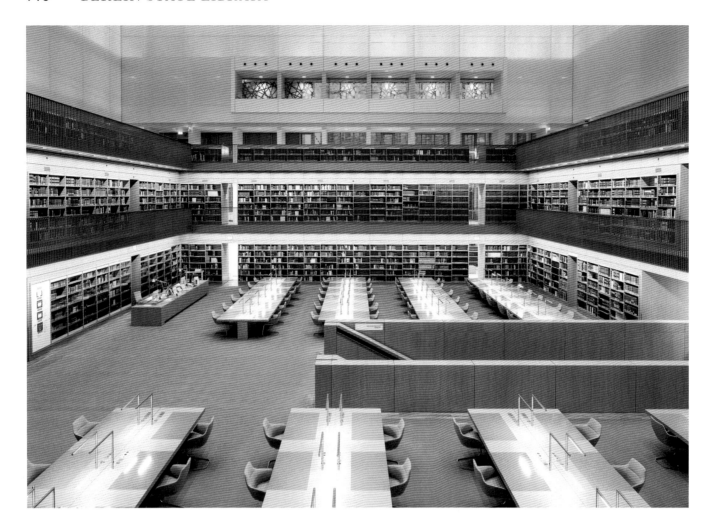

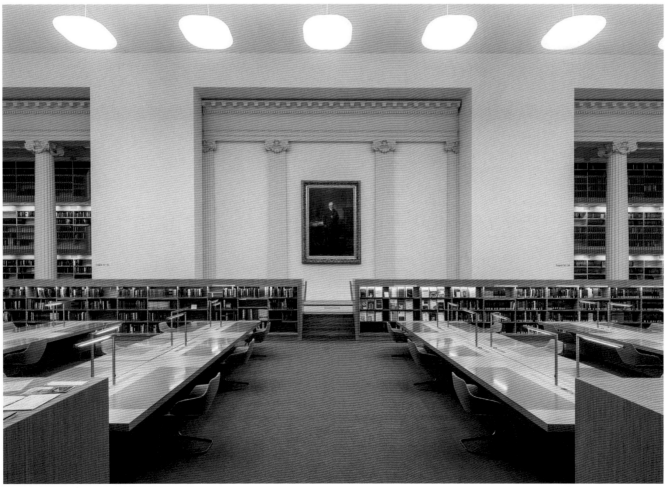

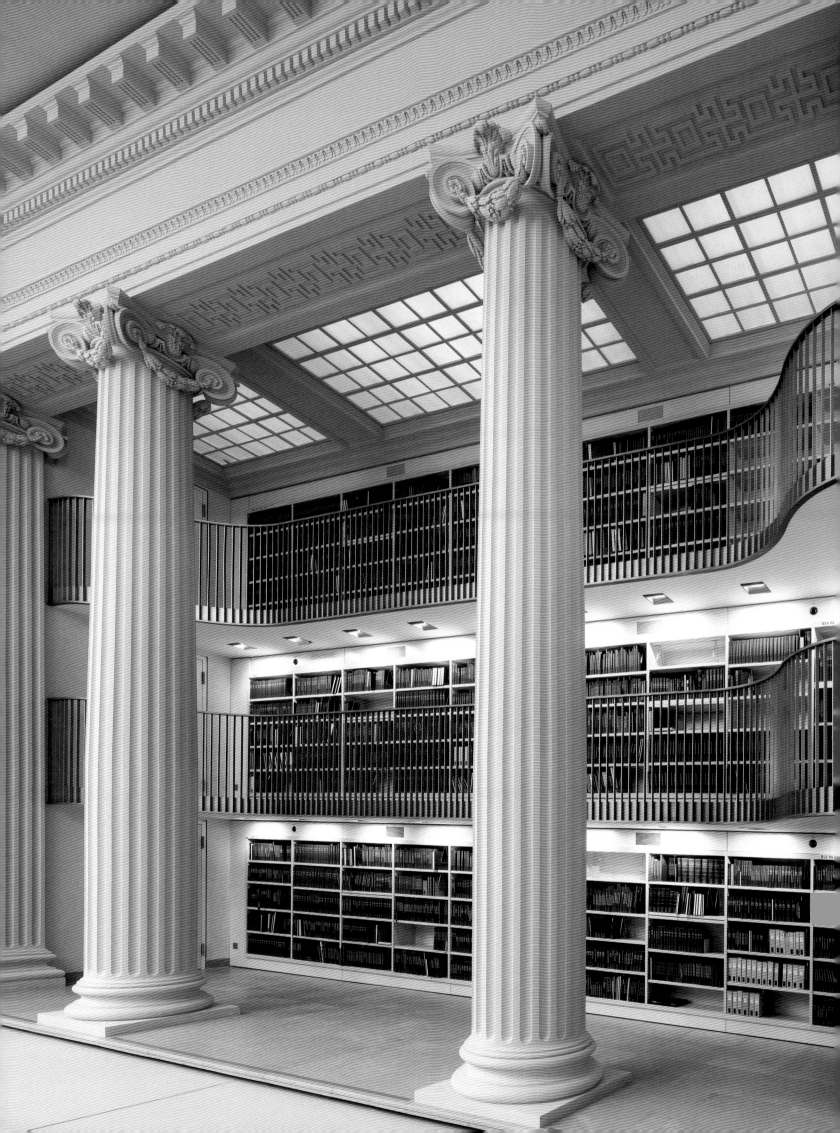

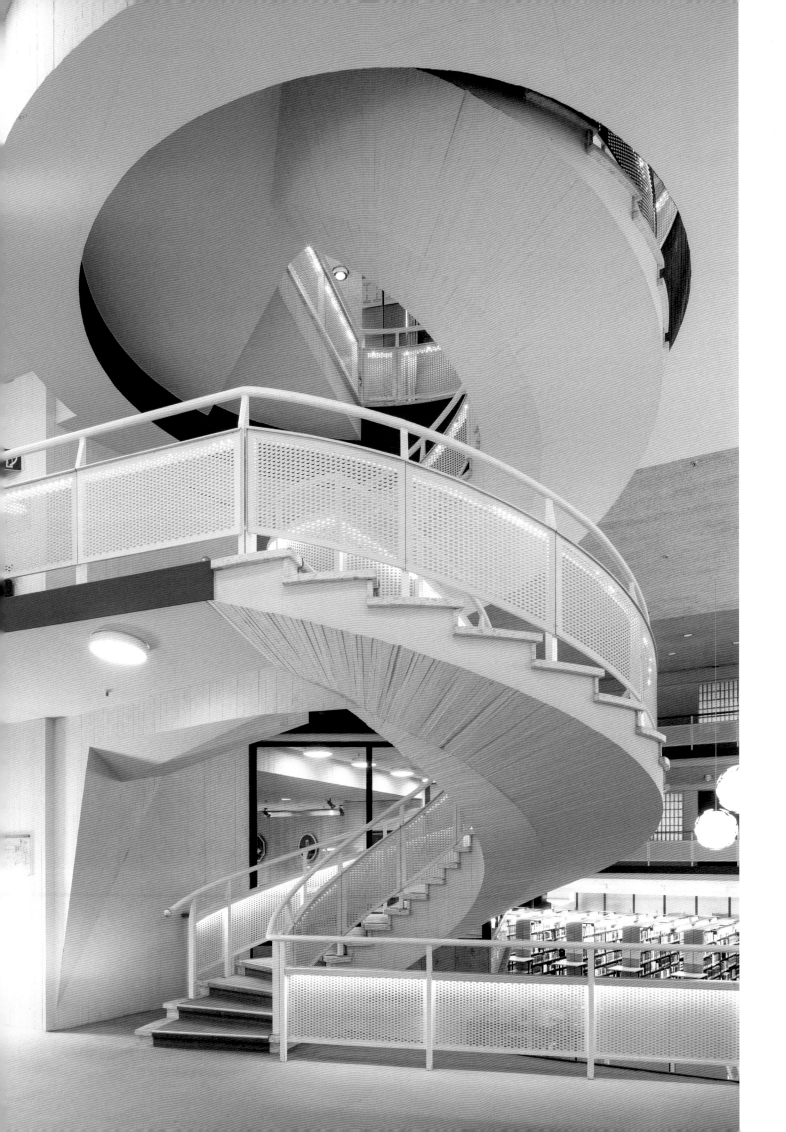

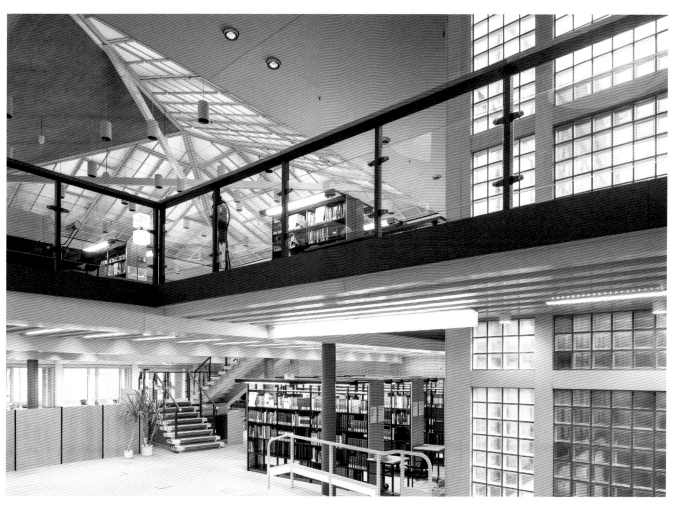

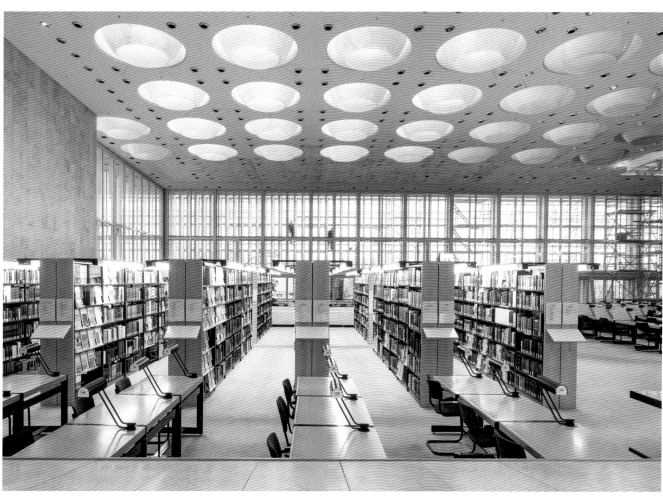

STATE LIBRARY VICTORIA

Following a successful makeover,
Australia's most popular library
is ready to take on the future

DESIGNED BY JOSEPH REED, ARCHITECTUS, AND SCHMIDT HAMMER LASSEN ARCHITECTS
BUILT IN 1854, REFURBISHED IN 2019
MELBOURNE, AUSTRALIA

The State Library Victoria was one of the world's very first free public libraries, and has continued along that pioneering path. The library was the brainchild of a handful of enthusiastic Melbourne residents in the mid-19th century, who commissioned English architect Joseph Reed to come up with the design. It went on to

become the most important and renowned library on the continent. The 23 buildings that make up this Melbourne institution occupy an entire city block. Its stock of books is constantly growing and passed the two-million mark years ago. More recently, Australian architecture studio Architectus and Danish firm Schmidt Hammer Lassen were tasked with modernizing and redesigning the library. The teams have skillfully combined the library's historical charm with contemporary facilities for families, researchers, creative artists, and students alike. The State Library Victoria is proud of its reputation as an open, inclusive, and visionary library. With a newfound focus on diversity, culture, and digitization, it is setting course for an inspiring future that is entirely in keeping with its 165-year trailblazing legacy.

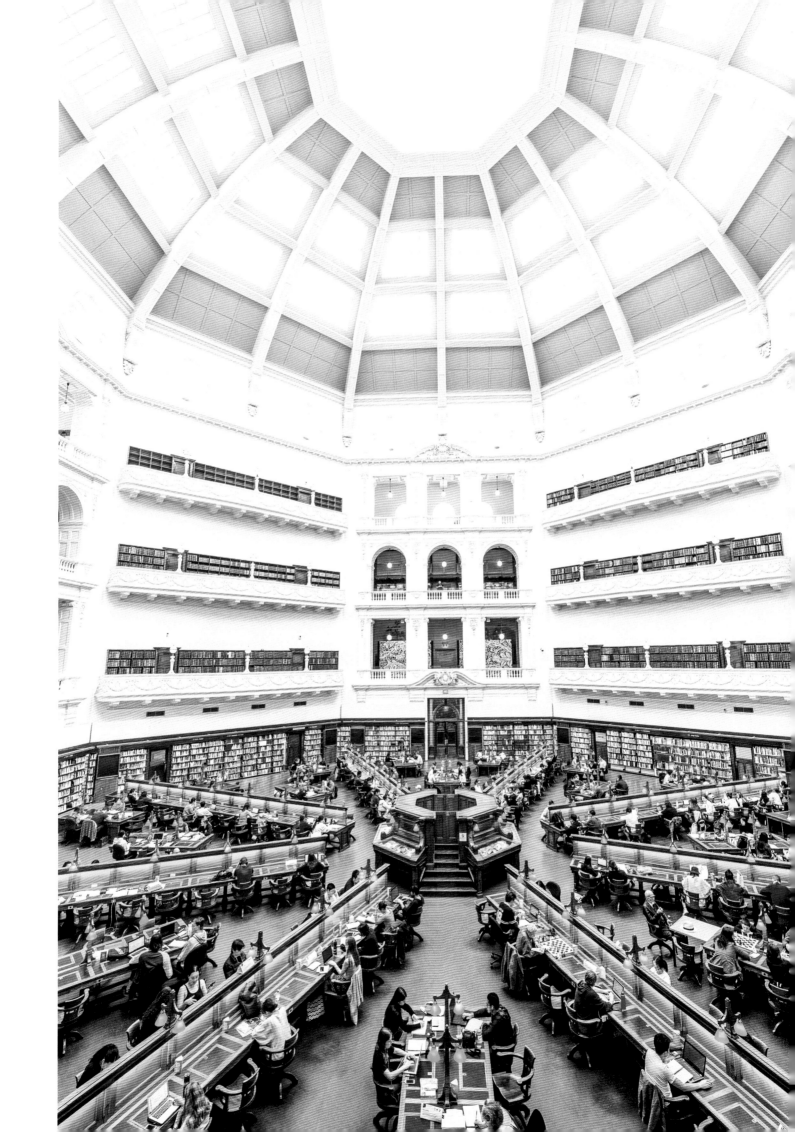

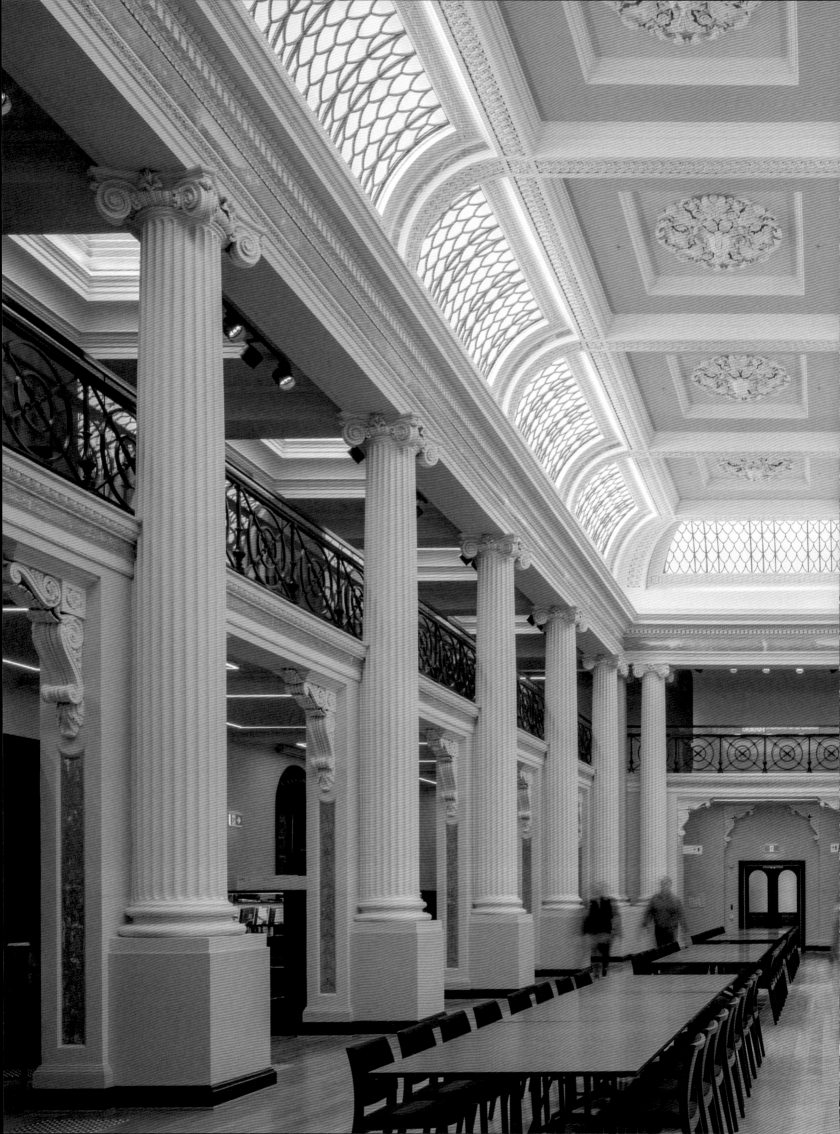

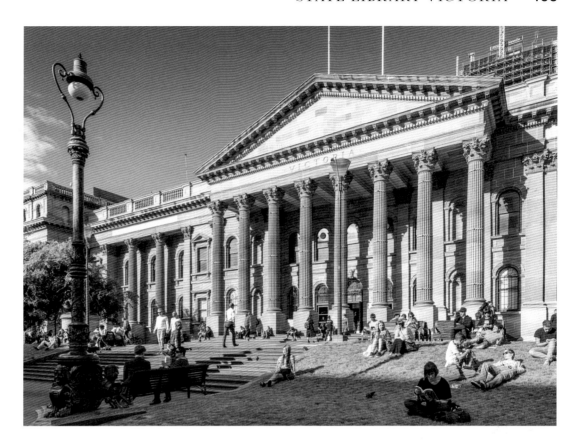

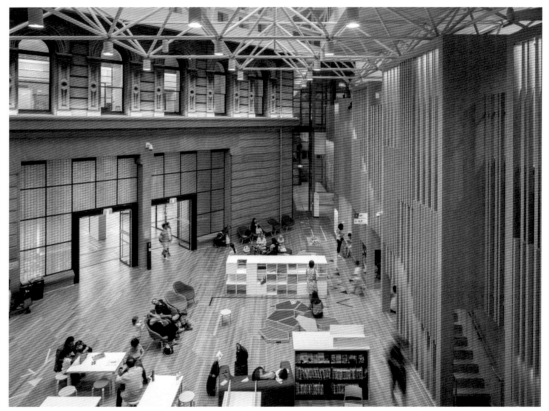

The State Library Victoria is a prime example of successful international collaboration between several renowned architecture studios. Today the building is a modern library that hasn't forgotten its strong historical roots.

THE MORGAN LIBRARY & MUSEUM

Thanks to one of the most generous bequests in U.S. history, this collection is now accessible to the public

DESIGNED BY CHARLES MCKIM
BUILT 1902–1906
NEW YORK, NEW YORK, USA

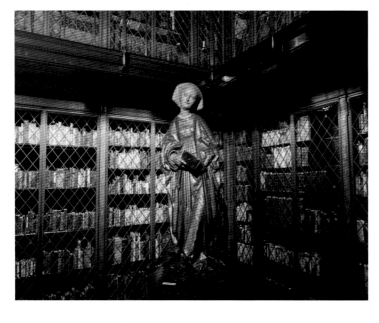

John Pierpont "J. P." Morgan would be delighted if he could see the Morgan Library today. By the end of the 19th century, the collector had already begun to assemble a private library of manuscripts and valuable prints. He had a magnificent palazzo built to house them right next to his own residence on Madison Avenue. Over the years, the collection grew and grew. Some time after his death, his son decided to make Morgan's life's work accessible to the public. Having been supplemented by donations and new acquisitions, the collection expanded so much over the years that the historic townhouses of its founder and his son were eventually integrated into the library. In 2006, renowned Italian architect Renzo Piano created three new glass pavilions around the historic buildings to create a single Morgan Library & Museum complex, complete with a new reading room, events space, café, and shop—just as J. P. Morgan would have wanted.

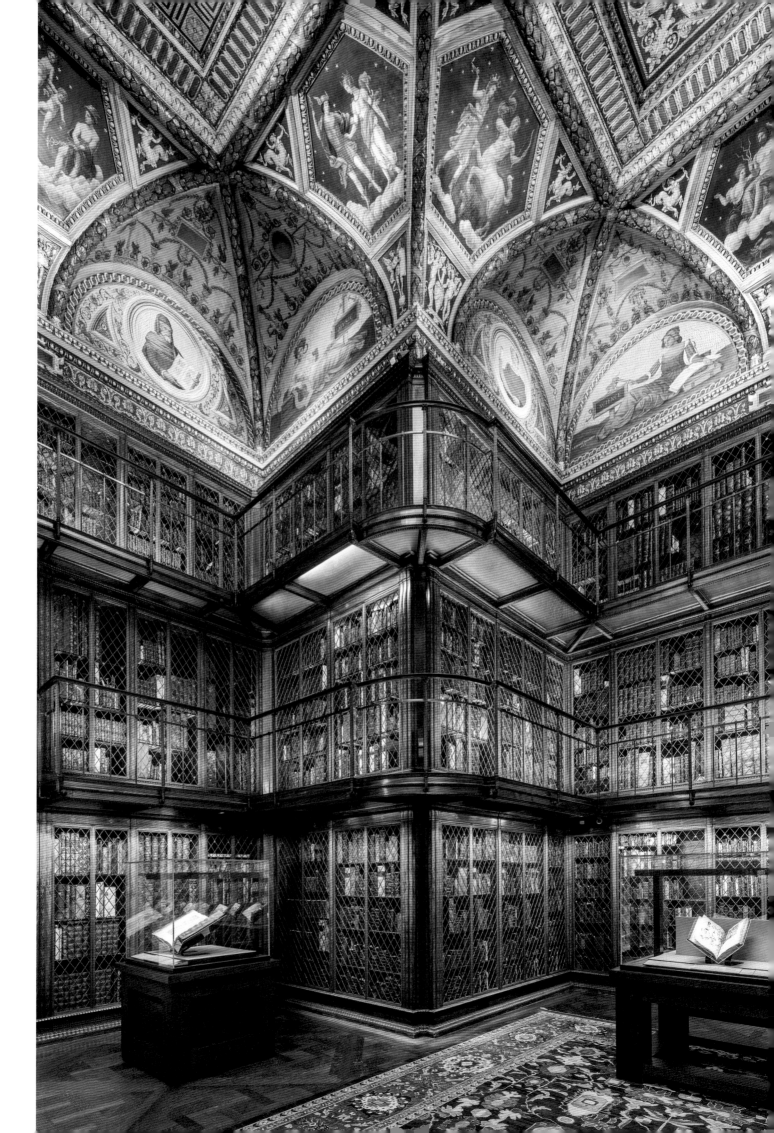

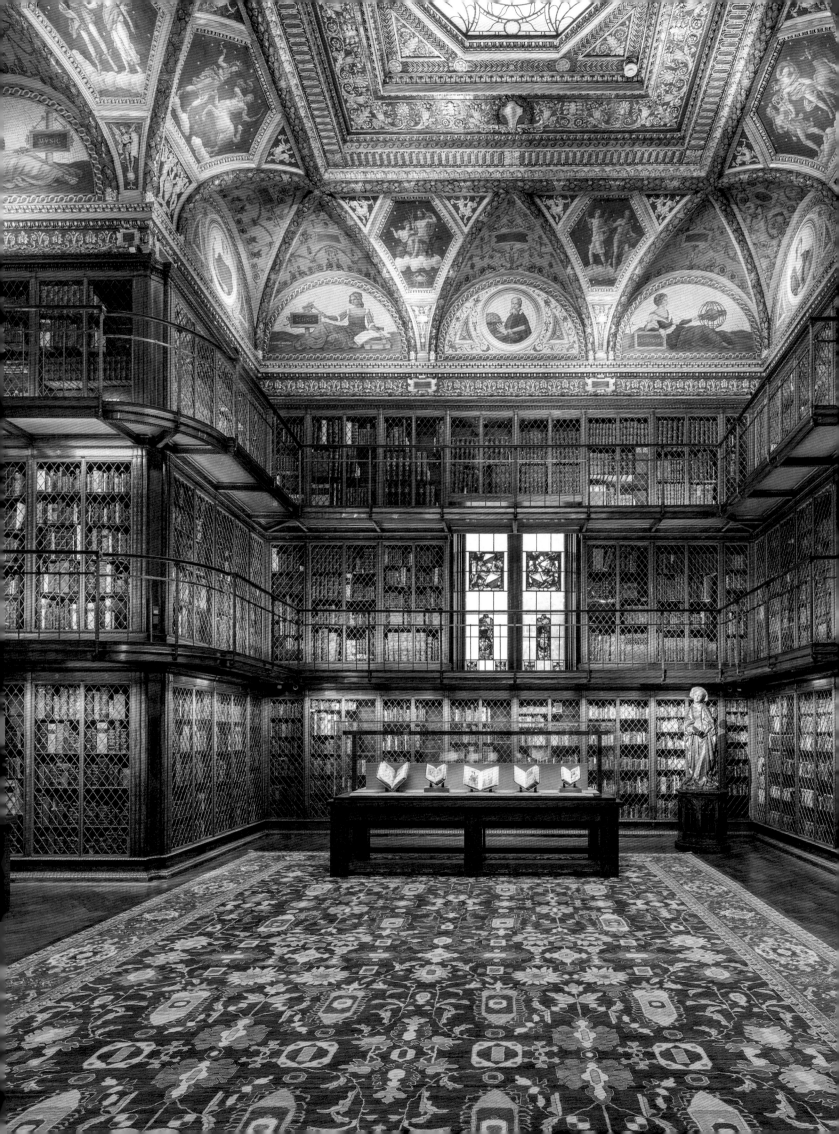

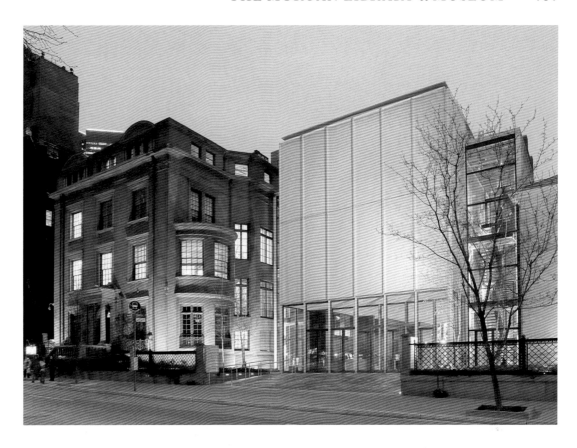

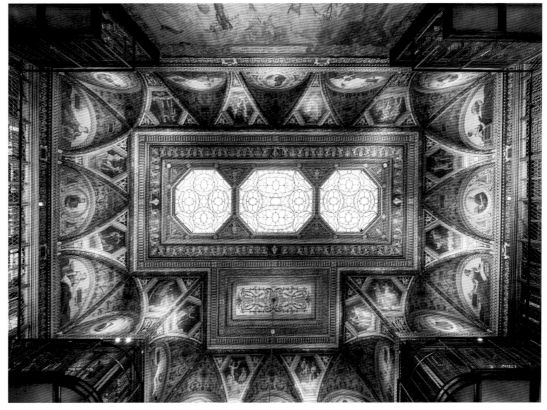

Most collectors would be in raptures at the thought of their private collections growing over 100 years into a magnificent library. Add a renowned architect like Renzo Piano, and this truly is the stuff of dreams.

CUYPERSBIBLIOTHEEK

The library in Amsterdam's Rijksmuseum is a work of art in its own right

DESIGNED BY PIERRE CUYPERS
BUILT 1876–1885
AMSTERDAM, NETHERLANDS

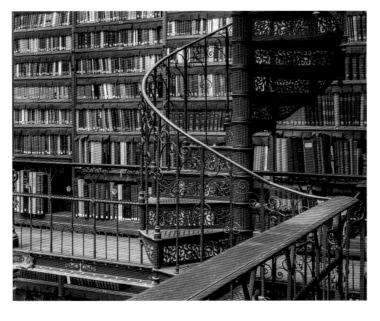

When Dutch architect Pierre Cuypers was entrusted with designing the Rijksmuseum in Amsterdam in 1877, he was determined from the very outset to give the museum a library where keen visitors could really delve into the history of the works of art on display. The Rijksmuseum Research Library—or Cuypers Library, as it is commonly known—is still thought to have the largest collection of works on art history in the Netherlands. The public has access to around 450,000 books, manuscripts, catalogs, drawings, and etchings by the Old Masters here. Most of the collection is stored in catacombs beneath the museum building, but the most prestigious works throng the shelves of the spectacular reading hall. During Cuypers's lifetime, the broad skylight in this room was fêted for its bold yet practical design: It brought daylight into the library, reducing the need for candles and gas lamps and saving the books from damage caused by excessive soot.

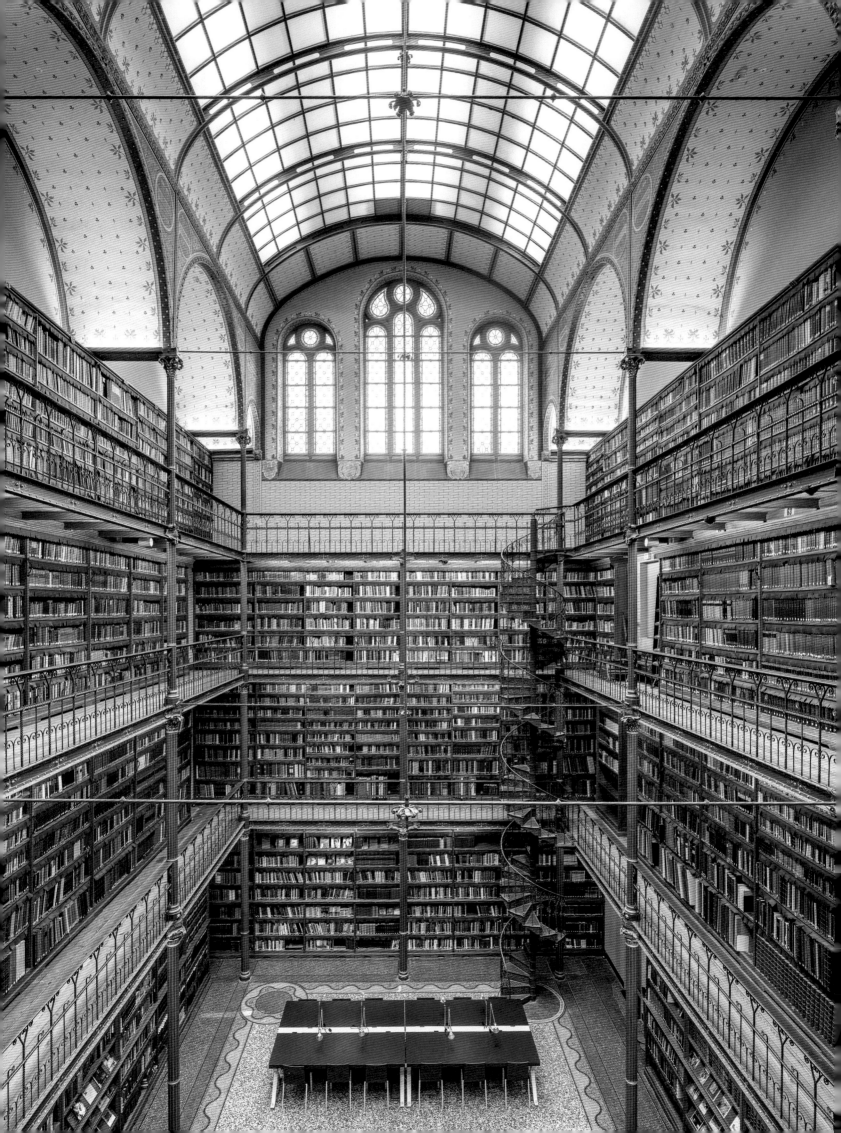

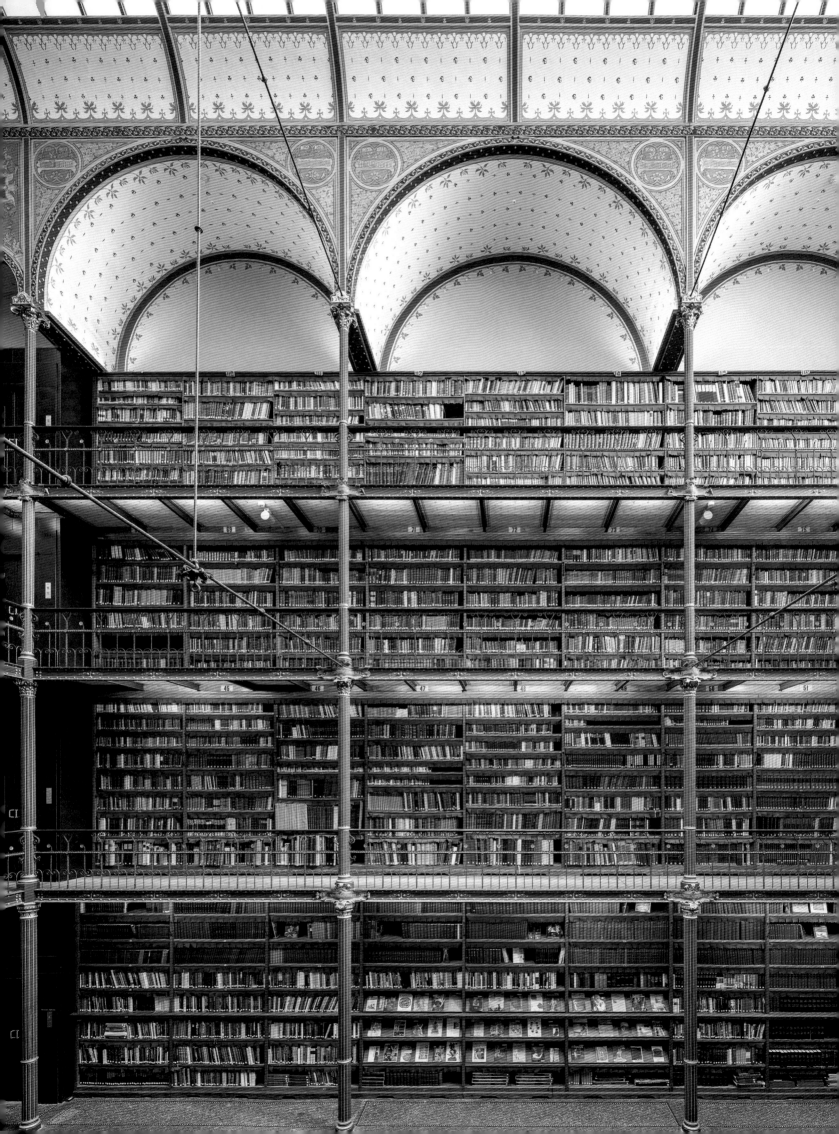

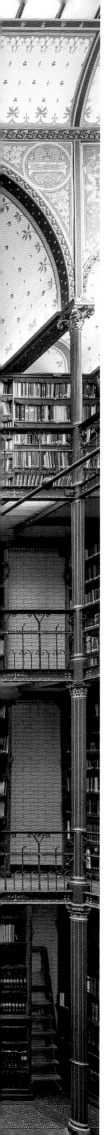

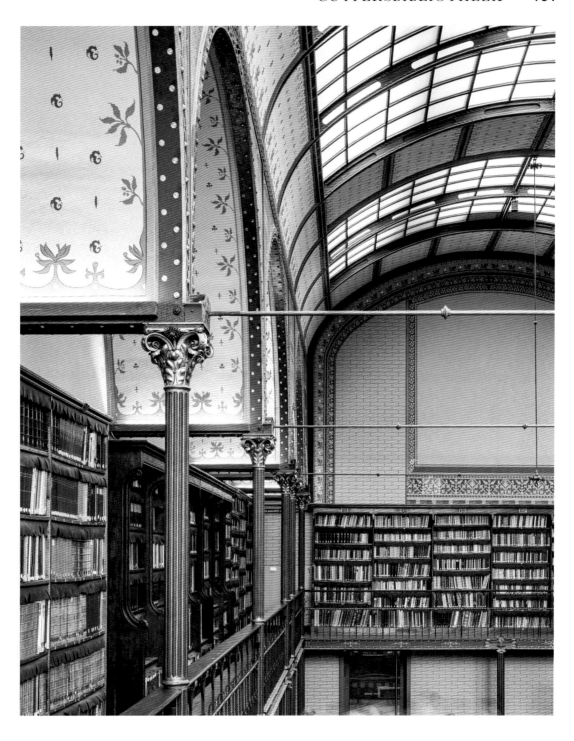

Cuyper had the idea of creating an imposing museum library that would look even bigger than it really was. If you look closely, you can see that the columns taper as they ascend, making the ceiling seem higher.

The Cuypersbibliotheek is one of the most beautiful rooms within Amsterdam's Rijksmuseum. If you enter the Science Hall from Museumstraat, a public cycleway that runs past the second floor, you'll find the entrance to the library behind it.

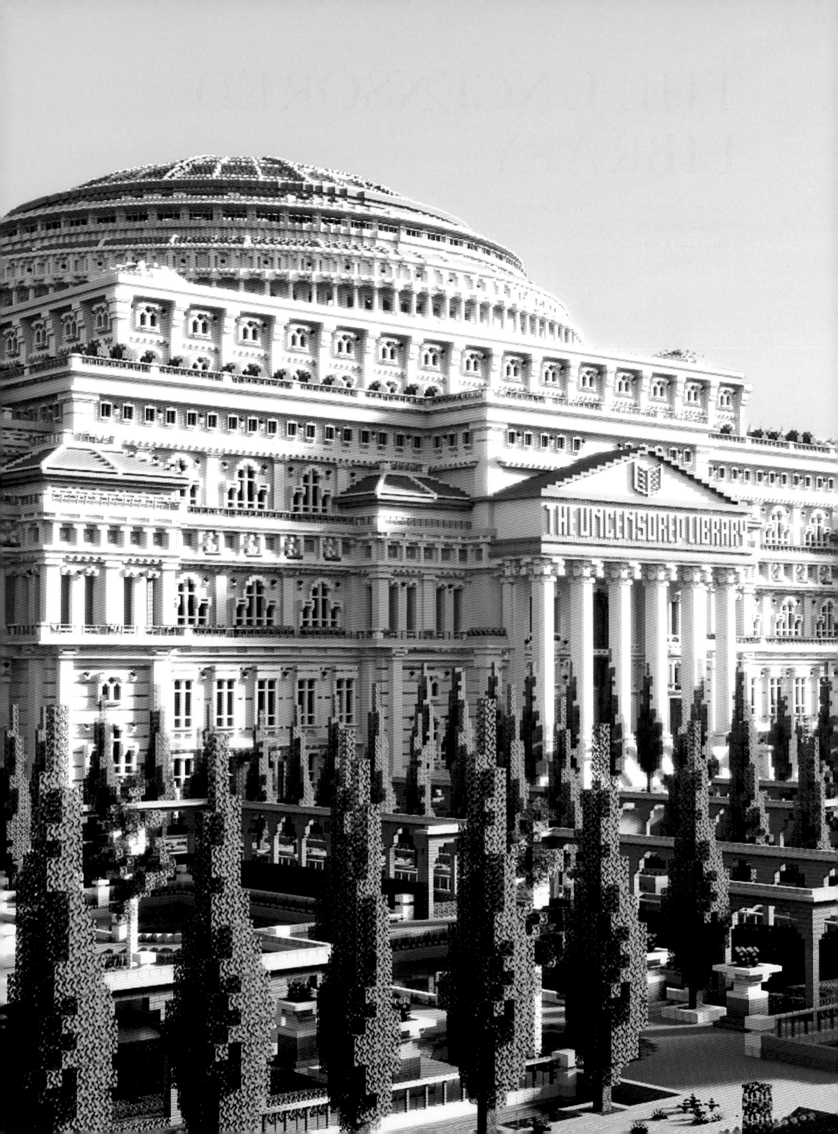

THE UNCENSORED LIBRARY

IDEA BY REPORTERS WITHOUT BORDERS
OPENED IN 2020
MINECRAFT, ONLINE

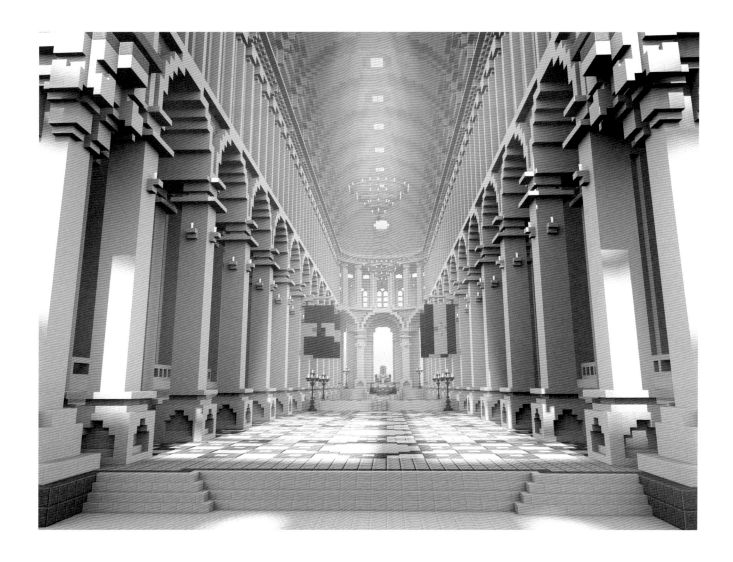

To circumvent censorship by authoritarian regimes, Reporters Without Borders uses a digital library in a computer game to publish incisive pieces by persecuted journalists worldwide

"Where the media cannot report on injustice, there can be no public oversight or freedom of opinion. That's precisely what authoritarian regimes are trying to achieve," says Kristin Bässe. As a PR officer at Reporters Without Borders in Berlin, she and her colleagues all over the world strive to promote freedom of the press against censorship. Previously, the authorities would only interfere with reporting in newspapers and TV programs, but today social media, blogs, and websites are also subject to control in authoritarian systems. In order to get around this kind of censorship, Reporters Without Borders, design collective BlockWorks, advertising agency DDB, and digital production company MediaMonks came up with the ingenious solution of the Uncensored Library. Articles and reports by brave journalists that have been censored elsewhere are freely accessible in this digital library, which exists on a secure server for the popular computer game Minecraft.

"With more than 126 million active players per month, Minecraft is one of the biggest computer games in the world. The game is also available worldwide, even in places where authoritarian regimes block the internet and censor the media," says Bässe. Players can build entire worlds using Lego-like blocks in this open-world game. Its vast digital inventory also includes books that you can write yourself and share with other players within Minecraft. Reporters Without Borders uses this feature to publish censored articles from all over the world.

Belarussian news portal Charta97, for example, is subject to censorship, and its editor-in-chief is currently living in exile. "The site publishes independent reporting on the political situation in Belarus and has been blocked since 2018," says Bässe. "We want to highlight the current state of affairs in Belarus by putting out pieces that have been censored by the regime.

"Since mass protests began in August 2020, President Alexander Lukashenko has been trying to completely suppress reports that are critical of the situation in the country. Hundreds of media workers were arrested for a time, with some sentenced to several years in prison. Belarus has faded from the public eye somewhat a year since mass protests began, but the situation has rapidly deteriorated for the people there. That's why I believe that it's vital for us to publish articles about the situation in Belarus in the Uncensored Library. We've created a place where this information is freely and safely accessible to all."

Welcome to the future, housed within digital neo-Classical halls. All areas of the Uncensored Library hold texts that have been censored elsewhere, in both their original languages and English, including reports by Saudi journalist Jamal Khashoggi.

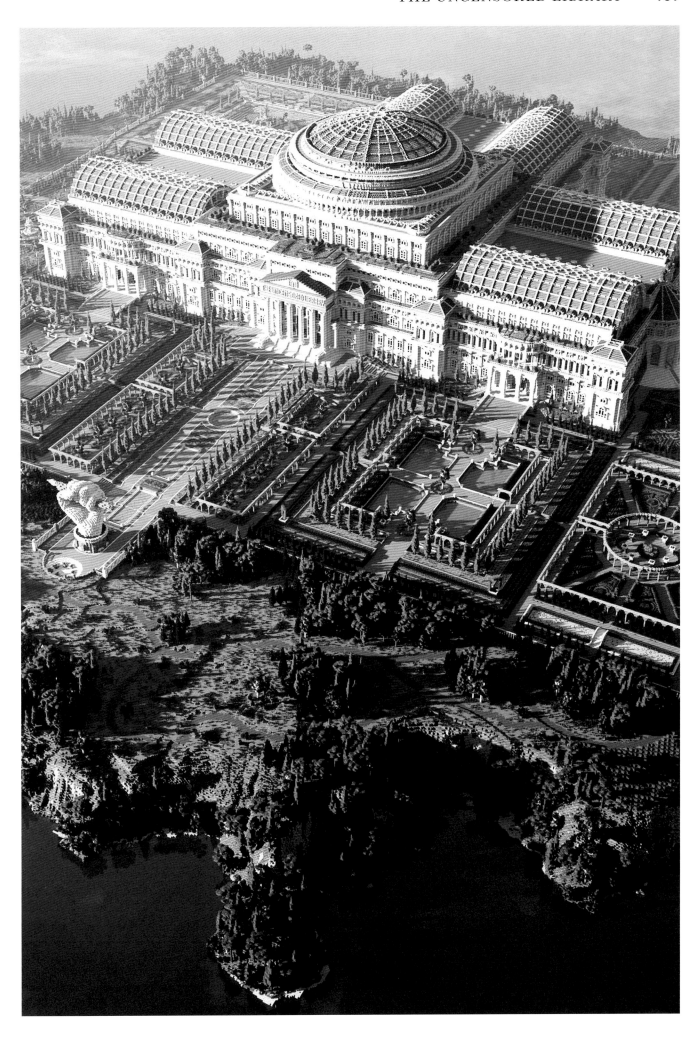

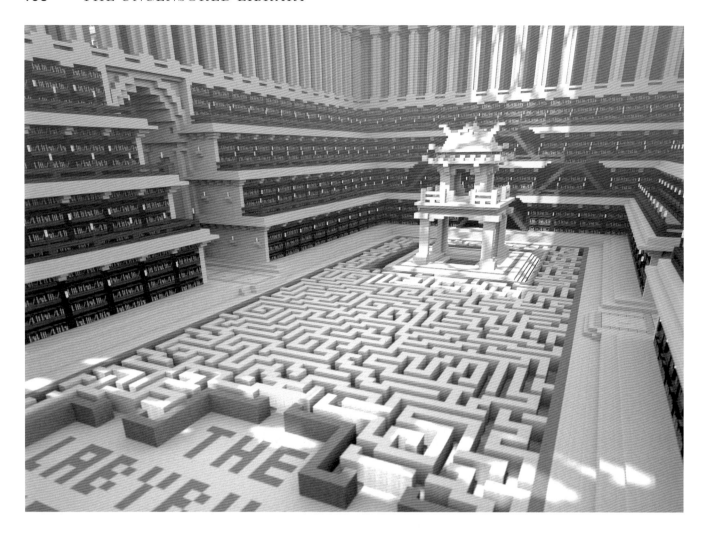

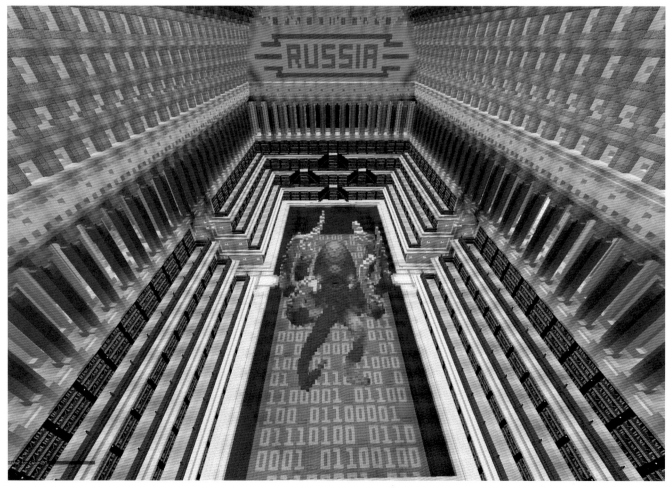

"With more than 126 million active players per month, Minecraft is one of the biggest computer games in the world. The game is also available worldwide, even in places where authoritarian regimes block the internet and censor the media."

You just need a Minecraft account to visit the Uncensored Library. The URL visit.uncensoredlibrary.com takes you to the server on which the Uncensored Library has been set up. A hundred people can be in the library at the same time, reading articles and writing messages to each other—to shed further light on the situation in their countries, for instance. "A player from Germany can communicate with another from Egypt," explains Bässe. "They can wander through the library together and chat about articles censored in Egypt." Critical reports by Yulia Berezovskaia, the editor-in-chief of grani.ru, the blocked activist website, are on display in the Russian Hall, while uncensored articles by the journalist Jamal Khashoggi, who was murdered in the fall of 2018, are on view in the Saudi Room. Reporting by Egyptian journalists once featured on the banned news portal Mada Masr is now published here. The writings of Vietnamese human rights lawyer and blogger Nguyen Van Dai, currently in exile, and Mexican journalist Javier Valdez, who reported on the drug war in Mexico before he was murdered, are both published as they were intended.

The hashtag for the accompanying Uncensored Library campaign is #TruthFindsAWay. The project has already won multiple awards. "Libraries are a source of information, but also a repository of expertise when it comes to evaluating and classifying information and sources," says Bässe. "And that's where it gets political: information is the first step towards change. That's why access to free, independent information is essential in a democracy. At the same time, it's about being able to disseminate information freely. Freedom of information is a human right, and that's exactly what the library symbolizes."

The design of the spaces within is a mixture of the architecture of the country in focus and features that echo criticism of authoritarian regimes. The labyrinth in the Vietnamese room, for instance, symbolizes how difficult it is to get reliable information in Vietnam.

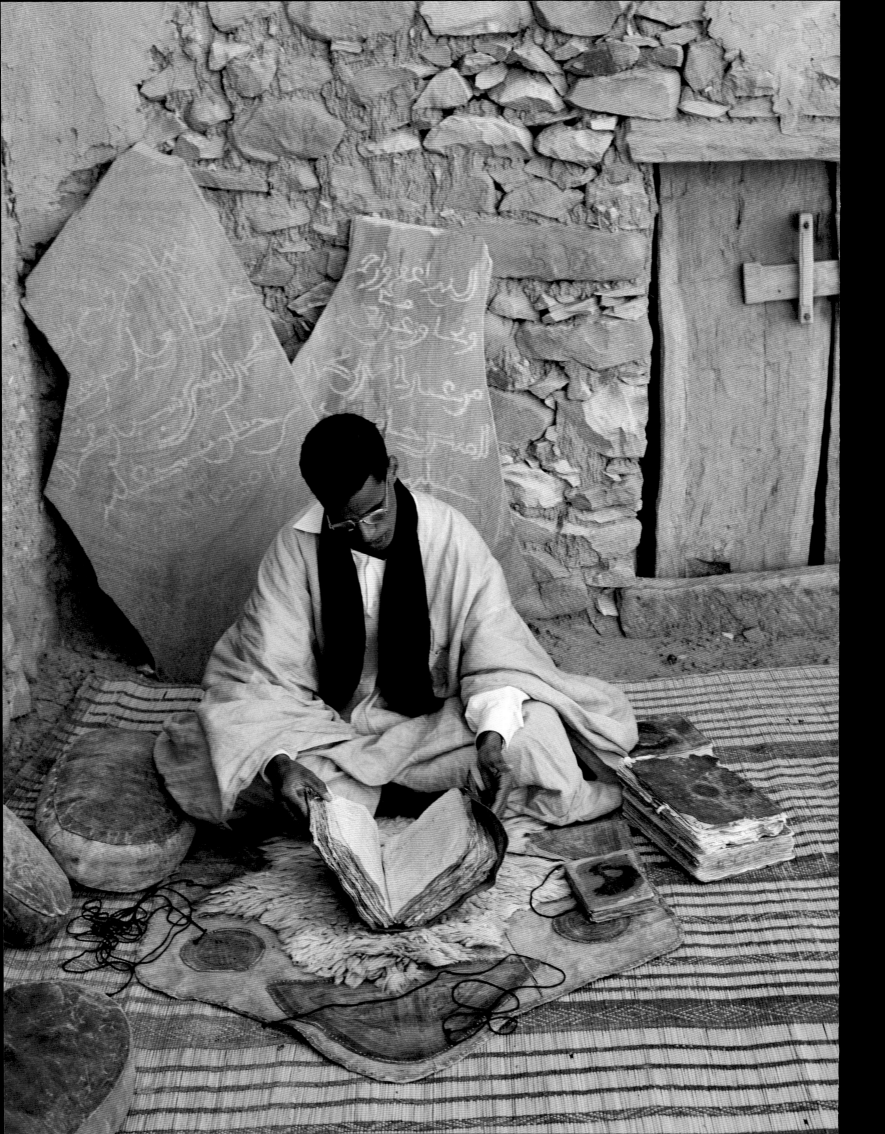

THE LIBRARIES OF CHINGUETTI

This ancient city and its priceless parchments are under threat from climate change

TRADITIONAL MUDBRICK BUILDINGS
BUILT FROM THE 8TH CENTURY ONWARDS
CHINGUETTI, MAURITANIA

In the dusty Sahara air, the guardians of Chinguetti's libraries watch over some 1,300 manuscripts that have defied the ravages of the desert for centuries. The allure of these delicate parchments remains undiminished for travelers and scholars alike. Between the 13th and 17th centuries, this caravan trading center at the foot of the imposing Erg Warane dunes developed into a flourishing desert city. Countless scholars and pilgrims left their traces—and manuscripts—as they passed through on their way to Mecca. Their scholarly discourses, writings, and medieval copies of the Qur'an made Chinguetti one of the most famous sites in West Africa. UNESCO has now declared the libraries of Chinguetti a World Heritage Site, but this distinction cannot hold back the ever-encroaching foothills of the Sahara, nor stop the spring floods. Through the years, the owners, bibliophiles, and conservationists have been fighting to preserve—and, in the worst-case scenario, relocate—these priceless cultural treasures.

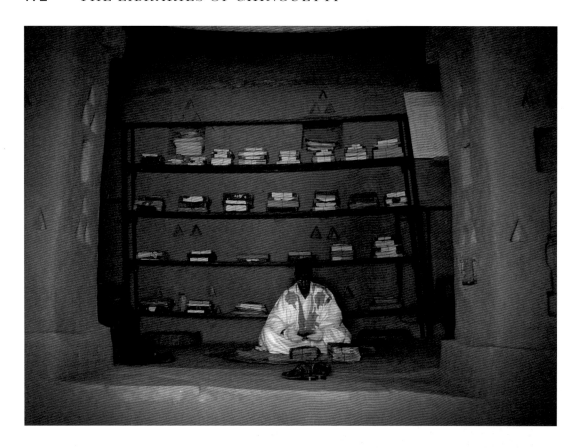

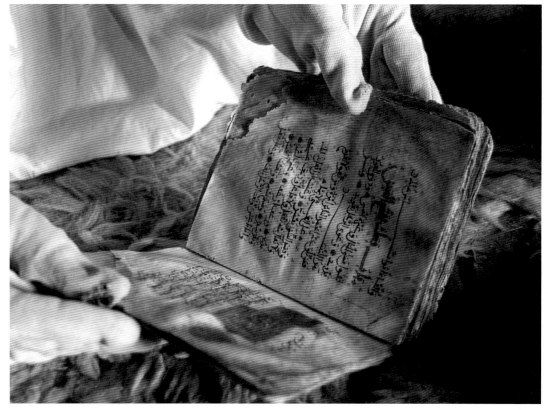

During its heyday between the 13th and 17th centuries, the desert city of Chinguetti was home to some 30 libraries. Of those, only five remain today. The librarians treat their priceless books and manuscripts with the greatest of care.

AL-QARAWIYYIN LIBRARY

How one young woman's thirst for knowledge led to the oldest surviving library in the world

TRADITIONAL CONSTRUCTION
BUILT IN 859
FEZ, MOROCCO

In the old town of Fez, the sun beats down on the world's oldest library in continuous operation. Beside the library, the al-Qarawiyyin complex also includes the university and mosque of the same name, founded in 859 by Fatima al-Fihri, the daughter of a wealthy family of merchants. As a young woman, she had a thirst for knowledge and personally oversaw the construction of the library and mosque. She attended lectures at the university even into old age. Today, the university has moved to a different part of Fez, but the mosque and library still dwell within the historic walls of al-Qarawiyyin. When the restoration was put out to tender in 2012, the commission was again won by a woman, Canadian-Moroccan architect Aziza Chaouni. She upgraded the library with new features including an air conditioning system, digital keys for the most valuable manuscripts, and solar panels on the roof. Part of the complex is now open to the public, too—just as Fatima al-Fihri would have wanted it.

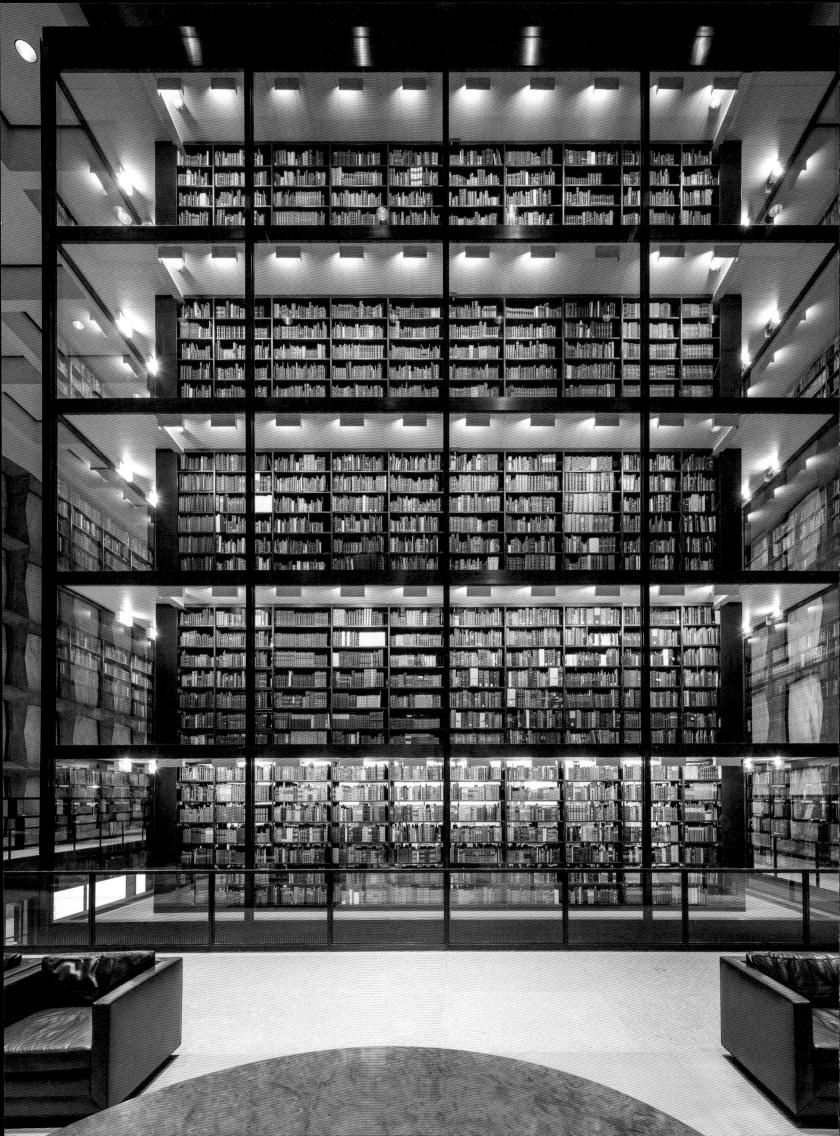

BEINECKE RARE BOOK AND MANUSCRIPT LIBRARY

Knowing the past is the best way to prepare for the future

DESIGNED BY GORDON BUNSHAFT AND SKIDMORE, OWINGS & MERRILL
BUILT IN 1963
NEW HAVEN, CONNECTICUT, USA

Behind the modernist façade of the Beinecke Rare Book and Manuscript Library lie more than a million books and one of the world's most important collections of rare manuscripts. The library's collection, which belongs to Yale University, has been steadily growing since it was founded in the early 18th century.

It moved into the present-day building in the 1960s. The Latin *manu scriptum* literally means "written by hand." This library collects ancient papyri, singular writings from China, Japan, and Korea, and medieval manuscripts, along with rare playing cards and maps. On request, researchers can examine many of the books and manuscripts first-hand—under supervision—in the large reading room, with the books placed on protective foam blocks to preserve the delicate pages. The Beinecke Rare Book and Manuscript Library is a veritable treasure trove for Yale students and scholars from all over the world, and more than lives up to its stated mission of "engaging the past in the present for the future."

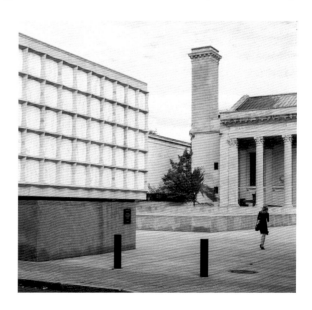

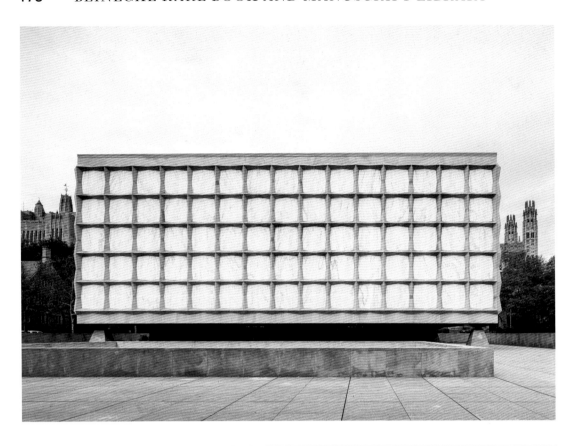

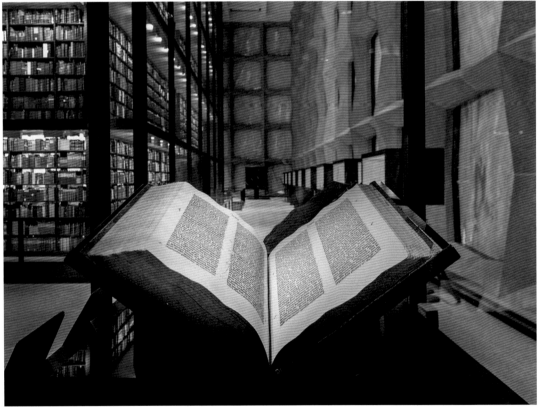

The translucent marble shell of the library is deliberately designed according to a 3:2:1 ratio, divided into blocks measuring 15 × 10 × 5. Many early books and manuscripts were made according to these proportions, which were considered especially pleasing to the eye.

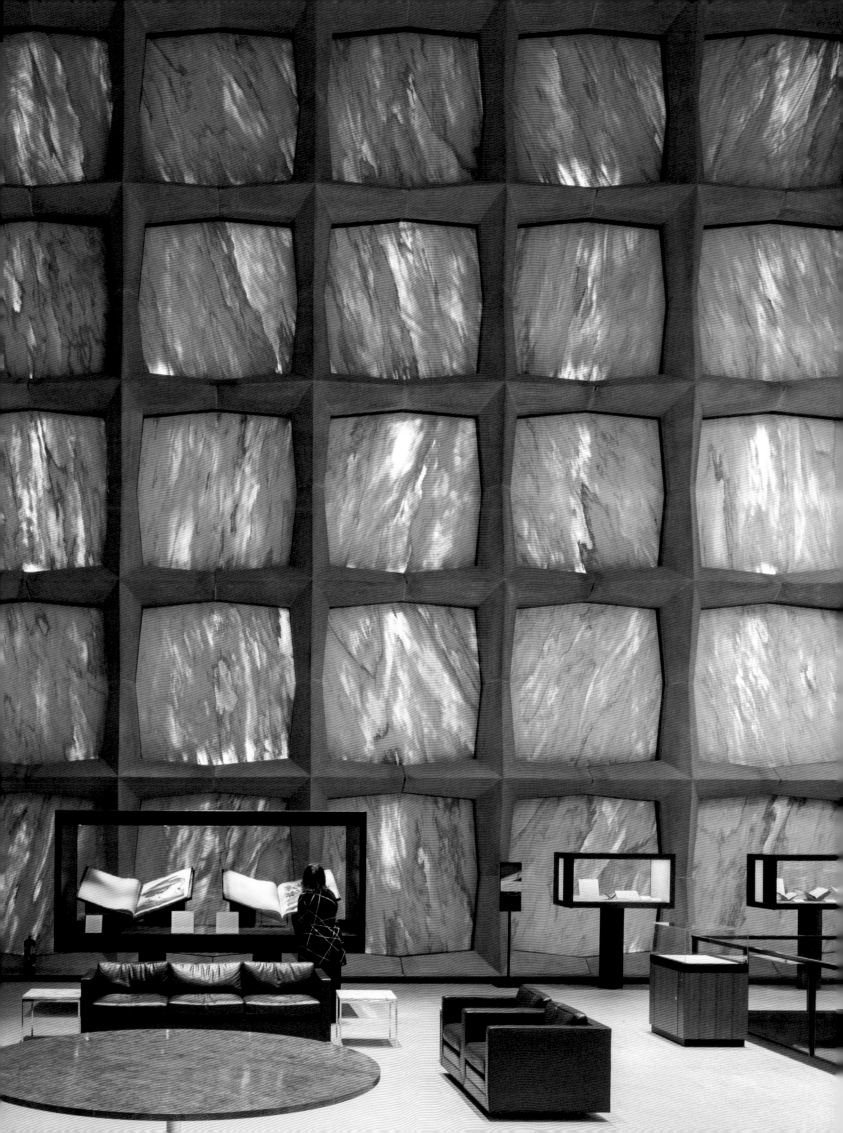

BIBLIOTECA DEL PIFFETTI

The true treasures of this library are its rare masterpieces of carpentry and priceless inlay work

DESIGNED BY PIETRO PIFFETTI
BUILT AROUND 1750
ROME, ITALY

When Piedmontese cabinetmaker Pietro Piffetti crafted a number of absolutely exquisite bookcases for a royal residence of the Savoy family in Turin in around 1750, he never could have dreamed that they would eventually find their way to the Quirinal Palace, now the residence of Italy's president. From 1879 onwards, his Baroque designs adorned the private chambers of Queen Margherita, whose dedications and bookplates can still be admired in many of the 19th-century books that remain here. However, the true treasures of the library are the fittings, made of materials specially selected by Piffetti. He clad the heavy poplar wood cabinets in boxwood, yew, olive wood, and rosewood, and combined them with magnificent ornamental ivory inlays, tortoiseshell detailing, and gilded wooden sculptures symbolizing the four seasons. The wooden floor and ceiling were crafted specially for the library when it moved from Turin to its new location in Rome, and they still enhance the royal library and its masterpieces of historic Italian carpentry.

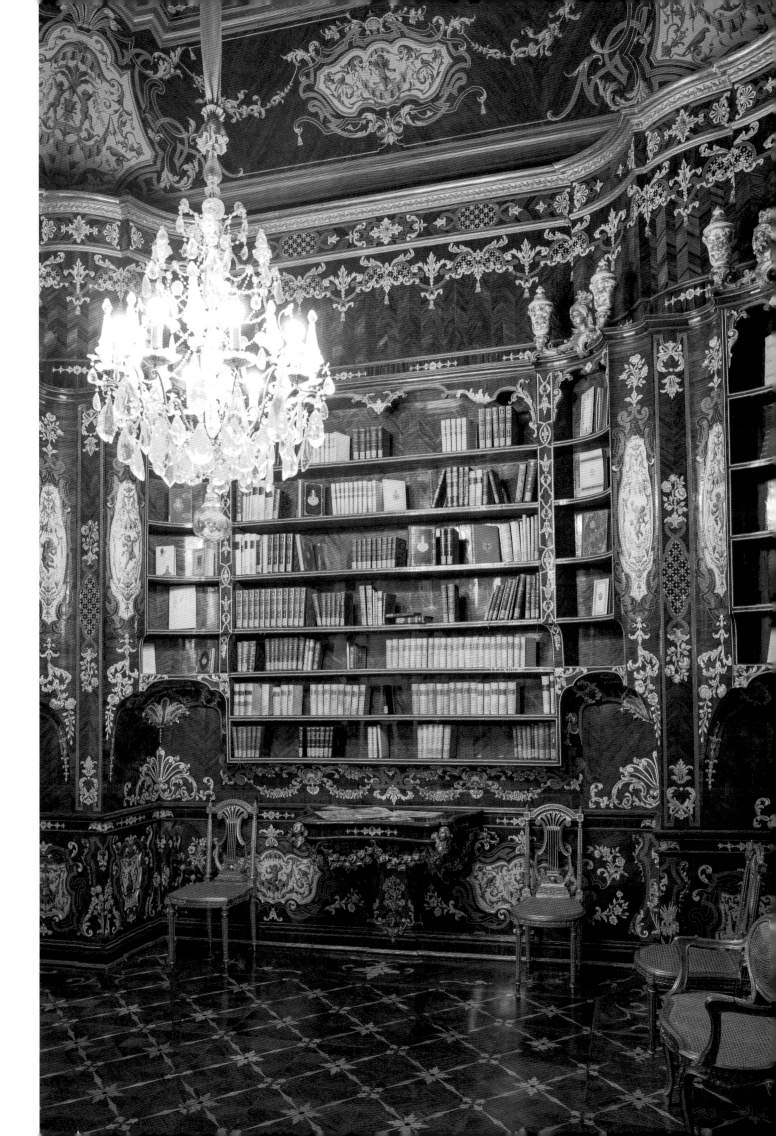

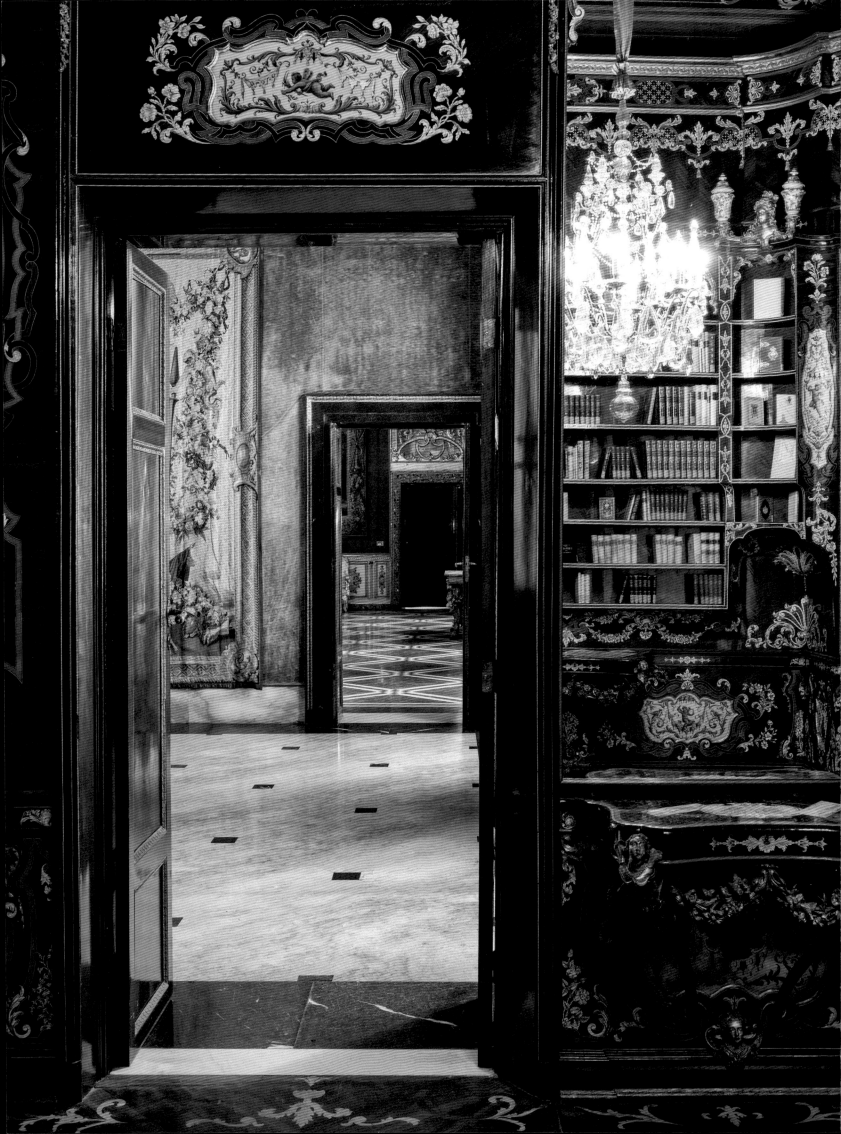

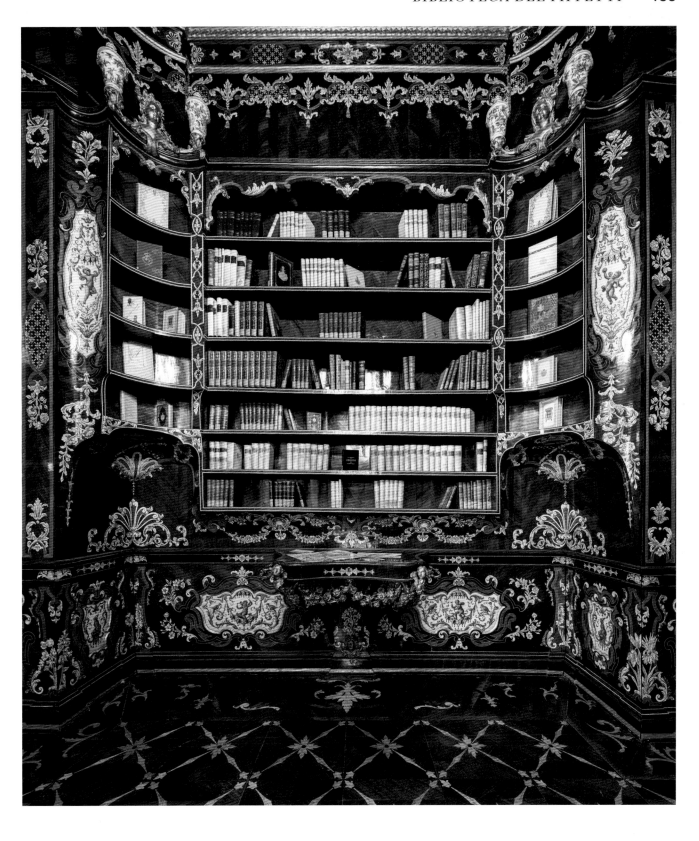

Fun fact: The prints and manuscripts casually set out on the little console table might look genuine, but they're far from it. Piffetti created these elaborate ivory inlays and carved his signature into one of the sheets.

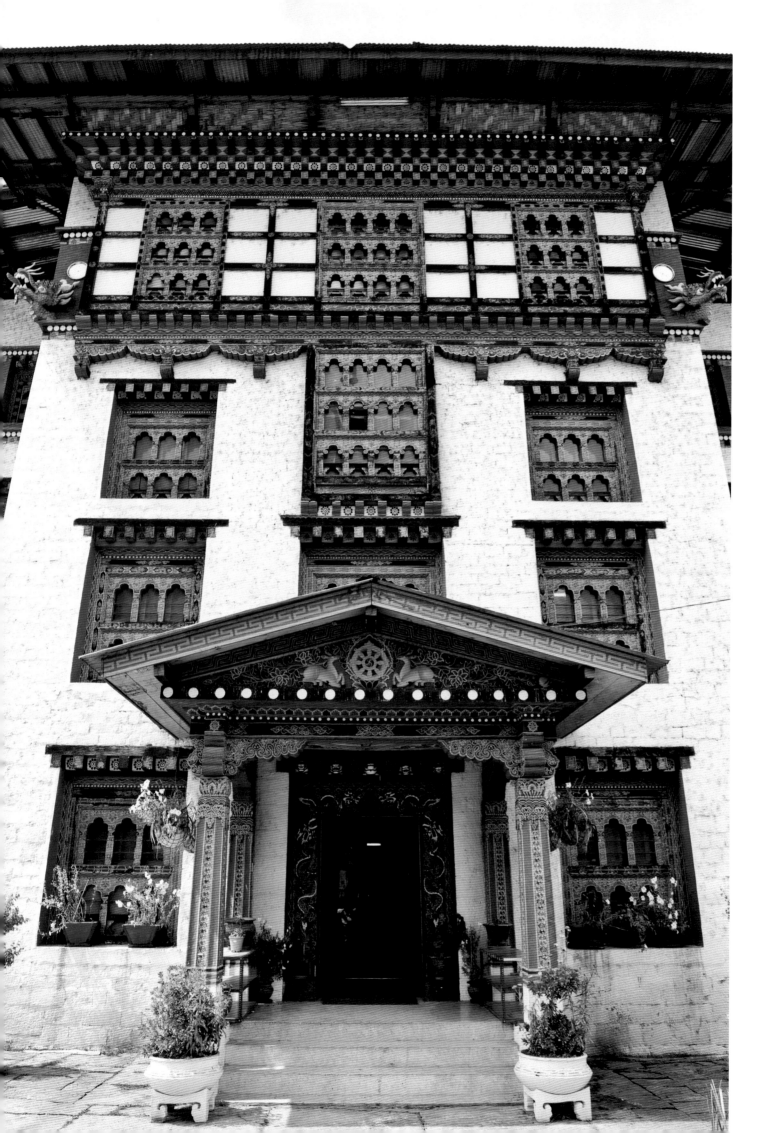

NATIONAL LIBRARY OF BHUTAN

Dedicated to cultural heritage, this institution on the edge of the Himalayas demonstrably contributes to Bhutan's gross national happiness

TRADITIONAL CONSTRUCTION
FOUNDED IN 1967
THIMPHU, BHUTAN

"The preservation and promotion of our rich cultural and religious heritage" is the mission of the National Library of Bhutan—the country that has enshrined happiness in its constitution. Founded in 1967 at the behest of then-Queen Ashi Phuntso Choden, it originally held just a handful of precious manuscripts. Over the years the library acquired more and more books, manuscripts, and documents. These were finally given a permanent home in the 1980s, when they were moved into the present-day building. The four-story library has an octagonal floor plan and is located in the Kawajangsa district of

Thimphu. It is also the national archive: storing everything that will help bring the history of Bhutan to life for future generations. Letters, photographs, microfilms, and sketches are painting an increasingly detailed picture of the country. The archivists welcome assistance from all over the world: anyone who possesses documents about Bhutan can send a copy to the archive, with heartfelt greetings from Bhutan as thanks.

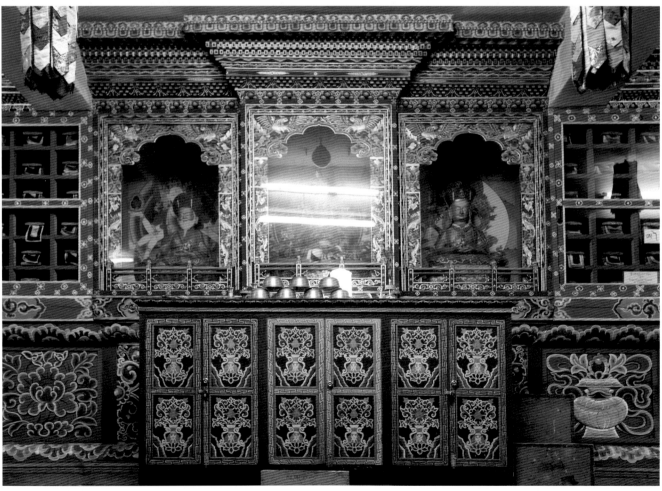

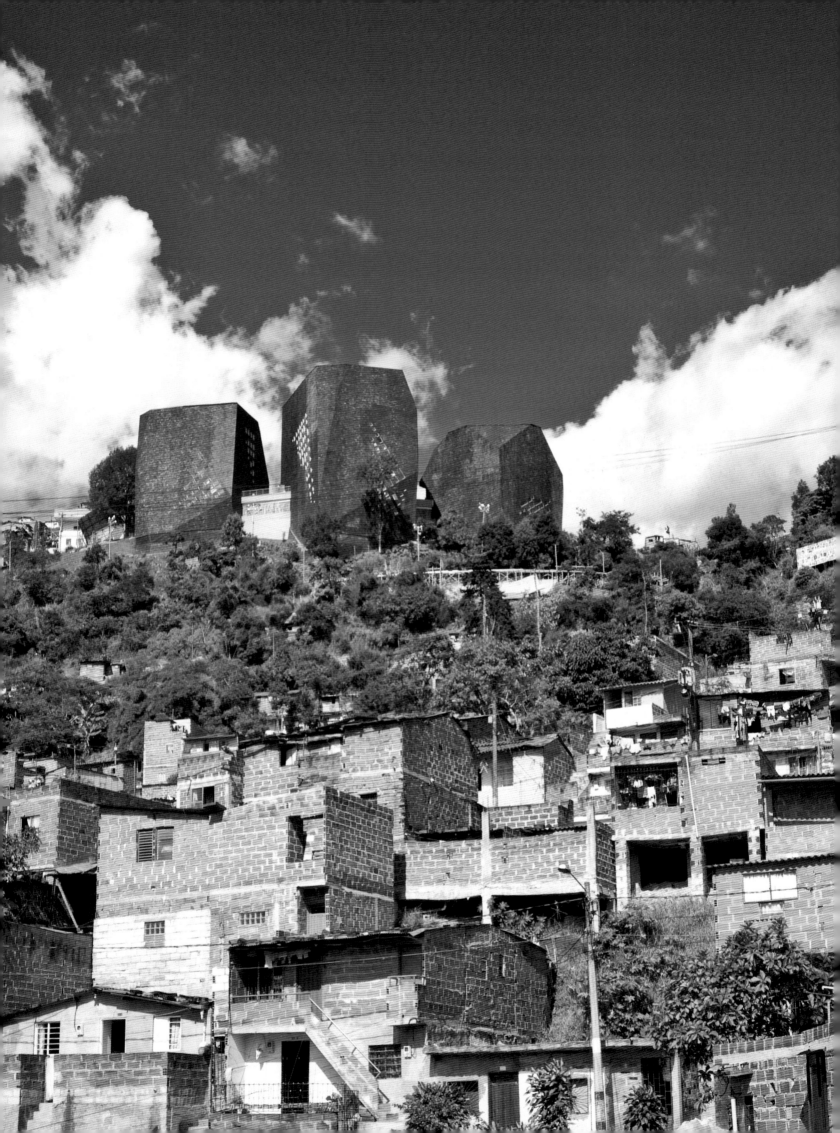

PARQUE BIBLIOTECA ESPAÑA

DESIGNED BY GIANCARLO MAZZANTI
BUILT IN 2007
MEDELLÍN, COLOMBIA

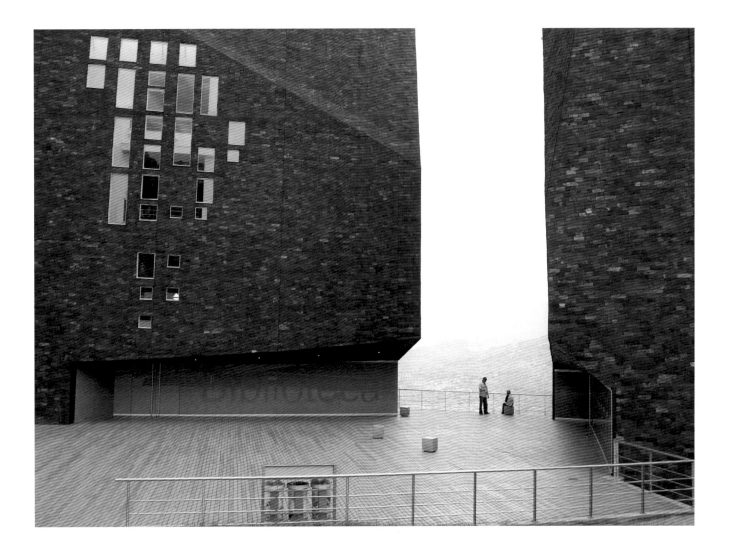

A mayor committed to bold policies of reform succeeded in transforming one of the most dangerous areas of his city into a model project for social change through education, in no small part thanks to this library

U p until a couple of years ago, the Santo Domingo Savio district of Medellín, Colombia, was pretty much the last place you'd expect to see an award-winning library. The rough neighborhood was in the vice-like grip of drug cartels; even walking the streets was dangerous. But when mathematician Sergio Farjado was unexpectedly elected mayor in 2004, he launched an ambitious education program for the city. His strategy for combating crime and drug-related violence was to provide appealing alternatives that would take children

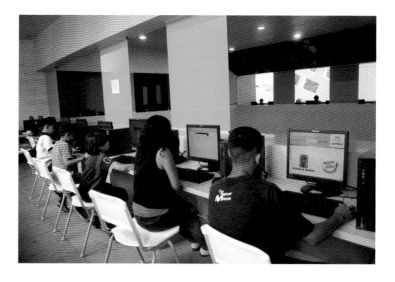

and teens off the streets and give them access to a safe future full of opportunities. Farjado was fond of declaring: "Our most beautiful buildings need to be in the poorest districts!" His slogan was "Medellín: The Most Educated."

The Parque Biblioteca España, created in 2007 by Giancarlo Mazzanti, founder and head of design at Colombian architecture studio El Equipo Mazzanti, was just one of ten major urban projects relating to education. Mazzanti and his team have been spearheading social change in Colombia for over 30 years. "The project is located on one of the hills of Medellín that was worst affected by drug trafficking-related violence in the 1980s," explains Mazzanti. "As part of the mayor's social inclusion agenda, the Parque Biblioteca España sought to promote equal opportunities."

Tasked with that mission, Mazzanti and his team created the colossal library as a flexible space for people to gather and be inspired. Alongside the usual reading rooms and an auditorium, the library also boasts an art gallery and a childcare center. All five floors are flooded with light and feature sweeping expanses. The large reading hall contains over 12,000 books and 30 computers with free internet access. Some floors

can be used for sports, art, and other purposes. The three blocks of the library are connected organically. Children play on the surrounding terraces; theater performances, concerts, readings, and movie screenings take place in the auditorium; and local residents gather here to discuss neighborhood issues and potential solutions.

"We designed the Parque Biblioteca España in a way that would encourage the community to take it on as their own, in tandem with its role as a public space," says Mazzanti. "Incompleteness, playfulness, emptiness, and anomaly all have an important role to play. Places like these serve as interstitial spaces between public and private life. They help to build trust between the community and the state."

New prospects are opening up where once no one dared to venture. Medellín's educational offensive has clearly paid off in Santo Domingo Savio—the neighborhood's declining crime rates have surprised even the greatest optimists.

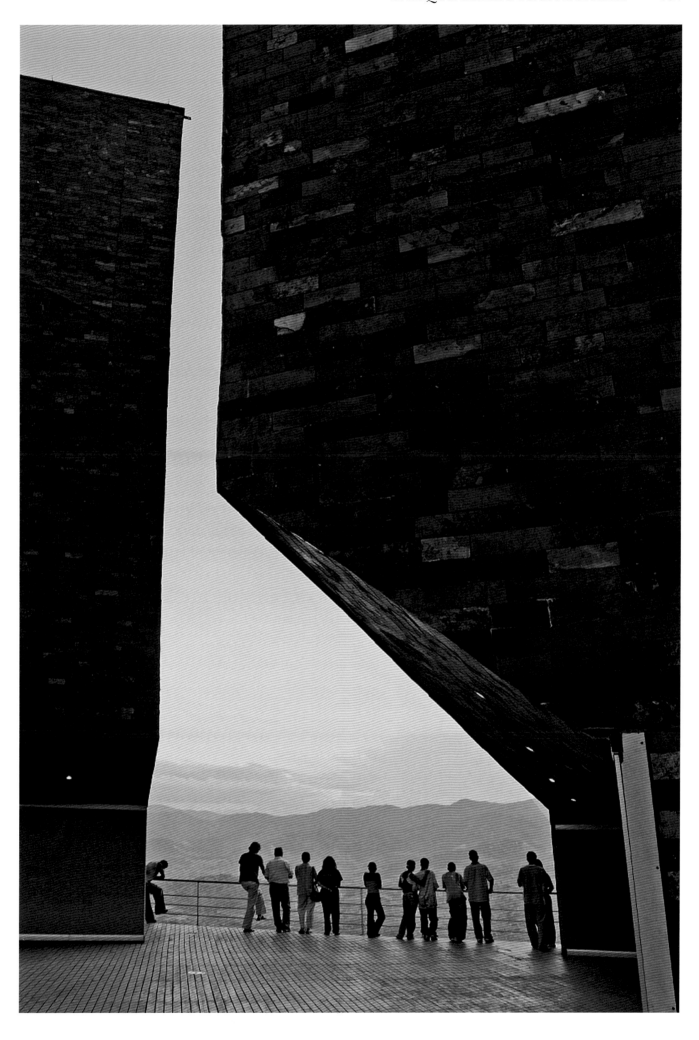

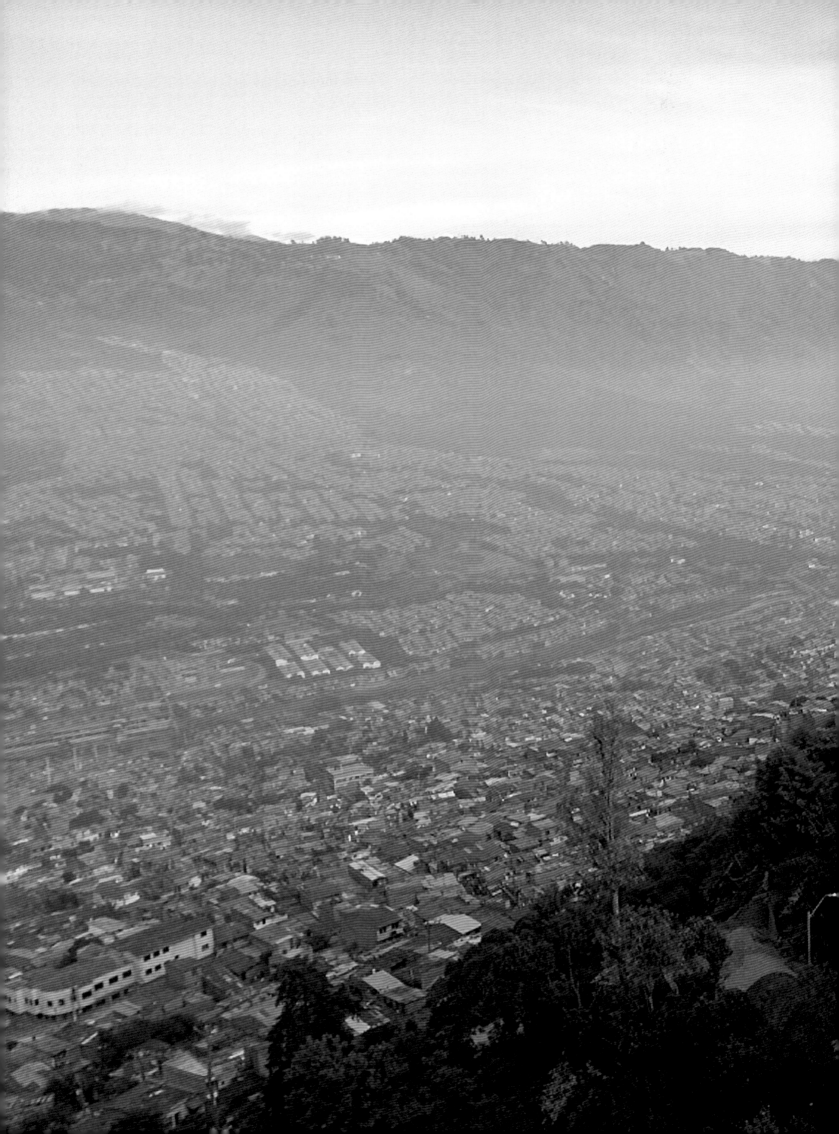

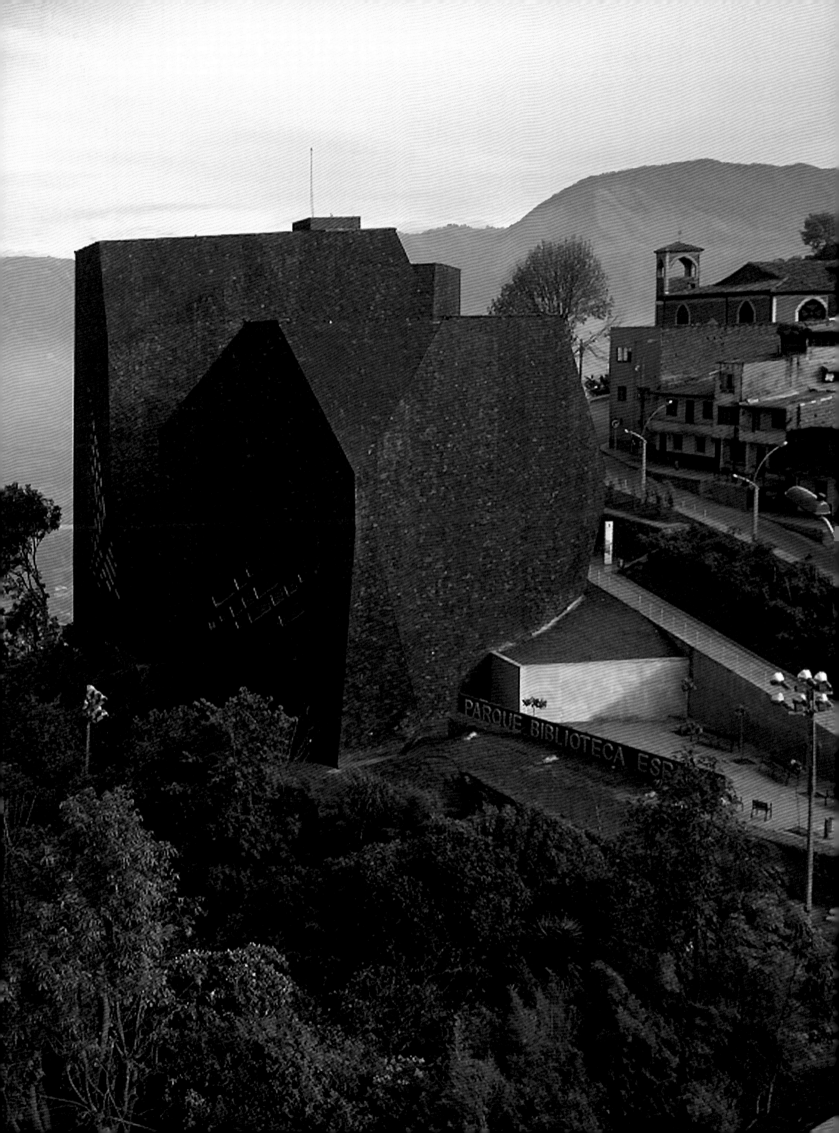

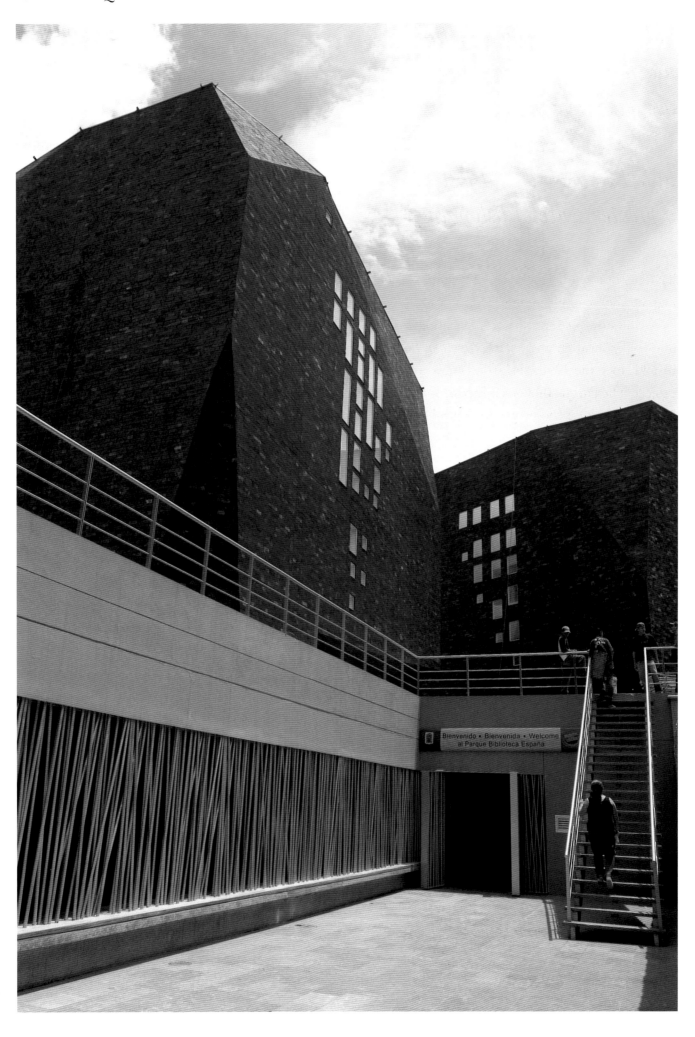

"The complex is visible from much of the city and has become a symbol of the new Medellín. It encourages people to feel connected and fosters a greater sense of belonging."

The three black blocks are symbolically enthroned on the slope overlooking Santo Domingo Savio. This is the northern Andes—some of the most rugged terrain in Colombia. The mountains and unique setting define the identity and image of the city and shape the way that people identify with it. This led the architects to draw inspiration from the surroundings when they came up with the shape of the library. They also hoped that the physical change to the neighborhood would spark change at its very heart.

"The complex is visible from much of the city and has become a symbol of the new Medellín," says Mazzanti. "It encourages people to feel connected and fosters a greater sense of belonging."

Initially, the new mayor's educational program met with heavy skepticism. Yet Fajardo's belief in the power of education and architecture paid off: the murder rate in this city of two million people has fallen 13-fold since the 1990s. Fajardo is now a Colombian presidential candidate, and Medellín is his flagship project. The Parque Biblioteca España is currently undergoing renovation work due to crumbling foundations, but its support for the people of Santo Domingo Savio remains as steadfast as ever. In fact, the library has transformed the once-dangerous district into an urban attraction that draws in tourists. Following Farjado's example, the region of Antioquia is now set to receive 80 library parks. After the renovations are complete, the Parque Biblioteca España will hopefully open its doors, terraces, and reading rooms once more so that it can carry on writing a better future for Medellín.

The Parque Biblioteca España is expressly aimed at children and young people. It provides a quiet place of retreat for reading and studying, plus a lot of space to play and computers with free internet access.

NATIONAL LIBRARY OF KOSOVO

Beneath these 99 windowed domes seethes a storied past of politics, ideology, and independence

DESIGNED BY ANDRIJA MUTNJAKOVIĆ
BUILT IN 1982
PRISTINA, KOSOVO

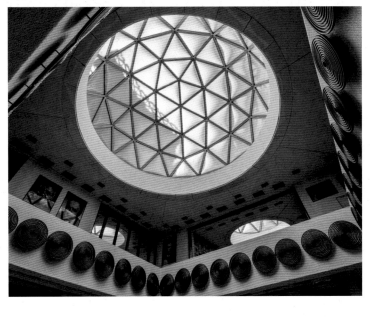

The 99 domes of the Pjetër Bogdani National Library simmer up from Pristina like a literary bubble bath. A delicate steel mesh envelops the entire building. The BKK, short for the Albanian *Biblioteka Kombëtare e Kosovës*, is Kosovo's largest and most striking library. Before it declared independence in 2008, Kosovo belonged first to Yugoslavia, and then to Serbia. With the changes in regime, the collection was repeatedly renamed and appropriated for political and ideological ends. After stints as the KAKM Library Centre and the Provincial Public Library, it moved into its present-day building in the early 1980s. Yugoslavian architect Andrija Mutnjaković designed the distinctive concrete building, which remains thrilling and evocative, not to mention a popular subject for photographers. In the past, the Museum of Modern Art in New York has devoted an entire photo wall to the library. Today a bookbindery, photo studio, two theaters, and a bookstore have taken up residence beneath the domes, alongside the library collection and its various reading rooms.

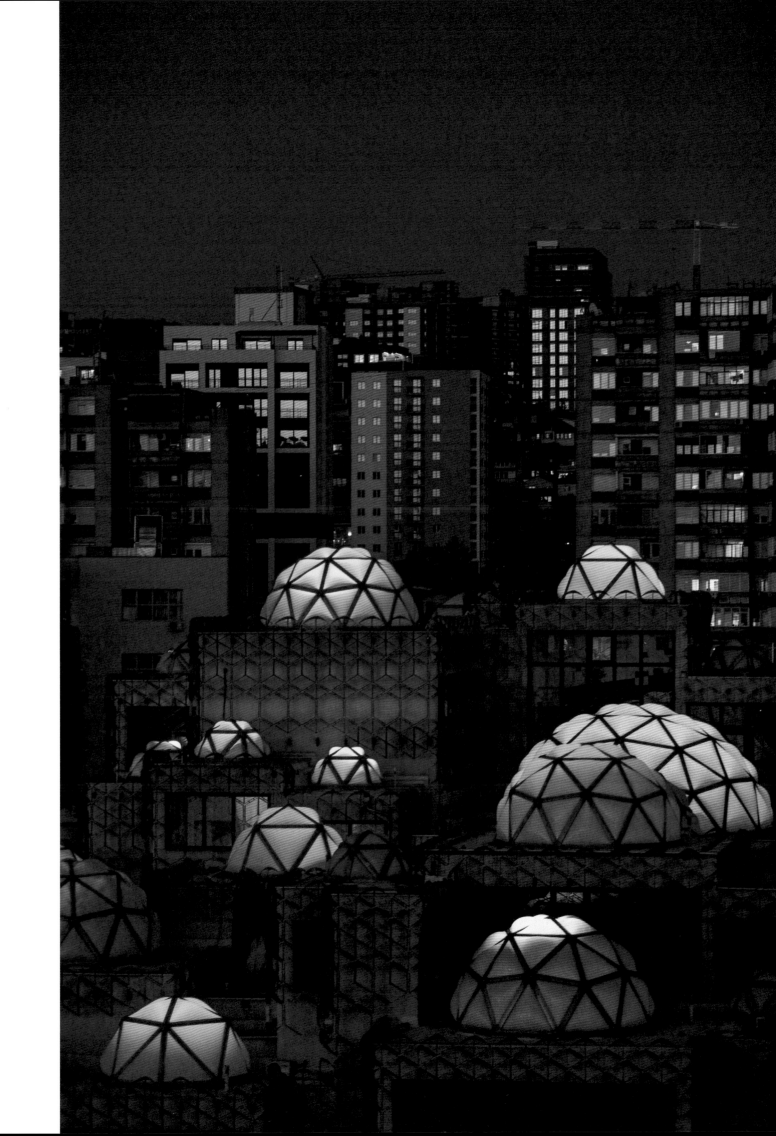

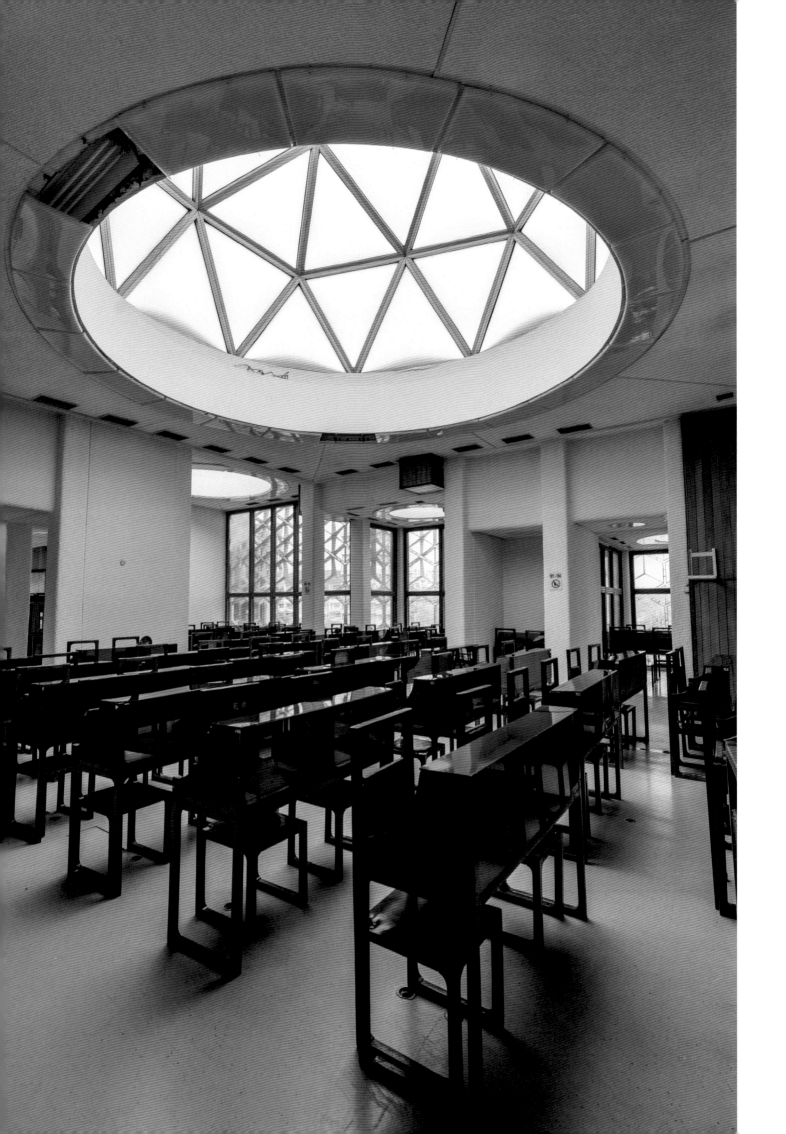

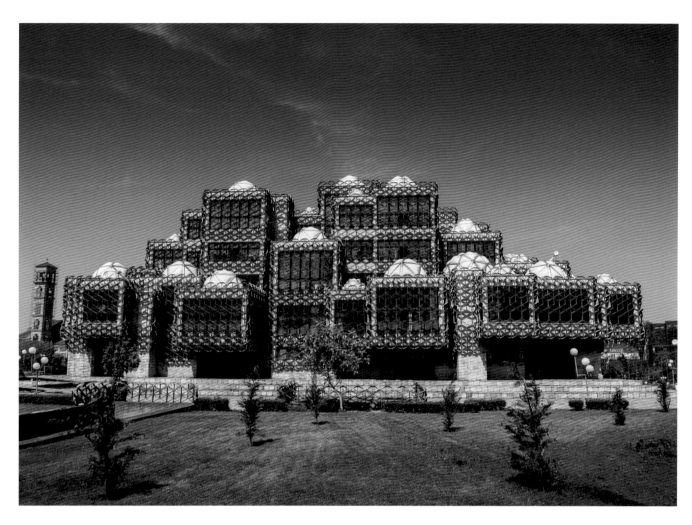

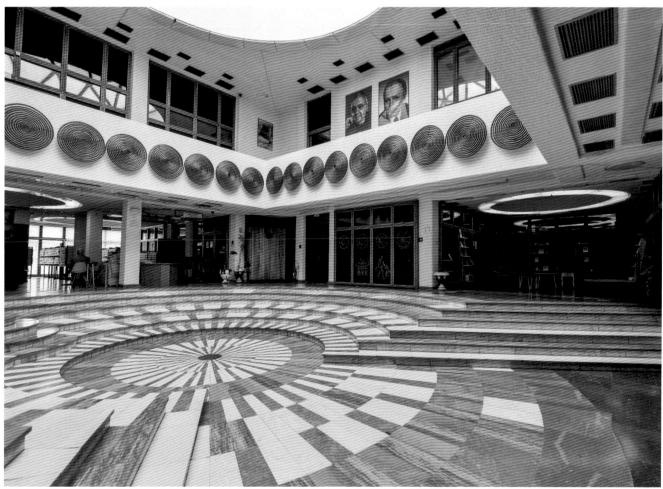

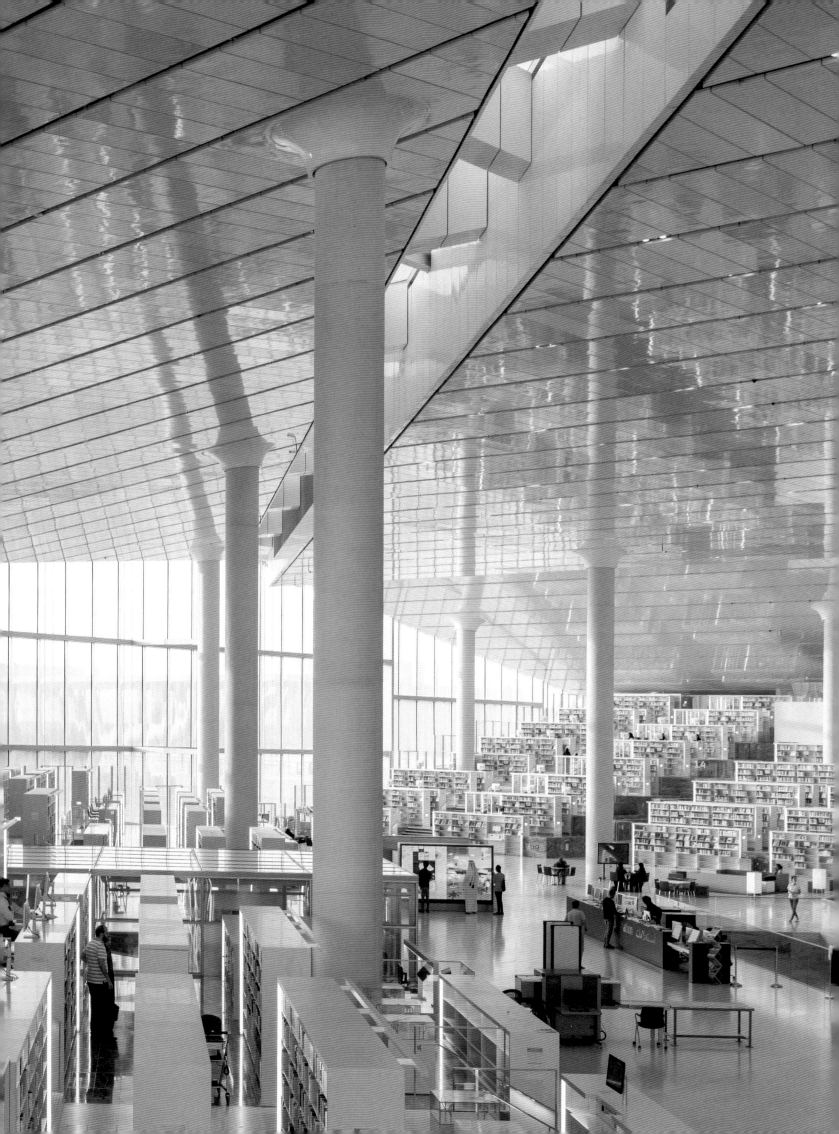

QATAR NATIONAL LIBRARY

As the first public library in the country, this architectural gem heralds a new openness to freedom of thought

DESIGNED BY REM KOOLHAAS
BUILT IN 2017
AL RAYYAN, QATAR

A masterpiece by star architect Rem Koolhaas towers over Education City in Doha. The future is the driving force behind the Qatar National Library. Visitors are presented with the most recently acquired books on a moving conveyor belt. A gigantic touchscreen for children successfully spans the gulf between video games and their venerable forebear, the book. Teenagers can use a computer lab—complete with a 3D printer—and a creative film studio. Priceless Qur'ans and manuscripts collected over the centuries lie behind thick glass at the heart of the library. The library serves as a popular gathering place for the citizens of Doha. Those who duck in here to get some respite from the blistering heat will find a vast selection of books and a wide range of events, from art exhibitions to workshops. The future certainly looks rosy here: Qatar's first public library marks the start of a more progressive education policy in the desert state.

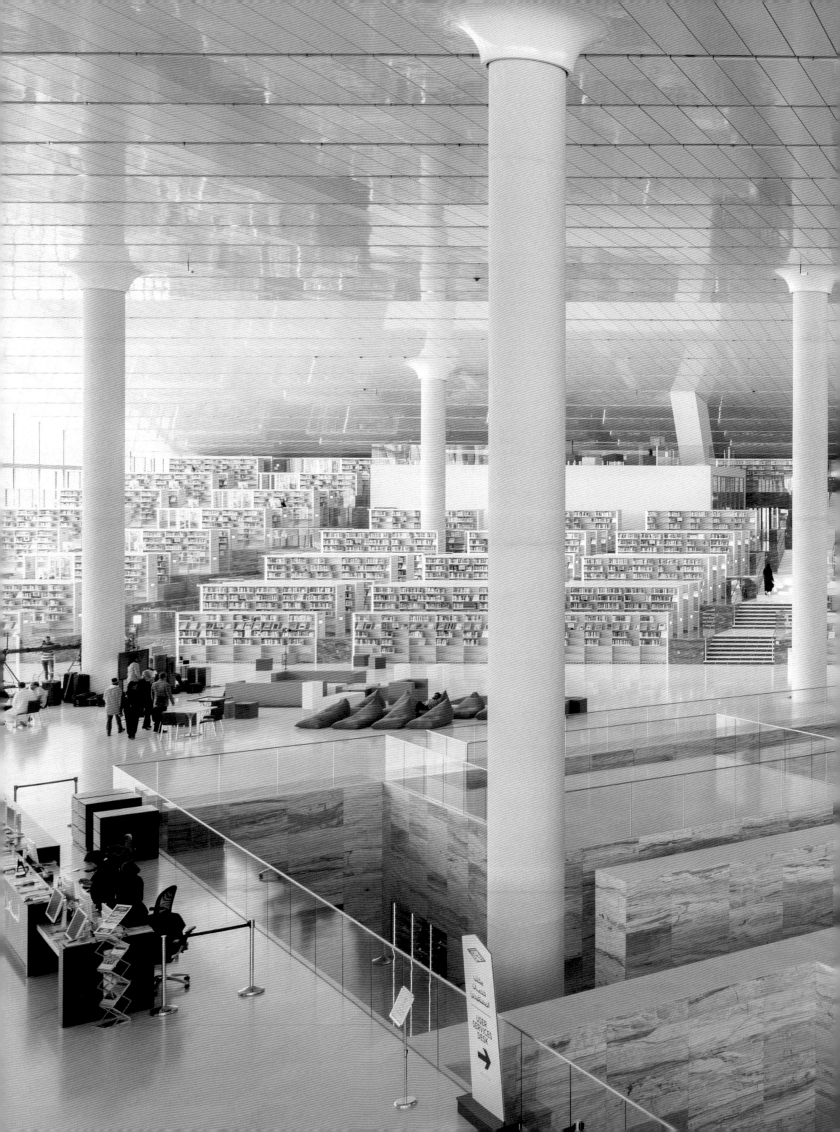

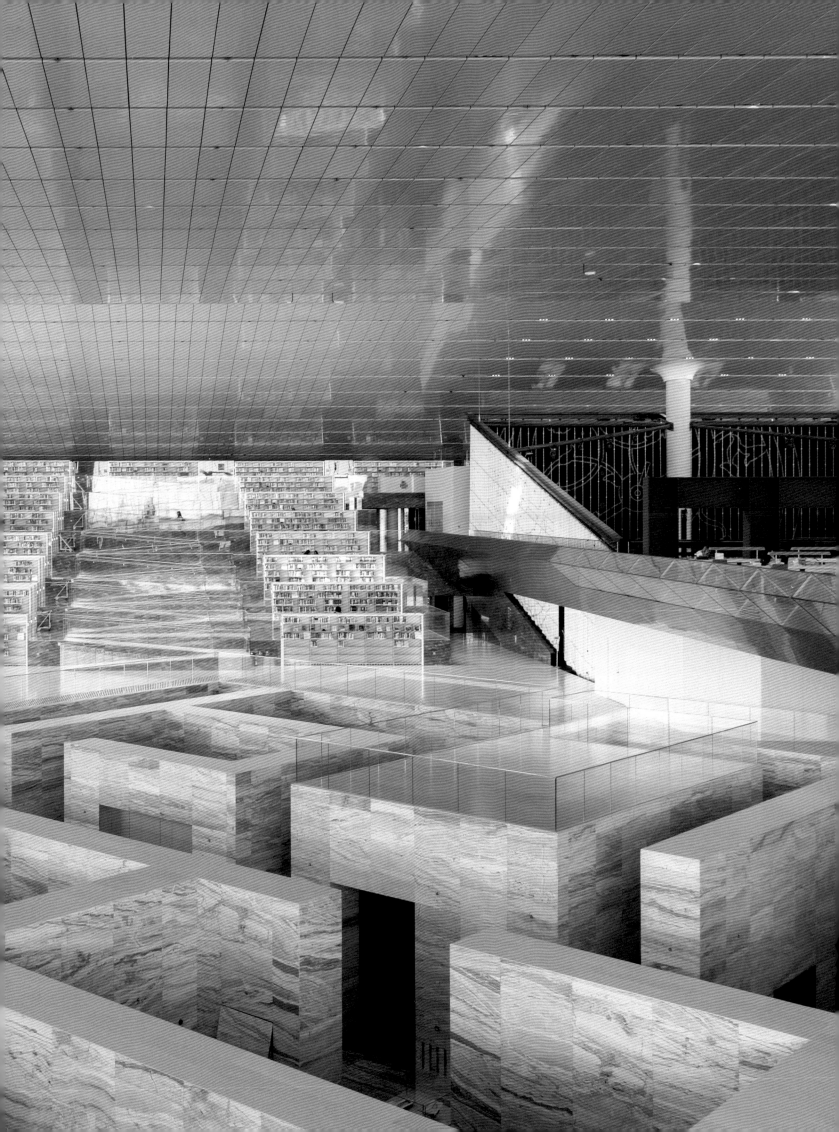

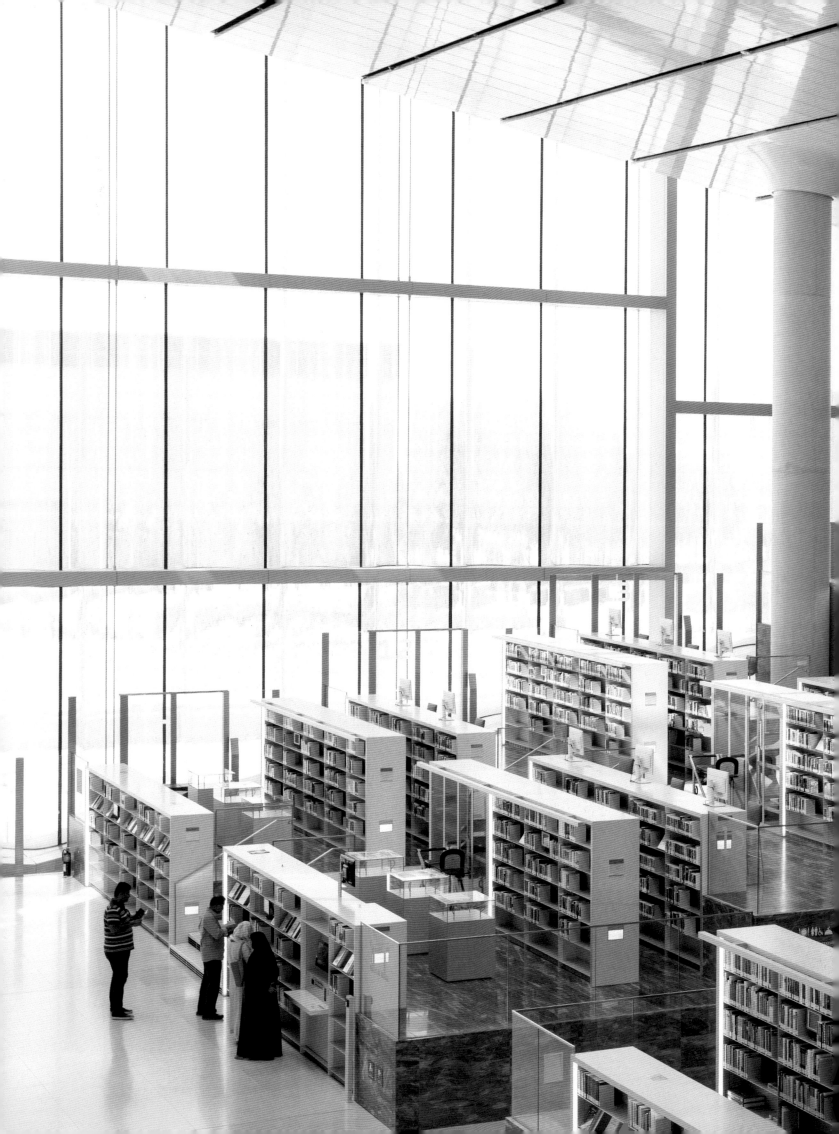

This ultra-modern building in Doha's Education City doubles as a municipal and university library. Valuable Arabic manuscripts are exhibited in showcases in the travertine-lined Heritage Collection.

The silver rhombus designed by Rem Koolhaas holds over 45,000 square meter (484,000 square feet) of library and event space.
The special glass used in its oval windows protects books and visitors alike from direct sunlight.

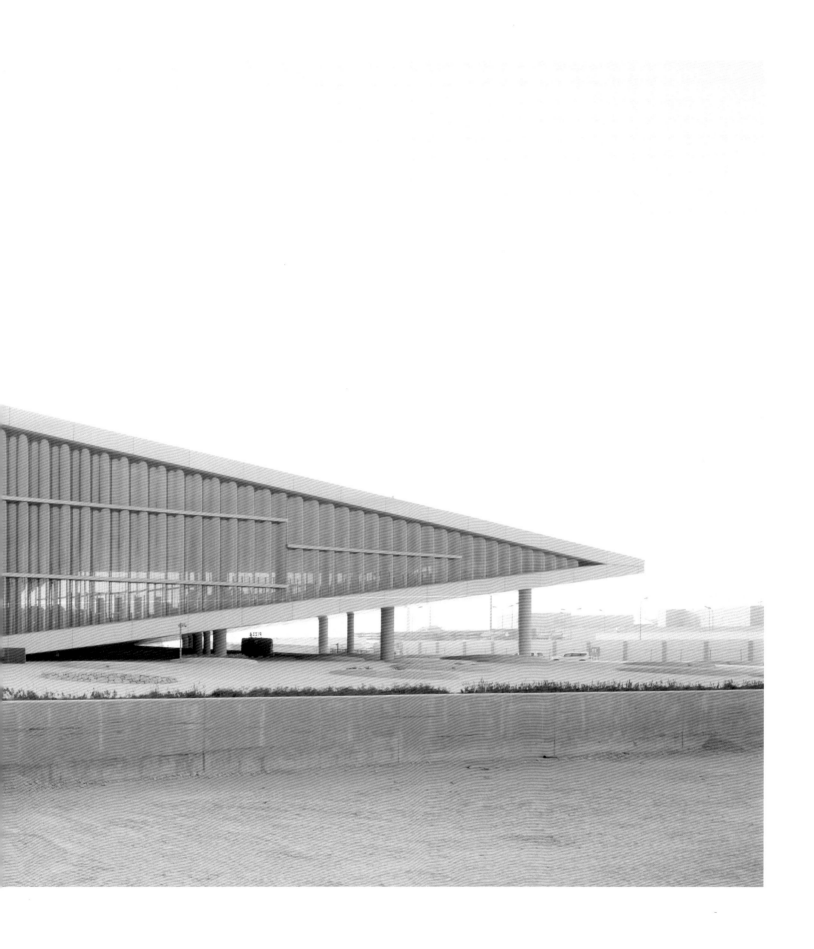

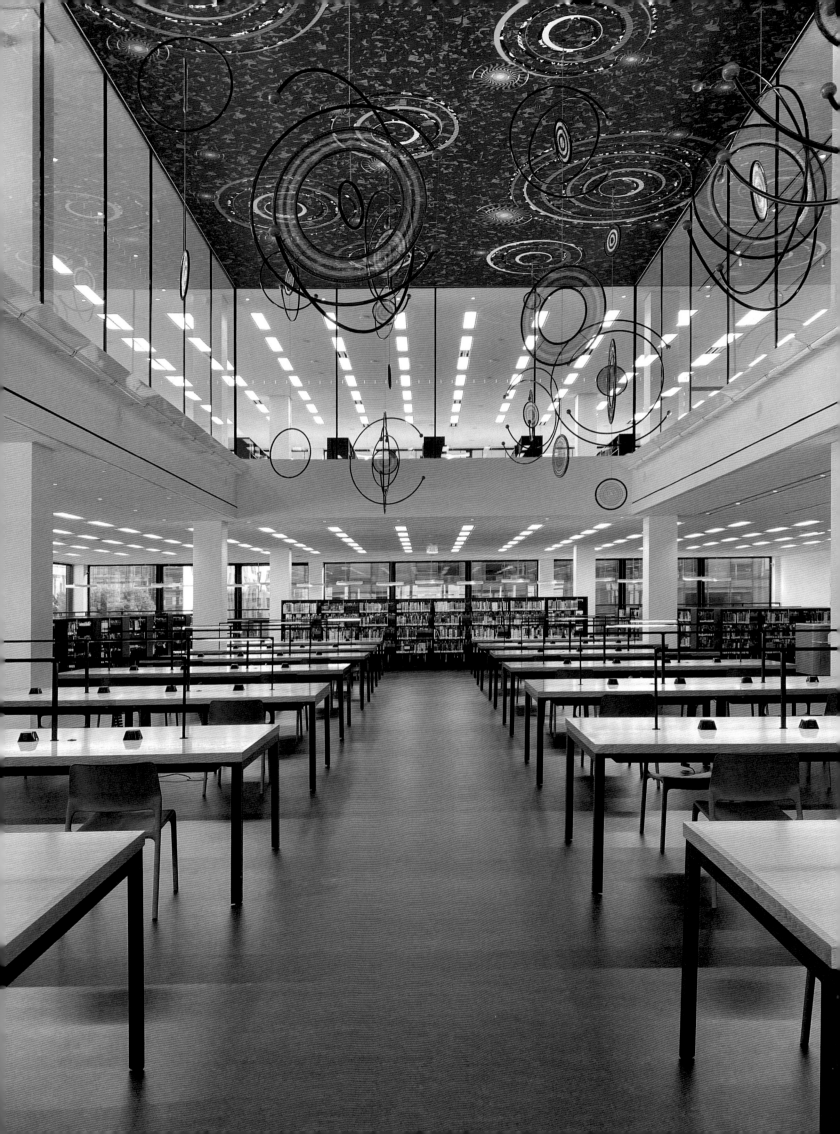

MARTIN LUTHER KING JR. MEMORIAL LIBRARY

How do you go about renovating a library designed by a legendary architect and inspired by the dream of a human rights activist?

DESIGNED BY LUDWIG MIES VAN DER ROHE, MECANOO AND MARTINEZ + JOHNSON
BUILT IN 1972, REOPENED IN 2020
WASHINGTON, D.C., USA

German-American architect Ludwig Mies van der Rohe created the original design for the Martin Luther King Jr. Memorial Library, which opened in 1972, after its namesake had passed away. When the renovation of the rectilinear library was put out to international tender, a team of architects from Mecanoo and Martinez + Johnson were awarded the commission for their bold yet respectful design. Inspired by the values of American civil rights activist Dr. Martin Luther King Jr., they proposed that the once-austere library become a place of togetherness. The small foyer was expanded and is now a more inviting, sociable space with plenty of new seating. The lower ground floor was made accessible to the public and transformed into a community center with a program of events. A community garden with paths designed to intersect now blooms on the previously unused roof. Dr. King would surely have loved this inclusive new library.

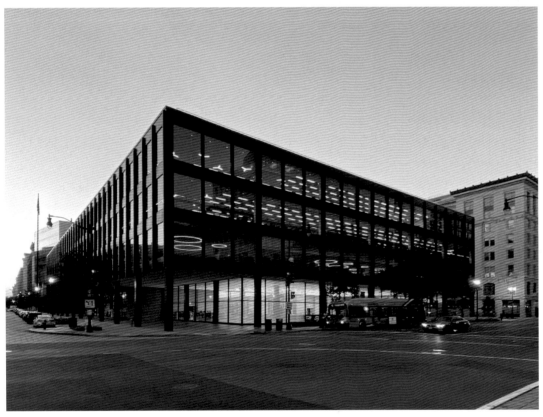

Following a fearless renovation, the library now feels softer and more welcoming. The team of architects contrasted the severe lines of Mies van der Rohe's design with organic shapes and open areas to be enjoyed by the community.

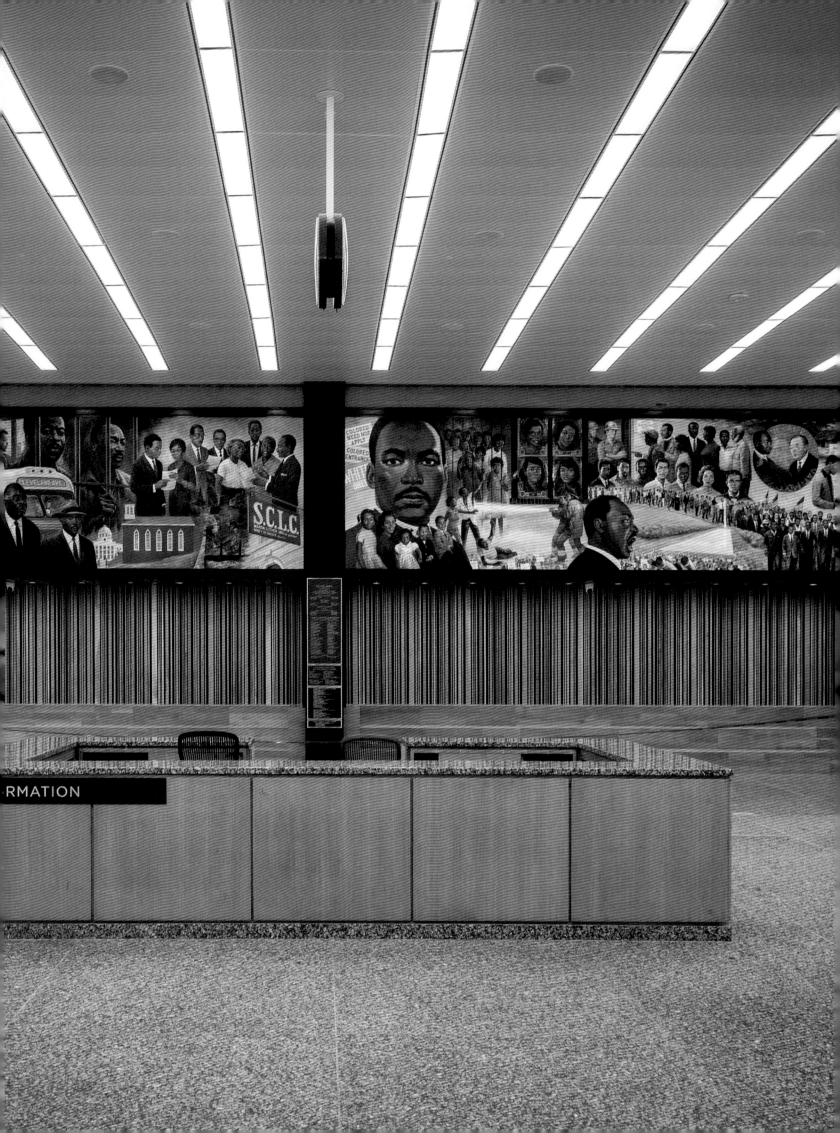

RMATION

THÁI BÌNH LÂU ROYAL LIBRARY

Having been shut away for two lonely centuries, the royal reading pavilion is now accessible to all

TRADITIONAL CONSTRUCTION
FOUNDED IN 1821
HUẾ, VIETNAM

Adorned with elaborate mosaics, the Thái Bình Lâu Royal Library looks out over the citadel of Huế. King Minh Mạng had the first reading pavilion built here in 1821 and named it "Trí Nhân Đường" ("House of Intelligence and Generosity"), in the hope that visitors would be infused with these virtues. Due to the constant risk of flooding, the most important documents were stored on the upper floor right from the start. Following various alterations, renovations, and name changes, the Thái Bình Ngự Lãm Thư Lâu—to give it its full name—was created under the emperor Đồng Khánh. This was the Royal Library. As the only building in the citadel, it survived raids by French and U.S. troops in the 20th century largely unscathed. Today the citadel is open to visitors from all over the world, with the Thái Bình Lâu one of the jewels in its crown. In 2015, the Huế Monuments Conservation Center invested over $1 million for the purpose of carefully restoring the library and putting its most precious books on display.

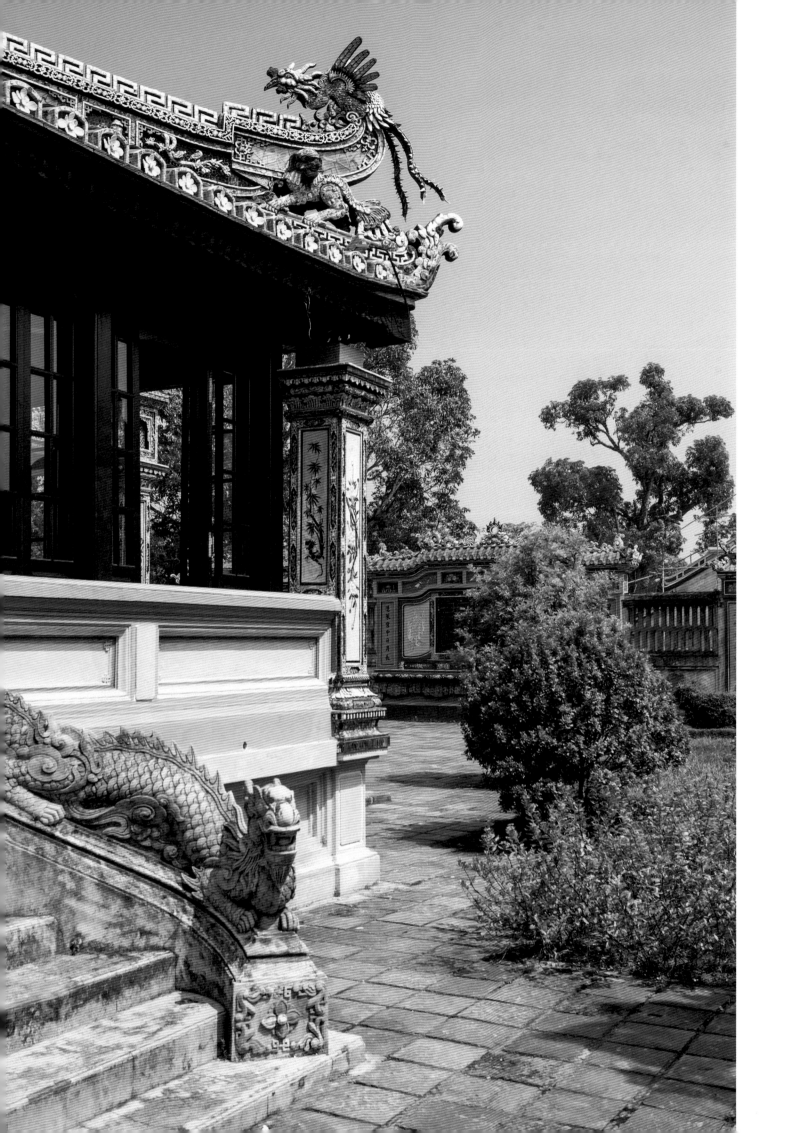

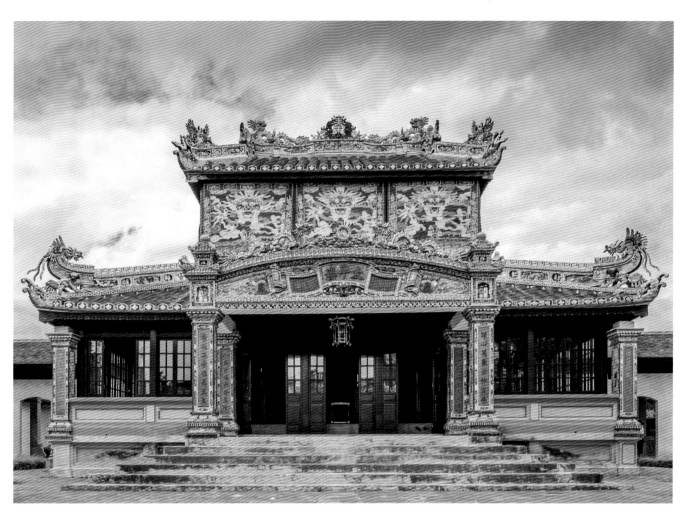

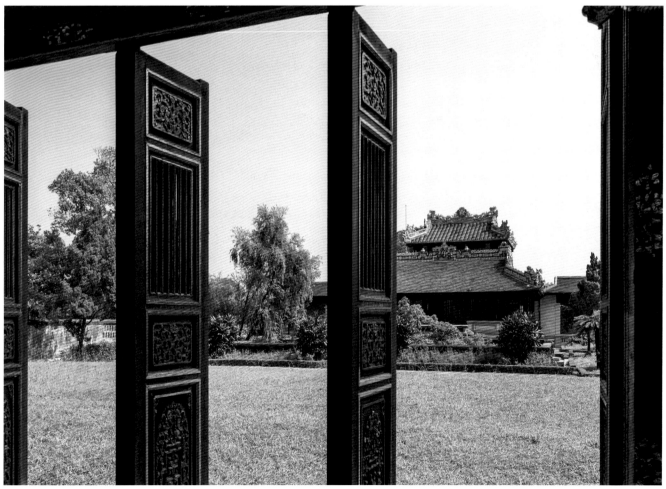

BODLEIAN LIBRARIES

This university library has to expand the stacks for its collection by five kilometers (three miles) of bookcases every year

GOTHIC STYLE
OPENED IN 1602
OXFORD, UK

"The Bod," as Oxford students affectionately call it, is one of the largest university libraries in the world. Under the United Kingdom's Copyright Act of 1911, every British publisher is obliged to send at least one copy of any published work to the five main libraries in the country, including the Bodleian Libraries. Around 3,000 publications are sent here every week and entered into the inventory, which is spread over several locations. Sir Thomas Bodley founded the library in the 17th century with the aim of creating a store of knowledge for the entire world. Over 400 years later, his dream has become a digital reality. Part of the library team is constantly working to digitize new works from the library's treasure troves and make them publicly accessible online. The digital versions also have the key advantage that they remain in a much better state of preservation than the original works. Today the Oxford Digital Library already offers over five million downloads, including everything from historical reference works to a Shakespeare First Folio.

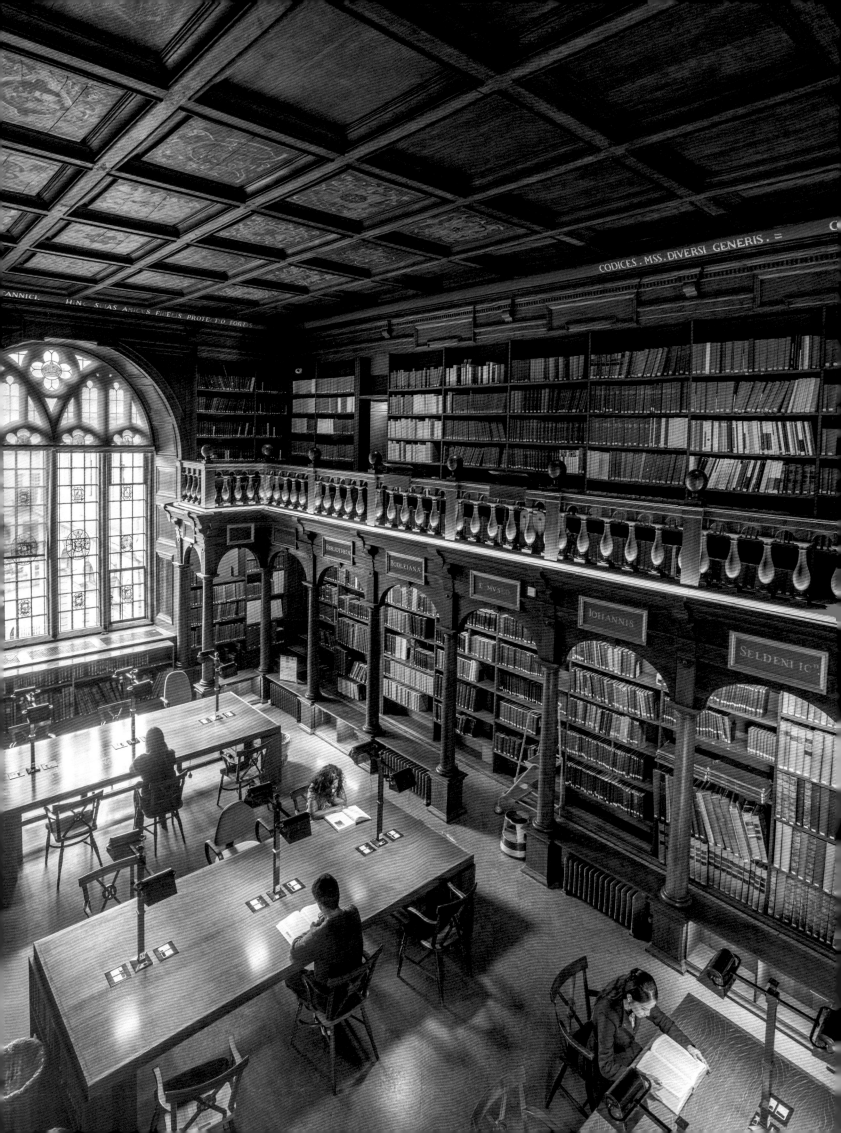

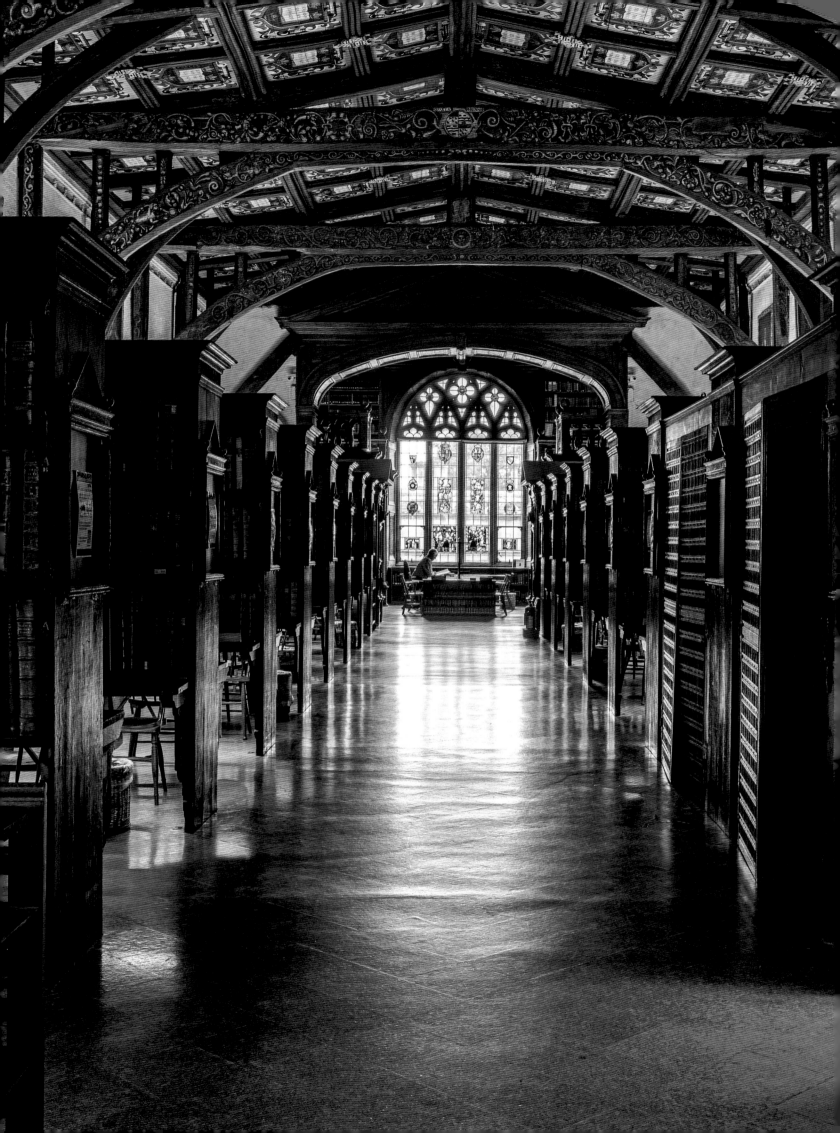

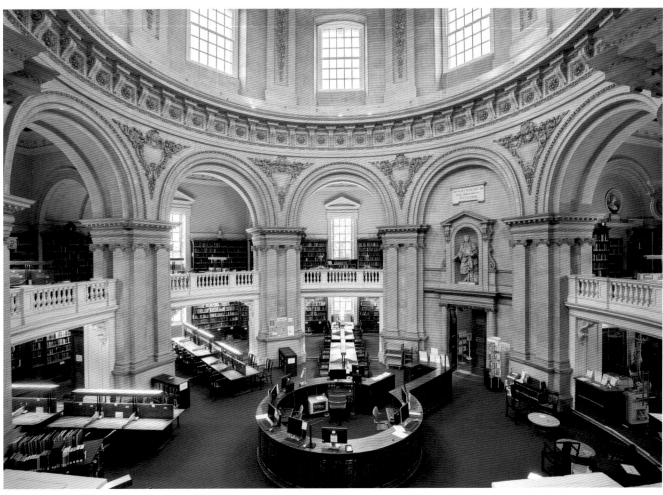

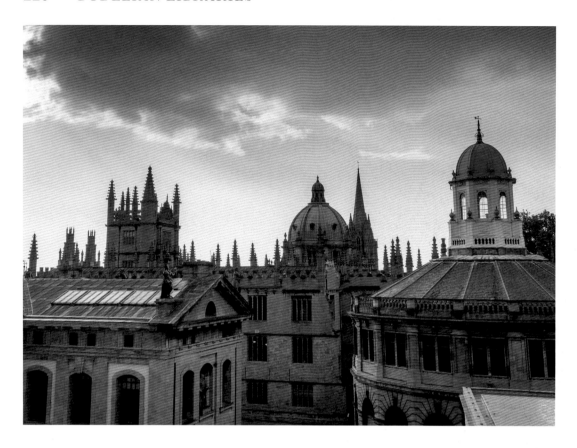

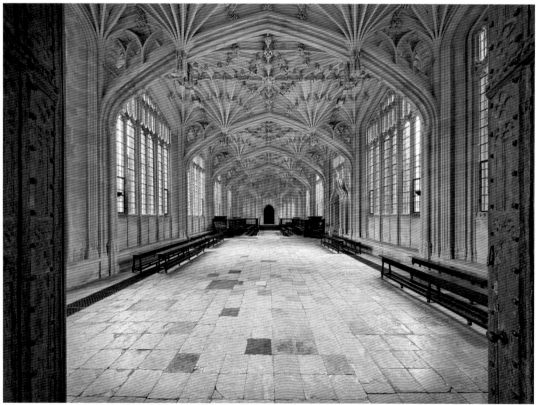

Do these interiors remind you of the Harry Potter films? Well spotted! Parts of the Bodleian Libraries were used as locations for the Hogwarts infirmary and the library where Harry, Ron, and Hermione would meet to concoct their plans.

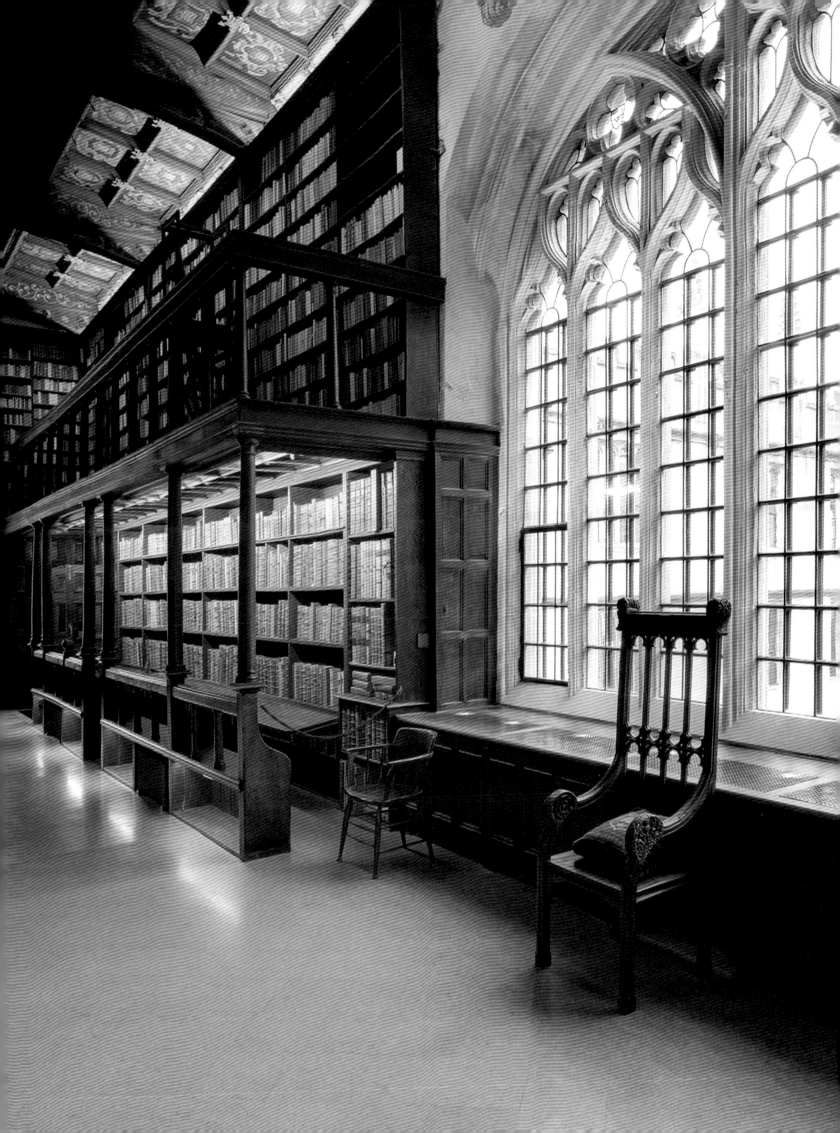

BIBLIOTHECA ALEXANDRINA

DESIGNED BY SNØHETTA
BUILT 1995–2001
ALEXANDRIA, EGYPT

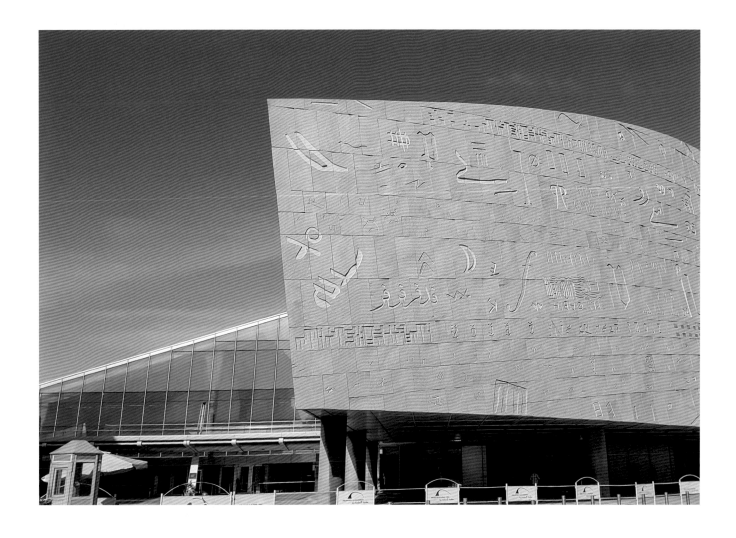

Some 2,300 years after the destruction of its famed predecessor, this Egyptian library is making a second attempt at bringing all the world's knowledge together in one place through dialogue, cosmopolitanism, and digitization

It's no coincidence that the Bibliotheca Alexandrina looks like a futuristic spaceship stranded on Earth. The levels of the building, which is located in the harbor district of the Egyptian city, bore deep down into the earth on one side and soar into the sky on the other. The legendary Library of Alexandria stood on roughly this spot some 2,300 years ago. The new building enjoys patronage from UNESCO and intends to build upon that ancient legacy.

"The aim of the new Bibliotheca Alexandrina is to revive the spirit of openness and erudition that characterized the original Library of Alexandria," says Sherine Ramadan, who has worked as a librarian and events manager here since 2006. "As an Egyptian and international institution, the Bibliotheca Alexandrina is focused on four main concerns. We want to be at once a window for the world onto Egypt, and Egypt's window onto the world. We aim to become a leading institution in the digital era and establish the library as a center for learning, tolerance, dialogue, and understanding."

There are all sorts of legends surrounding the fall of the ancient Library of Alexandria. To this day, neither newly excavated ruins nor papyrus fragments have been definitively attributed to that famous store of knowledge. The chances of finding any other remnants are now vanishingly small. Nevertheless, it has been a byword for learning down the centuries; even Alexa, Amazon's virtual voice assistant, is named after the library. From texts by ancient philosophers like Seneca, we now know that the Library of Alexandria was founded in the 3rd century BCE by Ptolemy I, one of Alexander the Great's generals. To stock the shelves, the authorities would confiscate scrolls from incoming ships, copy them, and only give them back as transcripts. The same fate befell the manuscripts of tragedies by Aeschylus and Sophocles. The Athenians attempted to loan them out to Alexandria for a costly fee, but it was all in vain. Ptolemy III reneged on the pledge and sent back only copies of the precious manuscripts. As a result, the quantity of valuable originals stored in the library grew ever greater, cementing Alexandria's reputation as the world's foremost center for learning.

So how did this fabled library come to be destroyed? Did it fall victim to the fires that Julius Caesar ordered to be started in Alexandria around 50 BCE? Was it damaged by the fighting in the 3rd century? Or was it hollowed out by the Arab conquest in the 7th century, when all writings that were deemed not in keeping with the Qur'an were burned? →

Alexander the Great founded the city of Alexandria following his victory at Issos. The city's famous library was created under Alexander's successor, Ptolemy, and transformed Alexandria into a major center of erudition in the ancient world.

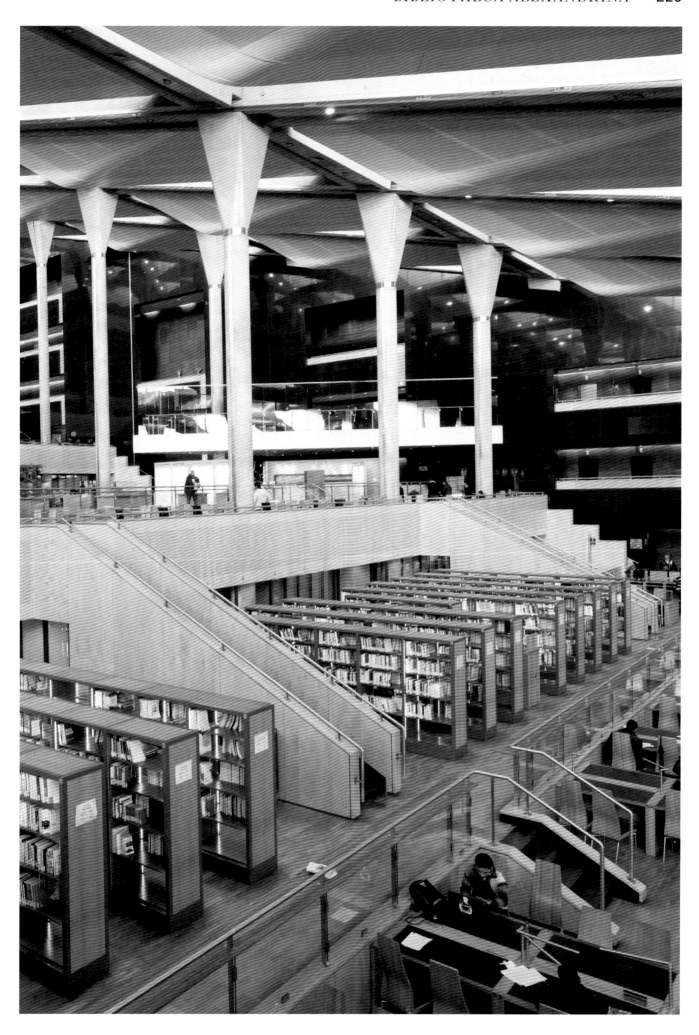

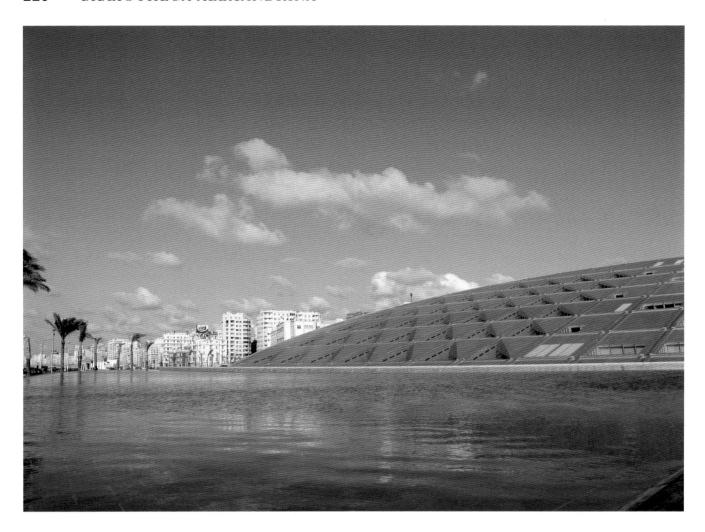

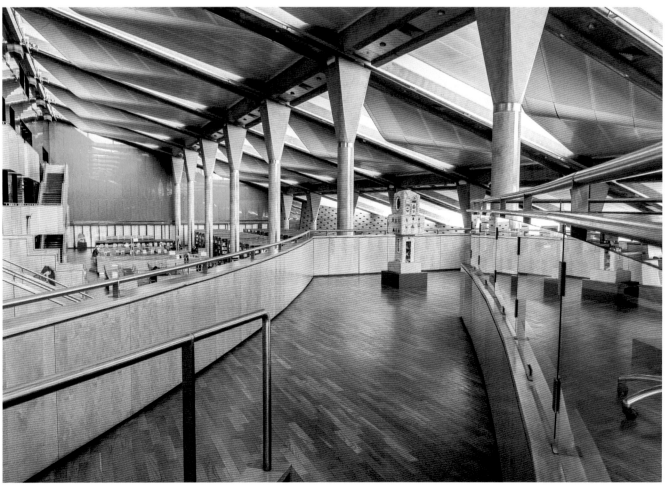

There are all sorts of legends surrounding the fall of the ancient Library of Alexandria. To this day, neither newly excavated ruins nor papyrus fragments have been definitively attributed to that famous store of knowledge.

→ Most present-day historians believe that the cumulative effect of these events proved so disastrous for the library that it gradually waned in influence over the subsequent centuries. As its collection of manuscripts shrank, so too did its standing in Alexandria and the wider world, until the library and its scientific, medical, and historical findings finally faded from view. *Sic transit gloria mundi*—thus passes worldly glory, as the 15th-century saying goes.

Since 2002, the new Bibliotheca Alexandrina has once again attempted to bring the world's knowledge together in one place. Although it holds some eight million actual books, it primarily relies on digitization. The International School of Information Science (ISIS, for short) is affiliated with the Bibliotheca Alexandrina.

"ISIS preserves the legacy of scholarship for future generations in digital form, enables unrestricted access to human knowledge, and promotes the development of a universal digital library," says Ramadan. One of the most important developments to come out of ISIS is the Digital Assets Repository (DAR), which can record and archive any type of media thanks to its flexible design: "DAR now comprises the world's largest collection of books in Arabic. For one thing, books that are no longer protected by copyright are fully available on the internet for people to read."

Strict security measures are in place to protect this valuable knowledge and should prevent history from repeating itself. These days, as we look hopefully towards the future, we can rephrase that old maxim: *Sic digitalisatur gloria mundi.*

The Bibliotheca Alexandrina has taken its mission of being a window to the world quite literally: the team of architects fitted this modern temple of knowledge with countless panes of glass that cast bright sunlight onto the low rows of shelves.

BIBLIOTECA VASCONCELOS

DESIGNED BY ALBERTO KALACH
BUILT 2004–2014
MEXICO CITY, MEXICO

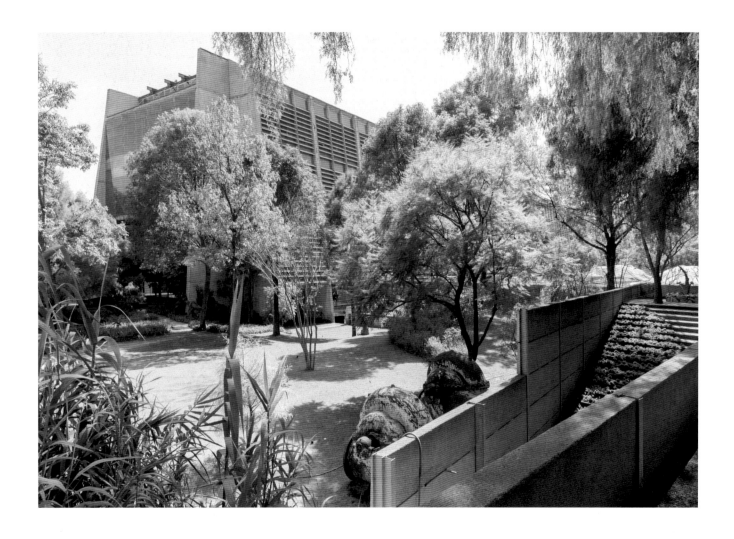

A living encyclopedia of nature flourishes around the book-filled
steel skeleton of this library: proof that learning and the living world
make a great pairing

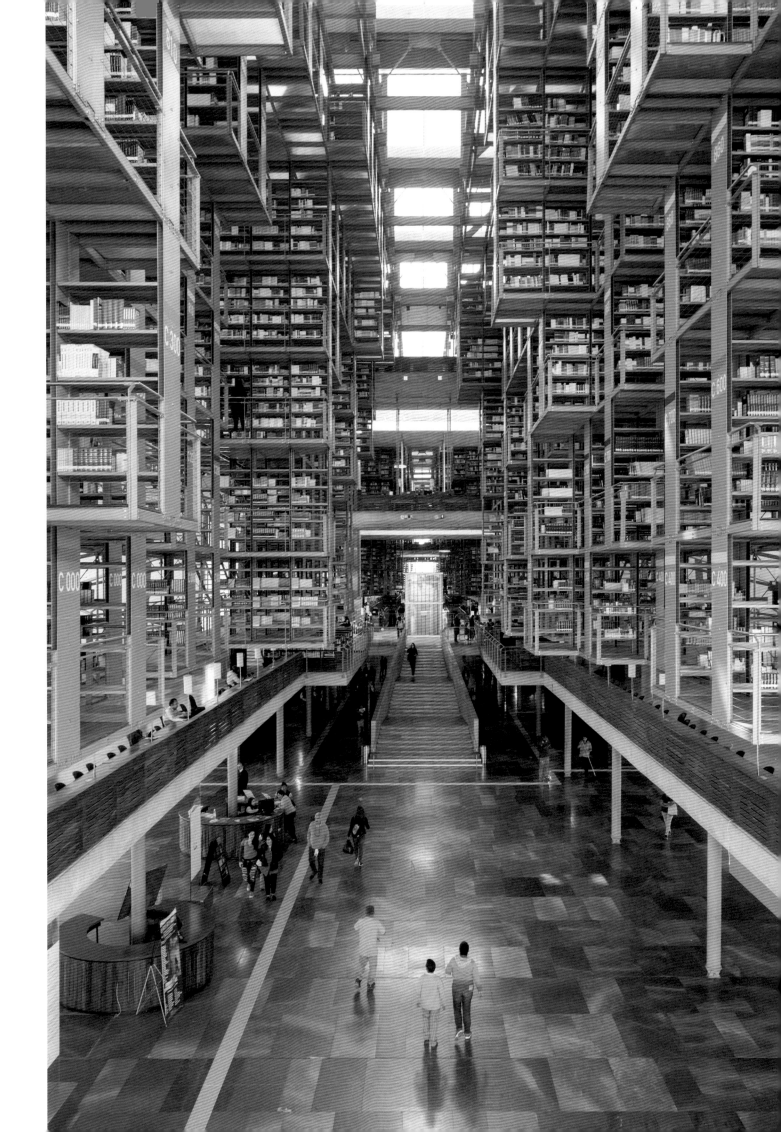

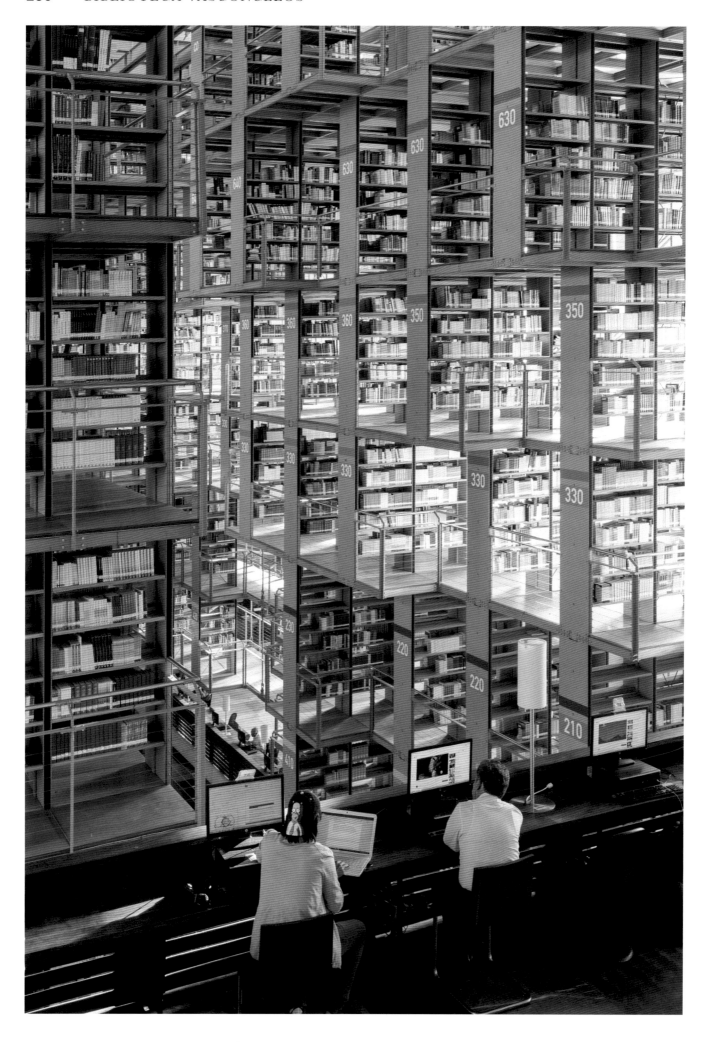

Unsuspecting visitors strolling through the popular Mexico City district of Cuauhtémoc will be astonished to stumble upon the mighty concrete hulk of the Biblioteca Vasconcelos, and even more surprised by its imposing yet sophisticated interior. Mexican architect Alberto Kalach and his team won the international tender for the new library building in the early 2000s with their spectacular design. Daylight floods into the interior and lush foliage glints between the 40,000 meters (131,230 feet) of bookshelves, which are made of a steel structure that appears to float. The vast main hall is around 238 meters long. Its elongated shape has echoes of classic library designs such as the imposing Long Room at Trinity College (see page 258).

In addition to the general collection, which numbers some 600,000 books, and the ambitious section for children and teens, the library also puts on a wide-ranging program of cultural events. "What we do comes about organically, in response to the needs of the local people," writes the team at the Biblioteca Vasconcelos. "Besides providing information, culture, education, and leisure all feature here. We aim to cater to those needs by providing a traditional library service, a range of art-related activities, and free access to our collections, plus a contemporary visitor concept." In practical terms, this means exhibitions, concerts, theater performances, dance classes, workshops, book launches, storytelling evenings, and movie screenings.

The library is inclusive and accessible, with a Braille area and a remarkable collection of media in sign language. "This collection mainly deals with deaf culture and Mexican sign language," writes the team. "Our deaf visitors can also enjoy books in other languages that address sign language or the lives of those with hearing impairments, plus books for deaf children. We also have books without words, which can help

people understand what it's like to live without sound. Stories can be told without words, after all." The collection is also enhanced by videos.

The principal artwork in the Biblioteca Vasconcelos is a sculpture by Mexican artist Gabriel Orozco, based on the skeleton of a gray whale that the artist found on a beach in Baja California. He placed a metal fitting beneath it and labeled the bones with thousands of graphite circles. Today the piece, entitled *Mátrix Móvil,* adorns the entrance to the library and provides a remarkable visual counterpoint to the building's skeletal shelving. The sculpture also forges a link with the nature present, in the form of the botanical garden that surround the colossal building. "Culture and →

In this building, the books ascend to dizzying heights. Sweeping, open spaces between the shelves invite visitors to read and study. The computers have internet access and can be used free of charge.

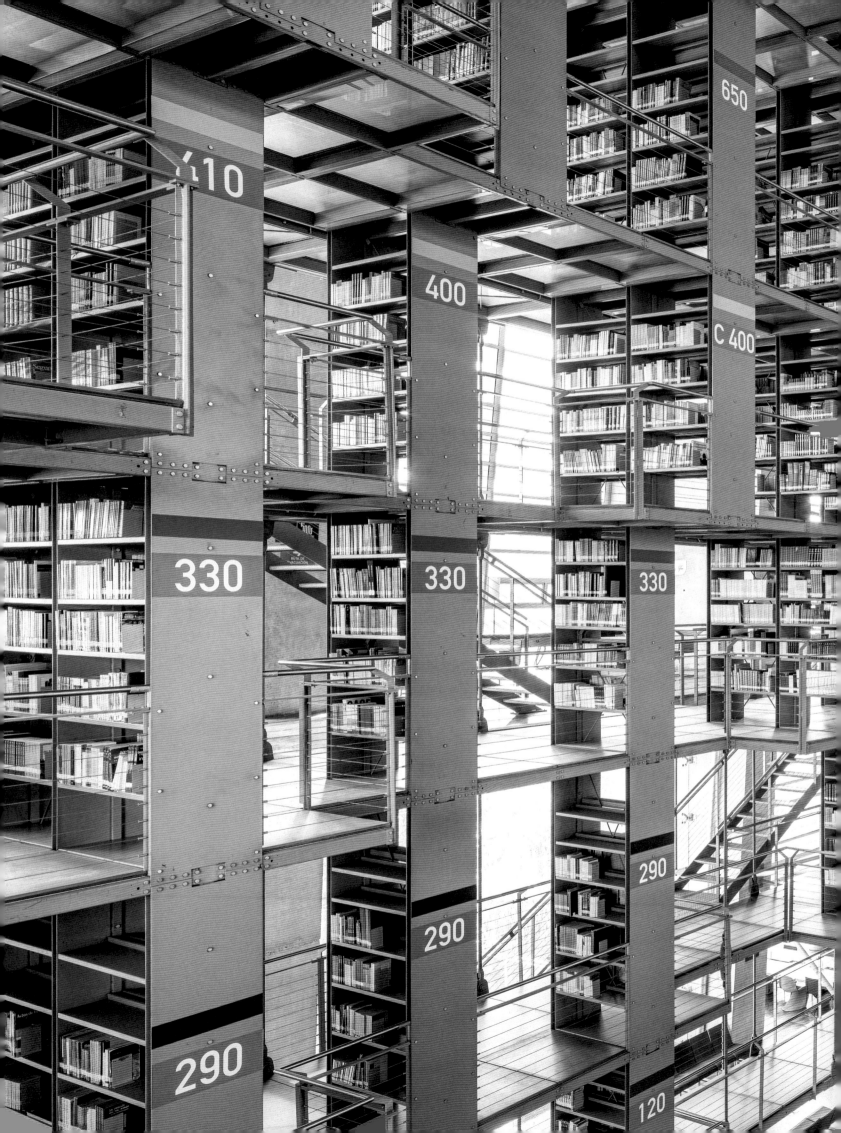

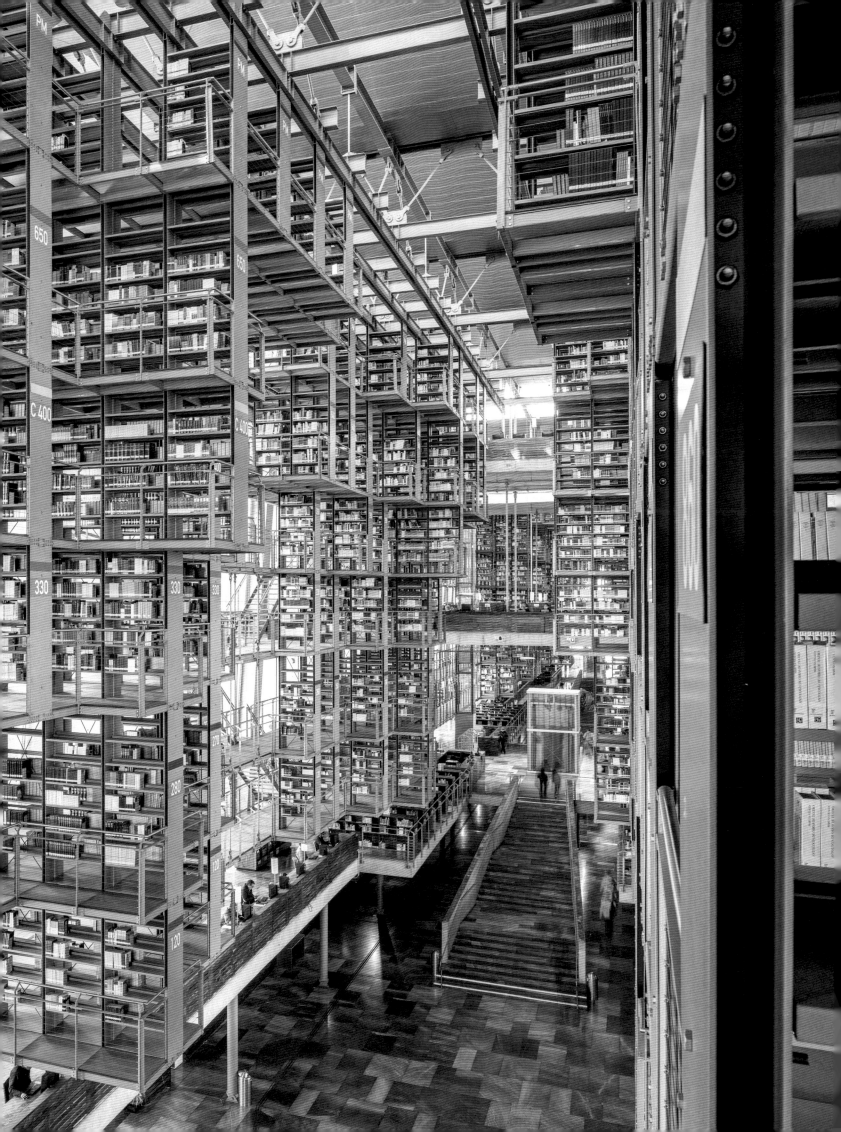

Today the Biblioteca Vasconcelos has joined the pre-Hispanic pyramid city of Teotihuacán, the Mayan buildings of Chichén Itzá, and the National Museum of Anthropology as one of the ten most popular cultural attractions in Mexico.

→ nature are often viewed as opposite extremes," says Alberto Kalach. His architectural designs repeatedly play with this notion and transgress apparent boundaries, revealing them to be nonexistent. The riotous greenery seems to make its way into the building itself through its transparent façade, while people outside have unobscured views into the library. Over 60,000 specimens of 170 typical Central American species of trees, shrubs, and perennials thrive in the green belt that encircles the Biblioteca Vasconcelos. Three small pavilions invite visitors in to read and relax. Nature is merely given a gentle steer; there are no manicured lawns or pruned vegetation in sight across the little hills and around the ornamental pond. It's a popular spot for teenagers to meet up and rehearse their new dance videos for TikTok. Abundant cultural offerings are also in full bloom in the surrounding neighborhood.

Today the Biblioteca Vasconcelos has joined the pre-Hispanic pyramid city of Teotihuacán, the Mayan buildings of Chichén Itzá, and the National Museum of Anthropology as one of the ten most popular cultural attractions in Mexico. According to estimates, between 6,000 and 9,000 people visit the library every day. In a country where the average reading rate of the population is just three books per year, the Biblioteca Vasconcelos is a key ally in the struggle for better education and future prospects. It has put down strong roots for literacy to flourish.

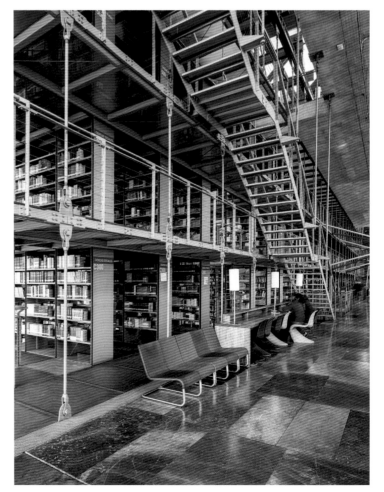

The huge glass façade means that the library requires almost no artificial lighting during the day. All around glints the lush greenery of the library's garden, where an abundance of native Central American plants thrive.

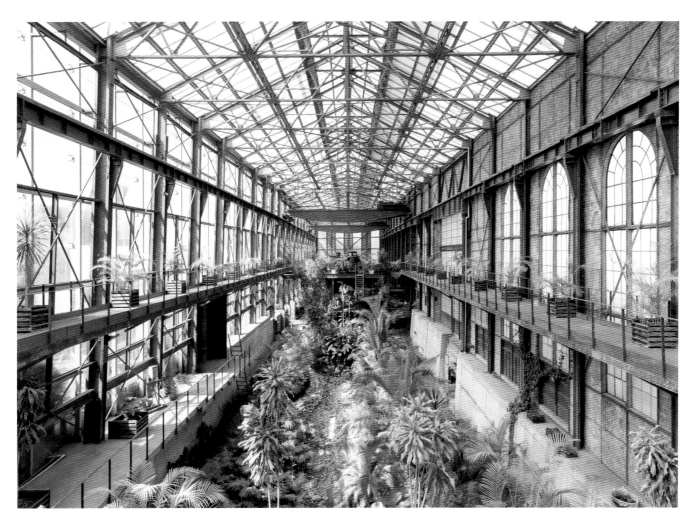

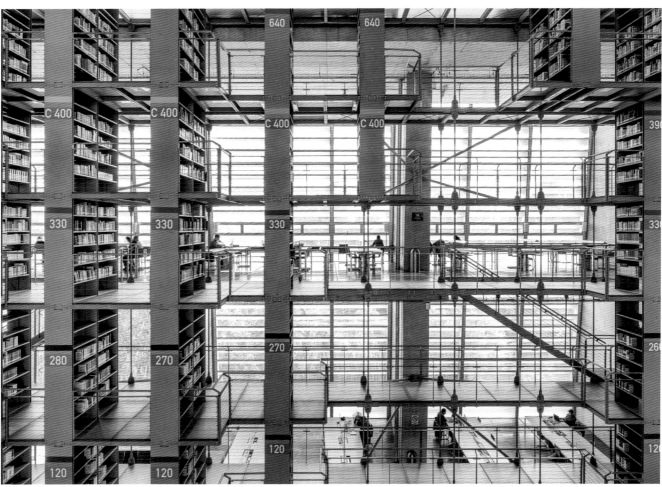

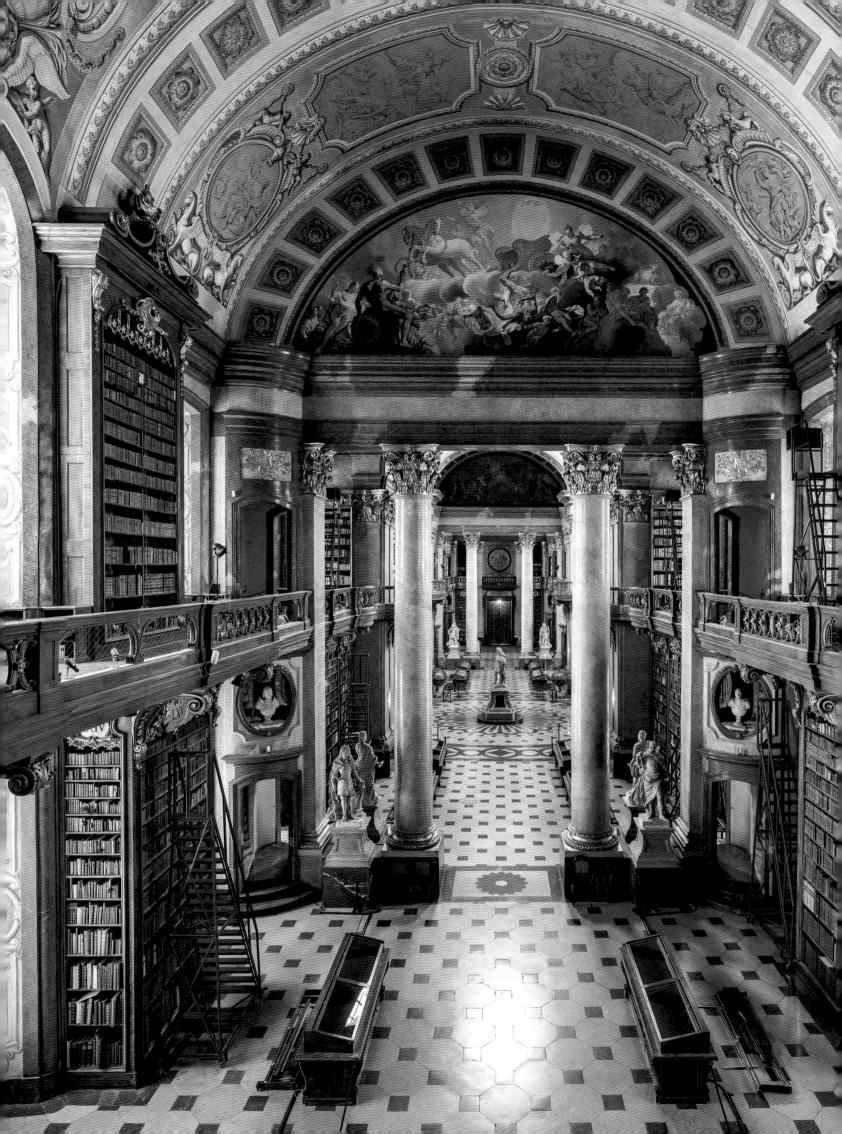

AUSTRIAN NATIONAL LIBRARY

Emperor Charles VI was a fan of both books and secular Baroque architecture; this is the remarkable result

DESIGNED BY JOHANN BERNHARD FISCHER VON ERLACH
BUILT 1723–1726
VIENNA, AUSTRIA

One of the key tasks of any national library is to preserve copies of all writings published or produced in the country in question. Some of Austria's books have really hit the jackpot—stored for posterity in the magnificent hall of one of the world's most beautiful national libraries. An exquisitely decorated, 30-meter-high (98-foot-high) dome and the finest frescoes look down on over 200,000 publications from this mountainous country. They include the extraordinary collection of Prince Eugen, whose 15,000 books in red, yellow, and blue Morocco leather bindings are displayed in the central oval of the hall. Emperor Charles VI, a famous bibliophile, commissioned the construction of the former court library in the 18th century. No expense was spared when it came to his collection of books. The fine walnut shelves, elaborate gold decoration, and statue of the emperor in the middle of the hall reflect the ruler's love of books; this was a man, after all, who filled a whole wing of his imperial residence with them.

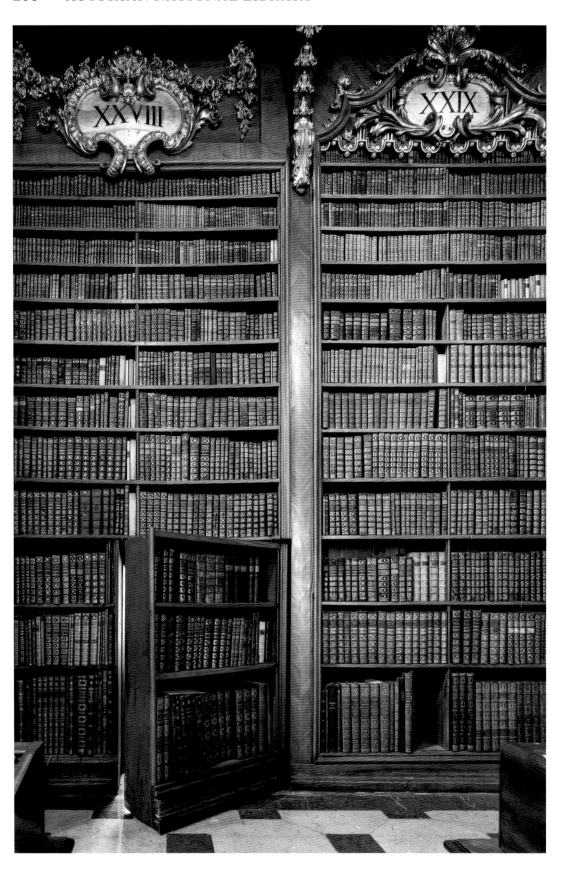

Hidden doors famously lead to thrilling stories! As the Austrian National Library holds a copy of every book published in Austria, there's every chance that a few crime thrillers are concealed behind this moving bookcase.

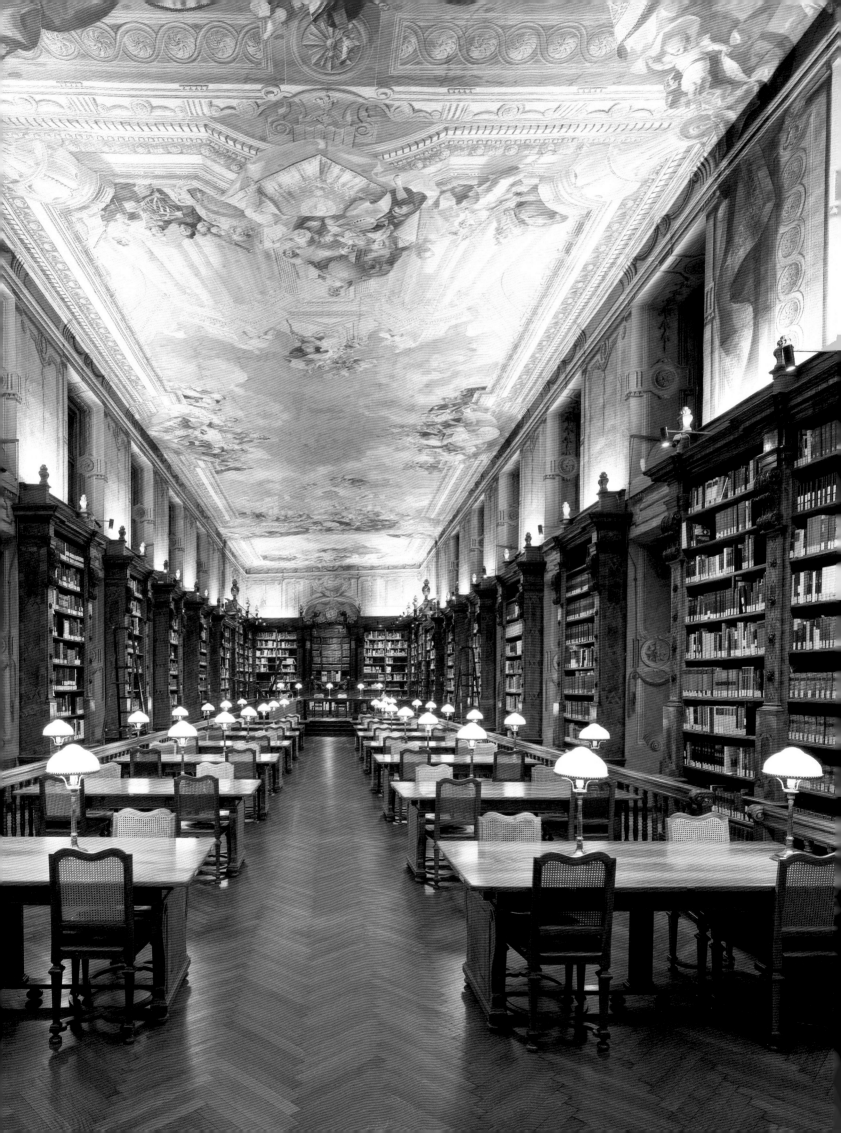

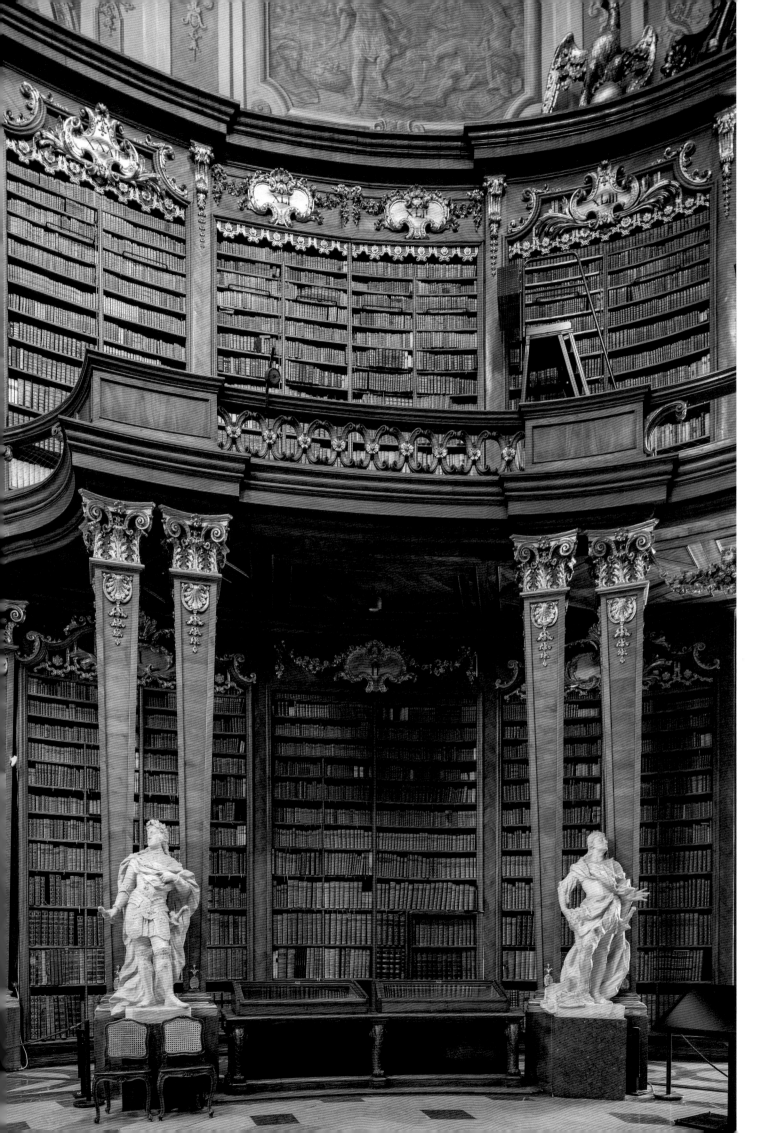

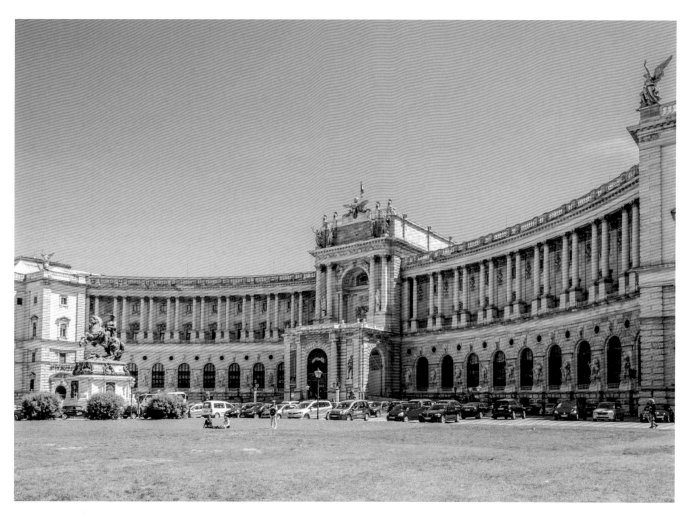

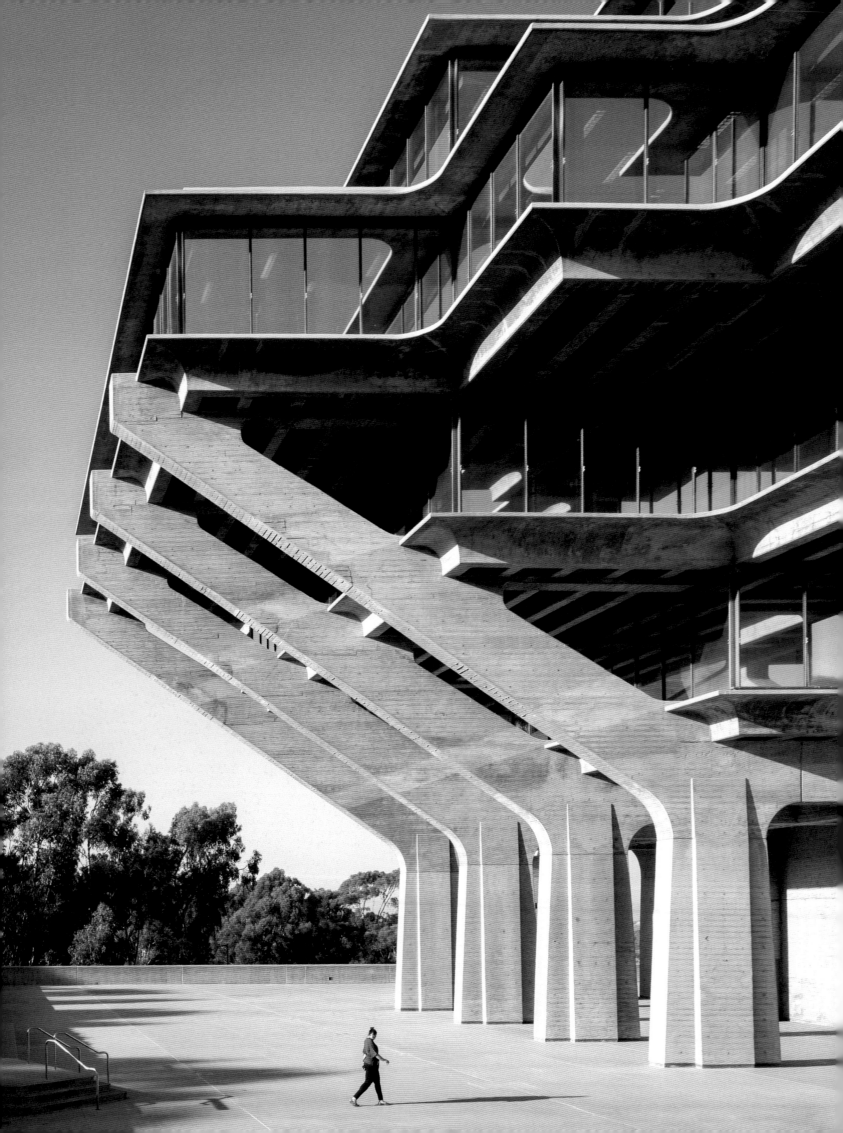

GEISEL LIBRARY

What do The Grinch *and this iconic Brutalist building in California have in common?*

DESIGNED BY WILLIAM PEREIRA
BUILT IN 1970
SAN DIEGO, CALIFORNIA, USA

The Geisel Library on the campus of the University of California, San Diego, has all the appearance of something beamed down from space in a sci-fi movie. American architect William Pereira designed the uncompromising, Brutalist building in the mid-1960s, having conducted countless studies of university libraries across the country. His observations of incident light, the arrangement of books, and natural walkways all informed the look of his library. Inside, the long bookshelves are spread over eight floors. With shrewd foresight, Pereira included two basement floors with the intention of housing the library's growing inventory. The

Geisel Library stands at the heart of the campus, overlooking a miniature gorge. It is named after Theodor Geisel, who wrote many beloved children's books—including *The Grinch*—under his pen name, Dr. Seuss. He and his wife Audrey bequeathed a generous sum to the library, plus something of incalculable value: his entire archive.

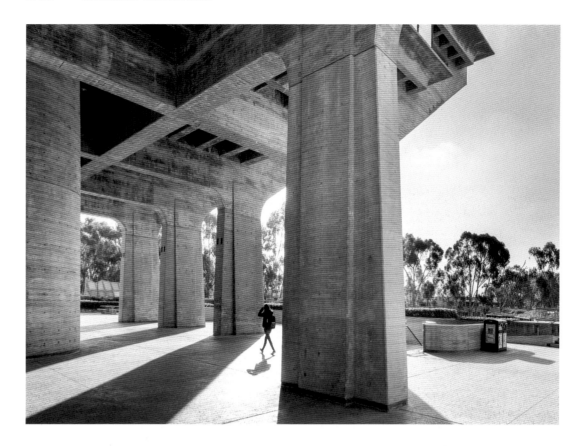

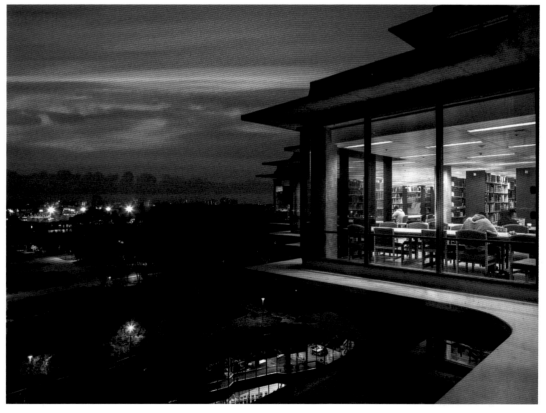

As in so many of his works, Pereira's Geisel Library is a combination of Brutalist and futuristic elements. Its unusual shape and mix of concrete and glass give it a sense of solidity, while also appearing to float.

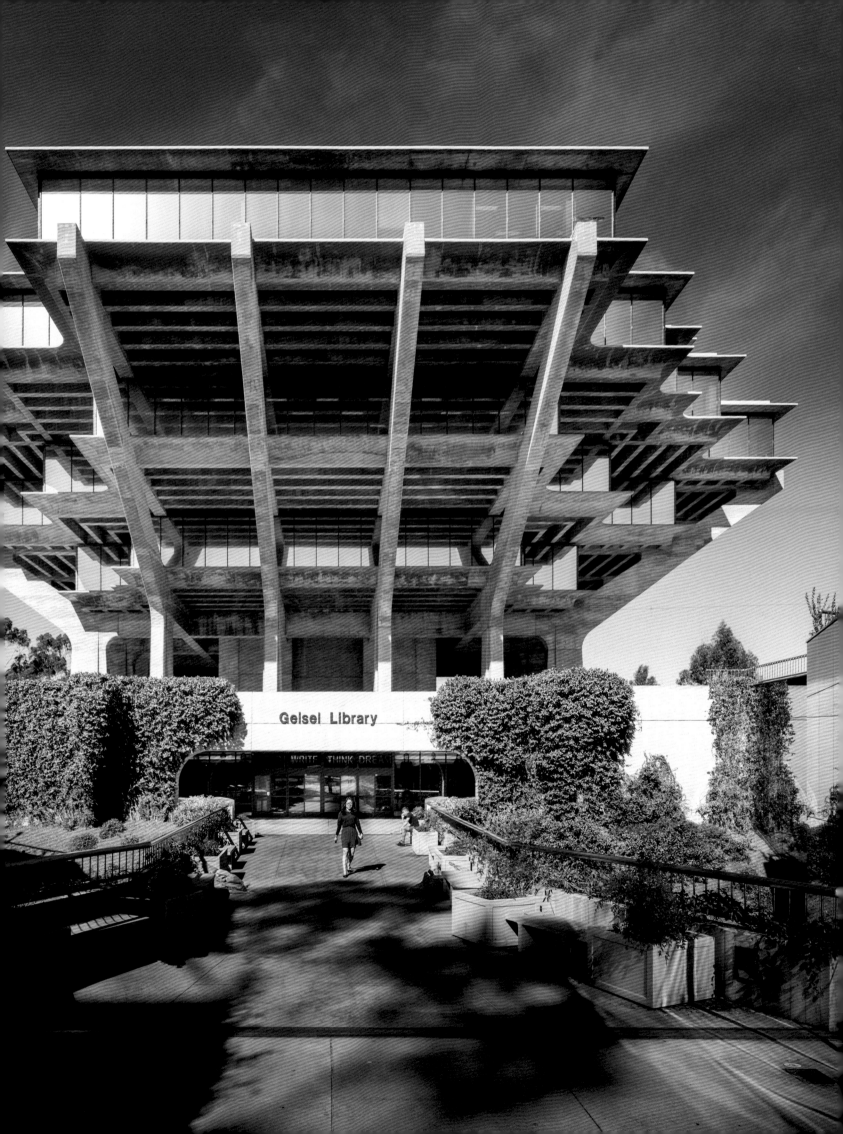

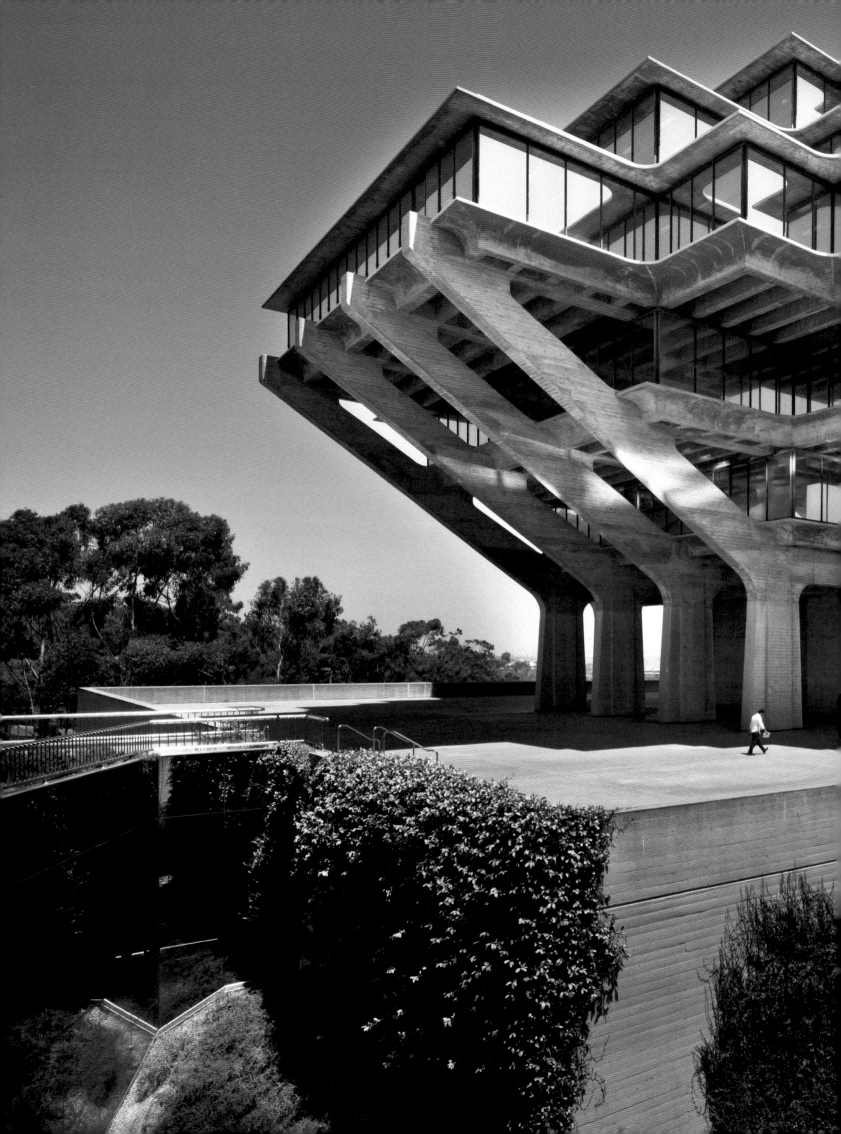

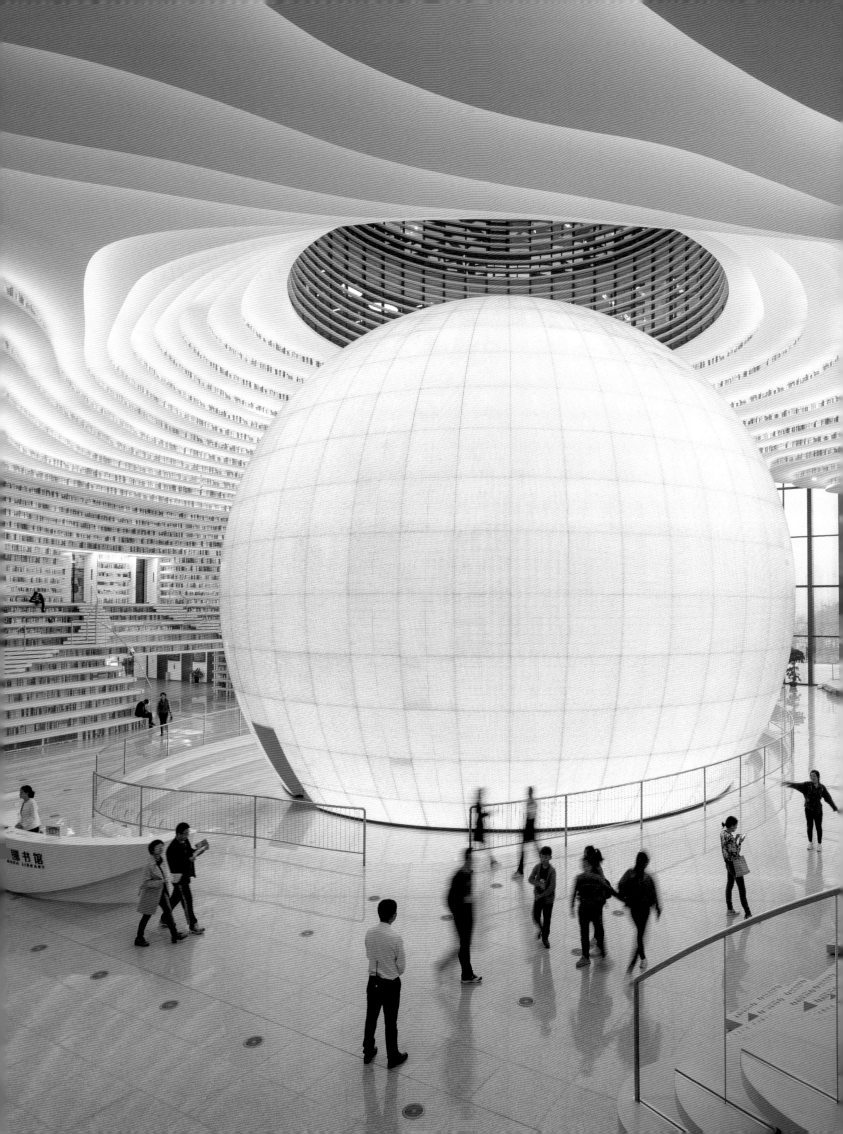

TIANJIN BINHAI LIBRARY

A futuristic new addition to one of the oldest libraries in China

DESIGNED BY MVRDV
BUILT IN 2017
TIANJIN, CHINA

Dutch architects Winy Maas, Jacob van Rijs, and Nathalie de Vries are known for their experimental designs. Their studio, MVRDV, combined form and function to perfection in the remarkable Binhai Library for the Chinese port city of Tianjin. The enormous ball at the heart of the building glows like an all-seeing eye. Its reflective surface makes the surrounding atrium seem even vaster. An auditorium is hidden away inside the sphere. The futuristic building was inaugurated in 2017 as part of Tianjin Municipal Library, one of the oldest public libraries in China. The shelves, which offer space for 1.2 million books, are gradually filling up; realistic photos of book spines are used in the empty spaces for now. On the upper floors, the architects installed an audio area, digital labs, more reading rooms, and several conference rooms. And this is the perfect spot for the project: a new cultural district is currently taking shape all around Tianjin Binhai Library.

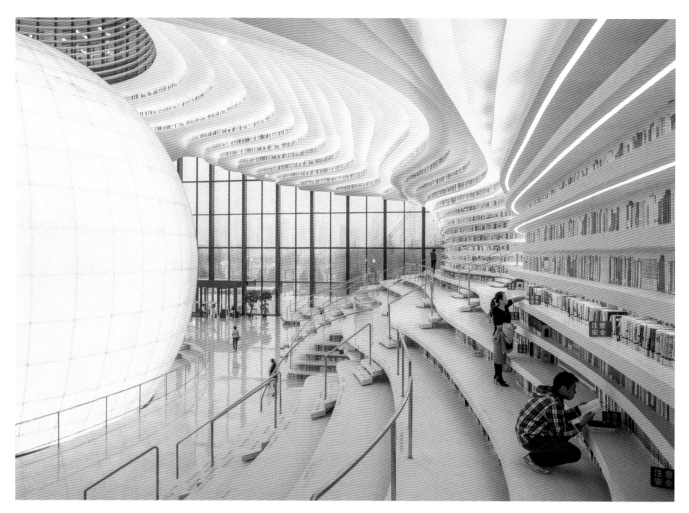

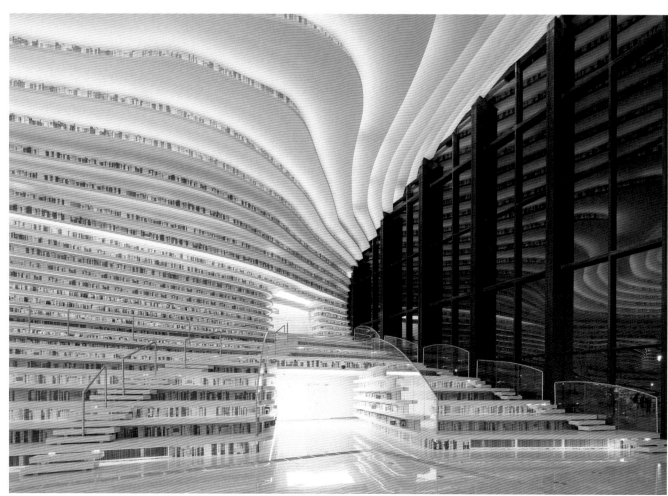

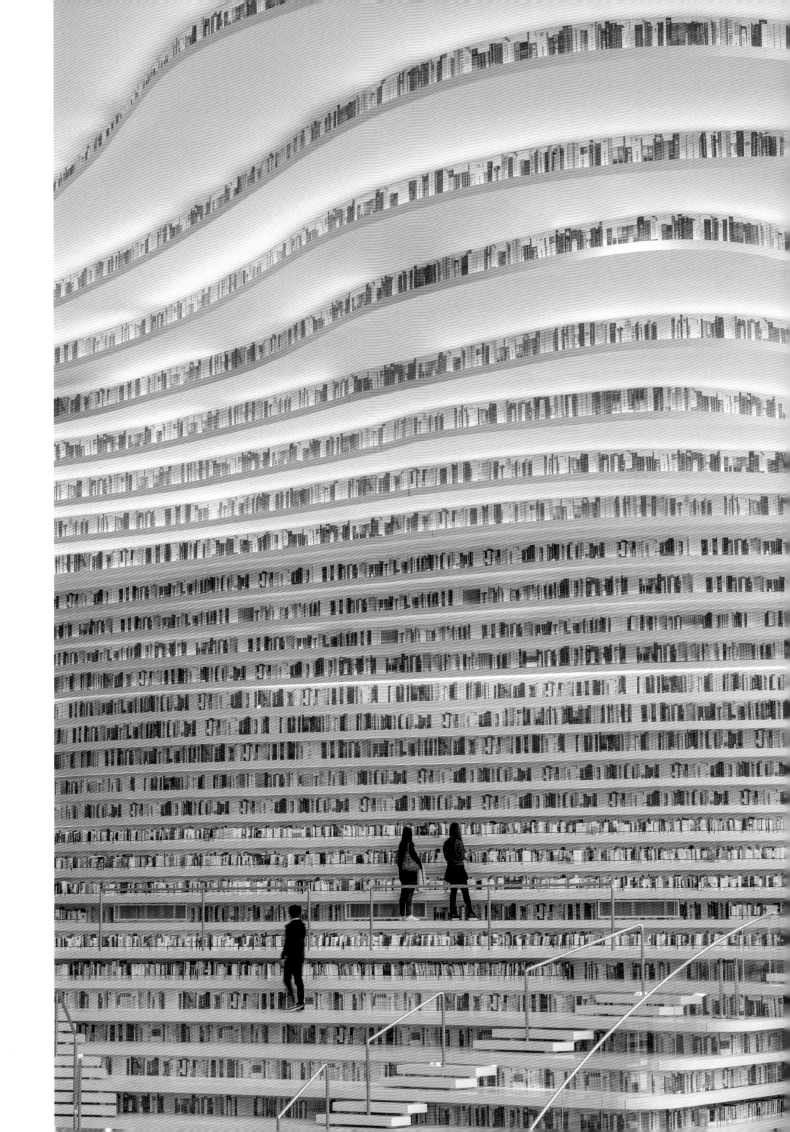

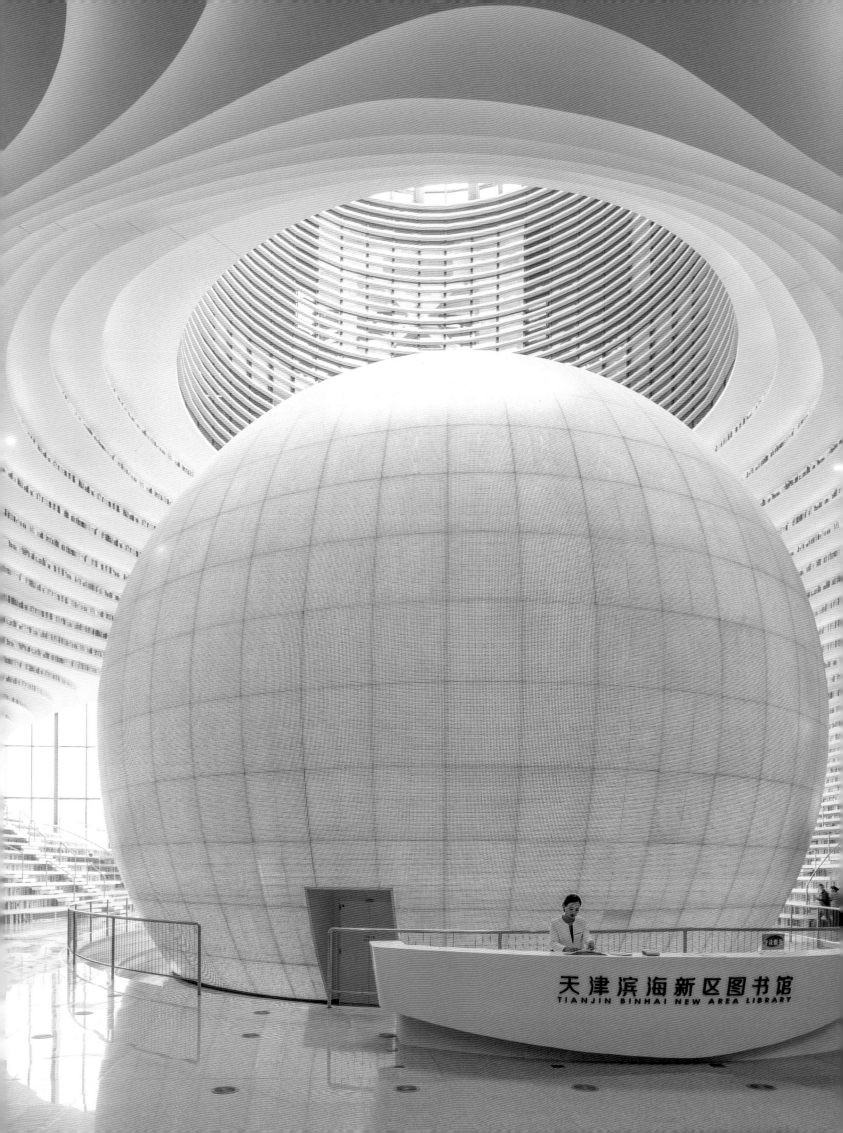

天津滨海新区图书馆
TIANJIN BINHAI NEW AREA LIBRARY

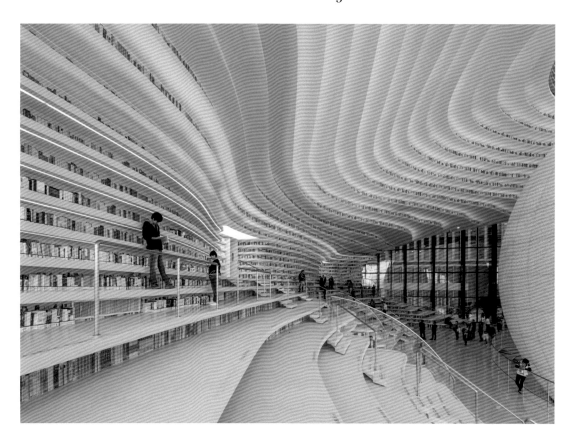

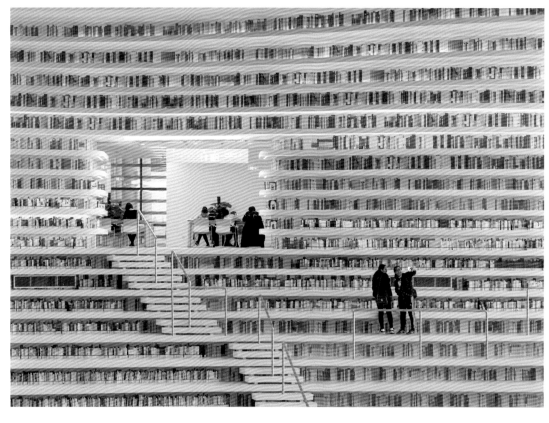

It took just three years to go from the initial draft sketches to the opening of the library. Due to time constraints, access to the uppermost bookshelves has not yet been provided, contrary to the architects' plans.

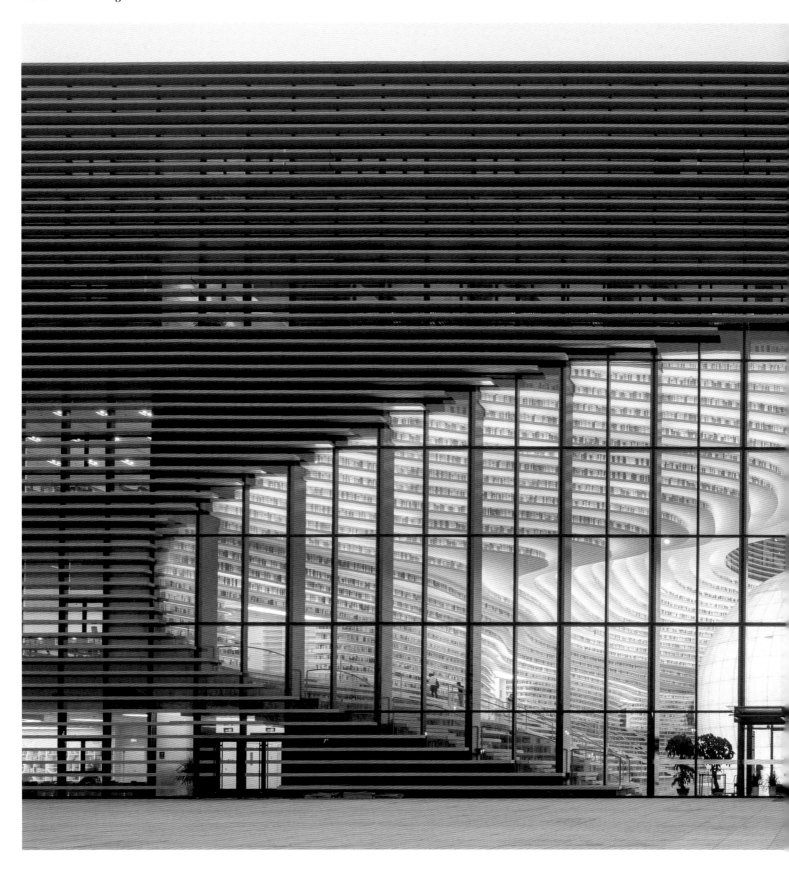

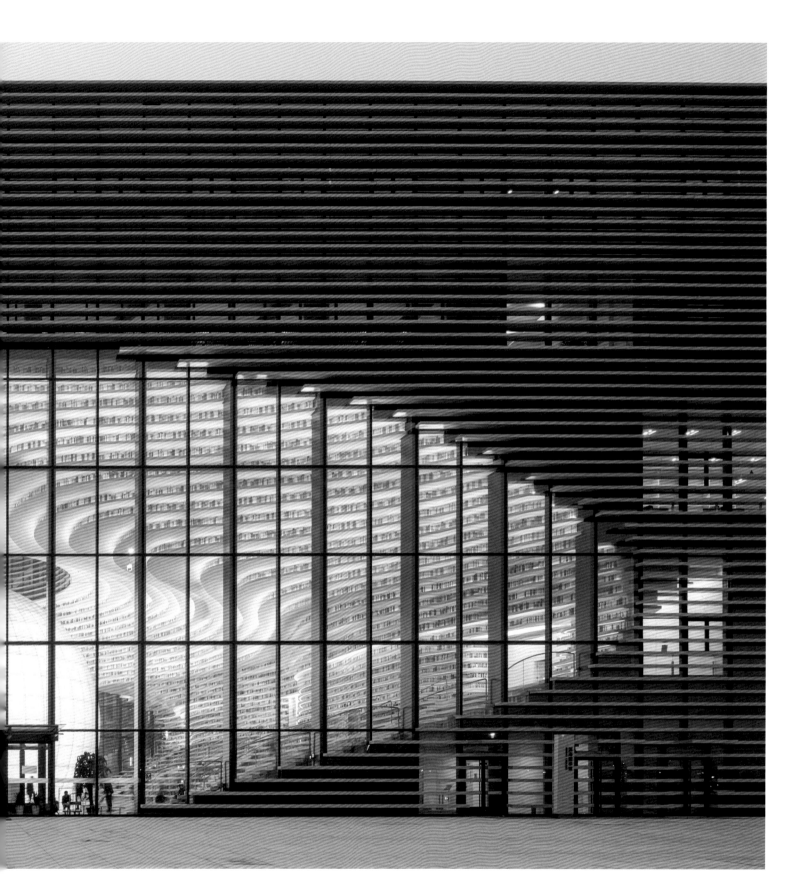

TRINITY COLLEGE LIBRARY

It is hard to imagine a better resting place for the 1,200-year-old Book of Kells than this library

DESIGNED BY THOMAS BURGH
BUILT 1712–1732
DUBLIN, IRELAND

The Long Room is far and away the most important part of the library at Trinity College, which was founded in the late 16th century. Despite its modest-sounding name, the view down this 70-yard treasure chamber is utterly breathtaking. Beneath the vaulted wooden ceiling, busts of figures from Isaac Newton to Aristotle watch over the tall bookshelves, which extend across two levels. The Long Room owes its present-day appearance to major renovations in the 19th century, which freed up much more space for the university's growing collection. Today, the 200,000 oldest books of the library's total of six million volumes are stored here. The other publications are spread across five large buildings. The most valuable item in the collection is the Book of Kells, with the four Gospels inscribed in elaborate script and illustrated with vivid images. After a turbulent journey over the centuries, the 1,200-year-old book is now safely stored in this incredible library. Visitors can marvel at two original pages from the priceless tome in a display case on the ground floor.

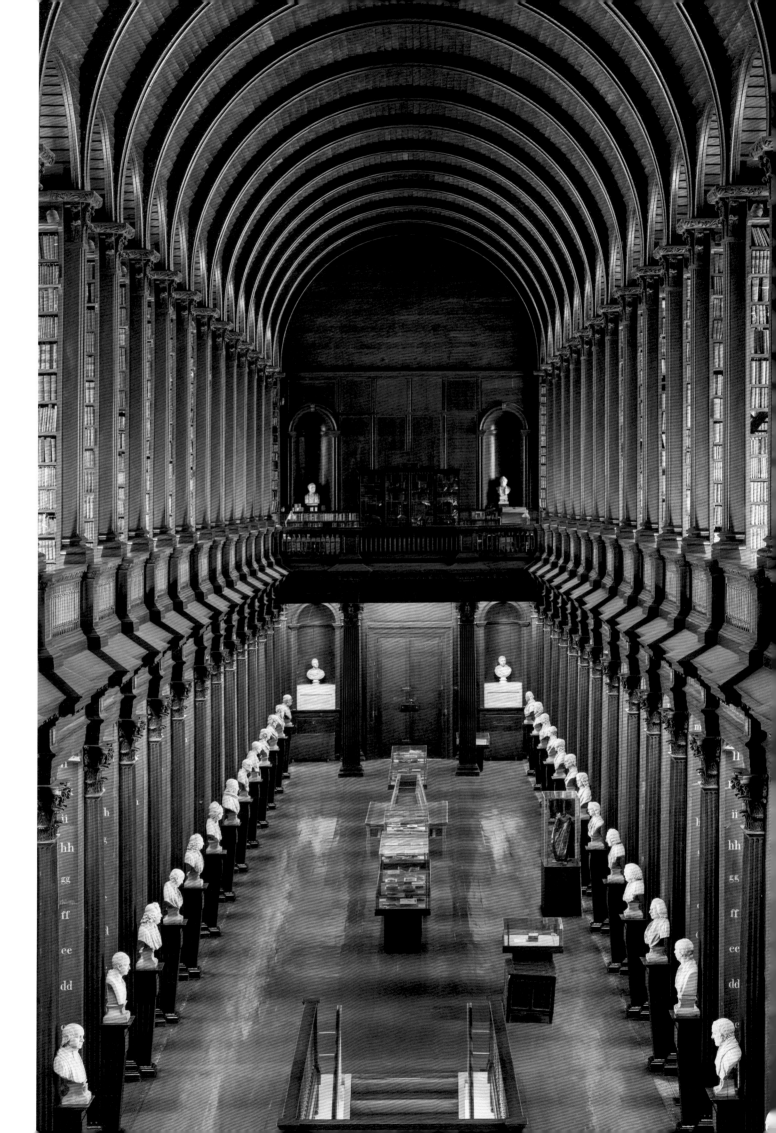

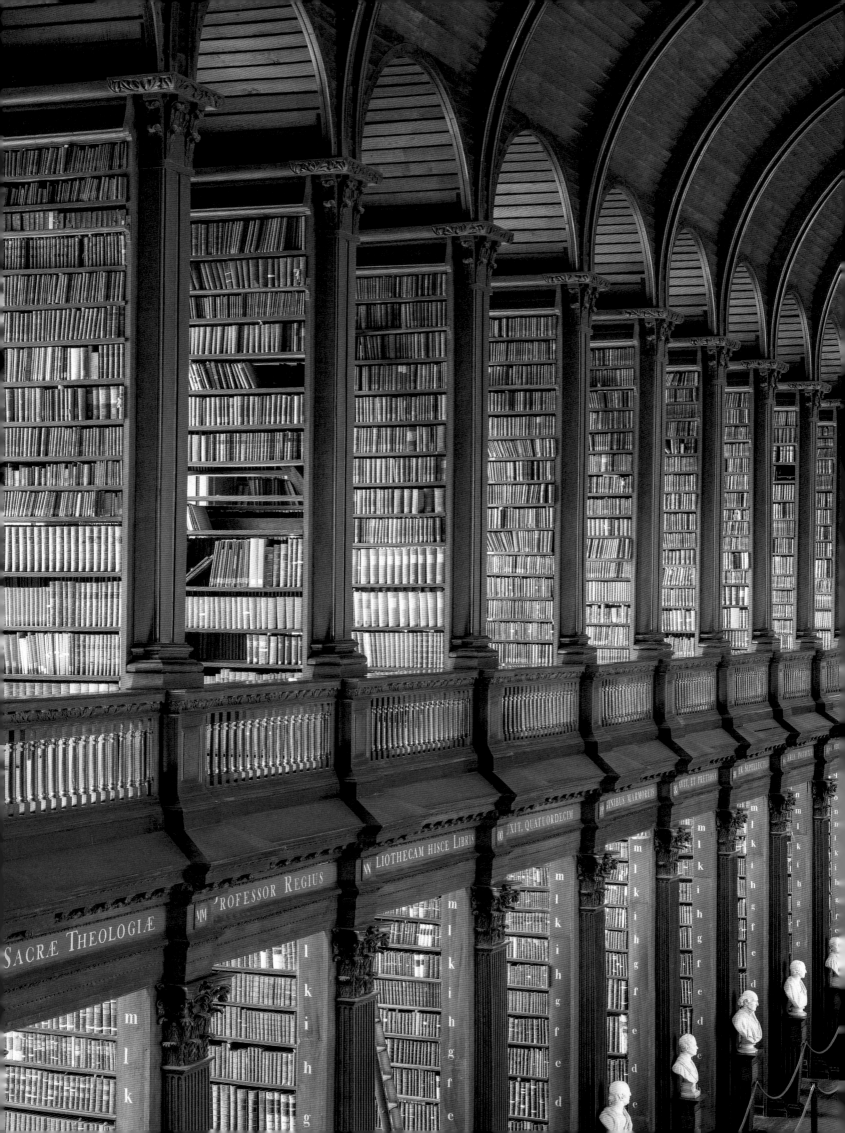

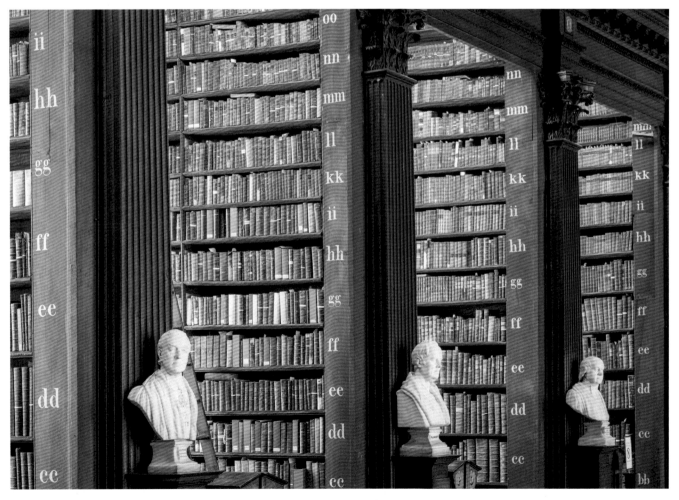

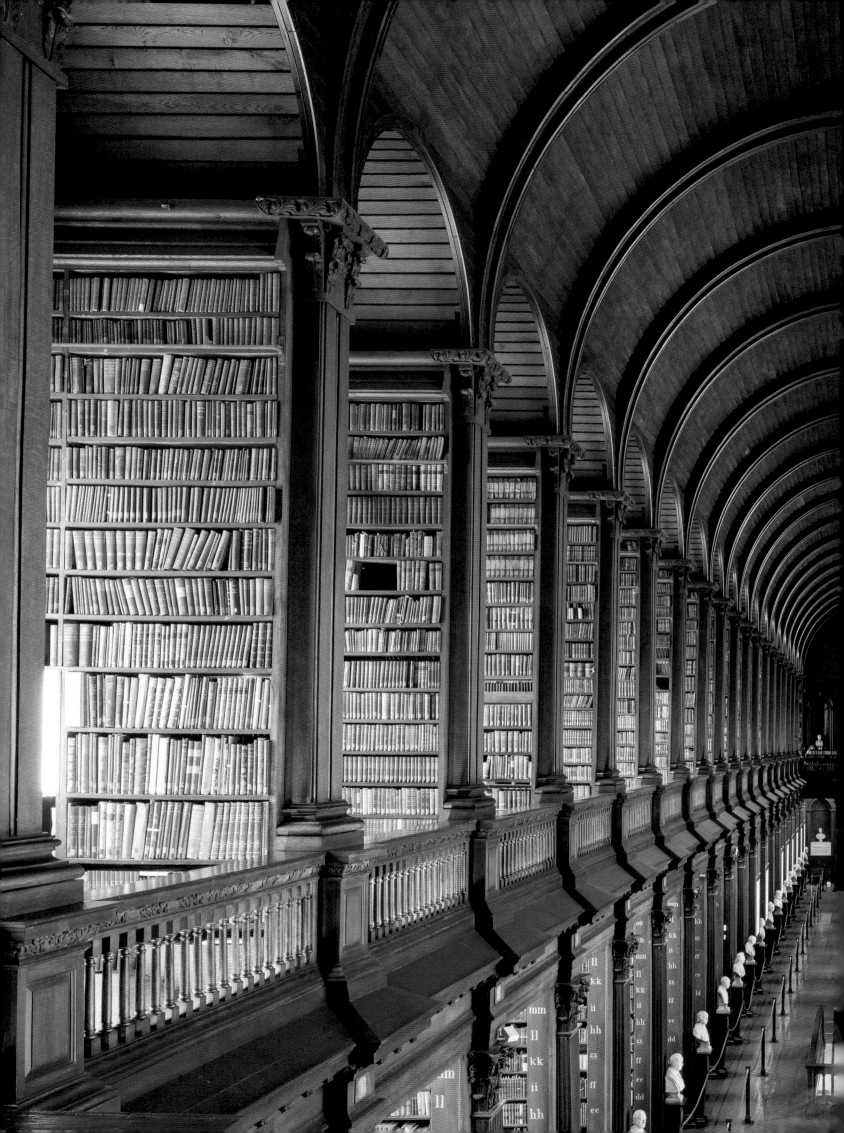

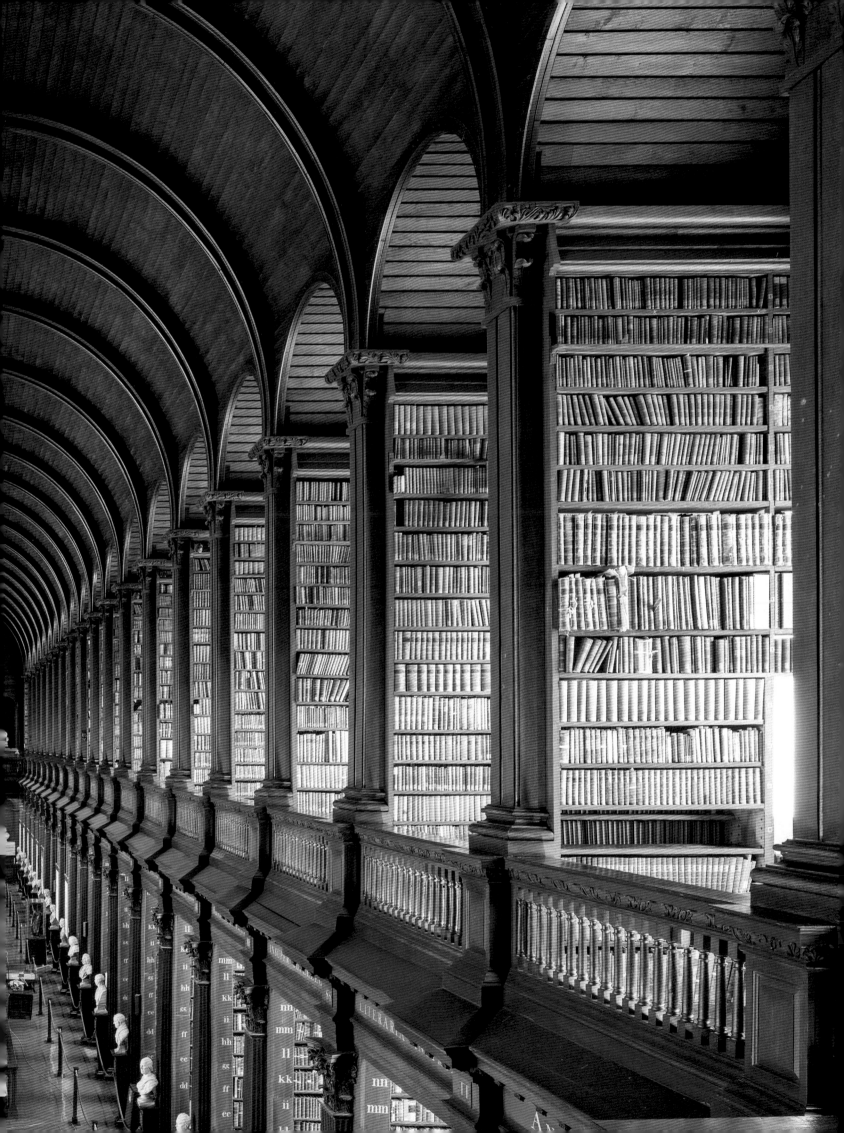

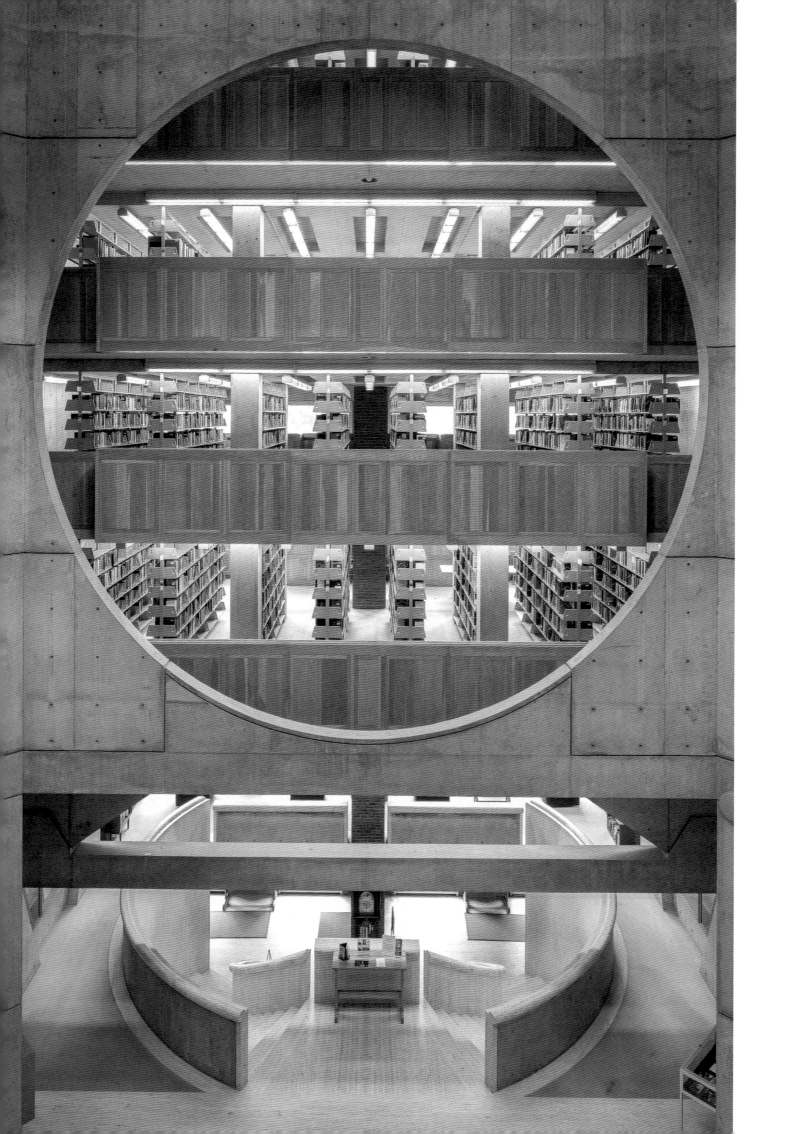

CLASS OF 1945 LIBRARY

DESIGNED BY LOUIS KAHN
BUILT 1965–1972
EXETER, NEW HAMPSHIRE, USA

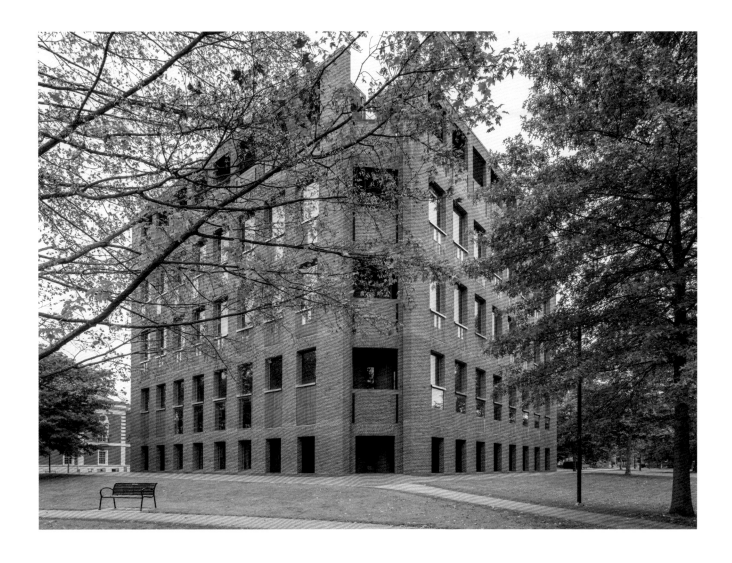

What happened when an architect was commissioned to design an inspiring, learning-friendly library for students at a private high school

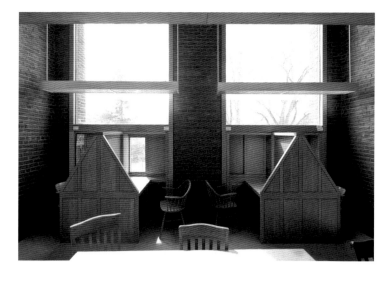

School libraries have an important job to do, as the wells of learning from which future leaders, mothers, fathers, founders, and role models will draw. The more inspiring they are, the more effectively they can impart the knowledge that lies within. Since it was founded in 1781, Phillips Exeter Academy has been renowned as one of the top private high schools in the United States. Its alumni include Nobel Prize winners, Olympic athletes, senators, and some of the most famous figures in global business. When the school's library started to outgrow its premises in the 1960s, U.S. architect Louis Kahn was commissioned to design a new building. The result was one of the most spectacular school libraries ever to be constructed.

"No matter where one is within the Class of 1945 Library, in stillness or movement, and in which direction one's gaze, one comes upon all kinds of thresholds, interstitial gaps and geometric openings, slices of light and rich gradients of shadow, provocative framings and obstructions," says Jon Sakata, who has taught at the Academy since 1994 and can regularly be found in the library. "Often, the very members or elements that are blocking one's view from a certain perspective form—from another vantage point or station—part of another structural aperture that allow one to see the most 'common' of objects in completely new light."

Sakata asks: "What does this teach us about the value of being able to change one's perspective on things? The obstructions also challenge one to imagine what is on the other side. How integral might obstructions be—not to speak of the imagination—to the process of learning?"

When the library opened in 1972, it was designed to hold 250,000 printed books, a computer lab, and audio and video areas. Today less space is required, as students tend to use their own mobile devices to study,

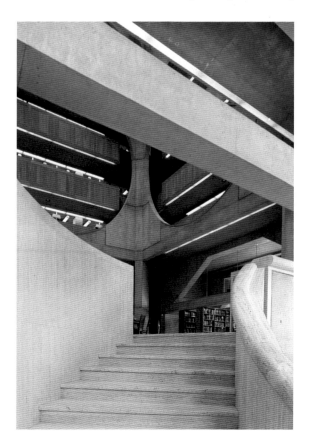

listen to music, and watch videos. The Class of 1945 Library has turned the new situation to its advantage. "In their place we have created spaces that are flexible enough to support activities such as student performances, poetry readings, group projects, club meetings, and large-scale exhibits," says Gail G. Scanlon, who has been the Academy's Librarian since 2011. She adds that the library also has a café and a dedicated Center for Archives & Special Collections.

"The vital element of our mission is to be flexible and respond to the needs of our community," Scanlon says. That has meant, for example, pivoting to acquiring materials primarily in digital formats when the COVID-19 pandemic hit. It has also meant curating exhibits that provide a historic →

The Class of 1945 Library appears by turns frank, mysterious, and highly structured, depending on how you look at it. The viewer's own imagination is key to all this and plays an essential part in any visit to the library.

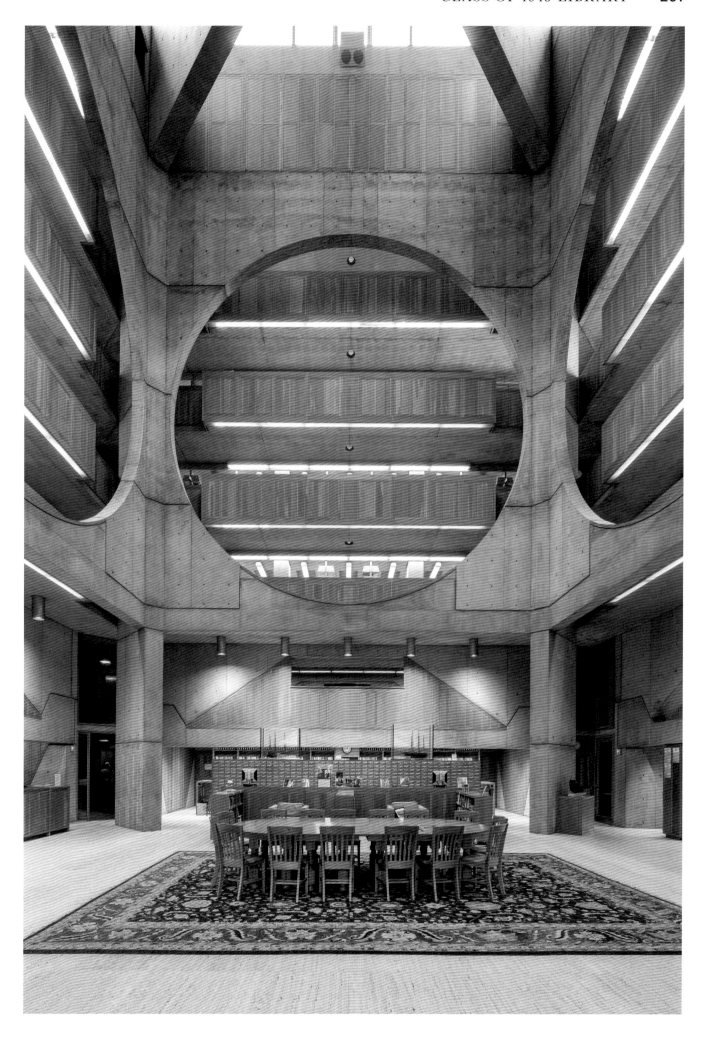

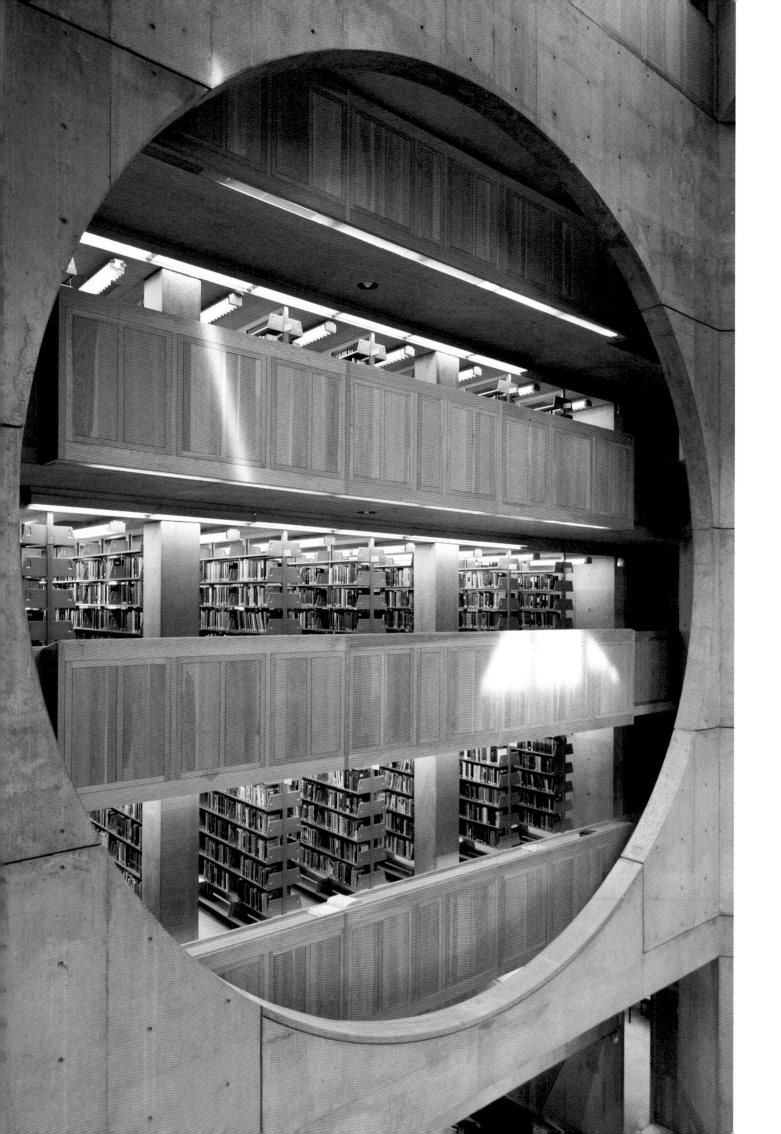

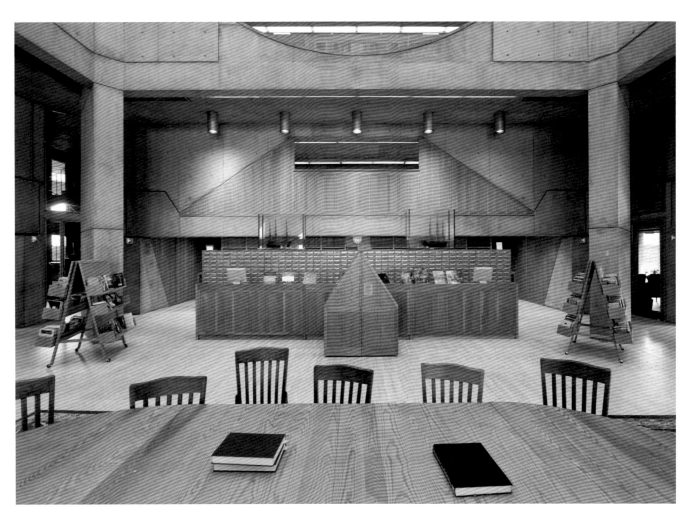

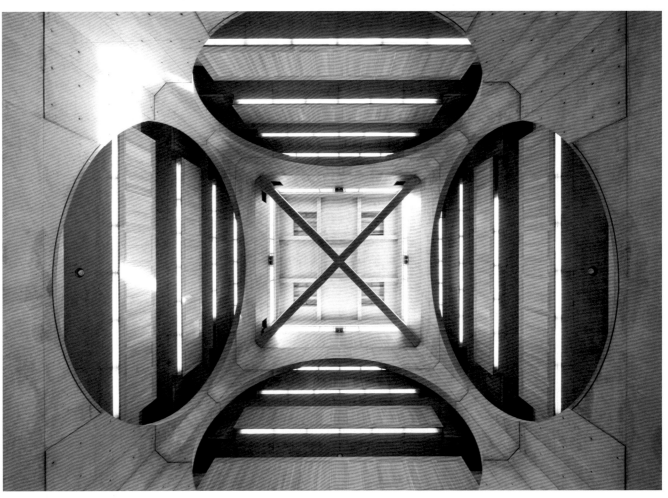

"It has also meant curating exhibits that provide a historic context to systemic inequality, in light of the Black Lives Matter movement and the school's commitment to become an anti-racist school."

→ context to systemic inequality, in light of the Black Lives Matter movement and the school's commitment to become an anti-racist school.

It took almost 15 years from the time of the initial idea for a new library to the final design. Initially, the Academy had only planned to extend the original Davis Library, before thinking better of it. They formed a dedicated committee to come up with a detailed list of requirements for an entirely new building. The idea was to focus not on accommodating books, but on accommodating the readers of those books. This was underpinned by a desire to create an environment that would foster and ensure a love of reading and studying.

Louis Kahn's timeless design fulfilled that mission to perfection. The Class of 1945 Library is laid out in an intuitive way. Kahn paired the typical Exeter bricks with white oak, teak, concrete, and travertine. Form and function come together seamlessly. "Through its very design, the library teaches and inspires us to see, feel, [and] imagine the world *otherwise,* and yet, *clearly,* and perhaps even *clearly anew,*" says Sakata (italics his). "In this way, Kahn has a created a library whose very structure invites curiosity, questioning, fascination, adventure, and puzzling—that is to say, *the library as portal into realms of untold wonderment and discovery.*"

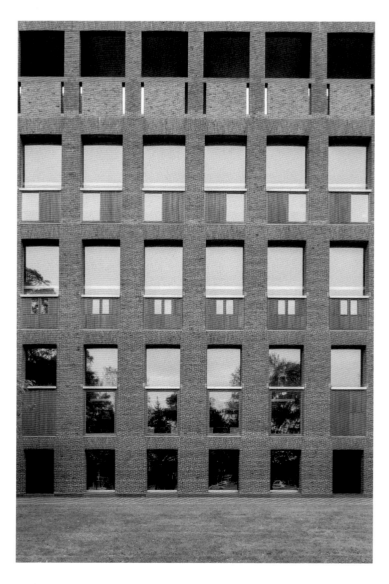

The red-brick façade of the Class of 1945 Library might be likened to an unadorned book cover that doesn't want away to give too much of its story at first glance. The surprises that lie within are all the more rewarding for it.

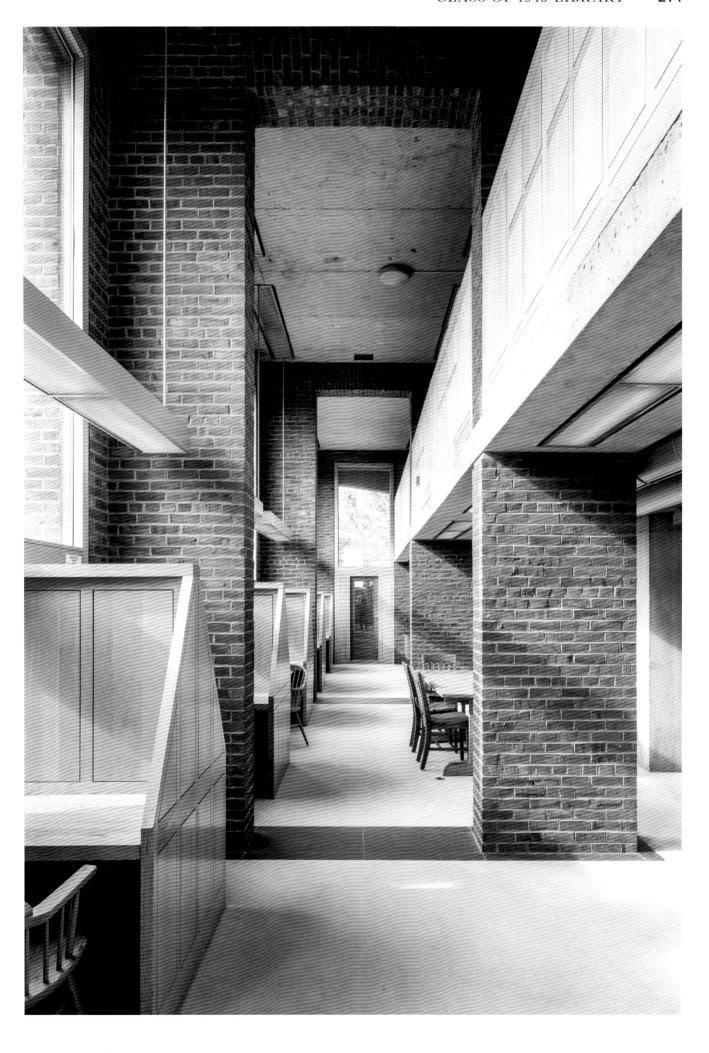

REAL GABINETE PORTUGUÊS DE LEITURA

DESIGNED BY RAFAEL DA SILVA E CASTRO

FOUNDED IN 1837

RIO DE JANEIRO, BRAZIL

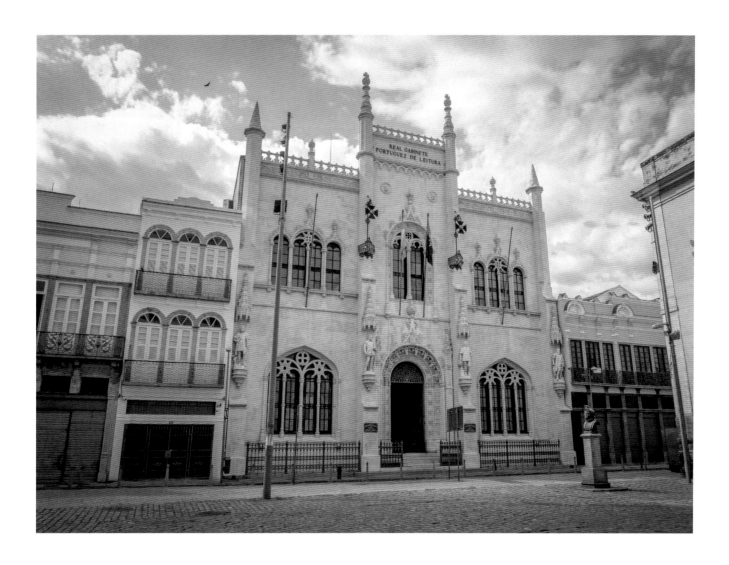

How a Portuguese colonial library served as an anchor point for book-loving immigrants and helped them establish a shared historical culture in their new homeland

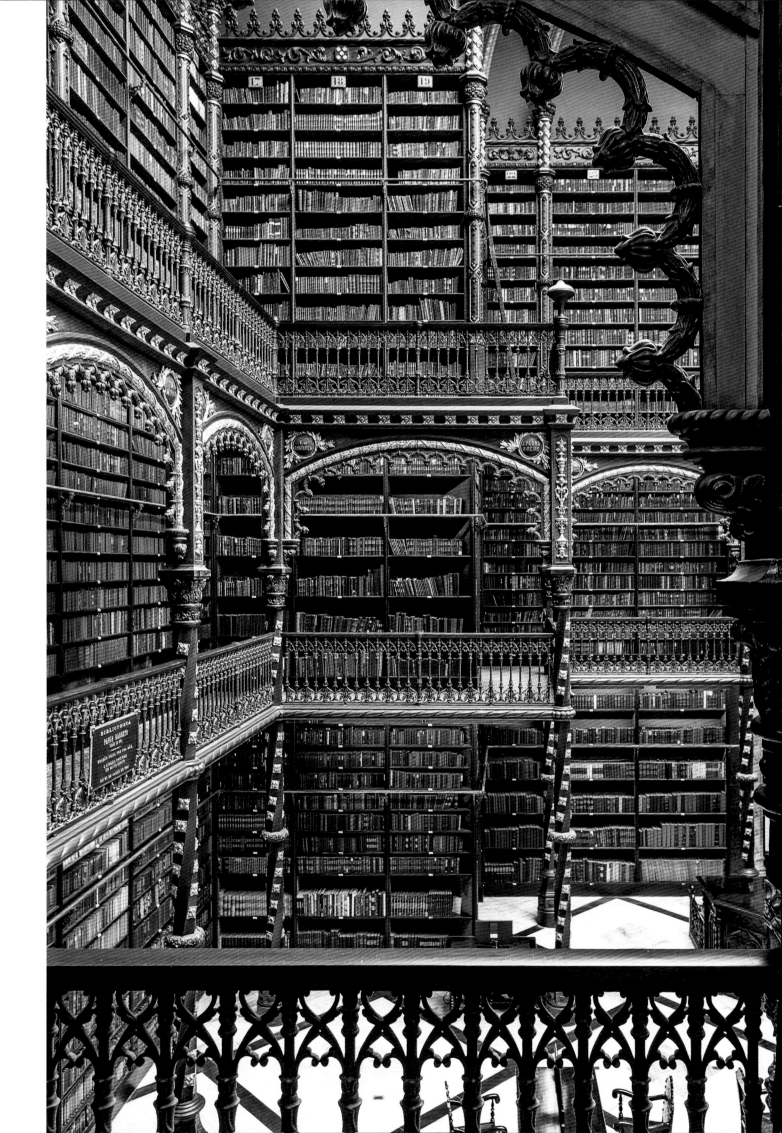

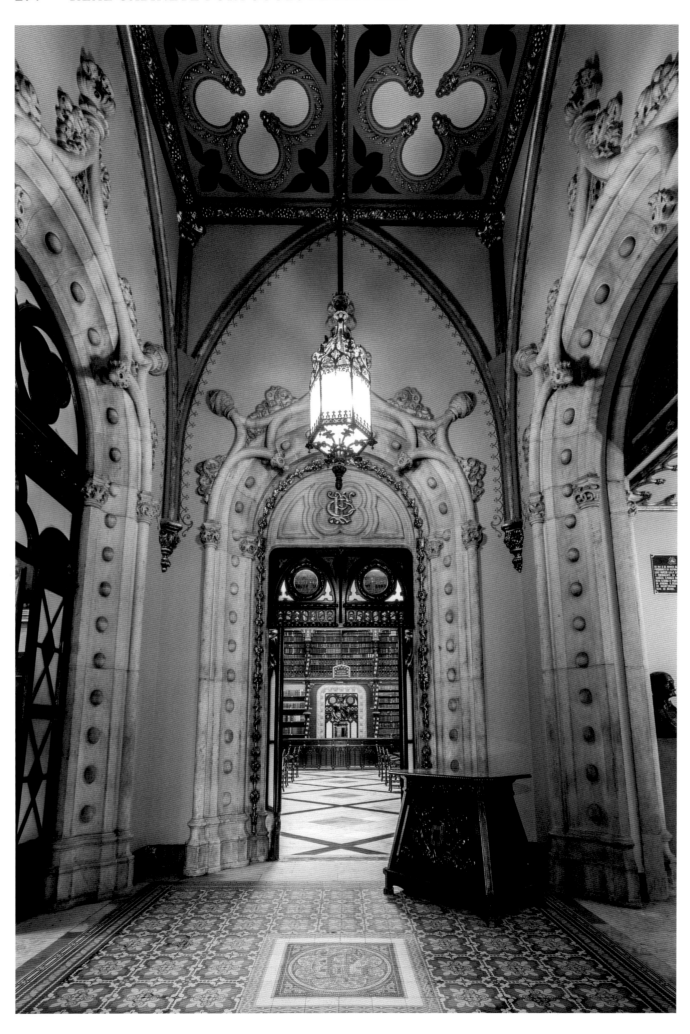

Those who emigrate take more with them than just their luggage. In the 19th century, Portuguese emigrants increasingly began settling in Rio de Janeiro, following some 200 years of colonial history in Brazil. Like the thousands before them, they brought a piece of their own little sphere with them. It was only a matter of time before the first Portuguese library was built, helping recent arrivals put down roots in their new homeland.

"At first, the library was more of an educational institution. In its statutes, the members stated that its purpose would be 'the cultivation of the spirit and advancement of knowledge,'" says Francisco Gomes da Costa, who presides over the Real Gabinete Português de Leitura today. The association, which was set up in May 1837 by 43 founding members, was initially restricted to Portuguese immigrants. "The basic idea was to found a collection for the Portuguese colony. Soon, however, it started to be frequented by Brazilians, too, and ever since 1900, it has been a public library accessible to all."

From the very start, members of the Real Gabinete Português de Leitura would import Portuguese publications, subscribe to newspapers from Lisbon, and invest in valuable books, some of which date back to the 16th century. These valuable volumes include a first edition from 1572 of *The Lusiads* by Portuguese poet Luís de Camões, telling the story of Portugal in verse. For over 50 years, the association moved from one location to another, its collection of books growing all the while, until in the early 1880s, the decision was made to build a central library from scratch. By this time, the number of books had crossed the 50,000 mark. "The library became one of Rio's architectural gems and has gradually morphed into a kind of Portuguese cultural embassy in Brazil," says Gomes da Costa.

The design for the magnificent building that houses the library today was the work of Portuguese architect Rafael da Silva e Castro. The impressive façade was inspired by the Jerónimos Monastery in Lisbon, which is considered to be a masterpiece of the Portuguese Manueline style. Its very stones were made specially in Lisbon and shipped to Rio de Janeiro. A number of statues stand guard at the entrance: the poet Luís de Camões; Henry the Navigator, the Portuguese Infante who initiated and funded many voyages of discovery; Pedro Álvares Cabral, the first Portuguese man to set foot on Brazilian soil; and Vasco da Gama, the explorer who discovered the southern sea route to India. →

Had it not been for Portuguese navigator Pedro Álvares Cabral (left), this library would never have existed. In April 1500, he became the first European to set foot on Brazilian soil and initiate barter trade with the indigenous peoples there.

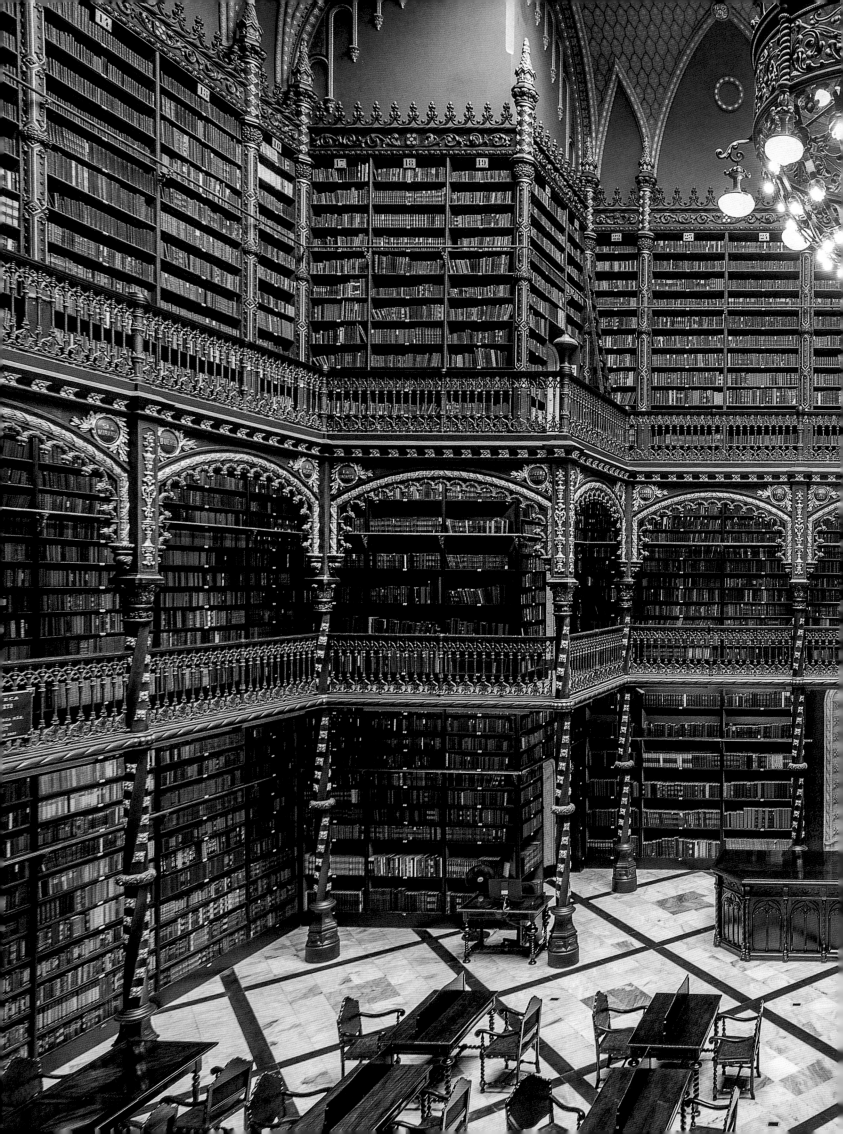

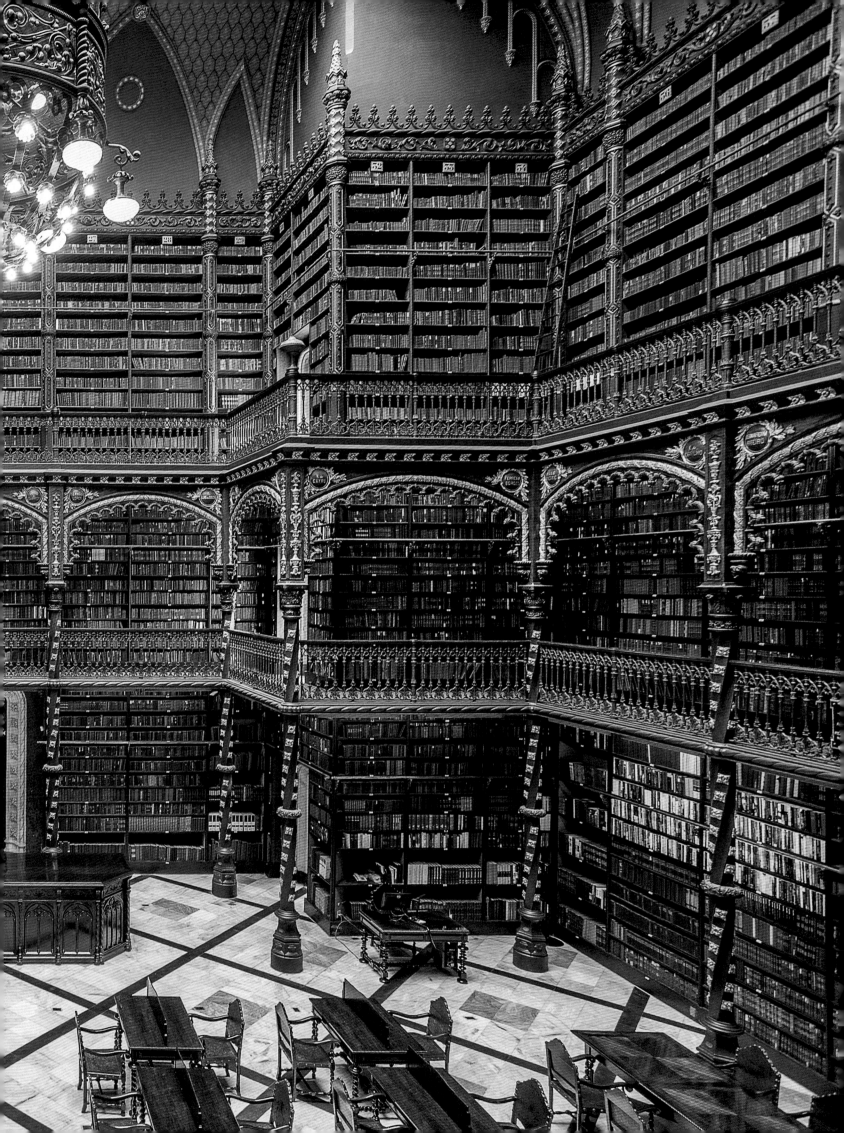

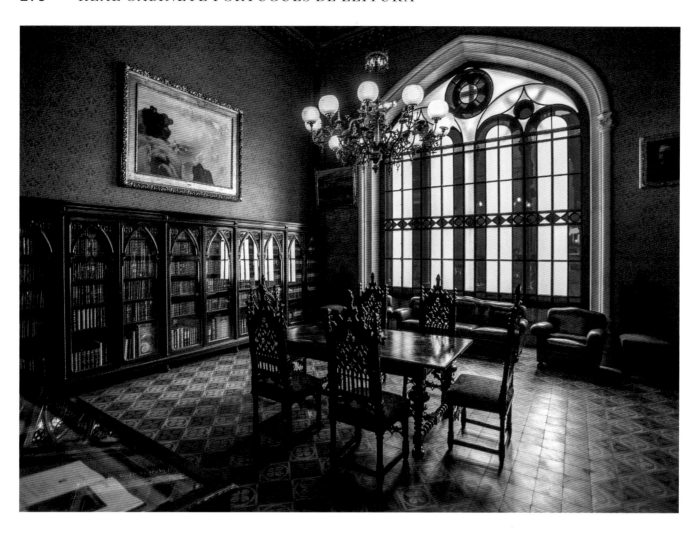

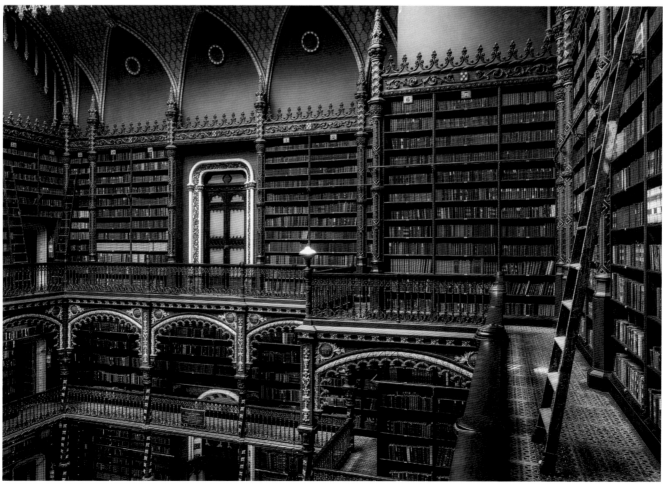

"The basic idea was to found a collection for the Portuguese colony. Soon, however, it started to be frequented by Brazilians, too, and ever since 1900, it has been a public library accessible to all."

→ The neo-Manueline style continues inside the library, in everything from the ornate bookshelves to the stained-glass windows. In the *Salão de Leitura*—the reading room—a sky-light and heavy chandeliers cast the perfect light for perusing books. The room is adorned with paintings and busts. The creation of its ironwork structures also brought Portuguese expertise in statics and construction engineering to South America. "Back then, the Real Gabinete was considered a hub of Portuguese culture in Brazil," says Gomes da Costa. "We are continuing that legacy. Among other things, we've expanded the library to include a study center focusing on the intersection of Portuguese and Brazilian culture. We put on workshops, seminars, conferences, art exhibitions, concerts, and lots of other cultural events there."

Today the Real Gabinete Português de Leitura is the largest Portuguese library outside of Portugal. Its collection of over 350,000 books is fully available in digital versions, and its online catalog is accessible for free. Gomes da Costa makes the most of digitization, uses Zoom video conferencing software, and records videos for his own YouTube channel in the library. As he sees it, every medium has its place here. After all, he says, "our stated mission is to preserve our cultural, historical, and bibliographical collections. They are simply irreplaceable and essential to understanding our common history." That history is one of two cultures enriching each another, and a library that started out as an idea among a small community of expatriates and developed into the pride of the entire country.

The founders of the Gabinete are thought to have been inspired by France, where popular *boutiques à lire* began popping up after the French Revolution in 1789. These boutiques lent out books for a period of time, in return for a small fee. Sounds familiar, no?

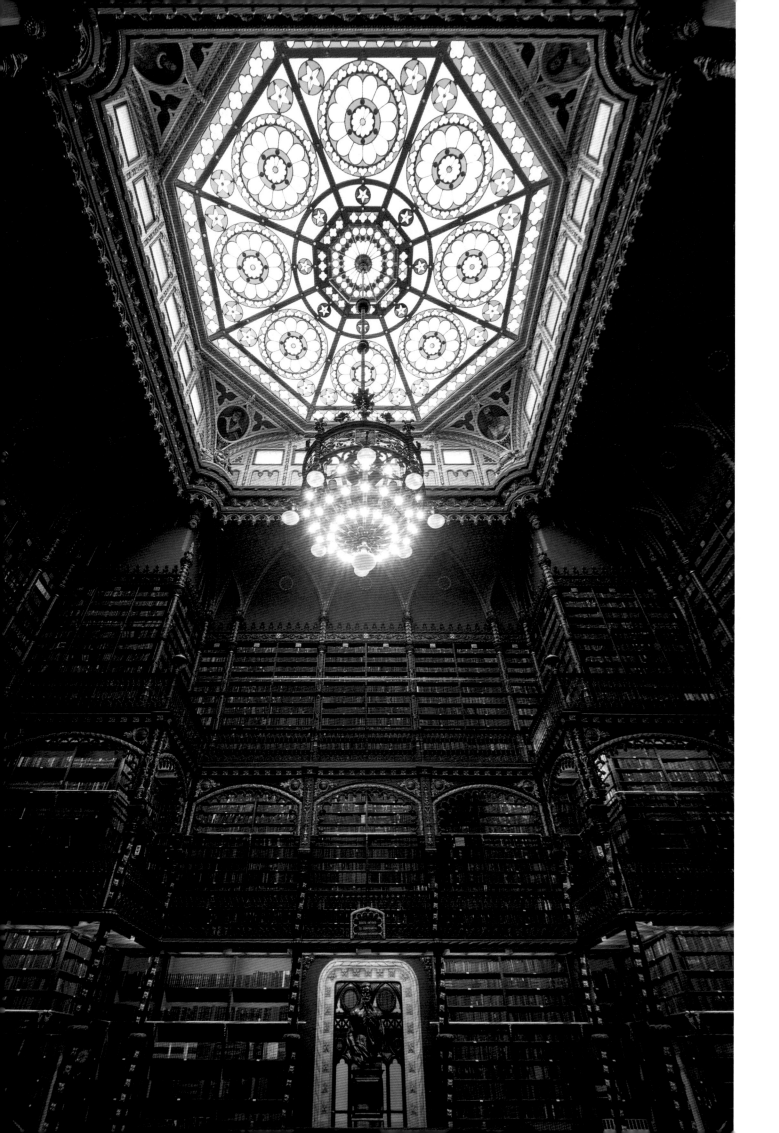

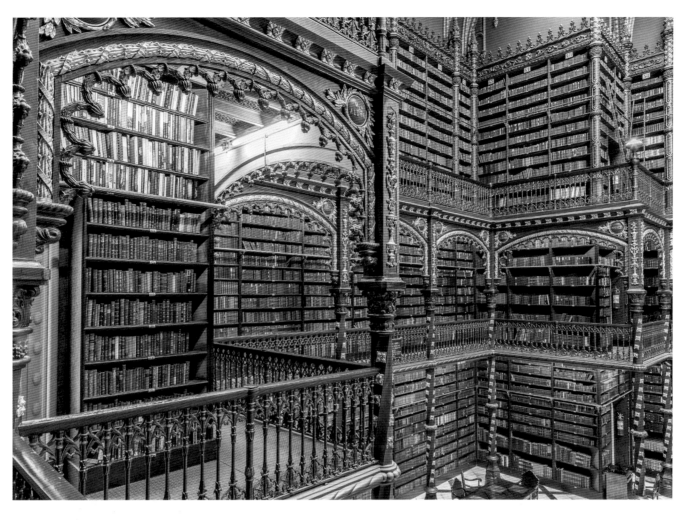

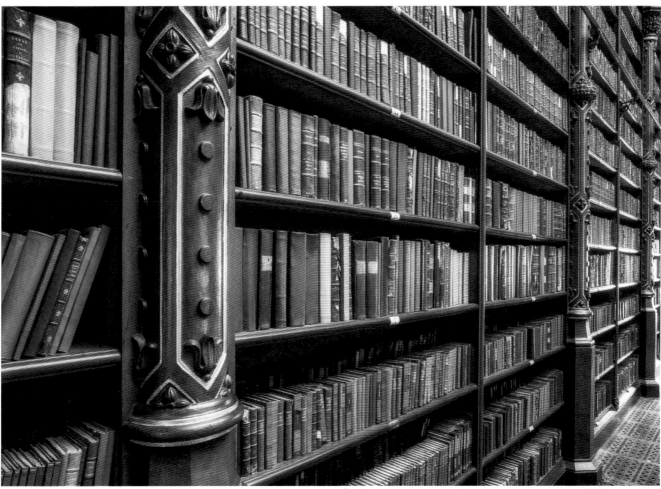

SIR HORACE WALPOLE STRAWBERRY HILL LIBRARY

*The country house library
of an illustrious art collector
and man of letters*

DESIGNED BY HORACE WALPOLE
BUILT IN 1754
TWICKENHAM, UK

"Strawberry Hill is the prettiest bauble you ever saw," wrote Horace Walpole on June 8, 1747, in a letter to his friend Henry Seymour Conway. That was just the beginning: over the next 40 years, the literary figure, art collector, and son of the first British prime minister, Sir Robert Walpole, would go on to convert the house into a Gothic-inspired summer residence. It became an early tourist attraction, too: four visitors from outside were allowed to view the house and its eccentric collections every day. Walpole was a famously good host and sought-after raconteur. He designed his "little Gothic castle," as he called it, mainly in collaboration with his closest friends, who styled themselves "The Committee of Taste." The library at Strawberry Hill was one of the first rooms that this illustrious group of friends decked out with Gothic elements. Walpole worked here on his own novels, some of which he published under a pseudonym, and had copies made on his in-house printing press.

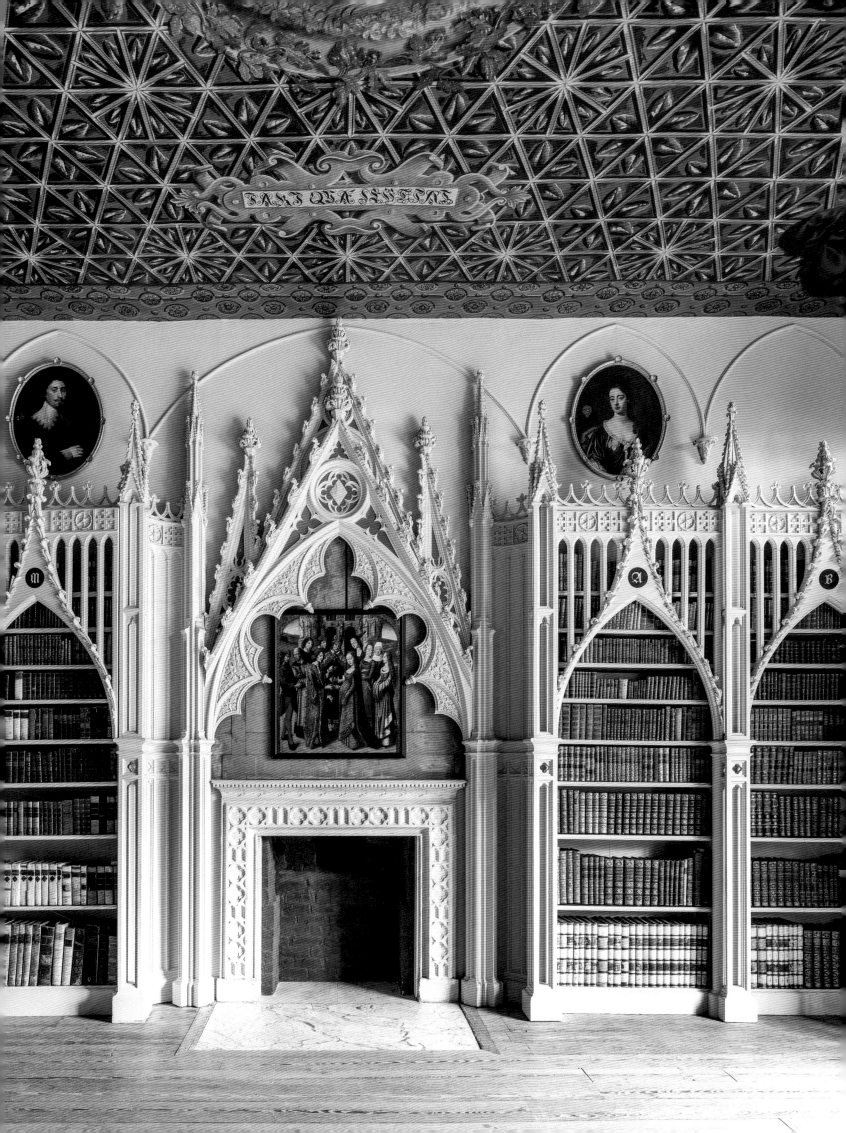

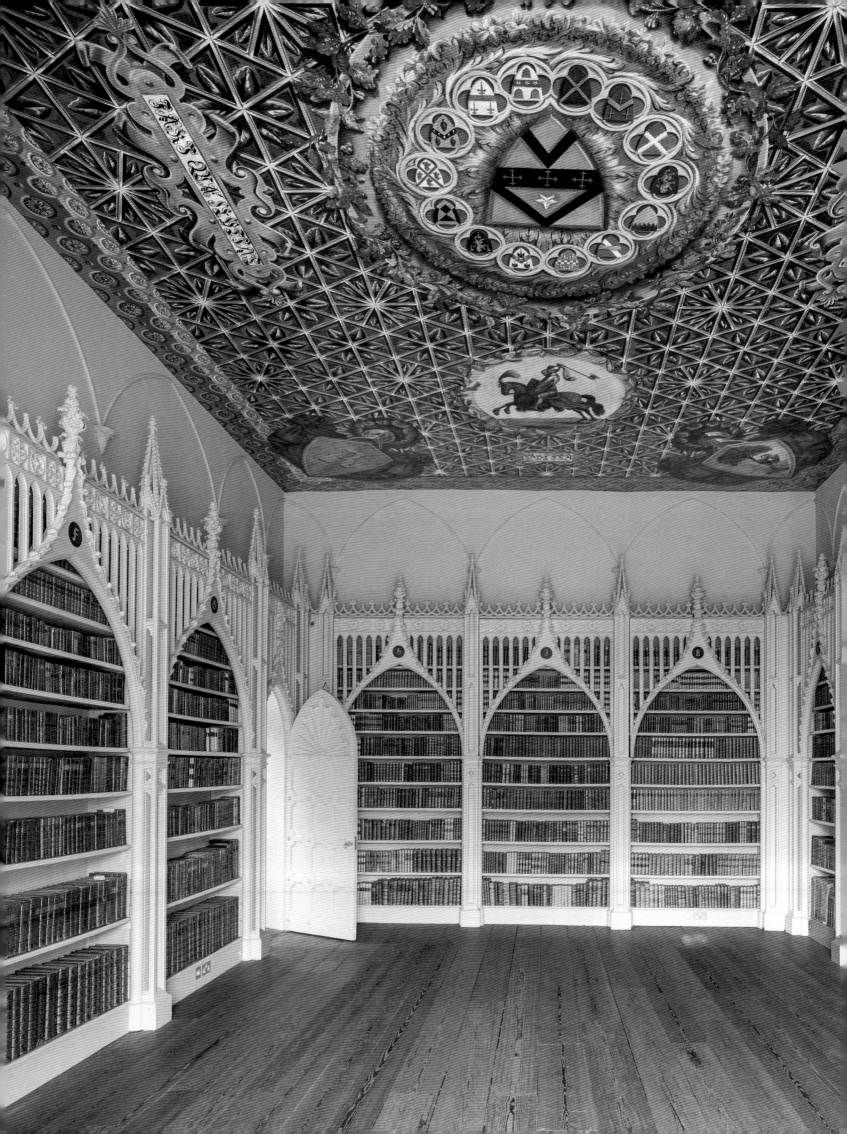

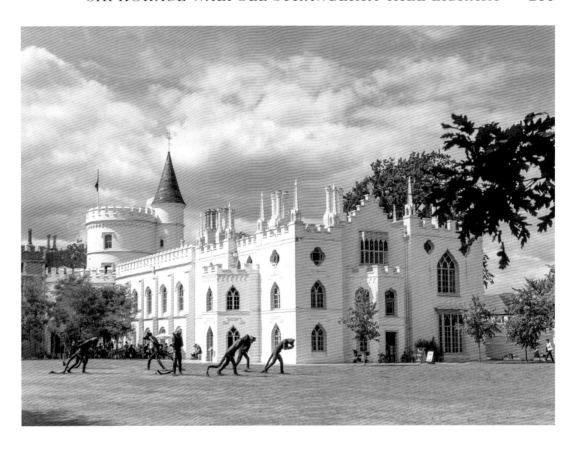

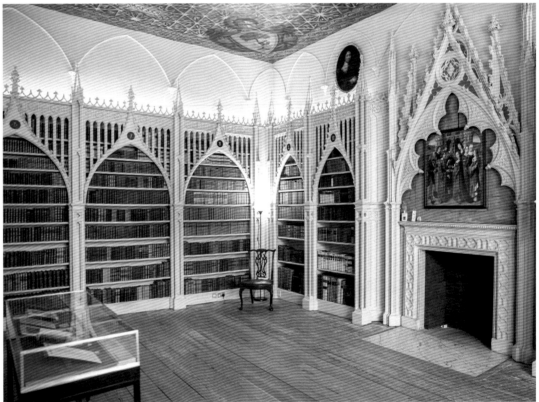

Making the detour to Strawberry Hill is worth it for the library alone. After one of the wonderful private tours, you can visit the café and drink in the views of the gardens, also designed by Horace Walpole.

WIBLINGEN MONASTERY LIBRARY

The "accumulated treasures of wisdom and scholarship" certainly merit a rococo hall of such splendor

DESIGNED BY CHRISTIAN WIEDEMANN
BUILT BETWEEN 1740 AND 1750
ULM, GERMANY

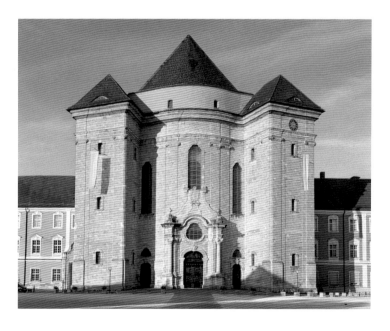

The inscription above the doorway of the magnificent library hall at Wiblingen Monastery probably encapsulates the loftiest goal of any library: *In quo omnes thesauri sapientiae et scientiae.* "All the treasures of wisdom and knowledge" do indeed await the awestruck visitor. The monastery, now secularized, has been collecting these treasures since the mid-18th century and storing them in its rococo hall, which is one of the finest of its kind anywhere in the world. With its curved balustrades, exquisite paintings, and incredible works of sculpture, the library takes up the entire north wing. Its splendor was such that it was used as a room for receiving important guests. To ensure that nothing could detract from the opulent interior, the spines of all the books were covered in light-colored paper or painted white—an unorthodox yet effective method. A breathtaking ceiling fresco painted by Franz Martin Kuen soars above the books. It depicts divine wisdom personified as a female figure surrounded by angels, watching over the treasures of Wiblingen.

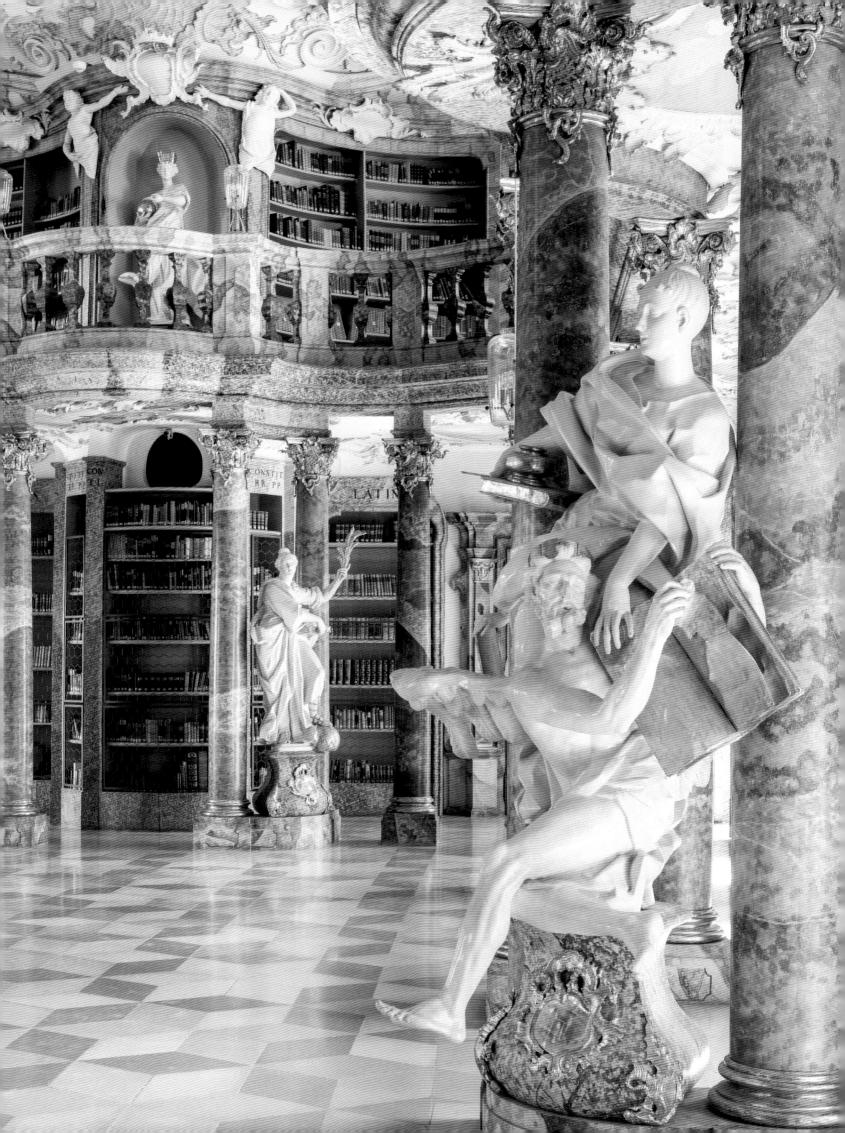

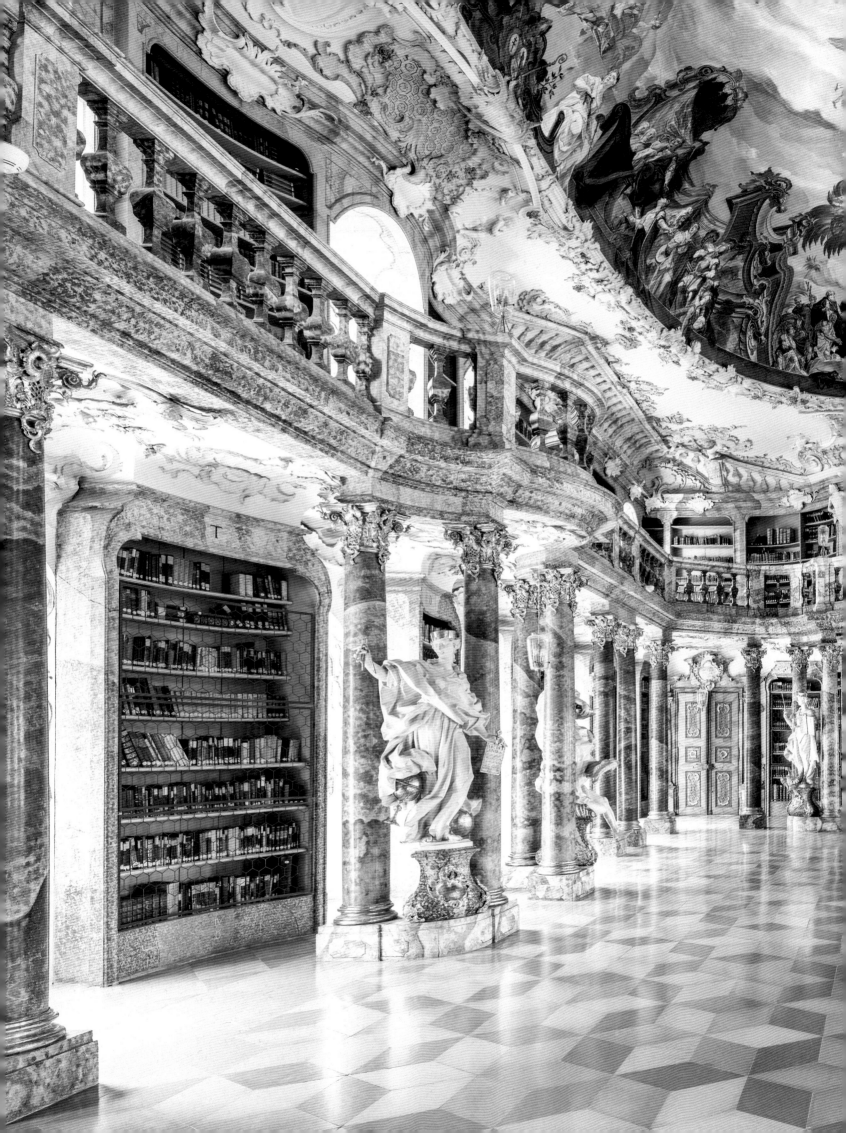

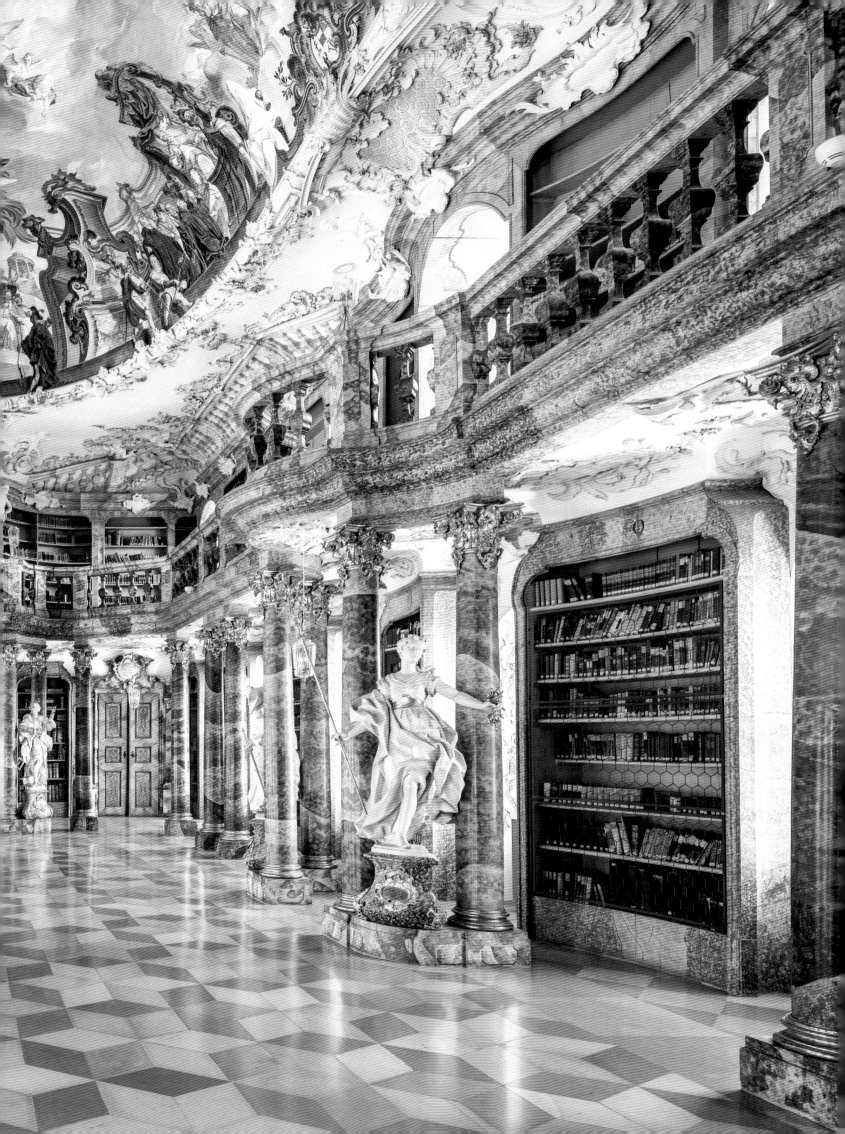

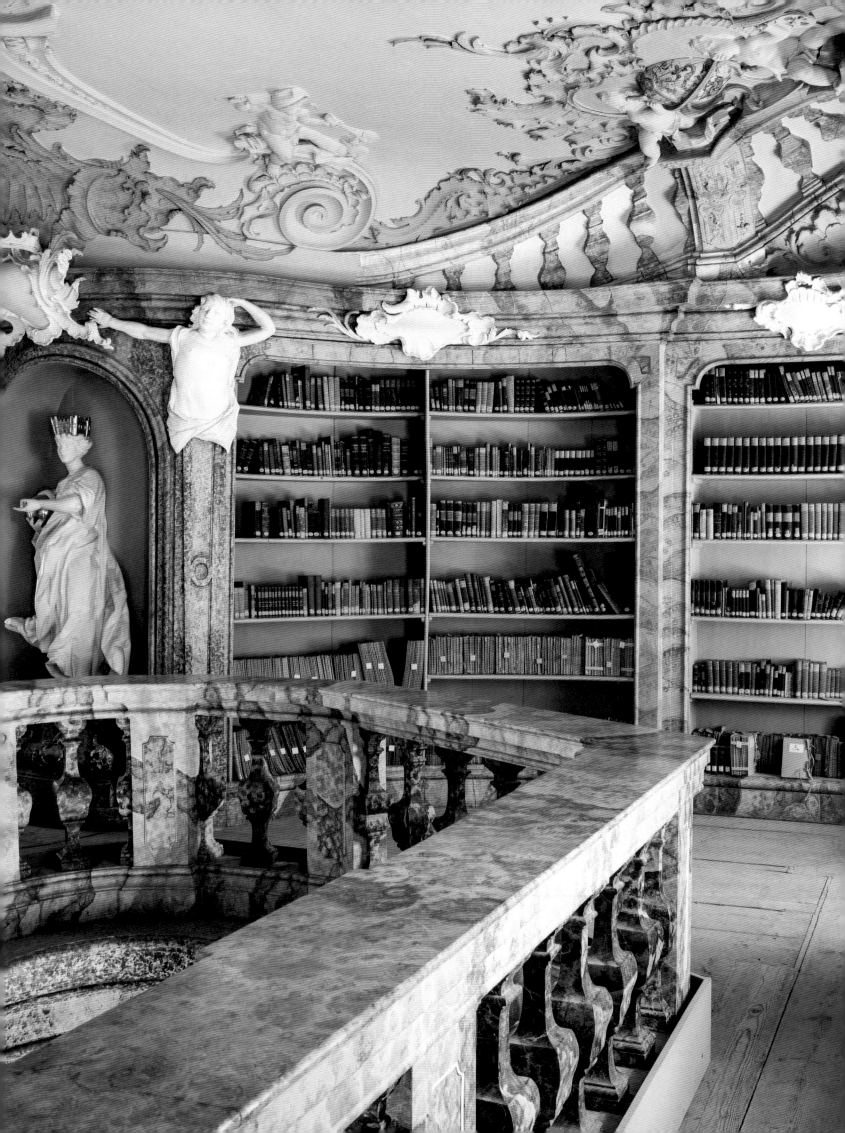

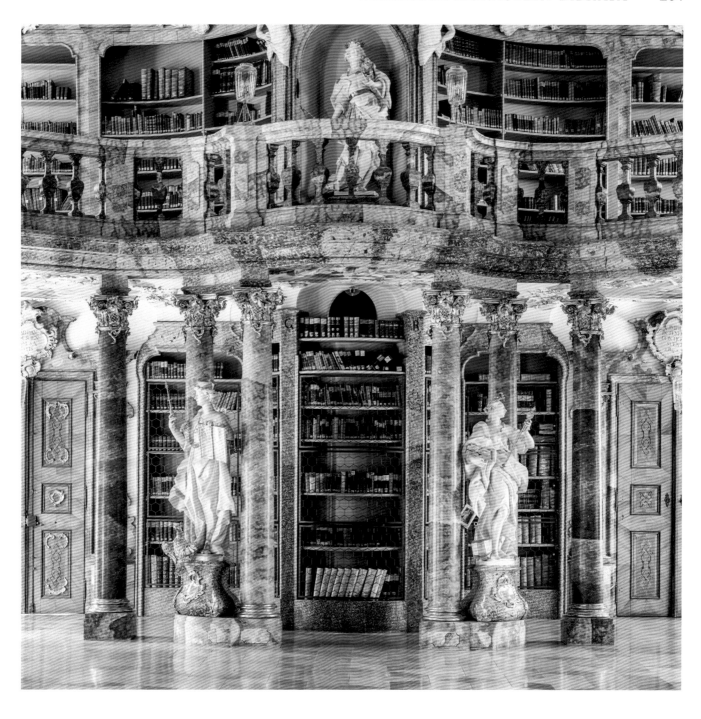

In its heyday, Wiblingen Monastery Library held some 15,000 books—more than the entire stocks of many university libraries today. When the site became secularized, most of the priceless volumes ended up in other libraries.

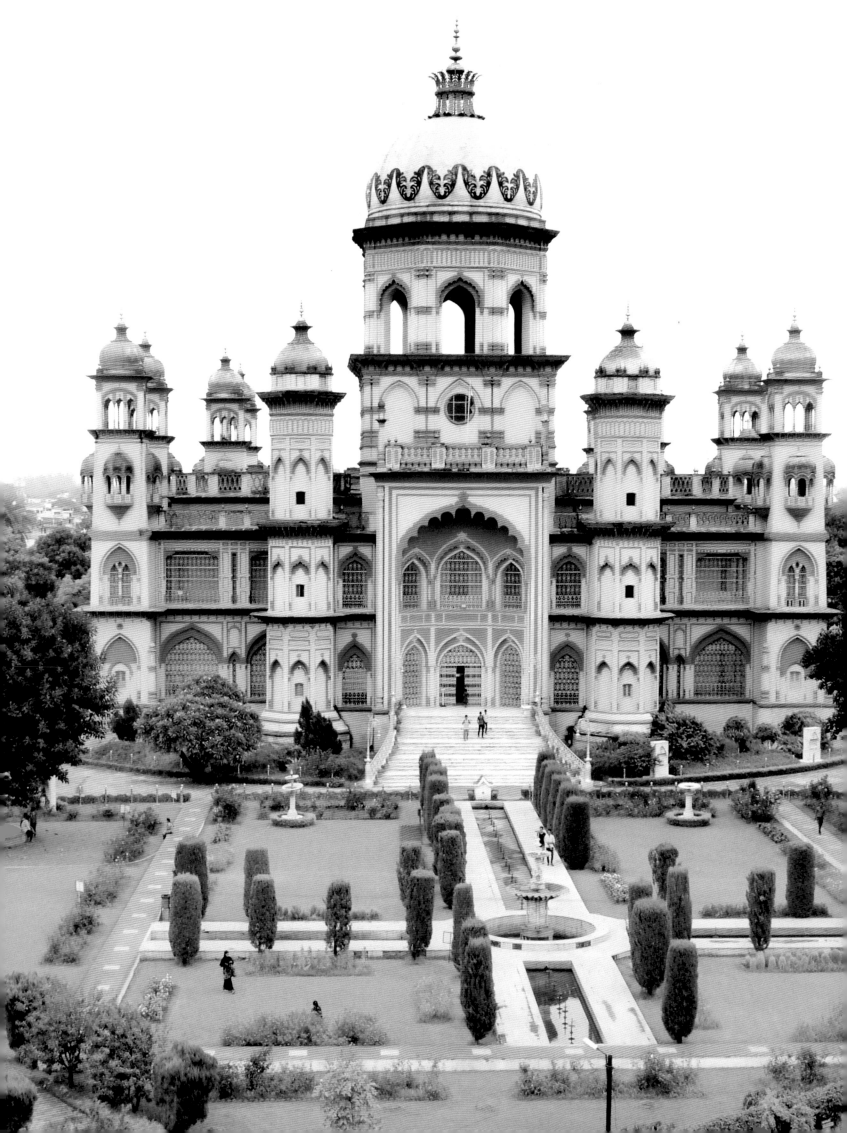

RAMPUR RAZA LIBRARY

How the personal collection of a state founder became one of the most important libraries in India

TRADITIONAL DESIGN
FOUNDED IN THE LATE 18TH CENTURY
RAMPUR, INDIA

If you can found an entire state, you can found a library! That was the thinking when Nawab Faizullah Khan, founder of Rampur State, decided to expand his personal collection of a few valuable manuscripts and Islamic texts into a remarkable treasury of knowledge. Over his reign (1774–1794), the Nawab acquired remarkable examples of calligraphy, astronomical instruments, illustrated works, and much more. His successor, Nawab Ahmad Ali Khan, also went down in history as a generous patron who lavished money on expanding the library and promoting poets, painters, calligraphers, and scholars. All this activity bolstered the city's reputation. India was rocked by the struggle for freedom from the British settlers in the mid-19th century, after which many writers and scholars settled in Rampur. More and more treasures found their way into the library. The rule of the Nawabs came to an end in 1949 when Rampur joined the Union of India, but their library exists to this day and is now in the care of the Indian Ministry of Culture.

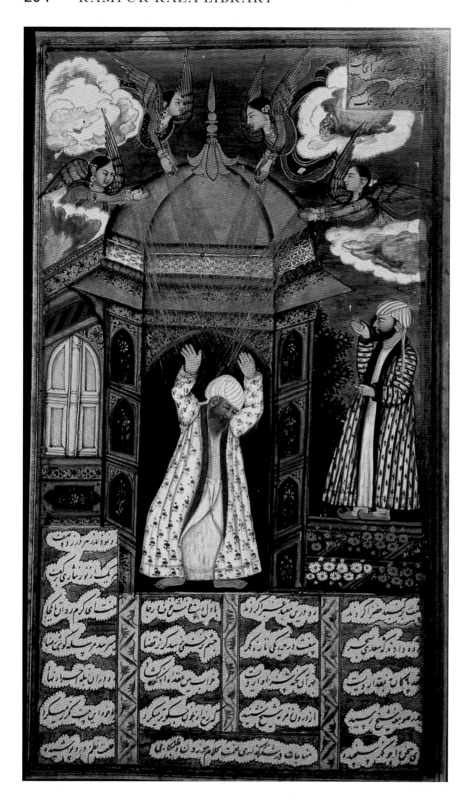

The Rampur Raza Library is home to priceless manuscripts and illustrated books.
Like other countries, India owes many of its most precious cultural assets to the zeal
for collecting of individual patrons and art lovers.

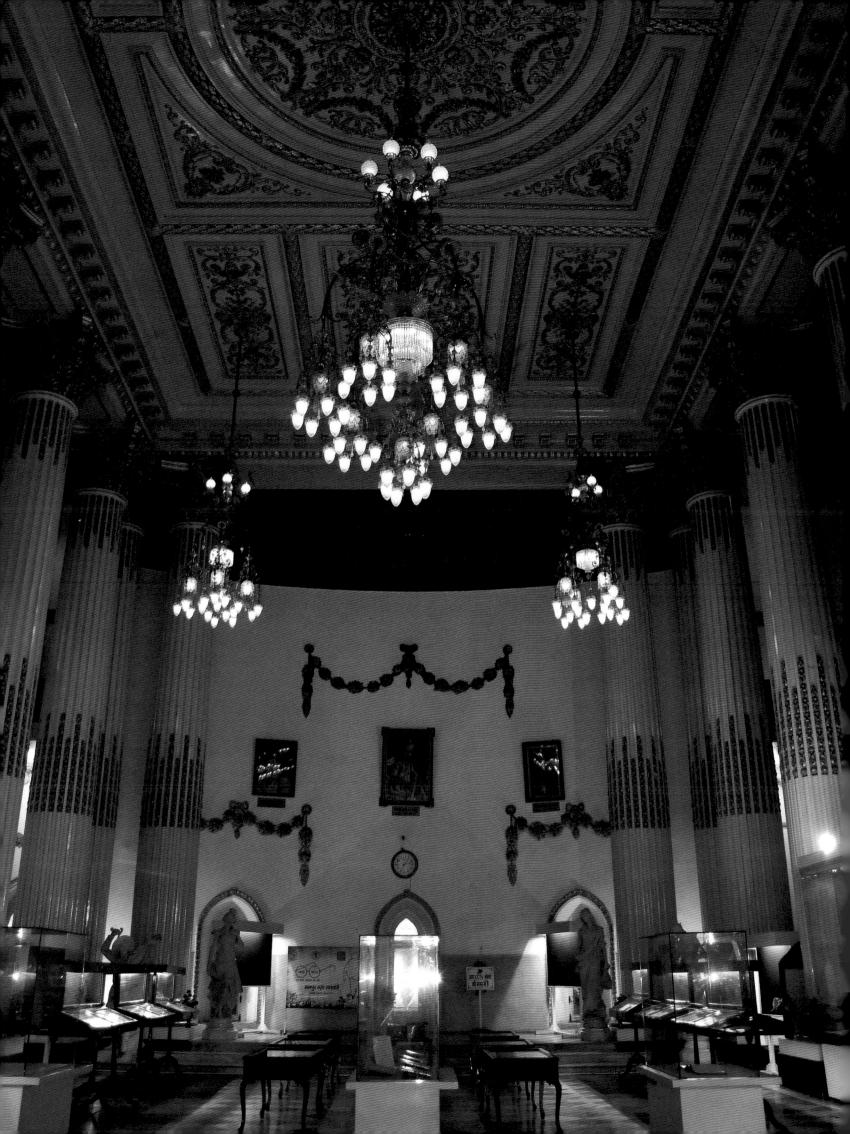

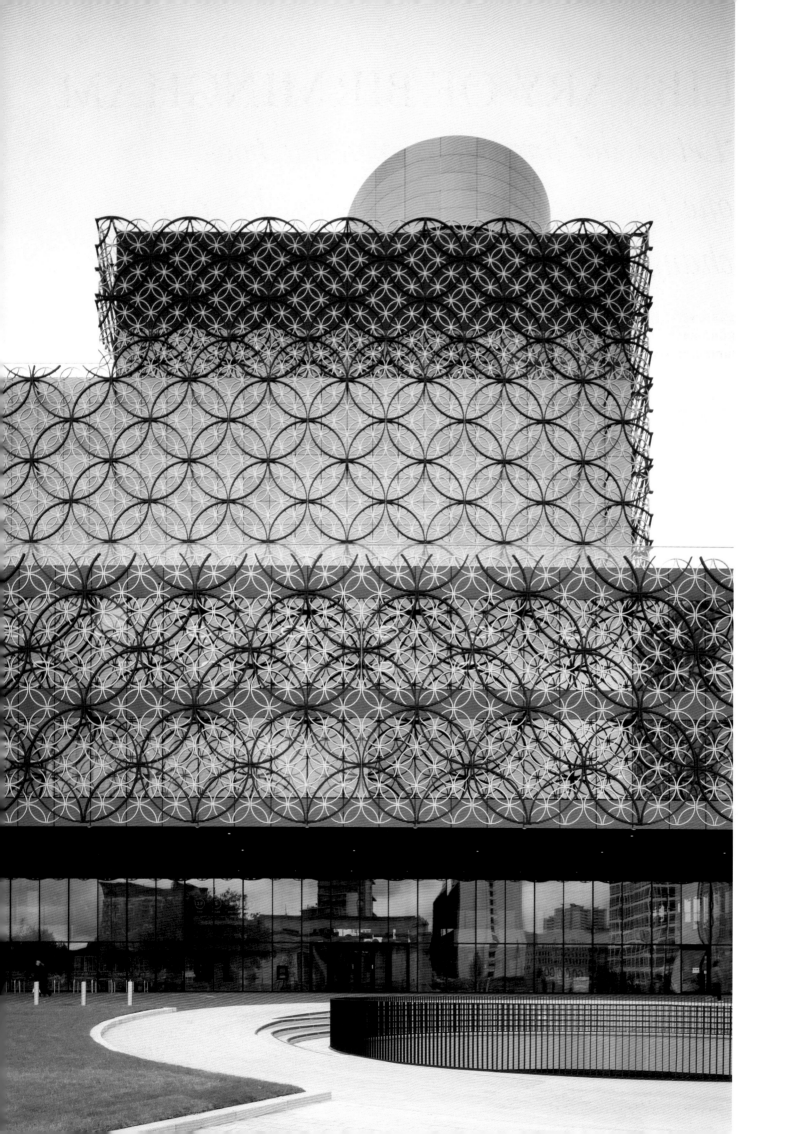

LIBRARY OF BIRMINGHAM

"Let us not forget that even one book, one pen, one child, and one teacher can change the world!"

DESIGNED BY FRANCINE HOUBEN / MECANOO
BUILT 2010–2013
BIRMINGHAM, UK

When Pakistani Nobel Peace Prize laureate Malala Yousafzai opened the Library of Birmingham on September 3, 2013, she gave a speech emphasizing the importance of books: "Some books can travel you back centuries, and some take you into the future. In some books, you will visit the core of your heart, and in others, you will go out into the universe. Books keep one's feelings alive. Aristotle's words are still breathing, Rumi's poetry will always inspire, and Shakespeare's soul will never die." Dutch architect Francine Houben and her studio Mecanoo designed the library to serve as the beating literary heart of this multicultural university city. The delicate metal rings on the façade make reference to Birmingham's craft traditions, which are founded on metalwork from steel processing to goldsmithing. The rings are also an integral part of the architecture, casting gentle shadow patterns into the library, depending on how they catch the light. Unusually, the library archives are stored on the upper floors, so their incalculable value is literally on show. Yousafzai's closing words expressed the whole ethos behind this library: "Let us not forget that even one book, one pen, one child, and one teacher can change the world."

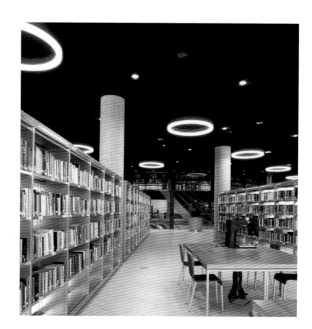

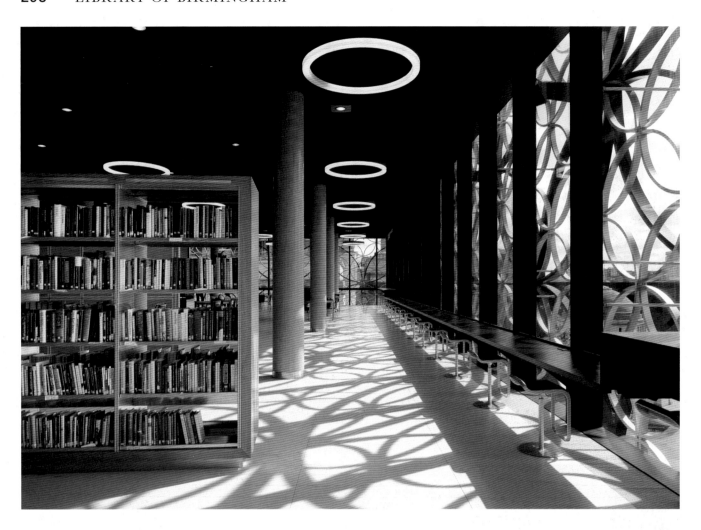

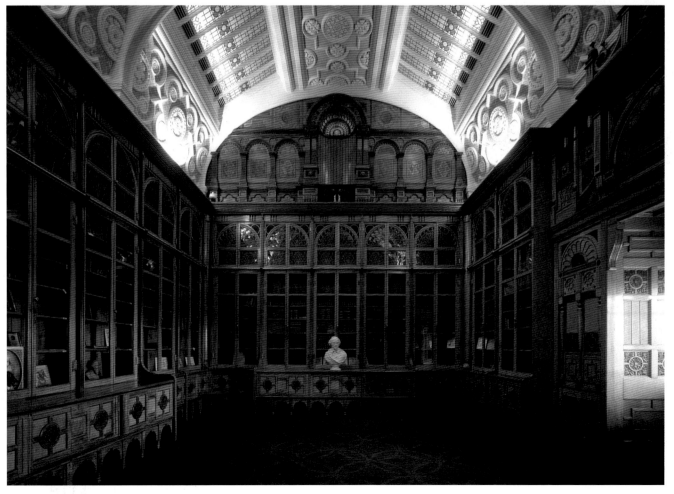

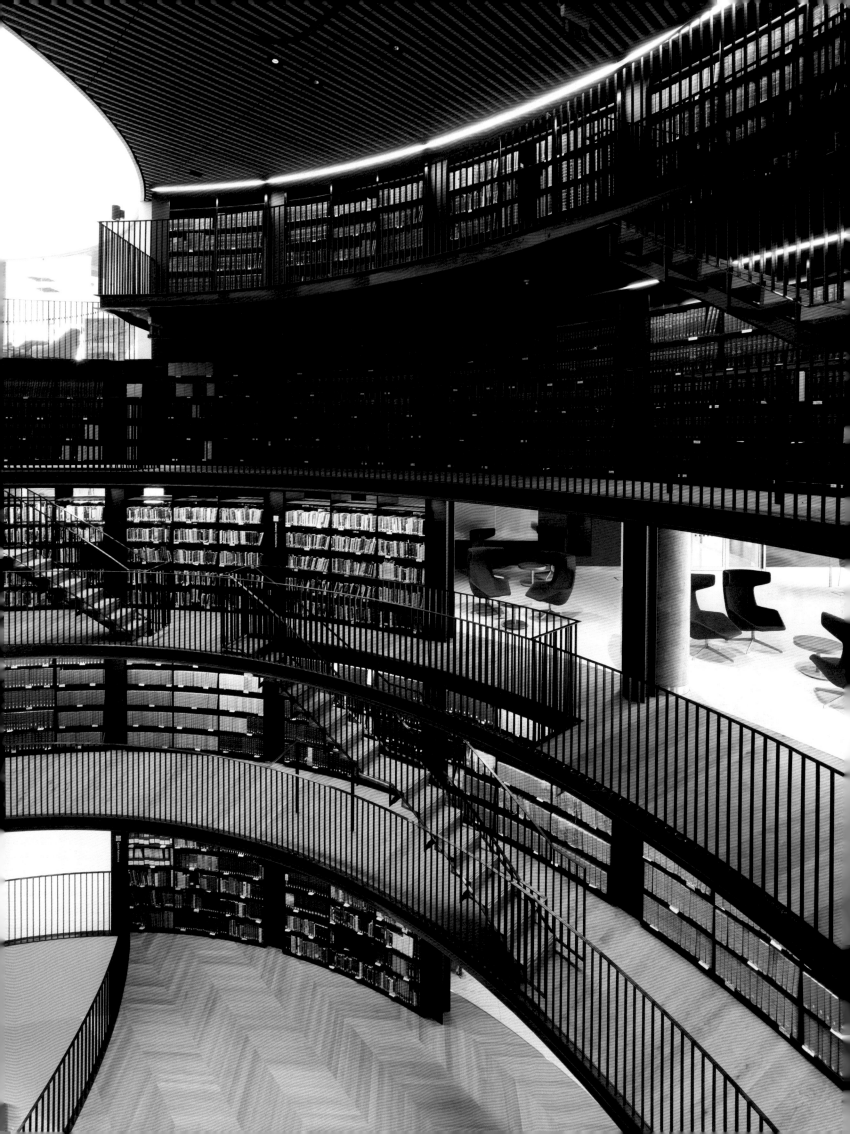

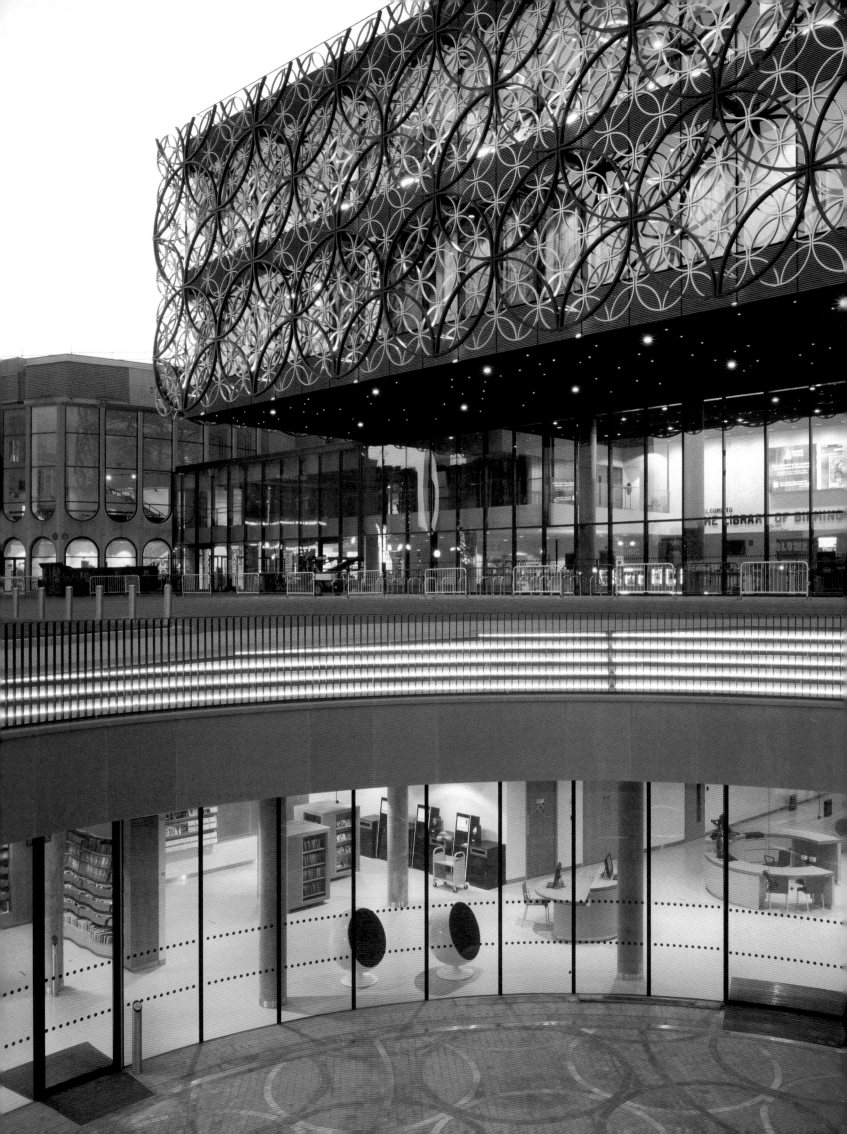

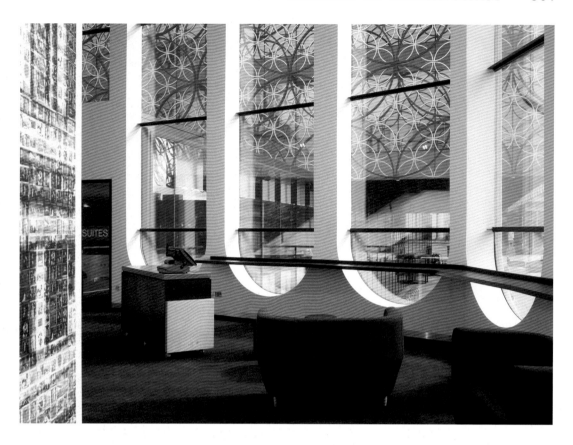

Behind the modern façade of the Library of Birmingham lies an unexpected scene from history. The upper floor contains the wood-paneled Shakespeare Memorial Room (see page 298), which was saved from the city's very first Central Library and reintegrated into its new incarnation.

AL-QARAWIYYIN LIBRARY
Fez, Morocco
Photos: Chris Griffiths/Getty Images
(pp. 174–175)

ALTENBURG MONASTERY
LIBRARY
Altenburg, Austria
stift-altenburg.at
Photos: Reinhard Görner (pp. 140, 142–143),
imageBROKER/Alamy Stock Photo (p. 141)

AUSTRIAN NATIONAL
LIBRARY
Vienna, Austria
onb.ac.at
Photos: Reinhard Görner (pp. 236, 238–240),
Pavel Dudek/Alamy Stock Photo (p. 241 top),
Peter Schickert/Alamy Stock Photo (p. 241
bottom), P. Batchelder/Alamy Stock Photo
(pp. 242–243)

BEINECKE RARE BOOK
AND MANUSCRIPT LIBRARY
New Haven, Connecticut, USA
beinecke.library.yale.edu
Photos: Reinhard Görner (pp. 176, 177, 178
top), Caryn B. Davis Photography (p. 178
bottom), Iwan Baan (p. 179)

BERLIN STATE LIBRARY
Berlin, Germany
staatsbibliothek-berlin.de
Photos: bpk/Jörg F. Müller (p. 144),
pundapanda/Alamy Stock Photo (p. 145),
Reinhard Görner (pp. 146–149)

BIBLIOTHECA ALEXANDRINA
Alexandria, Egypt
bibalex.org/en
Photos: Petr Svarc/Alamy Stock Photo (p. 222),
DigiLog/Alamy Stock Photo (p. 223),
John Carillet/Getty Images (p. 224 top),
Insights/Getty Images (p. 224 bottom),
Giuseppe Cacace/Getty Images (pp. 225, 227),
Athanasios Gioumpasis/Getty Images
(p. 226 top), Emily Marie Wilson/Alamy Stock
Photo (p. 226 bottom)

BIBLIOTECA DA CRUZ
VERMELHA PORTUGUESA
Lisbon, Portugal
cruzvermelha.pt/alugue-o-nosso-palácio
Photo: Reinhard Görner (p. 103)

BIBLIOTHÈQUE DE
L'INSTITUT NATIONAL
D'HISTOIRE DE L'ART
Paris, France
inha.fr
Photos: Raphael Gaillarde/Getty Images
(pp. 114, 117 top), Reinhard Görner
(pp. 115–116, 118–119), CNMages/
Alamy Stock Photo (p. 117 bottom)

BIBLIOTECA DEL PIFFETTI
Rome, Italy
palazzo.quirinale.it/palazzo_en
Photos: Image Source/Getty Images (p. 180),
AGF Srl/Alamy Stock Photo (p. 181),
Reinhard Görner (pp. 182–183)

BIBLIOTHÈQUE DU SÉNAT
Paris, France
senat.fr/patrimoine/bibliotheque.html
Photos: Thomas Guignard (pp. 126–129),
courtesy of Bibliothèque du Sénat

BIBLIOTECA JOANINA
Coimbra, Portugal
uc.pt/en/informacaopara/visit/paco/library
Photos: Reinhard Görner (pp. 84, 86–87),
Ana Fidalgo/Alamy Stock Photo (p. 85)

BIBLIOTECA VASCONCELOS
Mexico City, Mexico
bibliotecavasconcelos.gob.mx
Photos: Iwan Baan (pp. 228–231, 235 top),
Reinhard Görner (pp. 232–234, 235 bottom)

BODLEIAN LIBRARIES
Oxford, UK
bodleian.ox.ac.uk
Photos: Dan Patten (pp. 218, 219 bottom,
220 bottom), John Cairns (pp. 216–217),
Mieneke Andeweg-van Rijn/Alamy Stock
Photo (p. 219 top), Courtesy of Bodleian
Libraries (p. 220 top)

CLASS OF 1945 LIBRARY
Exeter, New Hampshire, USA
Photos: Reinhard Görner (pp. 264–265, 267,
270–271), Iwan Baan (pp. 266, 268–269)

CUYPERSBIBLIOTHEEK
Amsterdam, Netherlands
oba.nl
Photos: Reinhard Görner (pp. 158–161), Sjoerd
van der Wal/Getty Images (pp. 162–163)

DEPETRUS LIBRARY
Vught, Netherlands
depetrus.nl
Photos: Stijn Poelstra (pp. 18–21)

FYYRI LIBRARY
Kirkkonummi, Finland
Photos: Courtesy of JKMM
ARKKITEHDIT, Tuomas Uusheimo
(pp. 22, 24, 29), Pauliina Salonen (pp. 23, 25),
Marc Goodwin (pp. 26–27), Saas (p. 28)

GEISEL LIBRARY
San Diego, California, USA
libraries.ucsd.edu
Photos: Darren Bradley (pp. 244, 246–249),
Felix Lipov/Alamy Stock Photo (p. 245)

GEORGE PEABODY LIBRARY
Baltimore, Maryland, USA
peabodyevents.library.jhu.edu
Photos: Reinhard Görner (pp. 94, 96 bottom, 97),
Jon Bilous/Alamy Stock Photo (p. 96 top)

HUNTERS POINT LIBRARY
New York, New York, USA
queenslibrary.org/about-us/locations/hunters-point
Photos: Iwan Baan (pp. 44–51)

HYUNDAI CARD COOKING LIBRARY
Seoul, South Korea
Photos: Kyungsub Shin (pp. 78–83)

JESUIT LIBRARY AT
MARIA LAACH ABBEY
Maria Laach, Germany
maria-laach.de
Photos: Ernst Wrba/Alamy Stock Photo (p. 30),
Ferdinand Luckner (pp. 31–37)

LIBRARY OF BIRMINGHAM
Birmingham, UK
birmingham.gov.uk/libraryofbirmingham
Photos: Christian Richters (pp. 296–301)

THE LIBRARIES OF CHINGUETTI
Chinguetti, Mauritania
Photos: Jean Luc Manaud/Getty Images
(pp. 170, 173), Pascal Mannaerts/Alamy
Stock Photo (p. 172)

LIBRARY OF MUYINGA
Muyinga, Burundi
Photos: BC architects & studies (pp. 137–139)

LIBRARY OF THE HISTORY
OF HUMAN IMAGINATION
Ridgefield, Connecticut, USA
walkerdigital.com/
the-walker-library_welcome.html
Photos: Caryn B. Davis Photography
(pp. 108–112)

LIBRARY OF THE HUNGARIAN
PARLIAMENT
Budapest, Hungary
ogyk.hu/en
Photos: Thomas Guignard (pp. 130–136)

LINCOLN COLLEGE LIBRARY
Oxford, UK
lincoln.ox.ac.uk
Photos: LatitudeStock/Alamy Stock Photo (p. 56),
Reinhard Görner (p. 57)

LOCHAL
Tilburg, Netherlands
bibliotheekmb.nl/vest/lochal
Photos: Stijin Bollaert (pp. 64–71)

TEMPLES OF BOOKS
Magnificent Libraries Around the World

This book was conceived, edited, and designed by gestalten.

Edited by Robert Klanten and Elli Stuhler
Contributing editor: Marianne Julia Strauss
Written by Marianne Julia Strauss

Translation from German to English by Maisie Fitzpatrick in association with First Edition Translations Ltd, Cambridge, UK

Editorial Management by Lars Pietzschmann

Head of Design: Niklas Juli
Cover, design, and layout by Stefan Morgner

Photo Editor: Valentina Marinai

Typefaces: Baskerville by John Baskerville,
Neue Haas Unica by Toshi Omagari

Cover photography by Stijn Poelstra (DePetrus Library, Netherlands)
Backcover image by Pauliina Salonen (Fyyri Library, Finland)

Printed by Grafisches Centrum Cuno GmbH & Co.KG, Calbe (Saale)
Made in Germany

Published by gestalten, Berlin 2022
ISBN 978-3-96704-024-1

2nd printing, 2022

Bibliographic information published by the Deutsche Nationalbibliothek. The Deutsche Nationalbibliothek lists this publication in the Deutsche Nationalbibliografie; detailed bibliographic data is available online at www.dnb.de

None of the content in this book was published in exchange for payment by commercial parties or designers; gestalten selected all included work based solely on its artistic merit.